Ethics
and
the
Visual
Arts

Edited
by
Elaine A. King
and
Gail Levin

**ALLWORTH
PRESS**
NEW YORK

09 08 07 06 5 4 3 2 1

Published by Allworth Press
An imprint of Allworth Communications, Inc.
10 East 23rd Street, New York, NY 10010

Cover design by Derek Bacchus
Interior design by Joan O'Connor
Typography by Integra Software Services, Pondicherry, India
Cover photo by Anne Chauvet

ISBN-13: 978-1-58115-458-0
ISBN-10: 1-58115-458-5

Library of Congress Cataloging-in-Publication Data

Ethics and the visual arts / edited by Elaine A. King and Gail Levin.
 p. cm.
 Includes index.
1. Art—Moral and ethical aspects. I. King, Elaine A. II. Levin, Gail, 1948-

N72.E8E85 2006
701—dc22

 2006013942

Printed in the United States of America

CONTENTS

ILLUSTRATIONS

A Perspective
on Ethical
Art Practice

Elaine A. King and Gail Levin

In February 2002, at the annual meeting of the College Art Association, Gail Levin organized a panel entitled "Ethics in the Art World," on which Elaine A. King and Elizabeth A. Sackler presented papers. This session was well received by the audience—many people expressed an interest in seeing this session published. We ultimately decided to expand the range of topics and compile an anthology on this subject.

Questions of ethics in the art world usually receive little attention until breaches force issues into the public eye. Many ethical violations also constitute illegal acts; however, law enforcement is sporadic, while significant ethical issues remain. Throughout 2005, our subject, ethics and the visual arts, was so timely that as we were finalizing this manuscript, Michael Kimmelman, chief art critic for the *New York Times*, captioned his review of the year's "Highs and Lows" as "Old Masters and New Ethical Lapses."[1] In fact, ethical lapses in the visual arts during the past year—museums dealing with for-profit exhibition organizers and vain collectors who demand control, looted antiques from abroad, and the de-accessioning of civic treasures—came so fast and furious that our only regret was not having enough space to feature each instance in this volume. We are satisfied, however, that the range of essays already planned touches upon all of these issues.

In choosing the essayists and themes, we drew upon our joint experiences working in the capacities of curator, historian, artist, critic, and museum director. We sought out experts in the field in order to present an

overview of some of the most pressing ethical issues confronting art professionals on a daily basis. Some might question that the issue of ethics in the art world requires such treatment. Yet by now, works of art have gained increased investment value and commodity status. This significant shift affects both policy and practice in museums, artists' studios, conservation laboratories, commercial galleries, and auction houses, as well as among critics and historians.

Writers about art have suffered from the fashion called "appropriation," which since the onset of postmodernism in the early 1970s has encouraged plagiarism, by now a widespread and unethical cultural practice. The advent of the Internet as a global information marketplace has compounded this issue. Some museums have gone so far as to credit Web designers and other individuals, while pillaging original research from scholars whose names go unmentioned.

Museums frequently exploit curators as "writers for hire," sometimes demanding catalog texts without allowing the curator sufficient time to produce original scholarship. This too often serves to encourage curators to borrow without adequately acknowledging the sources consulted. Since museums generally control the copyright of employees' writing, curators who leave an institution have found that museums can publish or republish their work, even without notification or giving the writer the ability to correct or update a text. Other curators have faced the refusal of museums to allow them to collect or republish their own writings. This takes place despite the fact the institution has no further use for this material and no intention to reprint it. To deny a curator access to professional writings after he or she has left a museum only restricts the availability of often-valuable information to scholars and other interested parties.

Put into such a disadvantageous position, it is no wonder that curators routinely shift between the nonprofit sector and commercial galleries and auction houses. Over the past few decades, we have witnessed the breakdown of traditional boundaries between professional roles in the nonprofit and for-profit sectors of the art establishment. At the same time, museums have lost sight of their core values and begun to manifest some of the worst corporate practices.

Illegal and unethical behavior in the corporate and business worlds continues to proliferate, so much so that the notorious scandals at Enron, Tyco, and several auction houses no longer shock us. Corporate donors and collectors with questionable motives increasingly replace traditional sources of funding—as the seemingly more altruistic patrons of the past have given way to more materialistic and scheming collectors. At the same

time, government agencies have become more tenuous and restricted in what they fund. Yet, operating costs of museums keep rising, as both the public and the media demand bigger and more spectacular displays. Over the past few decades, this growing need for more and more money has prompted museums to engage in compromising and unethical practices. These changes in behavior have impacted all arts professionals for whom issues of ethics are constantly surfacing.

Art museums were among the most important arbitrators of culture in the twentieth century and continue to play a significant role in the twenty-first. These institutions evolved in an era of global politics and military conquest in the late nineteenth and early twentieth centuries. Therefore, they became the repositories and transmitters of national ideals and values. As such potent symbols of culture, they wield tremendous authority and power in contemporary society and as such must adhere to a high ethical standard. The artifacts museums house shape both the history of the institution and the broader culture. Thus, multiple ethical issues surround the acquisition and deaccessioning of art objects.

The nineteen authors whose essays are included in this anthology range from experienced professionals to emerging young scholars. We have drawn upon the experiences of art historians, critics, artists, museum curators, directors, trustees, arts administrators, and lawyers, as well as an appraiser and a foundation director. With the exception of the essays by Eric Fischl, Richard Serra, and the late Stephen Weil, all of the texts appear here for the first time.

Among the contributors, only the anthology's two editors have read all of the other essays in this volume. As editors, we have allowed each author to express his or her own opinion, but no reader should assume that any one contributor necessarily agrees with any other. In some cases, high-profile occurrences in the art world—such as the *Sensation* exhibition at the Brooklyn Museum, the Metropolitan's *Chanel* exhibition, and Nazi plundering during the Holocaust—are discussed for different reasons and from different angles by several authors in this volume. We purposely sought diverse viewpoints and do not endorse any single ideology. Instead we hope that the writings in this volume will open necessary, substantial, and on-going conversations on ethics and the visual arts.

In chapter 1, "So, What's the Price?—*The PM Principle*—Power, People, & Money," Elaine A. King focuses on museum ethics or how the lack of ethics governs an institution's philosophy and practice—behavior, content, and message. It deals with the interrelationship between people and the museum as a nonprofit organization. The effects of private and

corporate philanthropy on museums and its implications for museum management and mission are central to this essay. Like an individual, a museum is constantly called upon to make choices, to take actions, and, in so doing, measure its values. An important question for museum professionals and trustees is whether they deserve special norms and ethics to guide their conduct. Undeniably ethical right or wrong can vary enormously. We need to ask, when does a museum allow special privileges to one person or group of persons that is not available to everyone?

Alan Wallach in chapter 2, "The Unethical Art Museum," discusses the ethical obligation of museums to their publics and delves into questions of museum audiences: how the museum addresses them; the assumptions it makes about visitors, or what might be called an "ideal visitor"; and how this affects actual visitors—and non-visitors (why the museum is off-putting for so many).

In chapter 3, "Consuming Emancipation: Ethics, Culture, and Politics," Saul Ostrow focuses on the political and economic function of culture in the broadest sense. He argues that aesthetics and ideology now take priority over ethics as a result of capitalism's reorganization of its production strategies. Western society's emphasis on the cultural self-realization of the individual masks capitalism's resistance to economic and institutional reform of property and power relations.

Tom L. Freudenheim's "Museum Collecting, Clear Title, and the Ethics of Power," chapter 4, reviews differences among potentially difficult issues of collecting and ownership. He examines the issue of clear title and repatriation of art stolen during the Holocaust era, as well as of antiquities obtained illegally from Africa, Asia, Europe, and Iraq as a consequence of the current war. His discussion illuminates the issues surrounding the current controversies about the past collecting policies of the Getty and Metropolitan museums. He explores the way in which a variety of constituencies can politically affect acquisition policy.

In chapter 5, "Politics, Ethics, and Memory: Nazi Art Plunder and Holocaust Art Restitution," Ori Soltes asks how, morally and methodologically, the plunder of cultural property by the Nazis parallels or differs from plunder at other times and places and under other circumstances. In this essay, the author considers how the Nazi methodology of pillage not only informs us about the efforts of the Nazis and their associates, but also about the world and lives of those dispossessed of their belongings.

The important topic of repatriation and how ignorance, racism, and greed tend to fuel resistance and attitudes about American Indian "art" is the subject of Elizabeth A. Sackler's essay, "Calling for a Code of Ethics in

the Indian Art Market," in chapter 6. More than a decade has elapsed since the passage of the Native American Graves Protection and Repatriation Act (NAGPRA) that protects federal lands and requires federally funded institutions to repatriate specific ritual items. American Indian individuals, attorneys, spiritual healers, and advocates lobbied for ten years to usher this human rights crisis into legislation. NAGPRA, however, does not cover the private sector. Thus, the education of collectors of Indian "art" is critical to the creation of a moral philosophy that would inspire ethical behavior that parallels the spirit of the law. She argues that the large obstacle facing repatriation is that the conquest of the Western Hemisphere and the cultural genocide of the First Peoples are seldom taught in educational institutions.

Nada Shabout's text, "The Preservation of Iraqi Modern Heritage in the Aftermath of the U.S. Invasion of 2003," in chapter 7 provides significant insights about complex cultural implications that reach beyond the immediate loss and destruction of artifacts. Her essay delves into the ethical ramifications of the complete failure by the occupying power to protect Iraq's modern heritage. It unfolds in relation to two broad categories: the destruction and loss of the collection of the Iraqi Museum of Modern Art and the spatial reconfiguration of the city of Baghdad in combination with its public monuments. She warns that the results will alter the path of the future development of Iraq's contemporary visual production.

Alex Rosenberg in "Ethics of Appraising Fine Art," in chapter 8, examines the subject of ethics and unethical practice in the realm of art appraisals. Rosenberg stresses that in appraising one must only work for the truth. Ethical standards demand that an appraiser must be impartial, honest, and accurate at all times. Even though appraisers are hired and paid by a client, the results cannot and should not be influenced by the apparent needs of the client or organization. A small alteration of opinion brought about by one desiring to be helpful is the beginning of an often-imperceptible road to changing one's ethical standards.

In chapter 9, Gail Levin's essay, "Artists' Estates: When Trust Is Betrayed," explores the question of ethical practices surrounding the estates of such artists as Mark Rothko, Kurt Schwitters, Francis Bacon, and Edward Hopper and his artist wife, Jo Hopper. It questions how art from Hopper's childhood ended up in the art market and not with the rest of his artistic estate, which was bequeathed to the Whitney Museum of American Art. It asks what ethical responsibilities trustees of artists' estates have, how things go wrong, and what can be done to prevent future problems.

In "The Moral Case for Restoring Artworks," chapter 10, James Janowski raises philosophical questions that arise concerning the conservation of artworks. This essay focuses on when, if ever, it is appropriate to intervene on behalf of an artwork in the interest of restoring it. And, assuming intervention is at times appropriate, what sorts of restoration are justified? What sorts misguided? And why? Marking off a space in the debate between "purist" and those who defend "integral" restoration, Janowski argues that intervening on behalf of an artwork, though not metaphysically and morally cost-free, is, under certain circumstances, quite appropriate.

Joan Marter in chapter 11, "Ethical Issues and Curatorial Practices," imparts an insightful discussion about the complexities that arise when scholars are hired by museums as outside contractors or guest curators to work on specific projects that might fall outside the expertise of staff members. These assignments sometimes come about when curators at a specific institution are too busy to support a full schedule of temporary exhibitions. In any case, guest curators often bring innovative ideas as well as substantive expertise and knowledge to a museum project. For the guest curator, however, the collaboration with museum staff can result in problems that compromise the intellectual integrity of the contractor's work. The most egregious of these infractions is scholarly erasure, but there are other situations that can seriously affect the proper acknowledgment of a scholar's contributions to a project.

Stephen Weil's "Fair Use and the Visual Arts: Please Leave Some Room for Robin Hood," chapter 12, proposes that "the realms of verbal and the visual are so fundamentally different that the rules developed to govern the law of fair use in one realm—language-based rules developed primarily in the context of the printed word—are not necessarily the most productive rules by which to govern fair use in the other." His argument is that there should be a different standard for copyright in the visual arts and the examples he provides powerfully make this case.

In chapter 13, "Interrogating New Media: A Conversation with Joyce Cutler-Shaw and Margot Lovejoy," Deborah J. Haynes presents an interview with artists who work in electronic media. It explores the interrelationship of art, technology, and ethical issues, especially the human effects of the interface of the virtual and "the real." This discussion addresses a series of questions concerning artists' engagement with the virtual and the effects upon our phenomenological world such as: What are the dominant moral values that are defined by and are defining our engagement with virtual technologies? The addiction to virtual technologies seduces and controls

artists through creating pleasurable and entertaining experiences. How do issues of the digital divide and unequal access to new technologies affect artists? Why is this a significant ethical issue? What is the nature of ethical responsibility in a networked culture? To which community is an artist ethically responsible?

"Art and Censorship," chapter 14, is based on the sculptor Richard Serra's speech delivered in Des Moines, Iowa, on October 25, 1989, which first appeared in *Critical Inquiry* (Vol. 17, Spring 1991, pp. 574-581). The federal government's General Services Administration (GSA) commissioned this public artwork, entitled *Tilted Arc*, for a permanent installation on the plaza in front of the U.S. Federal Building in New York City in 1979 and installed it in 1981. After vociferous public complaints, a controversial legal hearing exercising proprietary rights took place and resulted in the GSA's removal of this sculpture on March 15, 1989, effectively destroying this site-specific work.

Eric Fischl's essay, in chapter 15, "The Trauma of 9/11 and Its Impact on Artists," first appeared as an op-ed piece in the *New York Times*. He was responding to the removal of his sculpture, which memorialized the tragedy of 9/11, by authorities at Rockefeller Center in New York City. His piece, *Tumbling Woman*, depicts a nude, falling figure. Fischl sought to memorialize the tragic deaths in order to foster strength among the living. This work is a powerful response to the vulnerability encountered that day and attempts to capture the universality of that traumatic event. The text printed here is the unedited version of the artist's views.

In her essay, "Art Enters the Biotechnology Debate: Questions of Ethics," in chapter 16, Ellen K. Levy focuses on how certain artists explore ethical questions surrounding biotechnology. She discusses the ethical concerns specifically raised by artists using "wet lab" techniques associated with biotechnology. As increasing numbers of artists use or purport to use recombinant DNA (rDNA) technology (also known as genetic engineering or "gene splicing") to make art, questions of significant ethical dimensions arise from these novel artistic practices. Should there be constraints on the artistic use of such technology, and if so, under what circumstances? Should all artists be afforded access to the necessary equipment? What is the proper role of the university with regard to monitoring wet labs? Should artists necessarily disclose whether their methods are real or simulated? She explores these and other possible consequences of artists who choose to experiment with new life forms.

In "Earthworks' Contingencies," in chapter 17, Suzaan Boettger examines issues of ethics surrounding earthworks. She considers the possible

degradation of the environment and that these works physically deteriorate. What should or perhaps should not be done about this process that is inevitable and ongoing? She also takes up the thorny issue of authorship with regard to the posthumous creation of works based only upon Robert Smithson's sketches. She raises the larger issue of whether an artist's estate can continue to produce work based upon that artist's ideas and plans, and still call it authentic.

Robert Morgan's essay in chapter 18, "Unraveling the Ethics in Cultural Globalization," states that human conscience must play a distinctive role in how we determine the ethical consequences of our actions in the future. His concern is with the future of cultural globalization. He feels that the role of art as a substantive and transformative force will only be realized if art liberates itself from the pressure that corporate constraints have on determining its future. He does not argue that artists should ignore economic opportunities to further their ability to work and to succeed. This is not his point. It is a matter of seeing the larger picture from within the perspective of history, not only from the presence of the past, but also in the context of the present. He affirms that if art continues to function according to the agenda of economic globalization without a clear cultural agenda, it will lose its significance and become a sideshow in the wake of commercial media.

In chapter 19, Barbara Hoffman explores conflict of interest issues in her essay, "Law, Ethics, and the Visual Arts: The Many Facets of Conflict of Interest." She considers that no art expert certifying authenticity, museum exhibition sponsor, or trustee of an artist's estate should be in a position to benefit financially from the decisions that they are in a position to make. Instead, people in these positions need to insure that they are not making decisions affected by the profit motive.

The need for a new text on ethics and the visual arts from the perspective of American culture is painfully evident. This volume does not provide readers with conclusive answers about ethics in the visual arts, but it raises questions that we all need to ask and think about.

Endnotes

[1] Michael Kimmelman, "Art: The Highs and Lows," *New York Times*, sec. 2, December 25, 2005, 35.

CHAPTER

So, What's the Price?
—*The PM Principle*—
Power, People, & Money

Elaine A. King

The base of this essay stems from a paper that I presented in a session at the College Art Association's conference that was organized by my co-editor Gail Levin in February 2001. This essay focuses on museum ethics and how the lack of enforcement of ethical policy influences an institution's philosophy and practice as well as its behavior, content, and message. The title for this article, "So, What's the Price?—*The PM Principle*—Power, People, & Money," was inspired by the financial controversy erupting over the survey exhibition *Sensation: Young British Artists from the Saatchi Collection*[1] presented at the Brooklyn Museum in October 1999.

The incredulous economic deals enclosing the *Sensation* exhibition stunned not only the museum profession in the United States but also in other countries, including Australia, where the National Gallery[2] cancelled the show's tour because of the hovering unethical shadow. The calamity, a result of the shady nexus between art and commerce, was brokered between the Brooklyn Museum's director, Arnold L. Lehman, and Charles Saatchi, a private London collector. Although the conflict initiated with a focus on the controversial art in the *Sensation* exhibition, it was the ensuing revelation of dubious financial transactions that shocked many and galvanized the American Association of Museums[3] to rewrite its ethical guidelines pertaining to the borrowing of objects and lender involvement.[4]

Before critiquing the *Sensation* conflict, an examination of cultural philanthropy needs to be addressed in order to put this scenario into a

broader context. I hope the following data will provide a cultural context about funding, as well as cast new light on underlying concepts governing the *PM Principle* and its pervasive presence in museums today. It is becoming increasingly difficult for museum directors and staff to act conscientiously when the state of cultural funding is unstable and magnified in a lean economy by the relentless pressures of fundraising and funder demands. As endowments shrink, museums are challenged to balance budgets, find new patrons, and expand their audience—an essential element to fund exhibitions, programs, and staff. The *PM Principle* looms large in shaping organizational policy in such a fiscal climate. Consequently, what is the value of ethics today?

Museums and Ethical Practice

In discussing contemporary culture, one needs to keep in mind that the cultural goods and services of the American cultural industries are not unique outputs of historical creative genius and talent. Much as they may be appreciated, imitated, and adopted, they remain by-products of a particular set of institutional arrangements. Market control of creativity and symbolic production have developed unevenly since the beginning of capitalism; nonetheless some creative fields possess special features or offer greater resistance to their commercial appropriation than others. By the close of the twentieth century, film and all forms of visual culture at least in highly developed market economies have become like most symbolic production and human creativity, captured by and subjected to high-powered market relations. Private ownership of the cultural means of production and the sale of the outputs for profit has become normal practice. The only exceptions until recent times were publicly supported libraries and museums. However, over the past few decades, museums have increasingly joined the ranks of the market—the concept of non-market controlled work of art or institution is almost extinct.

Parallel with private appropriation of symbolic activity has been the rationalization of artistic production. This includes the development of more efficient techniques and the invention of means to expand the market output to a global scale. It is in this respect that the term "cultural industries" assumes its meaning. The broadened production and distribution capabilities have increased immeasurably the profitability of cultural production, though this is generally left unspoken. Attention is directed instead to the undeniable impressiveness of the new technologies of message making and transmission and their alleged potential for

human enrichment, frequently through signature architecture and recycled colossal industrial structures. The Guggenheim Museum, DIA's newly opened Beacon facility in New York, and the New Tate Modern in London offer prominent examples of this trend.

The ethical criteria of our era reflects a society whose social values and norms are in flux, and whose many institutions from universities to museums conform to market pressure. What is especially notable about the last decade is the entrance of the profit motive into fields that for different reasons historically had escaped this now-pervasive force. These actions have occurred at unprecedented rates in different locations, and there can be little doubt that these changes have modified the behavior of many of this nation's prominent museums. In the past, museums have not been grassroots public institutions.

The modern concept of the museum was born in nineteenth-century Europe. By the twentieth century in the United States, its mission as an institution was predictable: to collect, preserve, and protect what it contained, whether modern art or ancient artifacts. The word "museum" has too often been used to describe a faded elitist palace where unseen things gather dust, forgotten and retired. In recent years, that concept has changed. In the United States, the museum, invariably first supported by wealthy patrons and eventually by private endowments, usually has served as a reminder and celebrant of the established order, past and present. In the rare instances where examples of social conflict might be on display, the exhibit might be relied upon to offer a social tableau more appropriate for a cryogenic installation than for current instruction in social change.

A Matter of Ethics

The very concept of ethics is often associated with the notion of right and wrong. Moral principles may be viewed either as the standard of conduct that human beings have constructed for themselves or as the body of obligations and duties to which a specific society's members are beholden. When applied to personal actions in real life, our principles are clearly upheld. When directed toward a group of people—particularly in a museum profession—the assumptions of application become more difficult to fix and endorse.

Most professions establish "norms" by which adherents to that profession are expected to act or perform their associated duties. In the museum profession, ethics establish the standard for actions that are acceptable, that is, good or correct within museological boundaries. However, the belief in

the universality of ethics has its detractors. Some contend that in our current postmodern society, there no longer exist any common ethical concerns that cross political and cultural affiliation. There are so many differences between one people and another. Because some group practices are relative to a particular culture, there is no reason to believe that all must be. It is equally illogical to presume that all persons within a particular culture will act or respond in the same way. Furthermore each new generation refutes certain social values and adopts newly ethical standards that tend to reflect the zeitgeist of their era.

Despite the lapse of scrupulous behavior in museums in recent years, the profession has been concerned with ethical inquiries for decades. Within only nineteen years of the founding of the American Association of Museums in 1906, it established a code of ethics. The AAM in 1925 published its first ethical code, titled a *Code of Ethics for Museum Workers*.[5] Over the past seventy-five years, this policy has been amended and rewritten so as to respond to social change and the evolutionary transformations of museums.

By fostering a code of ethical practices for museum personnel, I am not referring here to guards, sales people, or installers. Such a policy needs to include curators, museum directors, and trustees, who are the prominent players in an institution's ethical practice, because they are in positions of authority closest to the lure of financial gain and self-interest, and frequently succumb to both. On one hand, by outlining information about ethical issues that relate to the museum community, it may be assumed that the general knowledge base will be increased and principled good practice perhaps will follow. However, on the other hand, the process of developing a code of ethics has no ends or means of value if the process is not ultimately enforced for the good of the profession, as well as the society it serves. In 1991 AAM tried to empower the practice of ethics among member organizations by rewriting its *Code of Ethics for Museums* and making its adoption a condition of institutional membership; immediately this became a contentious point with some members of AAM. The points dealing with the disposal of collections was a paramount element of argument among those in opposition.[6]

Tableau of Cultural Support

Historically one can trace philanthropy for the arts among individual patrons and local city governments back to the time of the Medicis in Florence. For centuries, the church and aristocracy controlled and brokered

culture. They provided the economic foundation for culture in Western nations while the academia set the standards for what comprised noteworthy art. Often, those people and institutions were in solidarity, promoting similar artists and social agendas. Shifts in the production of culture from a propagandistic, academic approach to a commercial one became evident in France around the 1880s as the dealer-critic system began growing and displacing the academia's Salon system. Artists—unable to adapt to the rigid institutional aesthetic rules—sought modernistic systems to promote and exhibit their art. Their discontented attitude can be sensed in the works of Géricault, Courbet, and Manet. The Impressionists repudiated the Salon and its narrow principles. They moved in a new direction and welcomed an art market/business arrangement, anticipating it would provide a preferred alternative to the Salon and academia. Dealers zealous to sell artistic goods not only sought out a new line of art connoisseurs to purchase this work but also enlisted independent critics to promote certain artists and works. This system contrasted the academic model in which artists unequivocally produced masterpiece canvases illustrating historical or allegorical themes. The modern focus favored specialized styles that appealed to a more contemporary sensibility among collectors as far reaching as Chicago and St. Petersburg. Daniel-Henry Kahnweiler, Picasso's dealer, was a master strategist when it came to restricting the sales of his paintings to only the "right" collectors. This practice contributed to creating an elite class of private collectors in Europe. The selective availability of certain artists' work continues today and comprises the core paradigm of the contemporary art market, especially in primary centers such as New York, Los Angeles, Chicago, London, Paris, Berlin, and Frankfurt.

Early in the twentieth century, the museum building in the United States itself was customarily a tribute to older fortunes, whose owners' names oftentimes adorned the masonry. Such tributes were not intended as advertisements for corporate benefit or social status. Bluebloods such as Carnegie, Frick, Mellon, and Whitney, despite their concern with society, were confident about their financial and social status; they were different from nouveaux riches museum trustees and donors of today who are writing their "social résumés." Andrew Carnegie established his Carnegie Museum at the turn of the nineteenth century in Pittsburgh as an educational showcase for its working class community, as well as for other fellow robber barons. When the acclaimed Carnegie International was established in 1899, it was never intended to be a launching pad for emerging curators, or an authenticating showroom for art market dealers and private collectors. Its mission was to educate the people living

within a certain radius of Pittsburgh who could not travel afar to see the cultural wonders of the world from painting to masterpiece architecture. The Carnegie International afforded people within the Pittsburgh region an opportunity to witness "the art of their time" so to gain a broader worldwide perspective. Andy Warhol, a native Pittsburgher, benefited from Carnegie's vision.

Despite his power and money, Andrew Carnegie's relationship to the museum ran contrary to the *PM Principle*—at its advent the corporate games we've grown familiar with were not an issue nor was their money a critical factor in museum sustainability. In an earlier time, the museum, for all its moneyed origins, was primarily seen and used as a public resource—public education was the main focus of audience attendance. As a former museum director, I have been witness to countless "museum horror stories" regarding donor and trustees jockeying for power and name recognition.

Transformations and Corporate Power

The transformation of museums in the United States into public relations agents for the interests of big business and its ideological allies slowly evolved in the twentieth century. In the past, those who traditionally supported museums and culture were robber barons, like Andrew Carnegie and Henry Frick, and other museums patrons; contributors to the arts were usually individuals who collected art or ran museums. This would change as the century unfolded. In 1913 income tax became a permanent fixture when Congress passed the Sixteenth Amendment resulting in a revenue law that taxed incomes of both individuals and corporations. By 1945 tax collections amounted to $43 billion. The decreasing wealth among blueblood families restricted their contributions to museums and increasingly forced many cultural institutions to seek support from other sources and agencies.

In 1932 Alfred Barr faced a challenge to raise a $1 million endowment in order to secure the art collection of Lizzie Bliss for the Museum of Modern Art. To meet this goal he sought to organize a sensational exhibition in order to attract new donors, expand its audience, and to demonstrate that MoMA is a bedrock cultural institution for future generations. The show, *Seventy Years of American Painting and Sculpture 1862–1932,* attracted 50,000 within six weeks of its opening. The centerpiece of that display was the famous work by James McNeill Whistler, *Arrangement in Grey and Black: Portrait of the Painter's Mother.* Despite Barr's original concept for the exhibit, it was Conger Goodyear's

eleventh-hour negotiations with the French government that led to France's loaning of the work. This deal between the United States and France marked a new chapter in museum public relations and institutional bargaining.[7]

After World War II, a growing middle class emerged in the United States. By the onset of the 1960s, as prosperity flourished and an expanding educated middle class emerged, museums realized that they must undergo serious transformations. The public was increasingly becoming bourgeois—and an elite cultural paradigm was no longer relevant. The Metropolitan Museum of Art demonstrated the board's awareness of its public responsiveness when it hired Thomas Hoving, a former Park Commissioner and curator. This entrepreneurial director at once demonstrated his business adeptness by joining market forces. His vision for a viable museum led to bringing in public relations experts to advise the museum staff about broadening its programs to attract large audiences. Shortly after his arrival, the museum began a practice of installing huge banners denoting corporate sponsorship, draping them in front of the building to advertise "blockbuster" temporary exhibitions.

Years later the Met clearly demonstrated its ethical integrity, when it cancelled an exhibition of Coco Chanel's designs because it perceived Chanel wanted to control the contents of the show.[8] The Metropolitan's director Philippe de Montebello told the *New York Times* he was canceling the show because, according to de Montebello, Chanel's support called into question the museum's curatorial integrity, which "was being eroded, and I simply can't have that."[9] Yet five years later, he did a 180-degree turn and positively received the previously cancelled Chanel-sponsored exhibition that threatened the museum's curatorial honor. However this time the blockbuster exhibition displayed in the spring of 2005 featured not only the work of the late Coco Chanel, but also that of Chanel's chief designer since 1983, Karl Lagerfeld. According to Harold Koda, director of the Metropolitan's Costume Institute, Chanel provided "extravagant support" for the exhibition while Condé Nast came up with the additional money.[10] The Guggenheim Museum has nourished a commodious marriage with big business for over a decade. The Met's corporate philanthropic conduct of the 1960s appears innocent and restrained in comparison to the vaunting approach the Guggenheim took with such sponsors as Hugo Boss and Armani.[11]

Most recently, the Museum of Fine Arts, Boston, has come under the ethical microscope. Prominent collector William I. Koch, both the sponsor and subject of the exhibition *Things I Love: The Many Collections of William I. Koch*, founded the Oxbow Corporation.

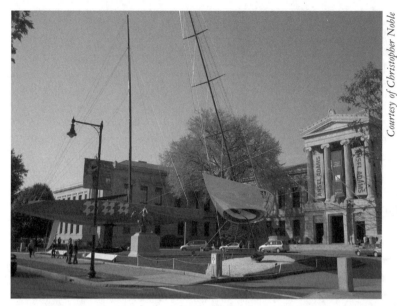

William Koch's America's Cup yachts on the lawn of the Boston Museum of Fine Arts. *From the Things I Love: The Many Collections of William I. Koch,* 2005.

This display of his treasures presents a very large survey of Koch's holdings that normally are not artifacts in an art museum exhibition— particularly his yachts that adorn the front lawn of the museum. The show triggered unfavorable responses from both newspaper critics and the blogosphere, implying that Malcolm Rogers, the MFA's director, is engaging in unethical practices in his pursuit of a wealthy patron.[12] Despite a selection of stellar Impressionist and modern paintings that includes works by Claude Monet, Pierre-Auguste Renoir, Pablo Picasso, and Jean Arp, the MFA has also given over precious museum space to display Koch's gun collection and selections of his rare wines (actually empty wine bottles). Furthermore, Koch shipped his yachts to the museum at the expense of his Foundation.

This public relation spectacle is accompanied with a vanity publication, a hardcover 200-page catalog funded by Koch. Although this exhibition of self-importance is disconcerting to many, be assured that this isn't the first time a museum has been bought by a wealthy patron. This subject will be revisited at the conclusion of this text. Most recently the J. Paul Getty Museum has come under public scrutiny, not only because of the behavior of its president, Barry Munitz. Its former curator of antiquities, Marion True,

Courtesy of Christopher Noble

Things I Love
the many
collections of William I. Koch

Installation of the America's Cup yachts was underwritten by the America³ Foundation. They, as well as many of the sculptures displayed outside the Museum, are included in the exhibition "Things I Love: The Many Collections of William I. Koch."

Exhibition label on the lawn of the Boston Museum of Fine Arts for *From the Things I Love: The Many Collections of William I. Koch*, 2005.

was forced to resign over accusations of improprieties involving real estate transactions in Greece. In Italy she faces criminal charges where she is accused of conspiring to acquire looted antiquities for the Getty.[13] "True and Robert Hecht, an American dealer who frequently sold artifacts to American museums, have been jointly on trial here since November on charges of conspiring to traffic in antiquities looted from Italian soil. Both have pleaded not guilty. According to court documents, the Getty bought the griffins from the New York diamond magnate Maurice Tempelsman in 1985 in a deal totaling $6,486,004. The sale was handled through the London dealer Robin Symes, the documents indicate."[14]

Without a doubt, corporate supporters are bedrock to nonprofit organizations; they have deep pockets and can afford to give away vast amounts of money for exhibitions and projects that they find exciting and relevant. Yet such sponsors often view cultural philanthropy as a positive way to construct corporate relations and reputations among a widespread public—philanthropy as a smart form of advertising. However, they want to see exhibitions that attract viewers and support social tastes that are not controversial or difficult to comprehend.

Regardless, it must be conceded that the museum is only one institution within the complex art world system. What is observed in current practices constitutes a subset of the larger art world. American corporations spent $22 million on the arts in 1967; however, most of that money did not go to museums. By the end of the 1980s, the outlay came to close to $1 billion, and today that figure has multiplied despite the economic slowdown in the United States.

Hans Haacke, an artist known for adopting a conceptual matrix, is invariably perceptive of the *PM Principle* and the intertwined relationship of power, people, and money among cultural organizations. In 1975 he focused his artistic cleverness to this rising corporate/art relationship when he produced an exhibition entitled *On Social Grease*. This display comprised of six plaques of photoengraved magnesium plates mounted on aluminum, reproduced the statement of six national figures (five corporate and one political) on the utility of the arts to business. Robert Kingsley, Exxon executive and founder and chairman of the Arts and Business Council, provided Haacke inspiration for the show's title by stating:

> Exxon's support of the arts serves as a social lubricant. And if business is to continue in big cities, it needs a lubricated environment.

David Rockefeller[15] was far more direct when he resolutely asserted:

> From an economic standpoint, such involvement in the arts can mean direct and tangible benefits. It can provide a company extensive publicity and advertising, a bright public reputation, and an improved corporate image. It can build better customer relations; a nimble acceptance of company products . . . promotion of the arts can improve the morale of employees and help attract qualified personnel.

The lubrication of the corporate connection to museums does not stop here. It is common knowledge that companies now utilize museums as heartwarming sites for ceremonial events, in addition to the regular schedule of weddings, anniversaries, private parties, and cocktail hours. This should not surprise anyone—as the old saying goes, "there is no free lunch." If you get, you must give—and how much you give affords how much you can demand to get. Nonetheless, corporate sponsorship of museum exhibition leads inevitably, as does advertising-supported television, to museum

self-censorship, with the result that public awareness of artistic potential becomes diminished. When planning their schedules, museums must take into consideration whether or not they will be attractive to the boards of major donors. It would be unthinkable for a corporation to fund a show that does not enhance its image or provide it with a varied menu of publicity and power packed social events. When some criticize the cautious exhibition record of several museums, one must pause and consider where the institution is located, as well as who sits on their board and which foundations are the principle benefactors in a particular locale.

Sensation Exhibition and the *PM Principle*

On September 22, 1999, Rudolph Giuliani—at that time the mayor of New York and a Republican-hopeful candidate running for the Senate against the former First Lady, Hillary Rodham Clinton—publicly denounced the Brooklyn Museum of Art's *Sensation* exhibition as being outrageous and full of "sick stuff." He vowed to retract all local funding for this organization. Despite the pathetic nature of the mayor's outbursts, the Brooklyn Museum of Art (BMA) made it a point to publicize the exhibition's controversially outrageous nature. Seeing this as a political opportunity in the culture wars, Giuliani enthusiastically responded and used this opportunity to sanction conservative values. Weeks prior to the opening of the *Sensation* exhibition, the BMA promoted the shocking nature of the British art exhibition in order to attract publicity—from the beginning the show was packaged as a blockbuster. A lesson learned from the upheaval surrounding the Robert Mapplethorpe debacle in Cincinnati was that "in-your-face art" attracts crowds. According to Roger Kimball, "the Museum even sent around a mock 'Health Warning' cautioning potential art viewers that the contents of this exhibition may cause shock, vomiting, confusion, panic, and so forth. Subsequently the museum purchased the cover art for an issue of the *Village Voice* depicting Mayor Guiliani as the Devil posed leeringly behind a picture of the Madonna."[16]

The public perceived Guiliani's reaction to Saatchi's collection of artwork by young British artists as yet another gesture of political censorship, and as a bid for personal and political gain. He was hoping to attract conservative Roman Catholic voters from upstate New York to vote for him against Hillary Rodham Clinton. The mayor's bullied threats successfully ignited a ferocious firestorm of controversy that finally burned itself out six months later, when a settlement was reached in federal court that ended legal hostilities with the museum's free speech rights affirmed

and its local funding saved. Nevertheless the political ramifications stemming from the conflict around the *Sensation* exhibition raised a series of ethical quandaries in the museum world that transcended issues of censorship and government funding for the arts.

In the fall of 1999 a type of "risky business" point of departure from the established corporate subsidy paradigm made national news. Curiously the disquieting heart of this exhibition was not its shocking subject matter, which had included erect penises; a portrait of a child molester; bisected cows and pigs suspended in formaldehyde; and most notably Christopher Ofili's *Holy Virgin Mary*, a painting garnished with collage images from porno magazines and elephant dung strategically placed on the canvas. More serious but less salient issues sounded an alarm for serious ethical investigation. A large portion of the artworks in *Sensation* had been seen in New York's art galleries in past months and the London installation had been extensively written about.[17] With the exception of a few pieces, the exhibition's content was tepid compared to the covert insidious financial dealings that transpired between the Brooklyn Museum, Charles Saatchi, Christie's auction house, and David Bowie—all of whom stood to gain financially from the event.

Enthusiastic to raise the visibility of the Brooklyn Museum in New York's metropolitan area, as well as to spark museum attendance,[18] Arnold Lehman realized that he could easily accomplish both objectives by bringing London's Royal Academy of Art's polemical show to the United States. Of course, he was warned that the museum would have to raise a substantial amount of money to transport the art from London to America, and to install the intricate works at the BMA. In an appeal to potential museum patrons, Lehman wrote a letter appealing for support: "We want to establish the BMA as a primary art destination for every tourist and every resident in New York City, reflecting the ethnic, racial, national, religious, economic, and lifestyle diversity of our population. . . . We want to see our galleries filled with young people, students, and artists. . . . And, we want the BMA recognized for what it has always been, one of America's great museums and centers for learning."[19]

Fundamentally such goals are commendable and just—no one could fault a museum for wanting to increase audiences or to gain more national prominence. Given the financial difficulties that the Brooklyn Museum faced in the 1990s and its ongoing dilemma to attract visitors from Manhattan, it is understandable that this new director desired to stimulate its exhibition programming. However, the challenge facing Lehman was at what price would he sacrifice ethical judgment so to raise the necessary funds to secure

an exhibit that appeared to be the very thing that promised to raise the museum's profile and perhaps in the near future attract deep-pocket benefactors.

Despite his aggressive attempts to recruit private sponsors to support an exhibit drawn exclusively from Charles Saatchi's contemporary art collection, his fundraising attempts failed. Lehman conceded that no one would support this exhibit when he reportedly said, "No private individual wants to put money into [his pockets]. . . . A private patron expressed, 'We are private collectors; he is a private collector. Why would I give my money to show his exhibition?'"[20] Obviously the pressure to raise donations within a short time frame blinded this director's ethical vision. Desperate to bring *Sensation* to the BMA, he asked Saatchi[21] to underwrite the show—despite the fact it was known that this collector was a domineering and difficult individual. Saatchi agreed to contribute $160,000 and from the start, he exerted his control over both the content and the presentation of the exhibit. As reported by the *New York Times* writer David Barstow, a museum staff member assigned to serve as an ambassador between the museum and private collector asked: "Who is doing this exhibition? The museum, or the collector [hoping] that the museum would soon get a 'bit closer to the driver's seat—or at least that we can all have a hand on the steering wheel.'"[22]

Saatchi perceived an economic advantage to exhibiting his collection in New York City. After the *Sensation* exhibition at the Royal Academy in London, he sold an estimated 130 works by artists included in the display. Concurrently when Lehman asked Saatchi to assist him in securing funds from the auction house Christie's, the museum director was meeting with the auction house about deaccessioning works of art. He suggested that if its underwriting support materialized for *Sensation*, the Brooklyn Museum would work exclusively with the auction house for future art sales. As reported in the *New York Times*, the president of Christie's wrote in a memo, "There might be something here worth exploring.. . . Several weeks later the BMA sold $21,000 in art through this auction house."[23] Christie's contributed $50,000 to the BMA for *Sensation*; a memo written by its director of museum services expressed, "I would like to see us capitalize on it as much as possible."[24] Beyond a reasonable doubt, this partnership among the museum, collector, and auction house was not about public interest but commercial profit.

Adding to an already complex conglomeration, the pop culture star David Bowie (also a collector of the works by artists included in *Sensation*) joined the enterprise/profit party after he pledged a handsome sum of $75,000 to *Sensation*. Shortly afterward the museum invited him to be the

voice for its audio tour and his Internet company was given the exclusive right to display *Sensation* online. Compounding the already complex layers of money games surrounding this exhibit, London's *Time Out* magazine voted *Sensation* the best art exhibit of the decade—curiously *Time Out* was a sponsor of *Sensation* in London, as well as its media sponsor in New York!

Michael Kimmelman, chief art critic of the *New York Times*, wrote of the coalition between art and commerce that brought the *Sensation* exhibition to New York City: "Impressions are important in these affairs. What Brooklyn did by soliciting money from people with direct financial involvement in the works in the exhibition was at the dubious extreme of museum practice, if it wasn't unethical, and it certainly makes a very bad impression by creating the image that the Brooklyn is for sale. The museum was additionally foolish to have shrouded the financing."[25]

Keeping in perspective what transpired at the Brooklyn Museum, it is essential to emphasize that an ethical standard is distinct from a legal standard. Legally the Brooklyn Museum did not violate the law. However, the *Sensation* exhibition came in conflict with accepted practice because the Brooklyn Museum went, in Michael Kimmelman's words, "way too far this time by turning in an unseemly way to collectors, dealers, and an auction house who will profit by its exhibition." But the blame isn't entirely Brooklyn's. In a perfect world, museums should have firmer rules about donations and private collection shows, with public perceptions more squarely in mind. David Barstow wrote that *Sensation* "blurred the line between art and commerce to a highly unusual degree." He noted that several current and former Brooklyn Museum officials had told him that they could not cite another exhibition that so directly linked the art on display with the financial interests of the exhibition's major underwriters. Responding to the controversy, Harold Holzer, vice president for communications at the Metropolitan Museum of Art, commented: "There are occasionally lines that have to be drawn, not only in the sand but also in the bedrock on issues of curatorial integrity."

I am in agreement that the Brooklyn Museum stepped out of ethical bounds when it came to the financial dealings of this exhibition. Despite the fact that a number of commentators have suggested that the arrangements in Brooklyn were not so unusual for hard-pressed American museums, still, the president of the American Association of Museums, Edward H. Able Jr., made this powerful assertion: "It would be a mistake to say that the Brooklyn Museum of Art exhibition did not prompt us to decide to take a close look at this." Within ten months of the *Sensation* conflict, the AAM's board adopted new guidelines on July 13, 2000. These revised

ethical guidelines were published on August 2, 2000. They clearly advise against some of the practices used by the Brooklyn Museum:

> Before considering borrowed objects, a museum should have in place a written policy, approved by its governing authority and publicly accessible on request, that addresses a number of issues:[26]

Association of Museums Ethical Guidelines:

I. Borrowing Objects. The policy will contain provisions:

A. Ensuring that the museum determines that there is a clear connection between the exhibition of the object(s) and the museum's mission, and that the inclusion of the object(s) is consistent with the intellectual integrity of the exhibition.

B. Requiring the museum to examine the lender's relationship to the institution to determine if there are potential conflicts of interest, or an appearance of a conflict, such as in cases where the lender has a formal or informal connection to museum decision-making (for example, as a board member, staff member or donor). Includes guidelines and procedures to address such conflicts or the appearance of conflicts or influence. Such guidelines and procedures may require withdrawal from the decision-making process of those with a real or perceived conflict, extra vigilance by decision-makers, disclosure of the conflict or declining the loan.

C. Prohibiting the museum from accepting any commission or fee from the sale of objects borrowed for exhibition. This prohibition does not apply to displays of objects explicitly organized for the sale of those objects, for example craft shows.[27]

II. Lender Involvement. The policy should assure that the museum will maintain intellectual integrity and institutional control over the exhibition. In following its policy, the museum:

A. Should retain full decision-making authority over the content and presentation of the exhibition.

B. May, while retaining the full decision making authority, consult with a potential lender on objects to be selected

from the lender's collection and the significance to be
given to those objects in the exhibition.

C. Should make public the source of funding where the
lender is also a funder of the exhibition. If a museum
receives a request for anonymity, the museum should
avoid such anonymity where it would conceal a conflict
of interest (real or perceived) or raise other ethical
issues.[28]

The guidelines are voluntary for now but appear likely to be adopted
by the Association's Accreditation Commission. This group advises on
which museums are appropriate for accreditation and could disallow muse-
ums that fail to comply with the guidelines. AAM's new Ethical
Guidelines make clear where Brooklyn breached the accepted museum
ethical practices. The museum concealed until pressed that the owner of the
works in the show was also its single largest financial backer, who expect-
ed to make a financial profit from its controversial status. In the beginning,
the Brooklyn Museum denied that Charles Saatchi was a patron on the
grounds that they were protecting his wishes to be anonymous. This fram-
ing of the issue remains nebulous.

As government support of the arts dwindles and endowments
decrease, museums are more than ever forced to seek and accept contribu-
tions from commercial or industrial organizations as well as private col-
lectors with their own motives. Unfortunately this increasing dependence
on such funding reservoirs can produce conflicting unethical scenarios.
The existing code of ethics still does not provide firm implementation for
policy and practice. The only advice the ICOM code of professional ethics
gives is that the museum must ensure that the standards and objectives
of the museum are not compromised by such a relationship (article 2.9).
Notably the topic of ethics remains unpopular among museum profes-
sionals. As reported by Michael Kimmelman on the 2001 Salzburg
Seminar that focused on museums in the twenty-first century: "It was
revealing that at the seminar, tutorials in management and finance were
packed while almost nobody signed up for a session about ethics, which
had to be cancelled."[29]

An important point for museum professionals and trustees is
whether they will require special norms and ethics to guide their con-
duct. Undeniably what defines ethical right or wrong can vary enor-
mously. When does a museum allow special privileges to one person or
group of persons that are not available to everyone? How does a

corporate model of economic benefit affect the selection of museum directors, trustees, and professional staff? Do we become victims of unethical practices because of fear of being fired or professionally blackballed? By complying and remaining silent we too are passive partners endorsing the *PM Principle*. Perhaps periodical checks by outside consultants are needed to monitor unethical practice. What we hear and read is only the tip of that iceberg regarding unethical practice among museums—the number of *PM Principle* instances that go undetected might surprise many.

In conclusion, I return to this thought: Contemporary ethics reflect contemporaneous society's ideals, and practices continuously change to conform to the conditions and beliefs of humankind. Perhaps as a society we need to accept the reality that art today in its many manifestations comprises a form of big business and that increasingly contemporary art exhibitions represent an extension of a market enterprise.[30] If we can admit to this reality, then perhaps we can begin to develop a code of ethics for museums that takes into consideration questions that pertain to the business community and find ways to abate the *PM Principle*. The relationship between a museum and its public is founded on trust—trust in the integrity of its professionalism and in what it presents.

Post Script

Scenario: A Blatant Example of the *PM Principle*:

- Location: Somewhere west of the Hudson River.
- Time: 1993
- Participants/Institution: For lawful reasons, specific names of the players and the organization involved in this scenario have to be withheld.
- Scene I: A sad but real allegation.
- Scene II: An ethical person survives and is now free of ugly museum politics, but not necessarily of people and the sway of money.

Scene I

A new museum director attended his first executive board meeting of an institution that was financially insolvent. Immediately, the director

was informed that a new board member, who happened to be a zealous collector of contemporary art, recently contributed $40,000 to this organization that was in financial deficit. Although this museum was celebrating its fiftieth anniversary, its endowment was almost nonexistent. This generous gift appeared to be good news (however for only a few minutes) because quickly the chairman of the board went on to clarify that the trustee had targeted how the money would specifically be used. The funds would be used to mount a major exhibition of his private collection and a catalog would be produced. However, Mr. X's curator, an artist represented by a gallery in New York, which endorsed his brand of collectables, would oversee all details pertaining to this project. He and a senior staff member would exclusively oversee the catalog and installation production. Even though the museum director was asked to write an introduction to the catalog, he was told that he would have no other involvement with the show and publication. Prior to offering the museum his gift, this collector already had invited a New York curator to write the main text—one who also supported his type of art. Shocked by this decree, the director informed the board that he felt this was unethical practice and some discussions were needed.

Obviously the *PM Principle* again is at play here: However, the board couldn't understand the director's concern. All they could say was, "We are getting money and prestige—what is wrong?" Conceivably their take or view was veiled in marketing and its whim. All the board could see was that the "donation/self-interested-gift" was going to cover the costs for a major show and that the collector/board member was a wealthy patron. Obviously the director now stood between a rock and a hard place. Because of the newness of his position in this organization, caution was adhered to and he remained silent for months regarding this gift and the orchestration of this vanity show and catalog (a pretentious coffee-table book).

The resultant exhibition/catalog became yet another self-importance project, aggrandizing a collector and raising the financial bar on his collection's worth. Within a year, the trustee member joined the museum board of a trendy institution in New York City, obtained media coverage and recognition for his collection, and shortly resigned from the original museum to which he gave his gift. Only after a distinguished museum director conducted an American Association of Museums, Museum Assessment Program (MAP I),[31] assessment of this museum was the inappropriateness of the gift acknowledged by the board, as well as its overt micromanaging across many organizational lines.

Scene II

After countless incidents of unethical practices and the board's recurrent interference in day-to-day policy and procedures, as well as their shortfall regarding fundraising obligations, the director auspiciously fled this unscrupulous organization intact with the help of a team of ethically astute lawyers. His contract was bought out with enough to allow him a one-year paid leave to write, think, and reflect. I am delighted to report that he is now mentally sound and continues to prosper. What's more, this individual no longer desires any direct affiliation with museums—however he has become a zealous advocate of upholding ethical practices in the arts and alerting us about the gravity of the *PM Principle*!

Endnotes

[1] Michael Kimmelman, "In the End, the 'Sensation' Is Less the Art Than the Money," *New York Times*, sec. E.P.1, November 3, 1999.

[2] Brian Kennedy, "How Much Do We Care about Museum Ethics," Museum Ethics, National Gallery of Australia, *http//nga.gov.au./Director/musethics.htm.*

[3] The Ethics Committee of the American Association of Museums was charged with developing new guidelines for museums and corporate funding on July 13, 2000. This resulted partially in response to the unethical issues raised regarding the *Sensation* exhibition.

[4] On August 2, 2000, the American Association of Museums issued new guidelines pertaining to ethical practice regarding the borrowing of Objects and Lender Involvement. At the end of this essay, selected sections are reprinted from the newly drafted American Association of Museums—Ethical Guidelines.

[5] This code has been revised and rewritten several times: In 1978 a new code proclaiming a new ethics professional practice was produced, stressing management and governance. Again in 1991 another revision was made. In 1987 the International Council of Museums produced *Statues, Code of Professional Ethics* (Paris: ICOM, 1987), and in 2000 AAM revised its Code following the *Sensation* scandal. A new edition of the ICOM *Code of Ethics for Museums* was recently published in 2003.

[6] Robert Macdonald, "Museum Ethics: The Essence of Professionalism," 38–39, in *Museums: A Place to Work, Planning Museum Careers*, ed. Jane R. Glaser with Artemis A. Zenetou.

The 1991 AAM new code restricted funds acquired from the disposal of collections to only be used to replenish collections. "But unlike the ICOM document and earlier 1978 AAM ethics statement, the 1991 code included a voluntary but meaningful mechanism for its implementation by museums of all sizes and types throughout the country. . . . The 1991 code was a real ethics code that could not be ignored by those who wished to be members of the AAM and used only at a museum's convenience."

[7] In early October of 1932 Conger Goodyear went directly to the office of Jean Guiffrey, the chief curator of the Louvre and petitioned again for this work after Alfred Barr's requests were ignored. That year being a presidential election in the United States with Franklin D. Roosevelt challenging Republican Herbert Hoover, the French wanted to strengthen international ties with the United States, therefore agreeing to loan the painting to MoMA's exhibition.

[8] Michael Kimmelman, "At the Met, a Necessary Retreat," *New York Times*, sec. 2, May 28, 2000.

[9] Cathy Horyn, "The Met Cancels Exhibit on Chanel," *New York Times,* May 20, 2000.

[10] Judith Thurman, "Scenes from a Marriage: The House of Chanel at the Met," *New Yorker* (May 23, 2005), 82. However the actual amounts given to the Met were never disclosed.

[11] Carol Vogel, "Armani Gift to the Guggenheim Reviews Issue of Art and Commerce," *New York Times*, sec. B1 & B3, December 15, 1999.

[12] Geoff Edgers, "Things He Loves: Art, Sailing—and Attention," *Boston Globe*. Arts & Entertainment, August 31, 2005.
Keith Powers, "MFA Exhibit Puts Koch's Ego on Display," *Boston Herald*, August 31, 2005.
Both authors respond critically to the 100 works from the William I. Koch collection on display at the Boston Museum of Fine Arts. This sprawling display filled the MFA's Torf Gallery, the Rotunda, West Wing Lobby and the surrounding lawns of the museum. His America3 boat [winner of the 1992 America's Cup] dwarfed the Huntington entrance to the museum.

[13] Randy Kennedy, "Rift Grow, Challenging a Museum's Leadership," *New York Times*, sec. A, November 6, 2005. Also see *New York Times*, November 18, 2005.

[14] Elisabetta Povoledo, "Photographs of Getty Griffins Shown at Antiquities Trial in Rome," *New York Times*, June 1, 2006.

[15] Hans Haacke deliberately chose a statement by David Rockefeller. The Rockefeller family has been a pivotal cultural cornerstone in New York; the Museum of Modern Art, since its beginning, was supported by its money. Rockefeller's brother John was the founder of the museum, and David Rockefeller was, at the time, the chairman of MoMA's board.

[16] Roger Kimball, "The Elephant in the Gallery, or the Lessons of 'Sensation,'" *The New Criterion* 18, no. 3 (November 1999), *www.newcriterion. com/archive/18/nov99/sensation.htm.*

[17] Michael Kimmelamn, "Sensation: After All That Yelling, Time to Think," *New York Times*, October 1, 1999.

[18] In 1997, the year Arnold H. Lehman became the director of the Brooklyn Museum of Art, its annual attendance was an estimated 300,000 people: Approximately 175,000 visitors came to the *Sensation* exhibition. The *Art Newspaper* reported the final visitor count on February 6, 2000.

[19] This communication to museum supporters could be found on the museum's Web site (*www.brooklynart.org*). It appeared on November 10, 1999.

[20] David Barstow, "Artistic Differences: A Special Report: Art, Money and Control: Elements of an Exhibition," *New York Times*, sec. A32, December 6, 1999. Also see David Barstow, "Art, Money, and Control: A Portrait of 'Sensation,'" *New York Times*, sec. A32, December 6, 1999.

[21] David Barstow, "Brooklyn Museum Recruited Donors Who Stood to Gain," *New York Times*, sec. A32, October 31, 1999.

[22] David Barstow, "Artistic Differences: A Special Report: Art, Money and Control: Elements of an Exhibition," *New York Times*, sec. A32, December 6, 1999.

[23] Ibid.

[24] Barstow, "Brooklyn Museum Recruited Donors Who Stood to Gain."

[25] Michael Kimmelman, "Critic's Notebook; In the End, the 'Sensation' Is Less the Art Than the Money," *New York Times*, November 3, 1999.

[26] AAM Guidelines on Exhibiting Borrowed Objects, 2000. In response to a need from the field, the AAM Ethics Committee (a Committee of the AAM board of directors) has developed a process for creating additional ethical

guidelines based on principles in the *Code of Ethics for Museums*. These guidelines are intended to assist museums in forming their own internal policies. A task force of museum professionals drafts each set of guidelines augmented by experts from outside the museum field, vetted widely within the field, and approved by the AAM board of directors. Copies of the *Code of Ethics for Museums*, as well as specific AAM Ethics Guidelines are available at the AAM bookstore or at their Web site, *www.aam-us.org*.

[27] Ibid.

[28] Ibid.

[29] Michael Kimmelman, "Museums in a Quandary: Where Are the Ideals?" *New York Times*, August 26, 2001.

[30] Dana Vachon, "Darling, You Look Marvelous in Matisse," *New York Times*, sec. A, January 15, 2006.

[31] American Association of Museums, Museum Assessment Program (MAP). MAP is a confidential, consultative process designed to help museums understand how they compare to standards and best practices in the field. There are three stages to the two-year long assessment: Self-Study, Peer Review, and Implementation. MAP provides suggestions for improvement; MAP is designed for museums, historic houses, botanical gardens and arboretums, zoos, nature centers, and art galleries.

The Unethical Art Museum

Alan Wallach

The word "ethics" denotes a set of moral principles found in religious texts, legal codes, and codes of professional standards. Unethical behavior may not be subject to legal penalties, but it often incurs the wrath of the affected community, which then finds ways to punish offenders through shame, censure, or ostracism. The threat of sanction may check or limit behavior, but the need for ethics attests to the possibility, indeed the likelihood, that at least some individuals will behave in an unethical fashion.

While ethical codes proclaim "thou shalt not," history, society, and culture often whisper "thou shalt." Consequently, those who loudly advocate strict adherences to moral principles are frequently caught violating those very principles. Still hypocrisy is only one of the many issues involved in ethical violations. Ethical codes devised in one set of historical circumstances may prove unworkable or unrealistic or seem oppressive in another. What to do when an ethical code sets an unattainable standard? Should the code be made less stringent? Or should those subject to the code undertake wide-ranging reforms?

Art museums confront a host of ethical questions. What is the museum's obligation to the public? To what extent should the museum be concerned with diversity? How should a museum respond when an individual, a tribe, or a nation claims as its property or cultural patrimony an object in the museum's collection? This question is especially worrisome since, as Walter Benjamin wrote, much of what passes in museums as cultural treasure can also be considered loot.[1] In this essay, I focus on the particular issue of the ethics of exhibition financing. For more than four

decades, American art museums have devoted considerable energy and resources to obtaining support from corporate sponsors for blockbuster and other exhibitions. Corporate sponsorship can improve the sponsor's image—not for nothing, Philip Morris was a major benefactor of the arts during the 1980s and 1990s—but direct financial gain is usually not anticipated. The cases that concern me here go beyond the by-now standard quid pro quo of image enhancement (already a questionable exchange from an ethical viewpoint). They involve situations in which a corporation pays for a chance to tout its products as "art" in a museum's galleries, or a private collector shoulders the cost of displaying his or her collection and thus increases its market value.

The ethical codes that govern museums assert the primacy of the public's interest in the institution. As the American Association of Museums states in its *Code of Ethics for Museums*:

> Museums in the United States are grounded in the tradition of public service. They are organized as public trusts, holding their collections and information as a benefit for those they were established to serve. Members of their governing authority, employees, and volunteers are committed to the interests of these beneficiaries.[2]

The AAM's code goes on to affirm that:

> No individual may use his or her position in a museum for personal gain or to benefit another at the expense of the museum, its mission, its reputation, and the society it serves.

The code makes these points repeatedly: "Programs promote the public good rather than individual financial gain." It also insists that museums be allowed to pursue their work free of outside interference. Museum "programs are founded on scholarship and marked by intellectual integrity"—a key point when it comes to exhibition financing, since corporate sponsorship and other types of patronage can readily undermine intellectual and curatorial independence.[3]

The cases I examine here implicate not only the museum professionals responsible for violations of well-established ethical norms but also a museum culture in which violations of this sort are now all but inevitable.

24

"Who's Running the Museum?"

In 2001, James Cuno, then the head of the Harvard Art Museums, invited six museum directors representing the power elite of the American and British museum worlds to participate in a lecture series devoted to the theme of museums and the public trust.[4] Cuno's timing was not fortuitous. Two recent scandals involving conflicts of interest between museums and exhibition sponsors had, in Cuno's view, done serious damage to the art museums' pubic image. The first occurred in the fall of 1999, when the Brooklyn Museum mounted *Sensation: Young British Artists from the Saatchi Collection*. Immediately following the opening of *Sensation*, New York City's conservative mayor, Rudolph Giuliani, outraged by the display of art he deemed blasphemous, threatened to cancel the city's support for the museum and evict it from its city-owned building. Both the mayor and the museum benefited from the ensuing uproar. The mayor embellished his reputation as a champion of "decency" and traditional religious values while the museum, which battled the mayor in court under the banner of First Amendment rights, enjoyed increased attendance and accolades for its role as defender of artistic freedom. Less spectacular but even more troubling from an ethical viewpoint than the museum's predictable *succès de scandale* was the way it financed *Sensation*. The museum solicited a donation of $160,000 from Charles Saatchi to help defray the cost of exhibiting Saatchi's collection. It then asked Saatchi to help it secure a donation from Christie's, an auction house with ties to the collector. In the end, Christie's obliged by pitching in $50,000.[5] Worse still, as Cuno noted in an essay entitled "The Ethics of Funding Exhibitions," the museum allowed the collector-patron to "determine much of [the show's] content and installation."[6]

The second scandal involved New York's Guggenheim Museum, which only a little more than a year after the opening of *Sensation*, mounted an exhibition that paid homage to the work of Giorgio Armani. The Guggenheim's Armani retrospective, which turned Frank Lloyd Wright's rotunda into an Armani showcase, came eight months after the designer handed the museum a $5 million donation along with a pledge to donate an additional $10 million.[7] To charges that Armani was simply renting space at the Guggenheim, the museum denied any relation between the $15 million gift and its Armani extravaganza. According to Judith Cox, the museum's deputy director, "we would do this exhibition regardless. The two things are completely separate."[8] *Sensation* and *Giorgio Armani* were not the only exhibitions in the late 1990s tainted by charges of commercialism and conflict of interest. In 1998, the Guggenheim endured

a barrage of criticism for allowing BMW to sponsor a show called *The Art of the Motorcycle*. Between 1996 and 1999, Dior, Tiffany, Fabergé, and Cartier paid for exhibitions at the Metropolitan Museum's Costume Institute that featured their products.[9] In addition, in 1997, Condé Nast, publisher of *Vogue*, put up funds for a Costume Institute exhibition of fashions by Gianni Versace, a major *Vogue* advertiser. Like the Guggenheim, the Metropolitan claimed that its exhibitions' sponsors in no way influenced its decision-making. In December 1999, Harold Holzer, the Metropolitan's vice president for communications, told Carol Vogel of the *New York Times*:

> We are very upfront about this. There's no question where the curatorial imperative lies. These shows are curatorially managed and conceived and the funders do not have input on the installation of the exhibition or the selection of items that go on view.[10]

Holzer's protestations did little to allay art world skepticism.

For a time, the *Sensation* and *Giorgio Armani* scandals had the effect of reducing the likelihood that museums would attempt to schedule exhibitions that could conceivably elicit charges of conflict of interest or curatorial compromise. Indeed, shortly after the *Giorgio Armani* scandal broke, the Metropolitan Museum canceled a Coco Chanel retrospective that was to have been sponsored by the house of Chanel. An internal memo put the issue of the patron's prerogatives succinctly by asking, "Who's running the museum?"[11] Philippe de Montebello, the Metropolitan's director, responded when he told the *New York Times* he was canceling the show because Chanel's support called into question the museum's curatorial integrity, which "was being eroded, and I simply can't have that."[12]

De Montebello may have saved his institution from embarrassment, but for Cuno and other museum professionals, the scandals of the late 1990s implied a need to rethink museum ethics. In 1999, the Harvard University Art Museums with help from James Wood, director of the Art Institute of Chicago, began developing an educational project for museum directors. As Carol Vogel reported in the *New York Times*, the project was meant to address the quandary of museums which "for the most part . . . are left to devise their own rules and to negotiate a thicket of ethical issues by themselves."[13] The project culminated in the Harvard lectures that subsequently appeared as essays in a volume, edited by Cuno, entitled *Whose Muse? Art Museums and the Public Trust*.[14]

Merchants in the Temple

Although they excoriate the Brooklyn Museum and the Guggenheim for scandals that tarnished, in Cuno's words, "the public image of museums as such," the directors contributing essays to *Whose Muse?* do not propose revisions to existing ethical codes or attempt to set new guidelines for the financing of exhibitions.[15] Instead, they take up a range of other issues that concern them. Because their essays lack a clear focus, one waggish reviewer suggested *Whose Muse?* "could have been more tellingly titled *Six Directors Kvetching*."[16] To be sure, kvetching abounds, with the directors complaining about everything from overcrowded galleries and relentless economic pressures to "the relish [in Philippe de Montebello's words] with which the slightest misstep in our museums is pounced upon and demolished by all the media and the press."[17] Still, an analysis of the essays and the subsequent roundtable discussion furnishes a clue to the reasons why ethical lapses and conflicts of interest of the sort that led to the museum scandals of the 1990s will persist into the foreseeable future.

For the directors whose views fill the pages of *Whose Muse?*, close scrutiny of individual works in the museum's permanent collection represents the ideal museum experience. In one way or another, each makes the claim that extended contemplation of a Rembrandt painting or a fragment of Attic pottery can result in a quasi-religious or life-transforming experience. John Walsh, director emeritus of the J. Paul Getty Museum, draws on James Elkins' book, *Pictures and Tears*, to argue that "the greatest and most valuable thing [a museum] can do, is give individual visitors a profound experience of works of art."[18] Glenn Lowry, director of New York's Museum of Modern Art, declares that "the ability to spend a quiet moment contemplating art in the midst of a hectic day, often in an architecturally notable space, makes possible the kind of spiritual repose and intellectual regeneration so essential to our emotional and psychic well-being."[19] The directors are unanimous in their belief that today's cluttered, overcrowded art museums diminish opportunities for this sort of inspired looking. As a remedy, Lowry suggests that museums pare down their collections to the point where only "absolutely astounding" works would be seen.[20] In a similar vein, Cuno proposes that museums reduce or eliminate such "distractions" as bookstores, gift shops, restaurants, educational materials, and temporary exhibitions with "all their attendant hype."[21]

If the directors writing in *Whose Muse?* are idealists in wanting to create conditions in which museum visitors enjoy epiphanies in front of works of art, they no doubt see themselves as realists or pragmatists when

it comes to the actual running of their institutions. To date, I have encountered no evidence that any of them has undertaken the reforms Lowry and Cuno recommend. Lowry's newly renovated and expanded Museum of Modern Art has not reduced the number of artworks in its galleries to the point where only the "absolutely astounding" are visible; if anything, the number of works on display has substantially increased. The Art Institute of Chicago, where Cuno succeeded James Wood as director in January 2004, has so far failed to announce plans to close its bookstore, museum shop, or restaurants, or to curtail its very active temporary exhibition program. Perhaps the best the directors can hope for is that visitors to their institutions will follow James Elkins' eight recommendations for "strong encounters with works of art," which John Walsh helpfully reproduces in his essay: "Go to museums alone. . . . Don't try to see everything. . . . Pay full attention," etc.[22] But to my knowledge, the directors have not asked their staffs to distribute copies of Elkins' eight-step program to visitors to their museums or to post it at the entrances to their permanent collections.

Why is it that the directors of some of the most prominent art museums in the United States and Britain are incapable of changing the nature of the institutions over which they preside? Why do they allow a state of affairs that runs counter to their deepest instincts as aesthetes and lovers of art to continue? The directors themselves supply at least a partial answer. Art museums, Philippe de Montebello writes, "have let the merchants into the 'temple,' though perhaps not quite yet into the 'sanctuary.' But there are indications that further invasion may not be far off."[23] De Montebello, as is his wont, resorts to biblical language to signal the extent to which museums have succumbed to the influence of their corporate patrons and the even greater inroads these patrons are very likely to make in the future. To satisfy them and thus be assured of relatively steady financial support, museum directors are under pressure to increase the number of visitors, which means multiplying the amenities and "distractions" Cuno says he would like to eliminate, and scheduling more of the blockbuster exhibitions (Monet! Van Gogh! Picasso! Pollock!) that the directors not-so-secretly loathe. It is almost as if the directors were obliged to play the role of old-fashioned aesthete or snob connoisseur—exemplar of the sort of cultural distinction that forty years ago characterized the pretentious, upper-class culture of American art museums—in order to convince their boards of trustees and corporate backers that they are qualified to preside over an art institution that is now primarily in the business of attracting ever-larger audiences.[24] Still, the bald fact remains that their museums have themselves become behemoth corporate-style operations whose most publicized "products"—exhibitions

that are often a species of "themed" entertainment—increasingly resemble the products of the culture industry.

Thus their self-righteous condemnations of *Sensation* and *Giorgio Armani* exemplify what Freud famously called "the narcissism of minor differences."[25] The directors writing in *Whose Muse?* may not be as flamboyant or as reckless as Thomas Krens, director of the Guggenheim, or as nakedly opportunistic as Arnold Lehman, director of the Brooklyn Museum, but they are subject to the same historical and institutional compulsions. Consequently, they are liable to find themselves faced with similar temptations and end up in situations in which they cannot avoid the appearance, and in all likelihood the reality, of conflict of interest.

Museum or Department Store?

It should thus come as no surprise that in the spring of 2005 it was none other than Philippe de Montebello himself who ushered Chanel, Inc., and Condé Nast into the Metropolitan Museum's "sanctuary." Five years after he had canceled a Chanel-sponsored Chanel exhibition because it threatened the museum's curatorial integrity, de Montebello welcomed the company's triumphal return, this time with a blockbuster exhibition that featured not only the work of the late Coco Chanel, but also Karl Lagerfeld, Chanel, Inc.'s, chief designer since 1983. According to Harold Koda, director of the Metropolitan's Costume Institute, Chanel, Inc., provided "extravagant support" for the exhibition while Condé Nast ponied up additional money.[26]

In the excitement of the opening of this fashion blockbuster, the issue of curatorial integrity was all but forgotten. At a press conference in the museum's Great Hall, Koda announced, "There couldn't have been a show without Karl's interventions."[27] The deluxe exhibition catalog, designed in part by Lagerfeld himself, contained a sponsor's statement and a director's foreword. Maureen Chiquet, Chanel, Inc.'s president and chief operating officer, saluted Chanel and Lagerfeld as "two visionaries forever ahead of their time" before going on to laud "Lagerfeld's incredible talent [which] constantly innovates and surprises, keeping CHANEL [sic] always in the forefront of fashion without betraying Coco Chanel's initial inspiration."[28] Not to be outdone, de Montebello hymned Lagerfeld's contributions to fashion: "By directing the great traditions of haute couture in order to reflect the sensibilities of women today, he has animated not only the tradition of Coco Chanel, but also the whole of the métier itself."[29]

The art press was quick to note that in staging *Chanel*, the Metropolitan was sullying its reputation. In an op ed piece in the *New York Times* entitled "Fashion Victim," Lee Rosenbaum, a contributing editor at *Art in America*, blasted the museum for having allowed professional standards to be "compromised by commercial interests."[30] Rosenbaum rightly observed that the show was "tainted by the same sort of self-interested sponsorship that brought notoriety" to *Sensation* and *Giorgio Armani*. She went on to report that with *Chanel*, Koda was testing the waters to see, in his words, "how the press treats us" before deciding whether to proceed with additional one-person shows featuring living haute couture designers.[31] In other words, public trust, which had so concerned the directors writing in *Whose Muse?* was now being reduced to a question of image and spin.

Koda answered Rosenbaum in a letter to the *Times* that was notable for its disingenuousness. Asserting that neither he nor his associate curator, Andrew Bolton, had surrendered their curatorial prerogatives to Lagerfeld, he went on to claim, "We would have been remiss had we not engaged Mr. Lagerfeld's expertise."[32] With impeccable logic, he added, "it is unfair to judge an exhibition by an imagined collusion between sponsor and museum, especially when all parties have been so sensitive to such criticism."[33]

A week after Koda's letter appeared, I visited the exhibition to gauge for myself the effects of Chanel, Inc., and Condé Nast's sponsorship. Greeting the visitor at the entrance was a large sign that announced, "This exhibition is made possible by CHANEL. Additional support has been provided by Condé Nast," with the words "CHANEL" and "Condé Nast" printed in the style of the companies' logos. The exhibition itself consisted of nineteen white "vitrines," large open-sided cubes, each containing two to six mannequins wearing Chanel or Lagerfeld outfits. Set in an environment where walls, floor, and ceiling were painted black, the vitrines underscored the stark modernism of Chanel's designs. Although visitors were obliged to follow a single path, the progression was neither historical nor biographical. "We don't do the biography thing," Koda told critic Judith Thurman. "That's my bias."[34] Lacking historical information or any sort of logical sequence, viewers unschooled in the history of fashion were left to admire the outfits on view along with perfume bottles, handbags, and jewelry displayed in actual vitrines much as they might have admired goods on display in a retailer's window.

The last gallery was the exhibition store where Chanel scarves and costume jewelry were exhibited in a manner reminiscent of the displays within

the exhibition proper. A museum-style label announced that a scarf, produced by Chanel especially for the exhibition and carrying a price tag of $245, showed "the image of Coco Chanel drawn by Karl Lagerfeld." Having eyeballed scarves, pins, and charm bracelets ($495), I turned to a passerby and asked, "Are we in a museum or a department store?" "Both," he answered, unperturbed. The answer struck me as both witty and ominous.

No doubt the Metropolitan's exhibition had its pleasures for aficionados of Chanel and Lagerfeld designs. For the remainder of the public, however, it could only be a baffling or incomplete experience—a situation for which the museum was ultimately responsible. With Chanel and Condé Nast overseeing the proceedings, *Chanel* marked a moment in which commodity fetishism—the sine qua non of corporate culture—became a substitute for aesthetic experience and historical understanding. The public suffered because the museum, abandoning its ethical obligations, allowed Chanel, Inc.'s, and Condé Nast's interests to take precedence. And as Thurman noted, those interests boiled down to nothing more serious or uplifting than "brand awareness."[35]

Conclusion

In an article entitled "What Price Love?" Michael Kimmelman, art critic for the *New York Times*, observes that in today's art museum:

> Money rules. It always has, of course. But at cultural institutions today, it seems increasingly to corrupt ethics and undermine bedrock goals like preserving collections and upholding the public interest. Curators are no longer making decisions. Rich collectors, shortsighted directors and outside commercial interests are.[36]

Yet despite the overwhelming evidence he cites to the contrary, Kimmelman concludes that "on the whole, the [current] system [of museum financing] works." As should now be evident, a different inference can be drawn from the same set of facts. As American art museums become more desperate for money, ethical failures and conflicts of interest will become increasingly common.

But does this imply that art institutions should bow to a seeming necessity and relax their ethical standards? The answer can only be a resounding "no." An ethical standard represents an absolute—at least until by common agreement it is eased or abandoned. To date, neither the American

Association of Museums nor any of the other bodies charged with overseeing the museum profession have rescinded or amended the basic tenets of their ethical codes. And, as we have seen, those codes stress the museum's obligation to the public. Thus, whatever their actual practice, public art museums invariably claim public service as their raison d'être. Even when it comes to the corporate underwriting of exhibitions, museums argue that corporate sponsorship benefits the museum-going public. However, such an argument, which is shaky to begin with, collapses entirely when corporations are allowed to use the museum to showcase their wares.

Marx wrote: "Men make their own history, but . . . they do not do so under conditions of their own choosing."[37] The same can be said for ethical choices. Because it may now be more difficult than in the past to adhere to a particular ethical standard does not excuse those who decide to violate it.

My thanks to Rodney Olsen for his critical reading of the manuscript and his keen editorial eye.

Endnotes

[1] Walter Benjamin, "Theses on the Philosophy of History," in *Illuminations*, trans. Harry Zohn (London: Fontana, 1973), 258–259.

[2] This document is available at *www.aam-us.org/museumresources/ethics/coe.cfm*. All citations from the AAM code are from this source.

[3] Although more compressed than the AAM's *Code of Ethics for Museums*, issued in 2004 by UNESCO's International Council on Museums (see *http://icom. museum/ethics.html#begin*), makes a set of related points: "Regardless of funding source, museums should maintain control of the content and integrity of their programmes, exhibitions, and activities. Income-generating activities should not compromise the standards of the institution or its public." The American Association of Museum Directors does not publish a code of ethics per se but has endorsed a series of position papers on such subjects as "Art Museums, Private Collectors, and the Public Benefit," "Managing the Relationship between Art Museums and Corporate Sponsors," and "Revenue Generation: An Investment in the Public Service of Art Museums." These papers set forth in great detail the ethical standards that, at least in theory, govern museum financing. See *www.aamd.org/papers*.

[4] The lectures along with a roundtable discussion were published in James Cuno, ed., *Whose Muse? Art Museums and the Public Trust* (Princeton: Princeton

University Press; Cambridge: Harvard University Art Museums, 2004). The speakers included Anne d'Harnoncourt of the Philadelphia Museum; Glenn Lowry of the Museum of Modern Art; Neil McGregor, former director the National Gallery in London and director of the British Museum; Philippe de Montebello of the Metropolitan Museum; John Walsh, director emeritus of the J. Paul Getty Museum; and James N. Wood of the Art Institute of Chicago. Anne d'Harnoncourt's lecture does not appear in *Whose Muse?*, but Cuno included his own contribution to the series so the book contains a total of six essays.

⁵ David Barstow, "Art, Money and Control: A Portrait of 'Sensation,'" *New York Times*, December 6, 1999.
Carol Vogel, "Armani Gift to the Guggenheim Revives Issue of Art and Commerce," *New York Times*, December 15, 1999.
James Cuno, "'Sensation' and the Funding of Art Exhibitions," in *Unsettling "Sensation": Arts-Policy Lessons from the Brooklyn Museum of Art Controversy*, ed. Lawrence Rothfield (New Brunswick: Rutgers University Press, 2001), 165–166.

⁶ Cuno, "'Sensation' and the Funding of Art Exhibitions," 165. See also Barstow, "Art, Money and Control: A Portrait of 'Sensation.'"

⁷ Vogel, "Armani Gift to the Guggenheim Revives Issue of Art and Commerce."

⁸ Ibid.

⁹ Ibid.

¹⁰ Ibid.

¹¹ Cathy Horyn, "The Met Cancels Exhibit on Chanel," *New York Times*, May 20, 2000.

¹² Ibid.

¹³ Vogel, "Armani Gift to the Guggenheim Revives Issue of Art and Commerce."

¹⁴ See n. 4.

¹⁵ Cuno, "Introduction," *Whose Muse?*, 14.

[16] Lee Rosenbaum, "Musings on Museums," *Art in America* 92, no. 9 (October 2004): 45.

[17] De Montebello, "Round Table Discussion," *Whose Muse?*, 196.

[18] Walsh, "Pictures, Tears, Lights, and Seats," *Whose Muse?*, 78.

[19] Lowry, "A Deontological Approach," *Whose Muse?*, 140.

[20] Lowry, "Round Table Discussion," *Whose Muse?*, 184.

[21] Cuno, "The Object of Art Museums," *Whose Muse?*, 73.

[22] Walsh, *Whose Muse?*, 85–86.

[23] De Montebello, "Art Museums, Inspiring Public Trust," *Whose Muse?*, 157.

[24] I use the word "distinction" in the sense that Pierre Bourdieu defined the term. See Bourdieu, *Distinction: A Social Critique of the Judgment of Taste*, Richard Nice, trans. (Cambridge, Mass: Harvard University Press, 1984).

[25] Sigmund Freud, *Civilization and Its Discontents*, trans. and ed. James Strachey (New York: W. W. Norton & Co., 1961), 61.

[26] Judith Thurman, "Scenes from a Marriage: The House of Chanel at the Met," *New Yorker*, May 23, 2005, 82. The actual amounts were never disclosed.

[27] Ibid.

[28] Maureen Chiquet, "Sponsor's Statement," in *Chanel*, ed. Harold Koda and Andrew Bolton (New York: The Metropolitan Museum of Art; London: Yale University Press, 2005), 7.

[29] De Montebello, "Director's Foreword," *Chanel*, 9.

[30] Rosenbaum, "Fashion Victim," *New York Times*, May 6 2005.

[31] Ibid.

[32] Harold Koda, letter to *New York Times*, May 11, 2005.

[33] Ibid.

[34] In Thurman, page 84. By leaving Chanel's life offstage, the museum shielded the public from a number of unpleasant facts about the designer's history, including her liaison with a German officer during and after World War II and her attempt to manipulate the Nazi racial laws to deny the claims of a Jewish business partner.

[35] In Thurman, page 86. The Metropolitan's Costume Institute has proved over the years especially susceptible to the sort of ethical lapses I have been describing. In *Selling Culture: Bloomingdale's, Diana Vreeland, and the New Aristocracy of Taste in Reagan's America* (New York: Pantheon Books, 1986), Debora Silverman details at length how Vreeland, a Condé Nast fashion editor who became a consultant to the institute in 1980, fed the Reagan image machine by staging exhibitions of unprecedented luxury and opulence—exhibitions that, in Silverman's words (p. 161), "were designed to limit critical judgment and curiosity." Silverman concludes her book with the observation that Vreeland's reign at the Metropolitan could be taken as a symptom of an era in American history notable for its "substitution of profits for ethics" and its "distrust of historical memory." On the evidence of the Metropolitan's *Chanel* exhibition, that era is far from over.

[36] Kimmelman, "What Price Love?," *New York Times*, July 17, 2005.

[37] My translation from Karl Marx's German of a famous passage from the Eighteenth Brumaire of Louis Bonaparte. See *www.sozialistische-klassiker.org/Marx/Marx05.html*

Consuming Emancipation: Ethics, Culture, and Politics

Saul Ostrow

The contemporary cultural sphere has inscribed upon its surface the interlocking boundaries of mass, popular, sub, critical, institutional, national, local, and international, Western, non-Western, et al., cultures. Within this context, I imagine that if we are to stave off the negative effects of a society willing to allow profit to be extracted from all aspects of life, it is time to self-reflectively engage in a process of evaluation, devaluation, and reevaluation. The goal of this project as always should be to seek ways in which we might have our social wealth serve us, rather than seek the ways by which we might make ourselves still more useful to business in the hope of improving our lot. The problem of late modernism was not its unfulfilled utopian dream, but that its utopianism as an approach had become reified and its means reactive. As such, problem solving, good faith, reform, and self-improvement are no longer ethical or political options if we are to keep thought alive in the service of humanity rather than merely as a strategy for staying alive.

This need to reassert political change at the structural level is a result of capitalism's resistance to any and all economic and institutional reforms of its political power. Such a state of affairs has been increasingly masked by Western society's emphasis on the cultural self-realization and empowerment of the individual. This vision of individual self-improvement and empowerment is used to sustain the view that, through consciousness-raising, changes in values, standards, and criteria would lead to economic and political reforms. Consequently, one result, within capitalism's social strategy, is that the political and economic function of culture (in the

broadest sense) has been quantitatively altered. Ethics is being subsumed by capitalism's new aesthetic ideology, which regards all personal judgments as nothing more than expressions of individual preference or taste that represents freedom, while attempting to bound us to a morality in which good or bad (evil) are rigidly fixed qualities. What is concealed within is the relativism by which good or bad is determined.

Capitalism's new aesthetic ideology is represented as being dedicated to maintaining independence from the vagaries of institutional power. It is also portrayed as maintaining traditional notions of autonomy and self-initiated practices. This strategy, which promotes the idea of a "better me through cleverness and consumption," is built on the historical model of self-improvement. The older ideological model of self-realization through cultural consumption, formulated in the nineteenth century, was intent on producing responsible members of a community based on common values and goals by which we may contextually judge our own actions as good or bad. The logic of this vision was that if we were to participate in the decision-making process, we should then be considered worthy.

The liberal view of culture as a political force arises from faith in the bourgeois view that culture is a self-critical and self-initiated practice dedicated to maintaining its independence from the vagaries of institutional power. Thus if culture is not an autonomous realm, it is at least self-determining. In addition, culture is conceived of as neither being circumscribed nor prescribed by the arbitrary exercise of institutional power. Inversely, the middle classes envision such practices as being capable of conferring upon their audience status and authority. This notion of culture as empowering is premised on the fact that the bourgeoisie used culture in the nineteenth century to displace religion as the primary determinant of ethical order and meaning. Culture, therefore, is meant to represent all that is good, noble, and "eternal" even if such qualities can only be determined after long periods of struggle and opposition. In this description, the cultural process is made to mirror the vision of entrepreneurial capital.

The developmental part of the equation is actually the product of the nineteenth century, the bourgeoisie's assault on the academy's monopoly over authoritative representations of "desirable" social and cultural values. Before the emergence of capitalism, all such values were believed to exist a priori and were as such defined by church and state. The irony of the bourgeoisie becoming the mediators of social and cultural values is that having gained power, and having become the guardians of the highest possible values, they also set about creating a culture industry to displace the

folk and provincial (regional) cultures of the general populace. This mass culture was premised on the basest values of profit, titillation, and distraction. In the cultural economy of self-improvement, the middle classes find themselves caught between the high culture aspirations of the haute bourgeoisie and the appeal of the common culture of the working class. It was under these conditions that the middle classes had foisted upon them the responsibility of being the standard-bearer of the compromised cultural ideology of the bourgeoisie.

It was in the 1970s that the liberal belief in cultural self-improvement was transformed into the logic of "it's all about me," which would come to undermine middle-class ambition of betterment as a tool of political and social change. Again, there is irony in the transition from the demanding vision of the nineteenth century of cultural redemption, which required hard work and self-reflection, to the promise offered up today, which is defined by the consumption of goods. As such, commerce has appropriated and reinterpreted the New Left slogan of "the personal is political." This rallying cry, which was meant to sum up the ideal that politics and life are intimate, intertwined in an everyday way, has been used to generate a model of self-improvement meant to create feckless consumers. This vision of self-improvement and the politics of choice as embodied in consumption corresponds to an increasing sense of powerlessness that resulted from successful co-optation of counterculture values by conservatives in the aftermath of the heady decades of the 1950s and 1960s, when both a progressive political and cultural revolution had seemed possible.

The appeal of redemption through consumption is built on the notion that while group identity is necessary, self-reflexivity is not—in part because this latter, long-held goal, rather than appearing to be a solution to our present unhappiness, appears to be its cause. Consequently, the idea "look successful—be successful" has replaced the ideal of raising one's ethical standards, criteria, and values to get ahead. The allure of celebrity, religion, and branding has all become interchangeable in that they promise rescue from banality and boredom. As such, it does not matter if the Man transports us to the Promised Land by Glad or by God. In this environment, "branding" is the only form of meaningful construction left to us.

Beyond the role mass media play in affirming corporate capitalism's vision of a world of flawed human beings committed to self-improvement, its inherent ability to disconnect information and experience from the world of knowledge also contributes to assuaging the middle-class ambition of seeking self-improvement and realization. This power to inform, misdirect, or redirect the middle classes gives mass media greater prominence in

the ordering of our everyday life by encouraging differing social entities to participate in a wide array of niche markets that promote narcissistic self-concern, as well as by means of a persistent and relentless undermining of our ability to make informed judgments. Consequently, we are seduced by mass culture's repetitive representation of the symbolic satisfaction to be obtained in the marketplace of goods and in the fantasy world of mass entertainment, which is portrayed not only as an affirmation of freedom of choice, but also as a political act in itself.

Thus we are encouraged to view the underlying causes of social conflicts and inequities to be nothing more than the product of prescribed ideological positions, unhappiness and bad attitudes brought about by divergent tastes or desires, regional demographics, or educational and cultural differences. The causes of these differences are of course left unstated, as though they were unimportant. This focus on effect rather than on cause is reinforced by our modern media world, which puts image before everything, and which, by emphasizing weaknesses and minimizing strengths, manipulates our perceptions of ourselves. These experiences lead us to believe that all that joins us together today as a community are the most fleeting and insubstantial aspects of our existence—our lifestyles and their attendant fetishes. The price for the self-satisfaction sought in consumption of the images and imaginary relationships induced by mass culture has been the loss of communal power in all spheres of society's organization. Where collective values and aspirations once connected us, today we have our predilections and tastes. Meanwhile, such critical discourses as feminism, multiculturalism, and postcolonial critique have given rise to "identity politics," which demands cultural equality and personal empowerment rather than the view that equality and self-determination are conditions inextricably a product of the division of political power along class lines. In turn, the social pressure known as "political correctness" has been proffered as a weapon capable of combating these bad predilections.

Inversely, engagement with issues of lifestyle consciously or unconsciously represents an attempt on our part to cope, not only with the anxiety produced by the indeterminacy that characterizes our present cultural and economic conditions, but also seemingly represents the last arena of individual control over some portion of our lives. So it is understandable how today, given a growing sense of insecurity induced by the global view of international corporate capitalism's abandonment of nationalism, conservatives seek expediently to blame the failure of the working classes to improve themselves on the liberal reforms achieved more than forty years ago. We are told this is because the relative equality and parity, which was

to be guaranteed by a culture of tolerance, failed to deliver the individuated self-improvement, while it severed the traditional bounds of community that promised equality only through homogeneity. Although this conflict is cast more than ever as the clash of two cultures, in actuality it is a political struggle instigated by capitalism so that the latter may sustain its power to order society. It is easy to see how important it is for capitalism to maintain the mythical view that material conditions and social relations are culturally informed rather than economically induced.

Given that my subject is the ethical issues and obligations that arise from the increasingly methodical incorporation of the culture as a means of political control, we should examine the 1930s when one of the most important aspects of the critique of mass media lay in its identification of its contradictory nature. The most striking example of this was the Nazis' successful use of myth and spectacle to motivate and control their audience. In place of the message of betterment through self-awareness and social action promoted by the Left, the Fascists used radio and film to spread their promise of the objectified pleasure to be achieved by sacrifice, discipline, and faith in a higher order. It was the Frankfurt School critics who analyzed the Right's ability to use mass media to create the illusion of their omnipresence, achieved by producing a phantasmagoric world in which our own actions are informed by an endless stream of images meant to provoke illusionary desires built on the promise of symbolic rather than actual satisfaction.

In the essay "The Work of Art in the Age of Its Technological Reproducibility," Walter Benjamin notes how fascism uses mass media to anesthetize politics, and also that mass media had created the conditions under which art was to make the transition from its roots in magic to being merely for exhibition. This new condition made art explicitly political. What is thus implied is that the new art, with its ability to form and inform mass perception and consciousness, was now an explicit rather than implicit political tool—and therefore as a perfecting mimesis, capable of giving form to the representation of the world of experience, it was a weapon in the struggle to unfetter the means of production and the consciousness of the masses.

While Benjamin's optimistic view has come to be embraced—it is often forgotten that the emergence of technological means of mass production and distribution of cultural material gives advantage only to those who control the means of production and distribution. The ethical conflicts encapsulated by the opposition of the political culture of self-improvement versus those of the cultural politics of consumption are deeply rooted in the

development of the bourgeoisie's cultural ideology under modernism, and the linkage of epistemological concerns to ethical concerns and ethical concerns to aesthetic concerns.

Returning to the beginning of the end of modernism in the late 1950s and early 1960s, we can track how the discourse network of self-improvement and political struggle came to be appropriated and turned upside down—becoming the driving force behind consumerism and lifestyle politics. As it continues to be mistakenly viewed today, cultural development was envisioned under modernism as the preserve of "progressives, vangardists, and radicals." This contributed to the idea that cultural revolution is a significant component of social(ist) revolution, and seemingly has led us to believe that it just might be a substitute for radical political change.

At the very moment in the 1960s when the cultural arena was the site of widespread contestation, the ultra-conservative cultural theorist Daniel Bell radically proposed that the struggle for self-representation and expression could be used to divert the demands of liberal labor and the middle classes for economic as well as political and cultural equality. In his books *The Coming of Post-Industrial Society* and *The Cultural Contradictions of Capital*, Bell hypothesized that the cultural sphere, with its attendant contradictions and uncertain freedoms, would become increasingly important in the ordering of capitalist society. Couched in idealistic terms and the political rhetoric of the Left, Bell promoted a utopian vision of a white-collar society in which the industrialized states of Western society would become primarily service and information providers. Meanwhile, industrial production was to be exported to the underdeveloped Second and the undeveloped Third World as part of the process of transforming them into developed countries. In this scenario, the process of cultural self-realization and the nominal freedoms of cultural emancipation were to be the optimal alternative to classes struggling for social and economic power.

For Bell, the cultural sphere was to be primarily a force of social control. He believed that it could be used to sustain the disenfranchised, liberal, middle-class ambition of one day gaining the necessary power to improve the lot of the vast majority of the people most affected by the desperate state of affairs created by the laws of capitalism. Bell understood that the Right could exploit the inherent contradiction in the modern liberal cause, which rather than seeking to resolve class conflict, actually created a division along cultural lines by obscuring and strengthening class division along economic lines. What liberals fail to notice is that the values they promoted are ideologically consistent with the self-image of

capitalism, which in word and not deed has traditionally promoted cultural development as a progressive force in the struggle against backwardness. The irony, of course, is that the advocates of cultural change are represented to those they seek to help as being a foolish, extravagant, and self-indulgent elite whose concerns are detached from everyday reality.

The cultural contradictions of capitalism as Bell understood them lay in the fact that if liberals and progressives actually set out to realize the bourgeoisie's cultural ideals, they would erode the fabric of duplicity within which capitalism's political hegemony is entwined. It appeared to him that, if left unchecked, liberalism's unrestrained belief in the value of the community of individuals committed to improving themselves socially and culturally would bring down Western civilization. For the good of "society," what was needed was to turn the cultural domain into a place detached from real politics in which liberals could safely (harmlessly) and systematically examine the opposition between the symbolic desirability of bourgeois ideals and how these antithetically registered in the economic domains. Bell formulated this analysis-cum-plan just as progressive workers, allied with the civil rights, women's, and gay movements, had successfully turned cultural demands into political demands.

Ironically, it was the struggle for political reform and cultural revision brought about by the activism of the 1950s and 1960s that set the stage for Bell's plans to be implemented not as a reaction, but as a form of redirection and appropriation. The most important element was the frustration generated by the process of co-optation, diversion, and placation set in motion by the "Establishment." This gave rise to an infantile terrorism detached from the social and political programs of the middle and working classes. The effect was compounded by an economic downswing, which forced the middle and working classes to retreat from direct political confrontation. What came to be an acceptable substitute for the politics of confrontation was the theme of self-empowerment. This time though it carried with it the weighty burden of "changing the culture."

The idea was that if you could not change things at the institutional level, it was possible to change them at the individual level by inducing culturally and socially correct behavior. Idealistically it was believed that we could do away with undesirable behaviors and values and consequently develop positive values that would then evolve into a political force—if you cannot stop industry from polluting, you could at least stop people from smoking. This course of action is premised on the Enlightenment view that our moral imperative requires us to do what is right once we are no longer befuddled by false consciousness. The obvious flaw in this reasoning is that

43

capitalism is a system rather than a collection of individuals, and therefore knows no such imperative. For proof we need go no further than capitalism's most effective cultural weapon: advertising. This multibillion-dollar industry strategically promotes products as the source of pleasurable and enjoyable experiences regardless of their usefulness, or necessity.

The growth of the advertising industry was a result of the realization that the propaganda techniques that had been developed during World War II could be used in advertising to extend a manufacturer's sociocultural influence over individual and communal dynamics. These techniques, in conjunction with mass media, are also applied to social and cultural issues to the extent that politics, as well as art, literature, museums, theaters, cinemas, sports teams, and operas have come to be included within this complex network of branding. Such goods, associated with material well-being, are part of a process by which all things may come to be commodities, including our leisure time. This commodifying of lifestyle and culture in general is inversely conceived in Adam Smith's initial utilitarian vision of the beneficial nature of the capitalist system of distribution and production. He believed that by making mass-produced goods available to ever-larger markets, the standard of living and therefore the lives of people would be changed for the good. Late capitalism's vision is that the appearance of a higher standard of living is as good as having one.

The transformation of the process of self-improvement and self-realization into one of consumption obliges us ethically to abandon the fruits of many hard-won victories because their underlying assumptions no longer correspond to our situation. In truth, capitalism in its corporate form exists independently of any class, and its dementia is a structural condition rather than merely one of individual, or even collective ignorance, abuse, or malfeasance. As an autonomous system (an artificial intelligence), whose reified, totalizing logic not only orders all modes and forms of production and distribution, but also seeks our complicity in gaining hegemony over all aspects of our lives, it can no longer be addressed in the traditional manner of social protest.

It is imperative that we find the means to establish an embodied sense of our individual and collective identity capable of denying capitalism access to the power that it accrues through the technological disembodiment of experience and the anesthetization of everyday life. Beyond the development of an ideology capable of imagining world whose evolution is unfettered by capitalism, we also require those cultural producers who seek to engage in politics and critique to abandon the reactive/defensive strategy of responding to social issues, or of promoting individual awareness and

outrage at the inequity that surrounds us, by critiquing the duplicity of the cultural sphere. Such a critique requires the abandonment of the reactive, defensive, and reformist reflexes that make us either seek to turn the cultural field into one of valueless homogeneity, or that would sustain its heterogeneity by preserving meaningless differentiation.

For more than a hundred years, generation after generation of artists have advocated for diversity, indeterminacy, and temporality, yet they have habitually participated in a game that is explicitly designed to produce a singularity by means of negation and reduction. Seemingly, it is such contradictions and unexplored foundations that continue to bind the epic struggle for emancipation from nature and self-determination to the existing social order. Such "habits" of mind and practice are rigid structures formed and allowed to "evolve" through repetition. Consciously or not, they promote the feeling that a successful effect will be achieved each and every time they are deployed. Consequently, in practice, habits appear to be fluid, while in theory they are tightly defined and rigid. In other words, habits are neurotic mechanisms that over time produce diminished results as circumstances change.

Our continued commitment to the unfulfilled bourgeois promise of liberation and individual self-realization, within the framework of individualism, can also be read as a habit that continues to feed our belief that a moralistic appeal to reason will set us free. This has long been the Sirens' song, sung to progressive artists and their audience. Yet, what seems to stand between us and achieving our goal is our own unwillingness to learn what Ulysses did when he plugged his crew's ears and tied himself to the mast so that he might hear the Sirens' song without wrecking his ship on the rocky shore of their isle. What Ulysses learns from this dangerous exercise is that the Sirens' song is full of promises meant to draw him ever closer to his destruction and nothing more. It is not the song, but the promises that become irresistible and lead to ruination.

Today's Sirens' song is both the promise of mindless consumption and better living through technology (or progress), or some other longheld bourgeois master narrative. The rejection of these narratives or their critique does not represent an alternative process or model of social relations. They merely constitute a dialectical form of engagement that is in accord with how the public and private, and the communal and personal spheres of daily life are being materially and politically standardized and ordered. Reciprocally, such acts replicate and reaffirm the notion that the self-reflexivity, doubt, and self-criticality promoted by bourgeois ideology can still play a significant role in the struggle to gain access to the

social power now held in reserve by the entity known as international corporate capital.

An example of the deceptive and corrosive nature that bourgeois ideals and ideology have had on the project of cultural resistance to capitalism can be found in the continued effect of the residual nineteenth-century project of making art more accessible, appealing, and relevant to a broader audience. This project, premised on the view that the political role of culture lies in its direct effect on how we perceive our "selves," and how we come to act in the world, led the practices of late modernist and postmodernist artists to challenge what they imagined to be both elitism and the appeal to bourgeois taste that circumscribed their endeavors. The downside of modernism's and then postmodernism's attempt to critique and democratize high culture has been the integration of new technologies, and new modes of expression, into the general culture without in any manner changing or overwriting the general operating program of society.

The substitution of the "accessibility" of irony and anecdote accompanied by what now constitutes a significant aspect of contemporary practice offers no alternative to capitalism's ideological deceit, just a knowingly complicitous sneer. Our failure to produce a politically viable cultural sphere has in turn been used to promote the view that there is no longer anything to be done that can constitute a relevant or meaningful counterculture, and that we should capitulate and accept our fate, or start the whole process all over again. The latter option, a bit like the movie *Groundhog Day*, that suggests we are doomed to repeat our mistakes until we learn our lesson, is itself an acknowledgment that we have again failed to apply what we have learned concerning the complex of discourses that regulate the cultural sphere. The failure of these "critical" practices has contributed to the very real possibility that in the near future the best our culture will be able to produce is MTV, reality TV, video games, Web-based pornography, recycled interior design, picture novels, and sociopolitical, psychotherapeutic Muzak.

To achieve our objective of emancipation, our critical criteria and aesthetic practices, which include all forms and categories of knowledge, and reflect the more general economy of intellectual and material production, must be rethought within the context of the political economy of social power. To begin with, we no longer need worry about what is and is not art, but instead what it means to create a culture capable of consciousness building not "raising." Art, not as a category of objects, but as a mode of production, stands in contradistinction to those practices that would reduce human possibility to a finite number of principles and conceptual

categories. Because of the significant role culture plays in constructing and sustaining our subjectivity, it requires an aesthetic ideology capable of generating embodied experiences that leave us with a sense of presence, and the ability to make judgments and act imaginatively and creatively rather than merely reactively.

But it is not enough to slow the progress of capitalism's totaling project of global control. We must, through a critique of the cognitive and aesthetic propositions that order relations such as immediacy and mediation, semblance and expression, action and judgment create a counterbalance to capitalism's promise of self-realization and transcendence through symbolic consumption. Consequently, because in such an increasingly instrumental society as ours, critical culture in form—though as I have indicated up to now, not necessarily in content—still appears capable of engaging in a comprehensive reformation of itself, it maintains the revolutionary possibility of being an exemplary and pragmatic model of a non-system-building practice that can actually afford us a political model able to rival that of liberal democracy. As such, rather than constituting a space of marginalized engagement, critical culture duly reordered can afford a space that permits us to step outside the existing reactive social model ordered by the instrumental logic of either/or.

Those who manage and maintain capital understand the consequences of this, and have sought to dismantle or transform those sectors of our culture, which continue to preserve the radical ideals of the Enlightenment. Because until now they have failed to fully integrate such sectors into their mechanism of social control, critical culture remains a highly contested arena, due to the inherent complicity it also constitutes an ethical challenge to those who seek to use it as a means to transform our political and cultural economy.

CHAPTER

Museum Collecting, Clear Title, and the Ethics of Power

Tom L. Freudenheim

For museum-based art historians, questions of provenance are conventional fare. The museum has somehow gained title to an object, and there is a natural curiosity to know about previous owners. Tracing ownership is also considered part of the scholarly background of the work, since scholarship remains among the pretensions governing the self-awareness of most museums. This despite our knowledge that museum collections often consist of material with questionable provenance; that is, an object's previous ownership is either unclear or unknown. That, too, has long been considered an acceptable aspect of museum collecting, along with the generally undiscussed (or even undisclosed) information that clear title may be murky.

In general this has not tended to be a matter of contention, because most countries recognize the concept of statutes of limitations: After a certain amount of time (which can vary greatly), no judicial claims can be made for recovery. In true fulfillment of the aphorism *ars longa, vita brevis*, museums often have owned works long before anyone really asks who previously owned them, which has quite effectively disposed of most legal title questions that might otherwise haunt museums. This essay attempts to provide some context for these issues in relation to events of the past several decades, arguing that ethical arguments have been used to obscure what are really issues of money and power.

In the postcolonial, post–World War II world, many new questions have been raised (or perhaps some of the old, never-asked ones have surfaced,

and new national laws and international treaties have tried to address them. A review of these laws and treaties is outside the scope of this discussion, but what does interest me is the way in which *ethics*—that is, "doing the right thing"—has generally been argued as the rationale for these regulations. In fact, they represent the newly emerging empowerment of whichever groups may be laying claim to works in museum collections, and thus are a reflection of shifts in political power balances, rather than rising ethical standards. In another, not-wholly-unrelated context, the lawyer-novelist Thane Rosenbaum, using the term "the myth of moral justice," argues that "sometimes what's right is simply obvious, because its opposite is so clearly wrong."[1] But that depends on the situation and whose judgment is determining right from wrong. Consider that the director of the Metropolitan Museum of Art, Philippe de Montebello, states that "works of art are the tangible manifestation, the highest aspirations, of man as he expresses himself in visual terms," and argues further that "our [i.e., the museum's] primary responsibility is to the works of art."[2] But it's not clear whether that responsibility is to all works of art, or just those that the museum itself holds. Is this a suggestion of museum collecting as a reflection of the "highest aspirations of man"?

Museums have, in fact, long been value-laden with a more expansive realm of considerations. The founding documents of our great institutions "all included references to the goal of public education—variously described as 'educating and uplifting,' 'enlightenment,' 'popular instruction,' and 'advancing general knowledge'—as well as to their mandate for collecting, preserving, and exhibiting objects."[3] While these several educational functions were never questioned or adequately spelled out[4]— probably because education per se tends to be considered an unassailable value—the collecting role has only recently been thoughtfully challenged.[5] After all, that's what museums do!

However, the "elevation [of collections] into sacred objects. . . . [analogous to] ecclesiastical property"[6] probably explains more about the collection impetus than any of the educational roles, which have increasingly become part of the public marketing face of museums as they seek to justify their increasingly high costs. Rationalizing the museum's existence in relation to lofty values has been common at least since these entities became public institutions toward the end of the eighteenth century. A newspaper ad for a lecture by de Montebello, entitled "Museums: Why Should We Care?" makes a case for the museum's ability to address issues that may appear unrelated to the isolated world of the art museum: "In the midst of such global turmoil, why is art important? Is it

indispensable? Does it bring order to the world? Does it provide assurances of renewal and survival?" The lecture includes what might be considered a plea:

> Who made these things? We did, our species did. Isn't that reason enough to maintain our faith in humankind? Especially when you consider that wars, massacres and nature's indiscriminate destructive forces have occurred throughout recorded history . . . and that through it all, men and women of genius have managed to give us their vision of the moment, at the highest level of inspiration. What we learn is that no matter the degree of chaos and adversity surrounding him, man has shown his capability to excel, to surpass. That is the ultimate assurance of renewal and survival. And it is one of the great lessons of the art museum.[7]

The ecclesiastical analogy has never seemed more apt, and has often been discussed, but perhaps nowhere more cynically than by the Russian-American artist, Alex Melamid: "Art has traditionally had its roots in religion, but now . . . it has become a religion itself, a full-blown religion . . . [that] has its own Holy Trinity—Leonardo, Rembrandt, and Van Gogh."[8] The claims (serious and/or ironic) that art may share with religion the power to address life's most pressing problems apparently doesn't include questions of ownership. How odd, considering that many of the legal strictures about provenance, made in the name of ethical values, have only come about relatively recently.

The *UNESCO Convention on the Means of Prohibiting and Preventing the Illicit Import, Export and Transfer of Ownership of Cultural Property* entered into force in 1972. By now over 100 countries are signatories to this Convention, which has raised significant, and often embarrassing, questions in regard to how materials move through the art market into public institutions, as well as into private hands. As someone who has worked in the art museum field for many years, I have watched with interest at the almost Talmudic casuistry engaged in by museums trying to make a case for acquisitions that probably contravene the UNESCO Convention, if not their own country's laws. That's because there are obviously different views on "doing the right thing." It might mean acquiring an object for a public institution and thus, theoretically, making it available/accessible to the public, as well as, again theoretically, preserving it for the future. In 2006 the Association of Art Museum Directors adopted new policies to address some of these

issues. Defending those policies, Timothy Potts, director of Fort Worth's Kimball Art Museum asserted that "if it [i.e., a work of antiquity] goes on view with other like objects, then scholars get to see it and study it; the public gets to come; the claimant, if there is one, gets to know where it is and file a claim."[9] But the Met's director wrote in another context: "Quite simply . . . acquiring art is the museum's single most important activity."[10] In that case, if from the museum's self-interested point of view "the opposite is so clearly wrong"—that is, letting go of a work of art—then one has described a dilemma which now haunts virtually all collecting institutions: the conflict between ethical and legal standards, and the pressure to develop field-wide, if unenforceable, policy guidelines.[11]

Some would claim that international agreements have had a salutary effect on curbing illicit traffic in works of art. Others have argued quite persuasively that only public institutions have suffered, since they are open to general scrutiny, while private collecting and a lively art market, both unregulated, continue to thrive, perhaps even at the expense of the public institution—if by "expense" we may include the deleterious impact on the collecting mission of the museum. But the basic premise of the UNESCO Convention remains important for what it says, even when not always followed. The Preamble is rich in terms about cultural property that have long been the province of museums:

> . . . enriches the cultural life of all peoples . . . inspires mutual respect and appreciation among nations . . . constitutes one of the basic elements of civilization and national culture . . . moral obligations with respect to [every nation's] cultural heritage . . . collections are [to be] built up in accordance with universally recognized moral principles.[12]

The inherent conflicts between nations and institutions are not addressed by UNESCO—nor realistically could they be. And yet there is an underlying assumption that all signatory parties, indeed everyone worldwide, agree on the definitions of moral principles and on the concept of what the basic elements of civilization might be, even when all evidence points to a contrary reality.

Into this highly principled system entered new circumstances. Over time, various countries have imposed their own laws, often more stringent and certainly more specific than the UNESCO Convention, while often lacking its articulation of high moral values. A prominent American art museum director argues "nothing museums do is more important than

adding to our nation's cultural legacy and providing visitors access to it."[13] One country's concept of cultural heritage might fly in the face of another's. A "national gallery" generally doesn't suggest a place in which a nation hangs works produced in or for that nation (except in countries with minimal access to internationally valued/validated art), but rather a venue for demonstrating the cultural wealth, and thus status, of a given nation. Even without its Trinitarian overtones, is the *Mona Lisa* part of the Italian national heritage (although it was produced long before there was a nation called Italy), or does it belong to the French patrimony? Or, as some might argue, is it a world treasure, whatever that might mean?[14] This problem seemed generally irrelevant prior to our era, because owner-nations were those with power and wealth, often of the colonial type, although even in antiquity treasures were taken by conquests, as is most articulately seen in the Arch of Titus, where the Romans are depicted carting away the treasures of the conquered Temple in Jerusalem.

But even if there may now be only a single world power, we are living in an age with other kinds of widespread empowerment—or at least a *sense* of such empowerment. And this has raised a new series of ethical questions. Thus Nigerian claims for recovery of Benin bronzes, which were looted by the British when they overtook, ransacked, and burned the Benin Kingdom in 1897, are in conflict with the possessiveness of the many museums worldwide that hold these bronzes on behalf of some vague notion of "world treasures" and the aforementioned primary obligation of the museum to collect. Furthermore, ammunition against the Nigerian claims include the somewhat persuasive arguments that Nigerian museum conditions don't provide the necessary security that would assure artworks safety from looting and thus subsequent reemerging on the world art market. The 2003 looting in Iraq added some power to this argument, although that was a result of war conditions, to which many countries continue to be at risk.

The most publicized of these issues is the dispute over the Elgin Marbles at the British Museum. The legitimacy of Lord Elgin's acquisition of the Parthenon sculptures has long been in dispute, as has the question of where the reliefs most appropriately belong. But it was only the reality of a newly emboldened Greek state, with eloquent spokespersons (e.g., celebrity Melina Mercouri) and the prospect of the 2004 Olympic Games that made the problem reemerge. And it has produced an astonishingly unresolved series of disputes. The Greeks were building a new museum at the foot of the Acropolis to house works now held in London, trying to use the Olympics as a lightning rod for the issue, which failed to take hold

53

because the Athens museum wasn't ready in time, and as of this writing (2005), is expected to open in 2007. Meanwhile, the arguments that the Parthenon sculptures belong at their original site is considerably weakened by the reality that even if returned to Athens they would not be shown *on/in* the Parthenon, but only nearby, in a museum that is quite distinct from the original site. The British Museum's argument that it holds treasures *of* the world *for* the world is probably no less compelling than the Greeks' claims that the sculptures ought to be shown *near* their source. In any case, these disputes get solved the way most such conflicts do: The more powerful party wins, and to date there is no question that the U.K. and British Museum are much the most powerful of the contestants.

When the growing voices of the Native American community began to be heard in the last decades of the twentieth century, the noise was not just about living conditions and other social and economic concerns of American Indians. Concerns about the disposition of material culture was included in many of the discussions, especially human remains and grave goods that were stored in many museums. The passage by the U.S. Congress of NAGPRA (Native American Graves Protection and Repatriation Act) in 1990 began the return of some Native American cultural items—human remains, funerary objects, sacred objects, and objects of cultural patrimony—to lineal descendants, culturally affiliated Indian tribes, and Native Hawaiian organizations. Because this law applies only in the United States, many major museum collections (e.g., Berlin, Vienna) are not affected. And some of the defined groups are satisfied that their patrimony is on display in major museums. But the task of repatriation continues, with "cultural affiliation" as the criterion. Again, the success of this effort on the part of the American Indian community is a reflection not so much of a shift in ethics as a shift in power: "Doing the right thing" became a political necessity.

If "cultural affiliation" becomes the criterion for "doing the right thing" in the United States, can it have impact elsewhere? That's a question with complex implications, as border shifts, ethnic conflicts (as well as ethnic cleansing), occupations, and population transfers have accelerated since the end of World War II. There is the ever-present suggestion that, as with Native Americans, the cultural patrimony issue rests with groups of people more than with geographic boundaries. In that case, the potential for further disputes about who should have ultimate possession of material culture (which often includes valuable and valued art) appears to be endless. Among those one can envision are the cultural affiliation of the Greeks with much of their heritage in what is now Turkey; traditional tribes versus

recently constructed nation definitions all over Africa; Jewish claims on materials in non-Israel Middle Eastern lands, and consequent Arab claims on materials in Israel; Christian and Muslim group conflicts in various countries, but especially in the former Soviet Union. It is quite likely that when and if such disputes arise, they will be settled in favor of the more powerful, or at least the most politically potent, rather than on the basis of ethical or moral decisions. Might generally makes right in these situations.

Which is why it has been interesting to observe the parallel development of the disputes about what gradually became known as "Holocaust-era assets"—especially the art involved in this all-inclusive term. Oddly enough, the beginnings of what has become an ongoing series of litigations may date to 1962, when a woman noticed that a Chagall painting that had belonged to her family in pre-war Brussels was reproduced in a book as belonging to a New York collector. The ensuing court case,[15] in which the painting was returned to the original owners, also involved financial compensation, including litigation between the New York collector and the gallery from which the Chagall had been purchased, because the value of the work had increased between the time of the work's sale and the time of its return. While this case has entered the legal textbooks as a study in issues of remedies, it was not understood at the time (1969) in relationship to what would later become an explosive issue involving museums and art whose ownership changed subsequent to 1933.

It is beyond the scope of this essay to cite all of the various restitution cases that have been filed over the past two decades as descendants of Nazi-era victims have been made aware of the potential for recovery of stolen art. A growing number of books and articles on the subject are testimony to how much is at stake.[16] Museums in America from Seattle to Chicago to New York have been involved in restitution cases, as have museums in other countries. Moreover, in an attempt to assure the public of its proper conduct in relation to these matters, the American museum community has gone to great lengths to demonstrate ethical behavior.

In 2001 the Association of Art Museum Directors (AAMD) released their policy:

> Among the 14 million objects held in American art museums in public trust, museum researchers have identified approximately one thousand works which, though not necessarily stolen by the Nazis, require further study into their ownership history during the Nazi era. These works have been published and/or posted by museums on their Web sites and on centralized databases to assist

researchers and claimants alike. Based on such new research, eight paintings to date have been identified in American museum collections as having been stolen by the Nazis and not properly restituted after the war and each of these paintings has been restituted to the heirs of Holocaust victims. In three of the cases, the heirs have graciously worked with the museums to allow the works to remain at the museums for the public's benefit.[17]

This highly ethical-sounding position is preceded by the ingenuous claim that:

> ... since 1943, America's art museums have taken a leadership role in the restitution of art and other property stolen by the Nazis. American museums were active partners with the United States Army's Monuments, Fine Art and Archives section, which succeeded in returning hundreds of thousands of objects to their country of origin in the years immediately following World War II.[18]

If that were really the case, why did most of the restitution cases only begin in the 1990s? Professor Jonathan Petropoulos, one of the leading experts in this burgeoning field, has noted "that an overlooked problem is Holocaust looted artworks currently in the hands of American private collectors, who, until the recent scandals and lawsuits, likewise eagerly participated in the 'no questions asked' policy."[19] Since it is reasonable to assume that at least some of these private collectors are on the boards of museums, might we ask whether the museum value systems, referred to above, have any significant impact on those most closely associated with these institutions?[20]

The reality is so obvious that it has been (quite purposefully) overlooked in virtually all of the writing that has so far appeared on the subject.[21] The driving force behind what keeps being called "justice" is really money, most significantly the burgeoning of the international art market. The Menzel family bought their Chagall in Brussels for about $150 in 1932. By 1955, the Perls Gallery in New York bought the painting from a Paris art gallery for $2,800, and subsequently sold it to a private collector for $4,000. At the time of the 1969 trial, the Chagall was valued at $22,500, which (adjusted for inflation) would be over $2.5 million in 2005. While that may be more than the painting would bring at auction, given the volatile nature of the market, the fact is that art prices are now so high that recovering looted works is worth the effort,

even if this involves sharing a considerable portion of the recovered assets with the legal team litigating the case. That this monetary motive is behind the relatively recent spate of recovery lawsuits is further evident in the fact that most of these cases involve high value paintings, rather than the vast amount of other material that was stolen by the Nazis.[22]

This case is forcefully made by Sophie Lillie in her book documenting the vast array of stolen or otherwise "appropriated" material that belonged to Viennese families.[23] The most astonishing aspect of Lillie's study is the extensive listing of objects that are never included in these attempts to assure that "justice" is done: furniture, carpets, silver, bronzes, porcelain, coins, etc.—as well as an endless array of prints, drawings, and paintings by artists whose market value is probably negligible—further proof of the selectivity of this "ethical" approach to restitution. Museums remain bastions of money and power, whatever their claims on providing venues for the transmission of higher values. For proof of this, one need only look at the major cases that have been, and continue to be, litigated: Schiele, Degas, Monet, and Matisse are among the disputed works—all costly and major stars in the art firmament. Bazyler argues that "about 2,000 Holocaust looted artworks around the world have been returned since 1998,"[24] but that number is almost inconsequential when compared with the massive number of stolen works, some large number of which were probably destroyed, although obviously many thousands could be made the subject of restitution claims.[25] So the focus has been on two primary targets: public institutions (museums) and high-value artworks.

There have also been issues of complexity, such as the still-pending case of the Egon Schiele painting, *Portrait of Wally*, seized by the New York State Attorney General after a 1997 loan exhibition at New York's Museum of Modern Art.[26] But in this case, money and power are the issues, rather than arrival at a "just" resolution. As Ashton Hawkins, former vice president and counsel at the Metropolitan Museum of Art stated, in defense of MoMA's position that its first responsibility was to return the painting to the Vienna museum from which it had been on loan:

> . . . people who would have previously considered lending now simply don't consider it. You can't quantify it very well, but I know from my colleagues who arrange these exhibitions in New York and in other cities that lending to the United States and particularly to New York has been more of a problem than it used to be. It doesn't mean you can't get the loans; you can. But many people just don't want to offer it up.[27]

We may ask whether there are conflicting arguments being made here: the museum's traditional roles to acquire and display art pitted against recent intrusion of ownership/title considerations.[28]

Another little-noted aspect of this ethics versus power issue concerns the vast amount of Judaica that was stolen during the Nazi era. Redistributed in the postwar years by a U.S. Government–constituted entity named "Jewish Cultural Reconstruction, Inc.," this material found homes in several of the significant institutions that were collecting similar material—in New York, Cincinnati, London, Jerusalem, among others.[29] The recipient museums were pleased to receive this Judaica, and proudly displayed it, almost as postwar trophies, given the tragic reality that so many millions of Jews had been murdered and most of their patrimony destroyed. Much of this material came from pre-Holocaust Jewish institutions in Europe, especially in Germany, and in the years immediately following the war there was a general sense that viable Jewish communities would never again be established in the places from which Jews had been so cruelly expelled. But Jewish communities have been reestablished, along with an astonishing number of Jewish communal institutions, including museums. And some of the Judaica that once belonged to earlier Jewish museums in such cities as Berlin and Frankfurt is now safely ensconced in New York or Los Angeles or Jerusalem. No effort has been made to return these objects to their earlier owners, because the successor institutions cannot clearly (and legally) be designated as such, given communal and governmental shifts in the half century that separates the old museums from the new.

The most ironic situation arose when the "new" Jewish Museum in Frankfurt opened its new facilities in 1988–89 with an exhibition of works that had once belonged to the prewar Frankfurt Jewish Museum.[30] Aside from displaying documents demonstrating the Nazi liquidation of the museum, the exhibition included major works that had once been part of the Frankfurt museum's collections and that reside in public Jewish collections in New York, Los Angeles, and Jerusalem. But there was no implication in the course of this spectacular display of treasures that any claims would be made for the return of the objects to their earlier home. It is difficult not to read this as yet another display of power,[31] in which the newly emerging Frankfurt museum was willing to borrow back works that by conventional ethical standards might well have been returned to the city from which the Nazis looted them. Legalisms and power will usually trump ethics.

It is worth noting shifts in power that are taking place as this is being written (2005). As the world's only superpower, the United States wields astonishing military strength while concurrently facing questions about its moral positions—whether in regard to following the Geneva Conventions on torture or the Kyoto Treaty on global warming. That may have contributed to new efforts by Italian authorities to recover antiquities from the Getty Museum, with further threats against (and compromise treaties being worked out with) the Metropolitan Museum of Art and other American museums. While some may view this as a battle about the ethics of public collecting, I find myself sufficiently cynical to see the current discussions as power struggles, and it is likely that whatever punishments are meted out, the negotiations will have been organized in relationship to which parties have the greatest power.

But this essay is not about conventional ethical standards. What I have tried to demonstrate is that museums have traditionally asserted themselves as being value-based, emerging out of Western traditions that convey to these institutions something akin to sanctity. They have claimed this ground in validating themselves to their several publics. Komar and Melamid's[32] art jokes may, in fact, be the most realistic way to approach the issue of the new museum/church. Like most institutions, museums assert one set of values and operate on another; they share this with churches and governments. This is not to single out museums, but rather to suggest that they are rather conventional organizations sharing, along with the fallible human beings who guide them, the same human flaws that we observe in the rest of society. We are accustomed to hearing nobly stated aims without expecting much.

In an earlier, more naïvely idealistic era, when museums could define themselves as purveyors of some higher set of values, perhaps people believed what they were saying. That was also a time when ruthless American capitalism financed the beginnings of our great museums, with an underlying belief in noblesse oblige, to assure that great wealth be accompanied by the sense of obligation to share some of its benefits with a wider public. Some of our greatest institutions owe their beginnings to this impulse, prior to the establishment of a tax code that made such benefactions not only noble but also financially shrewd. But the introduction of new challenges to the value systems and missions that museums espouse—accompanied by litigation, repatriation, and title disputes—have revealed another side of museums. We know there's trouble when the director of New York's Museum of Modern Art writes, "art museums are currently operating in an ambiguous climate, where the rules and expectations are

neither clear nor easily ascertainable. . . ."[33] I'm inclined to take a more realistic, if cynical, view: Institutions based on power will demonstrate their wealth and musculature well before they bow to ethics.

Endnotes

[1] Thane Rosenbaum, *The Myth of Moral Justice* (New York: HarperCollins, 2004), 14–15.

[2] Judith Dobrzynski, "Hip vs. Stately: The Tao of Two Museums," *New York Times*, sec. 2, Feb. 20, 2000.

[3] Edith Tonelli, "The Art Museum," Michael Steven Shapiro ed., *The Museum: A Reference Guide* (Westport CT: Greenwood Press, 1990), 34.
See also Susan M. Pearce, *Museums, Objects, and Collections* (Smithsonian Institution Press, 1993), 3–4, quoting Henry Cole in reference to the South Kensington (later Victoria & Albert) Museum.

[4] Newer terminology might include "'translation' of the collection into meaningful experiences for a broad public." Christopher Reynolds, "Which way, LACMA" in *Los Angeles Times*, June 12, 2005.

[5] Ivan Karp, Susan Vogel, Werner Muensterberger, and Philipp Blom are among the more interesting thinkers in this field.

[6] Pearce, 236.

[7] Philippe de Montebello, "Museums: Why Should We Care," *Wall Street Journal*, June 1, 2005.

[8] Quoted in Margaret Wertheim, "The World According to Komar and Melamid," *LA Weekly*, December 10–16, 1999.

[9] Quote in Hugh Eakin, "Museums Assert Right on Showing Antiquities," *New York Times*, February 25, 2006.

[10] On a card sent out by the Metropolitan Museum of Art, ca. 1999 (in author's possession).

[11] I am not including the ethics of what is now generally called "deaccessioning" as part of this argument. Disposing of collection items, and thus removing

them from public view/access, as well as potentially changing the conditions necessary for their preservation, is generally considered only from the point of view of the law (i.e., whether there are any legal restrictions on subjecting the work to change of ownership). Ethical questions (did the donor envision that the item would remain in the museum permanently because the gift/bequest was made at a time when museums were understood to be the final resting places for objects?), that is—"doing the right thing"—tends to be deemed less critical in such cases.

[12] Excerpted from UNESCO documents: United Nations Educational, Scientific, and Cultural Organization, "Convention on the Means of Prohibiting and Preventing Illicit Import, Export and Transfer of Ownership of Cultural Property," Paris, Nov. 14, 1970.

[13] James Cuno, "The Object of Art Museums," *Whose Muse? Art Museums and the Public Trust*, ed. James Cuno (Princeton: Princeton University Press, 2004), 52.

[14] See Kwame Anthony Appiah, "Whose Culture Is It," *New York Review*, February 9, 2006.

[15] Menzel vs. List, 246 N.E.2d 742 (N.Y.1969).

[16] The two basic texts are probably Hector Feliciano, *The Lost Museum: The Nazi Conspiracy to Steal the World's Greatest Works of Art* (Basic Books, 1997); Lynn H. Nicholas, *The Rape of Europa: The Fate of Europe's Treasures in the Third Reich and the Second World War* (Knopf, 1994). There are also a number of interesting Web sites devoted to these claims: http://www.lootedartcommission.com.

[17] Press release of AAMD, January 2001. See also the Addendum, April 30, 2001.

[18] Ibid.

[19] Michael J. Bazyler, *Holocaust Justice: The Battle for Restitution in America's Courts* (New York University Press, 2003), 207.

[20] Pearce, 235–6, notes: "Since museums hold material, they cannot avoid integration into the world of goods. Art galleries [i.e., art museums], in particular, have always been deeply embedded in the working of the capitalist mentality . . . although museums may wish to deny their implications in capitalist economic practices, they are in fact wholly integrated into them. This denial is based on the claim that museum collections are taken out of the sphere of commodities, that they are no longer available in the marketplace. . . ." But certainly this isn't

true in American art museums, where art works are regularly reentering the market through deaccessioning.

[21] In addition to Bazyler (cited above), it is worth noting Stuart E. Eizenstat, *Imperfect Justice: Looted Assets, Slave Labor, and the Unfinished Business of World War II* (Public Affairs, 2003); also the excellent small exhibition catalog, *Legalisierter Raub: Der Fiskus und die Auspluenderung der Juden in Hessen 1933–1945* (Sparkassen-Kulturstiftung Hessen-Thueringen, 2002), which in its very title—relating the "exchequer" and "plunder"—makes the financial connection clear.

[22] The much-publicized lawsuit of Los Angeles resident, Maria Altmann, who succeeded in the 2006 recovery of five Klimt paintings from a Viennese museum, may be the most sensational one to emerge. The blockbuster (and often cited monetary) value of the recovered paintings was evident in their being almost immediately exhibited at the Los Angeles County Museum of Art.

[23] Sophie Lillie, *Was Einmal War: Handbuch der enteigneten Kunstsammlungen Wiens* (Czernin Verlag, 2003). Lillie told me that aside from the considerable effort of going through all the existing records, she had great difficulty in deciding which collections to include. Her book of over 1,400 pages is still only a selection of looted collections, not a complete list. And it's only about Vienna!

[24] Bazyler, 208.

[25] Ibid., 202, cites Petropoulos as estimating that "between 1933 and 1945, the Germans stole approximately 600,000 pieces of art from both museums and private collections throughout Europe. . . . When rare books, stamps, coins, and fine furniture are added, the figure goes into the millions. It took 29,984 railroad cars . . . to transport all the stolen art to Germany."

[26] Museum of Modern Art, New York, "Egon Schiele: The Leopold Collection, Vienna," October 13, 1997–January 4, 1998.

[27] Interview on *All Things Considered*, National Public Radio, December 27, 2004.

[28] The most egregious exercise of this power came about in early 2005, when pressure from the Museum of Modern Art persuaded National Public Radio to dismiss a prominent arts reporter covering this case.

[29] The records of Jewish Cultural Reconstruction, Inc., seem to have disappeared, although one hopes they will eventually be rediscovered.

[30] *Was Uebrig Blieb: Das Museum juedischer Altertuemer in Frankfurt, 1922–1938* (*What remained: The Museum of Jewish Antiquities in Frankfurt*, 1922–1938), published by the Jewish Museum of the City of Frankfurt. Note that the museums have different names, so technically it is difficult to claim that the current one is the legal successor of the earlier one. The same would be true of the two Jewish museums in Berlin. The pre-war museum, which opened just prior to Hitler's seizure of power in January 1933, was part of the Jewish community. Of the current museums, the large Jewish Museum in Berlin is now a federally financed institution, while the Centrum Judaicum is an independent museum that is housed in an historic synagogue, but which again cannot quite (technically) claim to be the successor institution to the pre-war museum.

[31] I am taking some liberties in extending the sense of the term as used by Steven C. Dubin, *Displays of Power: Memory and Amnesia in the American Museum* (New York: New York University Press, 1999).

[32] Wertheim, op. cit.

[33] Glenn Lowry, "A Deontological Approach," in *Whose Muse?*, 137.

Politics, Ethics, and Memory: Nazi Art Plunder and Holocaust Art Restitution

Ori Z. Soltes

Socrates, in the late fifth century BCE, pushed Greek thought toward moral matters by introducing "ethics" as a concept into Western philosophical thinking. A century later, Greek culture came into extended contact with the Judaeans, whose primary texts referred ethical questions to a single God who was understood to embody all that is good.[1] The bifurcation of Judaean thought into Judaism and Christianity, each variously synthesized to Greek thinking, shaped the foundations of Western thought on ethics as well as other issues.

By then the notion of wartime art plunder already had a long history, attested in both literary and visual sources. Art plunder forms part of the *Iliad*, the first extensive war epic in the Western tradition; Agamemnon's attempt to assuage Achilles' anger includes the offer of war-plundered riches if Achilles agrees to return to battle.[2] Later, Assyrian art is studded with reliefs that include depictions of art as well as other plunder being ingathered after successful war and peace campaigns.[3]

The first individual specifically mentioned in Western historiography as a wartime plunderer is the Roman general Lucius Mummius. After his victory at Corinth in 146 BCE, this cultural barbarian carted "the most wonderful of votive decorations and other works of art" back to Rome.[4] As we follow Western civilization down the centuries, both war and art plunder flourish, with varied sensibilities and consequences. The Spanish denuded Central and South America of their glorious gold artifacts, melting most of

them down to be used as fiscal rather than cultural bounty. Napoleon, on the other hand, dragged Egyptian antiquities back to Paris wholesale, acquiring Classical works from Rome along the way, and ingathering more recent paintings and sculptures from Italy as well as from countries such as Germany and Austria.

Adolf Hitler certainly saw himself as the echo and continuation of this array of conquerors and colonialists—he whose goal it was to create a thousand-year, world-encompassing Reich. But Hitler differed from his predecessors in the sheer volume of his thievery—it is said that one-fifth of the world's art changed hands during World War II, with hundreds of thousands, perhaps millions, of precious objects involved, from silverware to sculpture.[5]

Nazi plundering also differed in being so systematic and meticulously detailed. In the hands of Alfred Rosenberg, whose institute articulated the Nazi distinctions between "superior" and "inferior" races, and of Herman Goering, whose tastes were broad and whose appetite for objets d'art was insatiable, squads of looters were organized.[6] Nazi plundering also differed in being part of the *prelude* to war and not only part of the war itself, and in having thus begun at home. The process had been an evolving one. In the first place a distinction between legitimate and degenerate art, applicable as a practical matter only to Germany, was already being shifted into place by the end of Hitler's first year as chancellor.[7] What Hitler regarded as defeatist, leftist imagery, and works that looked, to his banal eye, "unfinished" (like Impressionist or Fauvist paintings)—and individuals associated with making or exhibiting them—were already being removed from positions of prominence by late 1933.

At the Nuremberg rally of 1934, the Fuehrer would refer to modernists—he referred specifically to cubists, futurists, dadaists, and the like—as full of "twaddle."[8] Joseph Goebbels would ban art criticism by 1936: "From now on," he would assert, "the reporting of art will the take the place of an art criticism which has set itself up as a judge of art—a complete perversion of the concept of criticism which dates from the time of the *Jewish domination of art* . . . " [my italics].[9] That in the same year racial distinctions led to the deprivation of citizenship rights for Jews (and several other groups) should not be a surprise. By 1940, as the Reich expanded, its leaders began to apply the principle of non-rights to the growing circle of occupied territories. By 1941, Rosenberg's *Einsatzstab Reichsleiter Rosenberg* (ERR) had been empowered to create a task force to organize wholesale looting throughout countries conquered by the

German armies.[10] So a domestic, peacetime looting program could now join itself to an expanding war across forcibly disappearing borders.

The ERR staff worked independently of, but in the same places as, the German army, systematically stripping museums and galleries, families, and individuals. They sought artworks for the Fuehrer; for other important members of the Nazi hierarchy; for ERR higher-ups; for German museums—or to be traded or sold for other artwork; or, by 1943, to be sold in order to replenish the armament supplies that were beginning to diminish. But in what can be called the true spirit of Lucius Mummius, the overriding purpose for the accumulation of art was related to status and a sense of political self-assertion. The possession of art was an emblem of being civilized, not barbarous (other evidence to the contrary), just as the ability to decree *which* art was appropriate reinforced the sense of being in *control*.[11]

Countless works from French collections were brought back to the fatherland. Avant-garde works (Picasso, Braque, and the like) considered degenerate by Nazi ideologues were traded or sold. On the other hand, Slavic works, products of an inferior race which itself was to be enslaved, were by and large destroyed, or if the material of which they were made was potentially usable, transformed by deconstruction or melting down.[12] Where Jews and any Jewish-connected art were concerned, confiscation for destruction or trading and selling was prescribed. This applied not only to works by Jewish artists, but even to works by an admired artist like Rembrandt that offered an unacceptable, too Jewish, or Jewish-seeming subject: *Jacob Wrestling the Angel*, or *The Jewish Bride*, for instance. Jewish ritual objects were mostly consigned for destruction, like the Jews themselves—though as with non-art possessions and even body parts (such as gold teeth), any "Jewish" objects of precious metals that could be melted down or otherwise put to use, *were*.

By way of further-twisting strangeness, numbers of Jewish ritual objects (and also paintings and musical instruments) throughout Bohemia and Moravia were gathered by the Nazis and, rather than being destroyed, preserved for an exhaustive museum planned in Prague, of "an extinct race."[13] Its purpose was also political: the more significant the enemy, the more impressive the victory; the more rich and extensive the range of Jewish ritual objects, the more valid the powerful Nazi effort to destroy the Jews and Judaism. This project was the other side of Hitler's sweetest personal ambition—his dream of building the biggest museum (of approved art) that the world had ever seen, in Linz, Austria, his hometown, which he would transform into a "German Budapest": another part

67

of making a forceful statement that his was a civilized, and not merely a militarily impressive, regime.[14]

Precision and volume in all of this were made possible by the able and willing assistance that the ERR and its network obtained from various dealers and curators. Lists of precisely who had what, from the handful of artworks in a bourgeois household to the substantial collections of renowned gallerist Paul Rosenberg (no relation to Alfred), were assiduously compiled by an army of accomplices. Dealers like Fruccio Asia from Ancona and Carl Buemming from Darmstadt; Gustav Rochlitz and the notorious Dr. Haberstock, who shuttled between Berlin and Paris and between Paris and Switzerland— even Dr. Otto Foerster, director of the Reichartz Museum in Cologne (in other words, respected members of the museum community, and not only commercial dealers out to make money)—to name a few, were particularly useful.[15]

The ethical questions that haunt the narrative of World War II from Auschwitz to Nagasaki encompass this narrative as well. As with other aspects of their operations, the art plunder machine of the Nazis could not have functioned so smoothly without the cooperation of various kinds of individuals. Beyond Nazis and their sympathizers were those non-Nazi gallerists, dealers, and museum employees who had the option not to participate in the plunder process but who chose to do so—and whether or not to collaborate may or may not always have been a clear choice, nor is it always simple to assess now, nearly six decades later, levels of either sympathy *or* choice. So, too, were those "neutrals" who purchased their neutrality in part by transporting art from Nazi hands to buyers.[16] Finally, there were those on this side of the Atlantic who enabled an art market to flourish in the Americas by closing their eyes, ears, and consciences as to where, how, and from whom the art that they were purchasing and re-selling had come and the likely fate of its erstwhile owners.

This layered categorization reflects what Primo Levi referred to, with regard to the Holocaust in general, as a sliding scale of participation, a "gray zone" between the black and white of clear-cut victimizers and victims.[17] The general ethical "gray zone" condition shaped so adeptly by the Nazis applied to the specific matter of the plunder of cultural property, as well: a unique condition even among the abnormal conditions of war. This was in part because Nazi methodology honed the matter of collaboration/participation to an edge never achieved before. It was in part because the condition was developed *before* the war (not as part of war) and persisted long *after* Hitler's "enemies" had been defeated or incarcerated, and were no longer capable of fighting a "war" against the Nazis.[18]

A particularly difficult subset of the second, ethically "grayest" of the four categories of participants in the plunder of art, includes some of the victims of Nazi art plunder themselves. For questions no doubt surfaced, for this or that prominent *Jewish* dealer—in Paris, for instance, which was just far enough from Hitler's primary focus for a certain "flexibility"[19]—as to whether survival or more than mere survival might be gained by cooperation with the Nazis—or even be used to destroy former nemeses in the art business. The most notorious of such questions has remained attached to Georges Wildenstein, who has been accused of collaboration, and whose family has consistently and successfully defended his innocence.[20]

A different sort of subset is offered by details pertaining to the method by which particular communities were plundered. When the conquered country was largely a willing collaborator in its absorption into the Reich, the confiscation of Jewish property was typically organized by first requiring the head of every Jewish household[21] with property beyond a minimal value—usually, 5,000 Reichmarks—to fill out a property census form (PCF) to guide the confiscations. The most effective locale in which such a system was put into effect was Austria. There, in better-organized detail than anywhere else, forms delineated everything: bank accounts, gold, bonds and insurance policies, automobiles and real estate, carpets, furniture and knickknacks, paintings, drawings and sculptures, silverware, and cufflinks.

For the past several years, my colleague, Marc Masurovsky, and I have been in the process of studying the PCFs for the Vienna Jewish community that were filled out shortly after the 1938 anschluss. Our primary purpose has been to evaluate what works of cultural property were listed on those forms in order to get a sense of how much unclaimed cultural property remains unclaimed, out in the world or destroyed, by comparing them to claims for such property filed after the war.[22]

But in the course of studying thousands of such documents, I have been struck by two things. One is the obliging detail—they were filled out in a manner as meticulous as that of the Nazi bureaucrats who created and stamped them. Occasionally one finds the current address of the filer listed as Ankara, Paris, even New York. Occasionally gratuitous comments have been included, in a casual or even self-mockingly humorous tone—asides, for example indicating that some group of objects is hardly worth the trouble of listing them. One might gather from this how terrified some of these Jews were, that their cooperation must be complete, even at an apparently safe distance—or that, even safe in, say, Ankara, they still had family members back in Vienna who would be endangered if the forms

were not filed in a timely fashion. Or the decision to fill out and file from a distance may also be a symptom both of how *Viennese* they were—and how confident that the madness would soon blow over and their property, carefully recorded and preserved, restored to them. Both the filling out and the occasional witticisms suggest poignantly that they had no idea where all this was *leading*.

If the shifting of the earth beneath their feet was recognized it was ignored. The creators of these forms were, like them, Viennese, who, it is true, as Nazis, out-Nazied the Germans in tormenting their Jewish neighbors.[23] But both rich outbursts of anti-Semitism and meticulous bureaucratic traditions were familiar. The former came and went; the latter was a constant in their world. And who could imagine what was developing in the most "civilized" corner of the larger world, toward a people who had been resident in and interwoven into that corner for a thousand years?

One senses, poignantly, that the middle-class and upper-middle-class Jews of Vienna had no sense that the social, cultural, and economic lives that they had led with increasing confidence since Emancipation were not merely being temporarily disrupted, but on the verge of ending.[24] Indeed the second feature that leaps out of these documents, and helps explain why and how these Jews could be so disbelieving as to the fate that, in retrospect, may seem so transparent, is the *content: what* is listed, both within the realm of cultural property and beyond it. Thus the lion's share of paintings is not comprised of Rembrandts and Monets, but second- and third-rank *Austrian* painters whom few but Austrians were collecting, like the Biedermeirer painter Georg Waldmueller, or Albin Egger-Linz—and others of whom today even most Austrians have not heard. Conversely, some of them possessed works by relative unknowns, such as Richard Gerstl or Egon Schiele whom the more aesthetically adventurous collected in spite of their modernist style and the likelihood that such works would never be worth more than the small amounts for which, prior to World War I, they were purchased.[25]

They were not purchased with *financial* matters in mind. To own works by Austrian artists, both academic and avant garde, reflected the pride with which such families defined and identified themselves as Austrian. Their homes seem to have been stuffed with Austria-specific knick-knacks of all sorts. Perhaps most significant is the fact that so many of them *owned* the homes that they packed with belongings—as well as owning other real estate. Rarely do these forms *not* include *some* sort of real estate, from a small-percentage interest in an apartment building to an entire factory. However small or large the volume of material possessions,

nearly all of those with enough to require a PCF, had invested in *remaining where they were* and had the confidence that they would never have to leave as refugees, much less as concentration camp inmates. They could not imagine that the census forms were preludes to death warrants. The Nazi desire to deceive them regarding their fate was met perfectly by self-blinding nationalist pride.[26]

The cultural earthquake had its after-tremors. The Soviet armies that swept into Germany toward the end of the war were accompanied by trophy squads that often took from the Nazis what the Nazis had looted from their victims; the Soviets termed this "war reparations."[27] With the subsequent closing of the Iron Curtain, tens of thousands of private and public ownership mysteries would lose any chance of being solved at least until the late 1990s. On the other hand, albeit on a presumably much smaller scale, thousands of little objects (and occasionally valuable drawings or paintings cut from their frames and rolled up for easy transport)—like small "souvenirs" removed by tourists from archaeological sites—were brought or sent back to England or America by allied soldiers.[28]

Both Soviet and Allied plunder are part of the gray zone of ethical behavior that fills out the space between the Nazi plunderers and their victims. And the tangle of Nazi plunder was dumped into the laps of the victorious allies after the war. Collecting points were established, into which, in theory, everything that the American, British, and French were able to take control of, was sent. The Wiesbaden summary of December 1950 reported that, since the setting in place of the return mechanism, some 340,846 items that had been taken into the collecting points had been restituted: But again, each "item" is really a "lot," so the number of objects is much higher. For instance, one "item" listed was a library containing 1.2 million objects; another "item" contained three million. As of that date, there were still some 100,000 items in the storerooms awaiting distribution—and more would come in during the last two years of occupation.[29]

A commission of art experts—the American branch was known as the Roberts Commission—had been formed toward the middle of the war, and did its best in the few years of its existence to return endless numbers of misplaced works of art and artifacts to those from whom they had been taken, or to their surviving heirs.[30] But given limited time and resources, this primarily meant returning objects to the countries from which they had been taken, and leaving it up to individual governments to restore them to museums, galleries, and private families. There was no unified effort to consider the points of origin to which the tens of thousands of art-object-trails might *ultimately* lead back. And

each country differed with respect to the energy and integrity with which restitution efforts were made internally.[31]

Meanwhile an ongoing debate was in process regarding whether the Allies should be taking art from the Germans as a form of reparations, as the Soviets were (unofficially) doing. Sumner Crosby of the Roberts Commission observed that a number of his American colleagues "favor the use of works of art as a basis for reparations," arguing that " . . . [my colleagues] say there is little in Germany that the United States wants unless it is art or cultural property." But on the other hand, the United States "must prove to the world that we have no intention of fulfilling Nazi propaganda and that we are sufficiently civilized not to engage in looting ourselves."[32] Given the issues prompting Nazi plunder, there is some irony in the American concern to show that *we* are civilized in *not* doing what other victors since before the time of Lucius Mummius have done, and in particular in the decision not to plunder those who outdid all plunderers before them, and whose goal in plundering was largely related to their desire to represent themselves as culturally informed and civilized.

By then, too, the Cold War was slowly setting in. This meant not only that cooperation between East and West on all matters was shrinking fast, but that the issue of art restitution—indeed the memory of the Holocaust in general—was shifting well off center stage. The atmosphere in the West was not one in which obsessing about stolen art would be favorably received by governments who felt much more threatened by the Communist present than the Nazi past.[33] Moreover, survivors themselves were not overly eager to relive the horror of that era: their primary concern was to figure out how to reshape and move forward with their lives. After the commission closed down, the documents with which it had dealt were classified in European and American archives as secret, making it almost impossible for all but the most determined and politically skilled researcher to obtain information.[34]

The matter of dealing with Nazi-plundered art would await a slow process of awakening, requiring both reemergent memory and redirected political thinking. For our purposes, suffice it to say that by 1993, beginning with Lynn Nicholas's landmark work, *The Rape of Europa*, a growing number of books have accompanied the growing volume of interest in the issue of Nazi-plundered art.[35] A succession of further developments followed.[36] And there emerged or expanded a small group of organizations that address aspects of Nazi art plunder and restitution.[37]

Spurred by the Klutznick Conference (see endnote 36), congressional and state department awareness of this issue led to congressional hearings,

in February, 1998, and again in 2000, held by Congressman Jim Leach's banking committee; to the establishment of a presidential commission that, like the hearings, would address a number of recently-surfaced Holocaust-era matters—plundered art, unpaid insurance claims, "unclaimed" Swiss bank accounts, and hoarded gold; and to an international conference held in Washington, DC.[38]

In turn, the museum world—albeit slowly—felt the need to react to the new questions being raised. In 1998 and 1999 both the AAM (American Association of Museums) and the AAMD (American Association of Museum Directors) took serious strides to guide their respective memberships to reexamine holdings with relevance to the period of Nazi plunder.[39] They also addressed the matter of loan exhibitions with regard to provenance matters. Following these various guidelines, however, remains the decision and responsibility of individual museums. Two years later the AAM sponsored a guide to provenance research directed to its thousands of member institutions.[40] By November 2001, the Canadian Art Museum Association was sponsoring a several-day conference to which experts in this field were invited, so that *that* museum community's sensibilities might be more sharply honed with regard to this issue.[41]

On the other hand, in April 2000, the Metropolitan Museum of Art placed on the Internet the names of nearly 400 works from its European paintings collections with provenance holes during the Nazi era.[42] Not only have several other key museums followed the MMA's lead with respect to Web site publication, but beyond such outreach, the National Gallery of Art in Washington sought out the family from which a work was determined by its own research to have been plundered by the Nazis.[43] Yet to date, when claims have been put forth to museums, I am aware of *no other instance*, in the United States at least, in which restitution has been offered other than reluctantly and due to external, media-generated pressure, rather than internal compulsion. So moral progress has been limited.

Meanwhile there has been a small but steady stream of cases. No two of them are identical, and the terms according to which, both legally and ethically, they might be decided, is varied.[44] They have involved governments, museums, galleries, families, and individuals, on both sides of the Atlantic.[45] Many more hover in the background as of this writing, each with its own complications. One of the twists that my colleagues and I encountered in comparing Viennese PCFs with postwar claim forms was that the claimant had a different last name from the person who filled out the PCF.[46] And how many not only famous works, but thousands of

lesser-known works not so quickly recognized, were destroyed and how many are still out there, merely missing?[47]

Each case involves somewhat different issues, ethical and otherwise. As a public trust, the Seattle Art Museum could not give up its Matisse a few years back until reasonably certain that it rightfully belonged to the Paul Rosenberg heirs. But a museum may claim that the chain of ownership that led to a given work's presence in its collections is too difficult to trace, or that a particular work is essential to its collections as a teaching mechanism.[48] Private collectors may assert that they should not be deprived of an object for which they paid considerable money in good faith, as happened in the Art Institute of Chicago's Degas case. And this is apart from the difference in approaching the matter of stolen art that distinguishes Anglo-American from Continental law.[49]

The argument that there are two equal victims, or that an event of sixty years ago has no connection to the present, seems ethically false regardless of legality. A Holocaust victim whose art was stolen or who was forced into a bargain-basement-price sale, as with any victim of theft, had no choices or options.[50] But every buyer or gift-recipient, private or public, is free to accept or refuse, to inquire or not to inquire regarding provenance. Our desire, as individuals or as museums, to see our collections grow, can lead and sometimes has led to ignoring these options. This is an ironic contradiction of how in every other respect art professionals and *culturati* claim to operate: by definition, we want to know everything that we can about the art we collect. All of its history is our concern, including the question of who owned it when. It would seem crucial for museums in particular to be in the forefront of insuring the ethical and legal validity of what we own and borrow for exhibition, if we are to assert that we are centers of civilized values.

Given the numbers, it is likely that in the years to come more Nazi-plundered works will appear on the market. Each appearance will raise variants of the same moral questions. Should there not be legislation that requires the kind of point-of-purchase due diligence for art that is expected of a home- or car-buyer? Critics of this idea in the art world have argued that this would be an inappropriate invasion of their realm by non-experts, or that it would yield unfairly expensive obligations for the art world. Such assertions suggest that when we deal with works of art, the rules of a civilized society ought to be suspended, or that those involved with art are inherently without moral flaw. That any number among us may be potentially flawed is obvious from history—and in particular *this* history. Such suspension is to follow where the Nazis led.[51]

For the survivors or heirs of those from whom art was plundered during the Holocaust, the real value of that art is often its tie to memory, and not its aesthetic or its financial value. It is the connection to parents or grandparents whose lives and material goods were destroyed. This may be what separates the current questions regarding Nazi-plundered art and its restitution not only from the sort of depradations that Napoleon accomplished, but the sort that stripped Native Americans of their burial sites and the descendants of the Maya of sculptures from their ancestors' temples.[52] While the Nazis plundered museums and collections as others have, they targeted thousands of families and individuals who disappeared as their artifacts did. A study of the thousands of Viennese PCFs strongly concretizes the carefully constructed and suddenly destroyed lives of those families and individuals, with all of their idiosyncrasies. Family members cannot be brought back from the dead, but perhaps objects that reflect and recall them, brought back from oblivion, can offer resolution if not precisely happy endings to some of the myriad unhappy stories that are the legacy of World War II.

The push to ignore ethical issues as too painful or too complicated is part of the human heritage. The urge for resolution of difficult moral issues—or at least, not to desist from addressing ethical questions even when they are without absolute resolution—is also part of the human heritage. That urge was brought to the center of Western thinking by Socrates, halfway between the time of the *Iliad* and Lucius Mummius. It is the legacy of Socrates, interwoven with the evolving discussion of ethics that bridges Israelite prophets to New Testament apostles, that offers an antidote to the code propounded by Socrates' interlocutors and by the opponents of those prophets and apostles—and definitively shaped by Hitler. In the visual arts as in other matters, situations such as that highlighted by the plunder of art by the Nazis and its aftermath offer us an ongoing opportunity to choose which part of the human legacy to affirm.

Postscript

The push to ignore ethical issues and the urge to resolve them in the matter of plundered art has always extended beyond what was plundered by the Nazis. Just as art theft in time of war extends back throughout history and across geography, the major museums of the world are filled with objects illegally and/or immorally removed from this country or that.[53] What distinguishes the Holocaust context from all others is, to repeat, not only the volume of displacement in such a short time span, but the fact that such a high percentage of what was stolen was taken from private individuals,

families, and galleries rather than state museums and archaeological sites. Rarely does the discussion of Nazi-plundered cultural property turn on the issue of national patrimony, whereas most of the discussion of plundered antiquities, religious artifacts, coin hoards and jewelry is centered precisely on the question of whether a given country is entitled to hold onto its artifacts, or whether the larger cause of the international community ought to take precedence and thus objects of historical value ought to remain in museums where they are arguably better cared for and certainly accessible to millions more than they would be in their native museums.

There is some irony in the fact that the larger discussion of art plunder has reached the public during the last decade in large part because of the publicity accorded the discussion of Nazi-plundered art. I am adding this postscript because of the extraordinary matter that has surfaced in the past several months, more than a year after my article was completed. The same esteemed American museum director—Philippe de Montebello—who, in testifying before Congress in 1998 asserted that, at the *most*, there might be a dozen cases of Nazi-plundered art in the United States that would surface over the next several decades (there have been several dozen in the past eight years alone); who, in 1999, while accusing the media of "making a mountain out of a molehill" regarding this subject, announced that his museum was listing nearly 400 paintings on its Web site with provenance holes and questions for the period 1930–1945 (and that list excluded the much larger number of prints and drawings that would be likely to have such holes); announced that he had struck a deal with Italy regarding the return of a spectacular Greek vase.

That vase, known as the *Euphronios Vase*, first appeared in the Metropolitan Museum of Art's collections in the mid-1970s. It was placed in its own gloriously lit gallery—until a spate of articles suggested that the vase had been plundered from an Italian archaeological site and been sold to the museum by a notoriously unethical dealer. The accusation was amplified to include a number of other objects, including a number of silver vessels—but the furor somehow was quelled after a while, and the *Euphronios Vase* remained in the museum, albeit displayed less noticeably among other Greek vases of the same era.

Apparently the issue never fully died for the Italians, and in the last several years, with the emergence into the public eye of the matter of plundered art, it seems that the issue of the vase resurfaced. This in and of itself is not extraordinary. What is extraordinary, from the perspective of the discussion of ethics, is what pushed the settlement arrived at between the MMA and the Italians and the response to that settlement from the

American museum community. De Montebello is quoted as having concluded that the issue would not go away, and so "I began to reflect: 'What's the best way out'?"[54] In other words, it never crossed his mind that his institution ought to return these objects because it is unethical to keep them. Rather, he sought a deal with "our friends . . . our colleagues . . . [with whom] you want to get irritants . . . [and] vexing issues behind you." The objects will be returned in exchange for promises that others with provenance issues not be pursued, and that important future long-term loans to the museum be guaranteed.

De Montebello expressed puzzlement at "the zeal with which the United States rushes to embrace foreign laws that can ultimately deprive its own citizens of important objects useful to the education and delectation of it own citizens." Once more, ethics plays no role: that objects have been stolen from another country and perhaps ought to be returned so that the citizens of that country can enjoy their own patrimony is not considered.[55] It is a footnote to this postscript to observe that his observation that "ninety-eight percent of everything we know about antiquity we know from objects that were not out of digs" reveals an astounding lack of archaeological sophistication; an undergraduate student of antiquity recognizes how important the context in which an object is found can be in extracting from it full cultural and historical lessons.

Of more import than a footnote is the observation of one scholar[56] that the museum "was shrewd. They saw the writing on the wall and, by acting preemptively, they are getting a good deal," or the words of a prominent university art gallery director[57] that "in my estimation of him [de Montebello] and I think of everyone's, he's gone way up." It suggests that agreeing to return plundered art when forced to do so and in return for clearcut advantages to the one returning the art, rather than due to a sense of ethical propriety, is not merely an acceptable moral stance in the world of today, but a desideratum. I shudder to consider what Socrates, the Israelite Prophets, the New Testament apostles—or Hitler and Goering—would say to this.

Endnotes

[1] There was almost certainly Greek-Israelite and Greek-Judaean contact before the Hellenistic period, but it was not nearly as *extended*.

[2] *Iliad*, IX. 264–5; the traditional date of the Trojan War is 1194–1184 BCE, and the *Iliad* is dated in its first written form to ca. 750 BCE.

[3] Thus, for instance, both the so-called Black Obelisk (ca. 825 BCE) of Shalmaneser III, recording the receiving of tribute from the Israelite king Jehu, and the Lachish reliefs, which depict the conquest of that rebellious Judaean city by Sennacherib in 701 BCE, show carved objects being brought before the king. Sennacherib's palace in Nineveh includes a relief from ca. 640–30 in which functionaries are shown inventorying the loot from a Chaldean settlement, and among this are numerous objets d'art, including richly designed furniture. See, for example, Julian Reade, *Assyrian Sculpture (in the British Museum)* (Cambridge, Mass.: Harvard University Press, 1999), chapters five and six.

[4] Pausanius, *Guide to Greece*, Book VII (Achaia), 16:5.

[5] Lynn Nicholas, for example, on page 407 of her path-breaking *The Rape of Europa: The Fate of Europe's Treasures in the Third Reich and the Second World War* (New York: Vintage Books, 1995), refers to "the millions of displaced works which continued [at the end of the war] to be discovered daily by the Allied forces." Whether or not the specific statistic of one-fifth of the world's art is precisely correct, the volume was unprecedented.

[6] Alfred Rosenberg played a number of key roles on Hitler's stage. Early on, he was, within the Party structure, in charge of foreign policy. In July 1941, Hitler placed him in charge of the Eastern Territories (as such, one of fifteen individuals answering only to Goering and Hitler). (See Raul Hilberg, *The Destruction of the European Jews* [Chicago: Quadrangle Books, 1961], 33–4 and 37). In the first capacity he also became *Reichsleiter* for ideology. His institute promoted the articulation of a clear definition of Jews for the purposes of passing laws against them and all that followed with respect to them as a category separable from others. Ironically, Rosenberg was a Baltic German—a category of German that Hitler would later despise—as Lucy S. Davidowicz points out on page 19 of her *The War against the Jews, 1933–1945* (New York: Holt, Rinehart & Winston, 1975).

[7] Nicholas, 9–23.

[8] "They will see that the commissioning of what may be the greatest cultural and artistic projects of all time will pass them by as if they never existed." Cited in Berthold Hinz, *Art in the Third Reich* (New York: Pantheon, 1954), 35.

[9] Ibid., 37–8.

[10] See Hector Feliciano, *The Lost Museum: The Nazi Conspiracy to Steal the World's Greatest Works of Art* (New York: HarperCollins Publishers, Inc., 1997), 36–40.

[11] Among the plethora of ironies that define the Nazis is the tension between their obsession with neatness and control on the one hand and their hatred of the control and discipline implied by the legalistic nature of Judaism: their profound detestation of Judaism reflects, in part, a desire to be *free* of control—and of course the regime allowed its leading members virtually total freedom in everything from plundering art to casual experimentation in killing methodology. For an excellent discussion of the *infantilism* of Nazi ideology, with its resentment of parent-like constraints and an anal-obsessive sense of self, see Richard Rubenstein, *After Auschwitz*, 2nd ed. (Baltimore: The Johns Hopkins University Press, 1992), chapter 3, especially 51–61.

[12] See Nicholas, 58–61, in particular her quote (on page 61) from Hitler's speech on August 22, 1939, encouraging his forces to "act brutally . . . be harsh and remorseless [and] kill without pity or mercy all men, women and children of Polish descent or language. . . ." Shortly thereafter the Fuehrer moderated that violence of spirit slightly: In William Shirer's *The Rise and the Fall of the Third Reich* (New York: Simon & Schuster, 1960), page 944, Hitler is quoted as declaring that "the Poles shall be the slaves of the Greater German Reich," in a dinner conversation with two of his trusted lackeys, Martin Bormann and Hans Frank.

[13] An exhibition drawn from those vast collections traveled in the United States, under the auspices of the Smithsonian Institution Traveling Exhibit Service, in the early 1980s. The catalog of *The Precious Legacy: Judaic Treasures from the Czechoslovak State Collections* edited by David Altshuler (New York: Summit Books, 1983), gives one a sense of the range but not the phenomenal volume of what was ingathered and preserved in the also-preserved Jewish quarter of Prague, with its seven synagogues and extraordinary cemetery.

[14] Nicholas, 37–49. For sticklers for precise detail, Linz was not Hitler's birth town; it was where he grew up.

[15] See Nicholas, 158–68, and the archival documents delineated in Marc M. Masurovsky and Ori Z. Soltes (Holocaust Art Restitution Project), *Report on Matisse's Odalisque* (Seattle Art Museum), June 1999. These are only a fraction of the materials available in the National Archives of the United States and France, in Washington and Paris, respectively, that refer to these individuals and others.

[16] Thus countries such as Switzerland, Spain, Portugal, and Sweden and dealers within them were the primary middlemen between the plunderers and the marketplaces of North and South America.

[17] Primo Levi, *The Drowned and the Saved* (New York: Simon & Schuster, 1988). See especially chapter two, "The Gray Zone," and chapter three, "Shame." Even Adolf Eichmann could assert that he had no choice; even one who barely survived Auschwitz could feel that his survival derived from a few extra ounces of bread gained at someone else's expense.

[18] I don't mean to imply that resistance did not continue, both within and beyond Germany, but that was in part *because* of the nature of Nazi occupation (and in any case, Hitler's "enemies" were hardly limited to those who were actively and violently resisting his efforts), but Hitler was fighting neither other political parties nor other armies.

[19] Hitler visited the glorious city that he had dreamed of conquering, only once, for a whirlwind predawn tour.

[20] Hector Feliciano puts it more mildly than some: "Georges Wildenstein was very well known and actively involved in art circles in a number of countries, including those within the Nazi sphere of influence. Even after the French armistice and the German Occupation, Wildenstein seems to have taken advantage of this network to organize a number of deals with the Germans." See Feliciano, 61. My point is not to engage in the debate about Wildenstein, but to reference it in order to underscore the "gray zone" as it applies to Jewish art dealers in the matter of art plunder by the Nazis.

[21] And sometimes each spouse separately, if husband and wife owned cultural and other property separately.

[22] Our Viennese colleague, Alexandra Caruso, provides us with photocopies of the forms housed in the archives in Vienna where they are still in the process of being fully organized, and we analyze them. The forms from the various postwar allied collection points are located in the National Archives in College Park, Maryland.

[23] The image of old Jewish men forced to their knees to clean the cobbled Viennese streets with toothbrushes is by now notorious.

[24] One marks the emancipation of Austrian Jews from the late eighteenth century, when the Hapsburg emperor, Joseph II, began the process of officially permitting integration of Jews into various walks of life; it culminated with the enormously disproportionate role of Jews in the cultural and socioeconomic life of the fin de siècle, World War I and post–World War I Vienna. My comments would apply to the Jewish communities of Austria in general, although Vienna was the epicenter.

[25] They were also acquired in exchange for medical, dental, or legal services. My point is not to judge quality or the validity of subsequent renown or its lack, but merely to assert that such painters—such as Amerling, Schuster, Danhauser, Petterkoffen, and Maulpertsh, as *well* as Kokoshka and Schiele—locally celebrated then and now hardly known, or hardly known then and now celebrated, shared in common being *Austrian*, which is why their works were acquired.

[26] I hope in the near future to present this information in a more extensive study; it is difficult to feel the full effect of the property census forms without reviewing the details of a critical mass of them at once.

[27] See Konstantin Akinsha and Grigorii Kozlov, *Beautiful Loot: The Soviet Plunder of Europe's Art Treasures* (New York: Random House, 1995).

[28] Perhaps the most stunning instance .of this form of "souvenir" thievery concerned a G.I. in the 87th division, Lieutenant Joe Tom Meador. See *New York Times* journalist William H. Honan's very entertaining *Treasure Hunt* (New York: Fromm International Publishing Corp, 1997).

[29] Numbers quoted from the Howe Papers, "Summary of December, 1950 Monthly Report of the Central Collecting Point, Wiesbaden," at the Archives of American Art, Washington, DC, by Nicholas, 428.

[30] The American Commission for the Protection and Salvage of Artistic and Historic Monuments in War Areas was initialed by FDR into reality on June 21, 1943, and officially announced on August 20. It would come to be named for Supreme Court Justice Owen J. Roberts, who was its nominal chair. When Mason Hammond, the man initially and functionally in charge of the Commission, arrived in Palermo to begin operations, he was surprised to find that the British had already established a committee of Italian museum and library officials to work on the matter. Joint efforts followed. By the end of 1944, an Art Looting Investigation Unit had been established, whose members were art historians suggested by the Commission. By 1945 the French had appointed a committee for the recuperation of art, of which Rose Valland—who during the war had kept meticulous secret records of what was being brought into and taken out of the main Nazi repositories in Paris—was appointed the secretary. By that time, representatives of the three commissions were arriving at definitions of what constitutes "art" and what "looted," and discussions were being held regarding how the Germans might make reparations for works lost or destroyed through their depradations.

[31] Eastern Bloc countries tended to nationalize everything, leaving individual former owners with nothing. Austria kept what it wanted from the Rothschild

family holdings, while "generously" allowing surviving family members to leave with a handful of token items. France made strenuous efforts to return art initially, ultimately stranding the last 2,100 unrestituted paintings in the National Museums for lack of claimants and the resources (or perhaps will) to seek them out. Thus a painting stolen from France and returned to France might or might not get any further than the French National Museums, whether it came from a museum, from the collections of Paul Rosenberg, or from some member of the bourgeoisie who possessed a dozen works of art. The United States simply assumed that no Nazi-plundered art had ended up here. Few people were wondering and worrying about cultural property that, in the course of the war, with American art markets operating at a feverish pace, had *already* ended up in American museums and private collections.

[32] Quoted in Nicholas, from National Gallery of Art, Secretary General, excerpts from the Crosby Report on Mission to Europe, March 8–June 10, 1945.

[33] An America in which the State Department's "Operation Paperclip" made it possible for former Nazis who were deemed potentially useful against the Soviets to bypass normative immigration procedures to come to this country, was hardly an America in which inquiries into Nazi-plundered art would receive much interest or encouragement. Although this has been known for a long time by individuals in the field, the information became public only relatively recently. See, for example, George Lardner Jr.'s *Washington Post* article "CIA Files Confirm U.S. Used Nazis After WWI", (Saturday, April 28, 2001, A10). Moreover, a government that, for postwar political purposes, willfully chose to ignore Japanese war-crimes that, if less systematic, were at least as bad as those committed by the Nazis, was not one likely to assist those from whom mere *property* had been stolen—certainly not art, and *certainly* not art that had made its way into the United States and now graced the walls of museums or prominent citizens' homes.

See Sheldon H. Harris, *Factories of Death: Japanese Biological Warfare, 1932–45, and the American Cover-Up* (London: Routledge, 1994); Philip R. Piccipallo, *The Japanese on Trial: Allied War Crimes Operations in the East, 1945–1951* (Austin: University of Texas Press, 1979); Peter Williams and David Wallace, *Unit 731: The Japanese Army's Secret of Secrets* (London: Hodder and Stoughton, 1989); as well as the growing volume of archival information available in the National Archives in College Park, Maryland, regarding the nefarious activities of Shiro Ishii.

[34] A summary discussion of those subsequent developments will be found in Ori Z. Soltes, "Art, Politics and Memory: A Brief Introduction to Nazi-Plundered Art," Stephen Feinstein, ed. *Absence/Presence: Critical Essays on the Artistic Memory of the Holocaust* (Syracuse, NY: Syracuse University Press, 2005). Considerably more detail regarding both the period between 1945 and 1993 and the developments of the previous decade will be found in the epilogue essay in Soltes, *The Ashen Rainbow: Essays on the Arts and the Holocaust*, 2006.

[35] Key examples include the English-language edition of Hector Feliciano, which appeared in 1997 (The French original, *Le Musee Disparu*, appeared in 1995), which primarily focused on the fate of the collections of five major French Jewish collector-families. Similarly, Elizabeth Simpson edited *The Spoils of War* (New York: Harry N. Abrams, 1997), which offered a series of papers at an ambitious and broadly focused January 1995 symposium sponsored by the Bard Graduate Center for Studies in the Decorative Arts, New York. Several other works from this period deserve particular note. William H. Honan's *Treasure Hunt* also appeared in 1997. (See endnote 28.)

The record of the October 1996 auction in Mauerbach, Austria, organized by Christie's, of a large number of cultural objects plundered by the Nazis, and unclaimed at the time of the auction (of course, unclaimed—the issue was really only surfacing at that time!), "for the benefit of the victims of the Holocaust" offers some sense of the range and variety of middle-level works of art and furniture that were involved in the Nazi efforts—and many of which remain out in the world.

Konstantin Akinsha and Grigorii Kozlov's book, *Beautiful Loot*, appearing in 1995, was the first to peer deeply into the question from the other side of the Iron Curtain. A former employee of the Museum system in Ukraine, Akinsha was in a position to know intimately many of the details. More broadly, Jonathan Petropoulos's *Art as Politics in the Third Reich* (Chapel Hill; University of North Carolina Press, 1996) is a good introduction to the range of ways in which art was put to use for political purposes by the Nazi regime. Between the time of this writing and that of whoever is reading these words, still other books, now in progress, will have appeared.

[36] These include the symposium in January 1995, sponsored by the Bard Graduate Center for Studies in the Decorative Arts in New York City; the September 1997 conference held at the B'nai B'rith Klutznick National Jewish Museum; and the three-day conference in late November 1998, sponsored by the State Department and the U.S. Holocaust Memorial Museum to which delegates from forty-five nations came to discuss the future handling of these issues. Simpson's editing together of the papers for the Bard Symposium is referred to in the previous note. The transcript of the Proceedings from the Klutznick Museum Conference was published privately. (The transcript is available from the author of this essay.)

The participants in the Bard Symposium and Klutznick Conference (with less overlap than one might suppose) may be found in Simpson and the Klutznick transcript, respectively; space prohibits a listing here. Most of these individuals and a handful of others have been active in one or more aspects of this field before and since these two conferences. A number of journalists, such as Walter V. Robinson of the *Boston Globe*, Marilyn Henry of the *Jerusalem Post*, and David Darcie of the *Art Newspaper* and NPR, have been particularly significant in tracking down cases and putting public pressure on museums that have otherwise exhibited such recalcitrance to wrestle with this issue.

[37] Details will be found in Feinstein and Soltes, *The Ashen Rainbow*.

[38] The results of the Presidential Commission are contained in the report: *Plunder and Restitution: The U.S. and Holocaust Victims' Assets: Findings and Recommendations of the Presidential Advisory Commission on Holocaust Assets in the United States and Staff Report* (Washington, DC: Superintendent of Documents, US Government Printing Office), December 2000. It is unfortunate that the report is not very enlightening with respect to new information. On the other hand, one of its more important features is the emphasis it places on an obvious other unresolved side to the issue of Nazi plunder: Judaica that was neither destroyed nor preserved in Prague. It is reasonable to suppose that there must be much of it in various private and public hands—in the United States, mostly—by now. If the previously mentioned Danzig community collection is the most comprehensive and obvious example, there are clearly untold numbers of individual works or small groups of works for which there are surviving owners or their heirs. Since most of the Judaica that would fall into this category, if in public collections, would be in *Jewish* museums, the issues that apply to the art museums apply with even more profound ramifications to *them*. What should the Jewish Museum of New York do if a surviving member of the Danzig Jewish community asserts ownership of, say, a Sabbath wine goblet? And since Judaica is, by and large, less individually marked than paintings and drawings signed and sometimes dated and named by artists, the complexity merely of identification multiplies the issue exponentially. The angles of complication with regard to the identification and restitution of Nazi-plundered art are endless.

[39] These strides initially took the form of several statements to their memberships made by the AAM and AAMD, prescribing serious consideration of provenance issues within the 1930–1945 period associated with Nazi plunder.

[40] Nancy H. Yeide, Konstantin Akinsha, and Amy L. Walsh, *The AAM Guide to Provenance Research* (Washington, DC: American Association of Museums, 2001).

[41] There has continued to be a spate of conferences both domestically and internationally since that time.

[42] Following the MMA, the National Gallery of Art in Washington, the Art Institute of Chicago, and the Boston Museum of Fine Arts—this last, only reluctantly and after heavy pressure from the Boston press—began to list paintings with Nazi-era provenance holes on their Web sites. More than 700 works were listed. Many other museums have begun to follow suit since then.

[43] The NGA returned an oil painting by Frans Snyders, *Still Life with Fruit and Games* (ca. 1615–1620), to the heirs of Marguerite Stern on November 20, 2000. To my knowledge the NGA is alone to date in having gone so far in the realm of restitution.

[44] Space prohibits a discussion of any of these cases, but a number of them are in both citations noted in endnote 34.

[45] Between March 1997 and my first address of this issue in writing (May 2002), fifty-two claims for cultural property plundered by the Nazis were filed in Austria, Britain, Canada, France, Germany, Hungary, Israel, Italy, Japan, the Netherlands, Russia, Switzerland, and the United States (in many cases for more than one object; for example—although this is an extreme instance—the Baroness Bettina Looram-Rothschild filed a claim against the Austrian government pertaining to 250 objects, including thirty-one paintings); forty-five of these claims were resolved without litigation.

Of these two totals, fourteen came to light in the United States, and ten of these have been resolved out of court. All fifty-two cases have been concluded in support of the claimant's assertion of ownership. Ten led to a monetary settlement and the rest to the restitution of the art in question. In a few cases the claimant either extended a long-term loan of the art or sold it back at a significantly reduced rate to the museum in possession of the work. Forty-seven claims were filed against museums or governments, two of which included a private collector as codefendant. Three cases involved the claim of one government against another (Hungary claiming against Canada, Germany claiming against Russia, and Russia claiming against Germany). The remaining five claims were filed against private dealers or collectors—and one might infer that a good number of Nazi-plundered works remain undetected in private hands, and may for years. Several important cases remain unresolved as of this writing. Cases where the museum sought out the heir are rare and not included in these totals. In the last two and a half years, numerous further cases have either surfaced—including one that involves a painting now belonging to actress Elizabeth Taylor—or are on the verge of surfacing.

[46] Thus the married daughter, for instance, might have filed a claim without noting her maiden name, thereby complicating the process of connecting the object(s) with the original PCF. A second complication is that in some cases the PCFs apparently did *not*, in spite of all their detail, include everything: there were attempts to hide work from the Nazis' purview. Claims included entities that the Nazis managed to find and plunder anyway, but were not recorded on the PCFs and therefore not as obviously identifiable.

85

[47] By various estimates there are probably more than 20,000, and perhaps as many as 100,000 of these still out there.

[48] Both of these assertions were made, for example, by the North Carolina Museum of Art in the case of its *Madonna and Child in a Landscape* by Lucas Cranach the Elder. Once the effort had been made by others to clarify the provenance that the museum doubted but would or could not itself pursue, the NCMA mounted a letter campaign to the non-Jewish Austrian heirs of the Jewish collector from whom it had been plundered, in which the importance of the work as a teaching instrument was stressed. In the end, in fact, instead of demanding the work back, the claimants accepted a cash settlement from the museum (of considerably less than its appraised value), and the museum promised to continue to use the work as a focus for lessons regarding the era of Nazi plunder.

[49] In Anglo-American law, faulty title does not pass to a new owner: If you steal an object and sell it, the new "owner" doesn't legally own it. In Continental law, title passes even if faulty, as the new "owner" is regarded as innocent of a crime; the one from whom it was stolen has no legal recourse for laying claim to the stolen object.

[50] During the first few years of Hitler's regime, before outright confiscation/plunder became the norm, it was not uncommon for representatives of the Reich to appear at the door of an art owner and "offer" (insist without viable options) to "purchase" (at a rock-bottom price) the art desired by some Nazi higher-up, or to carry it off for "auction," so that Nazi higher-ups could bid to buy (at rock-bottom prices) for works. Cultural property disposed of through such "Jew auctions," as they were called, were officially declared part of the category of Nazi-plundered art in June 1999, by the German government. Similar procedures were also applied by the Nazis to non-cultural property, such as shops and homes.

[51] I am referring to the fact that Hitler never broke laws: he merely changed or suspended them.

[52] I am not suggesting a greater or lesser ethical question; I am merely suggesting that the Egyptian antiquities in the Louvre or Mayan statuary in the Met and the Art Institute of Chicago's possession of Fritz Guttman's Degas pastel, *Landscape with Smokestacks*, raise different kinds of questions.

[53] A vase taken out of Italy in 1990 in contravention of Italian export laws will have been removed illegally. A statue removed from Greece or Egypt in 1790, when the governing authorities permitted its departure was removed legally; whether the removal was immoral then, or whether in 2006 it might be viewed as having been removed immorally, is a different question. A silver plat-

ter removed illegally from Italy in 1980 to Switzerland, kept there under wraps for the necessary period of time so that, when it exited Switzerland and came to the United States its provenance was listed simply as "Swiss" will have been removed illegally from Italy but legally from Switzerland. There are any number of cases that conform to variations on these modes of removal and their implications.

[54] All of the quotes that follow come from three reports in the *New York Times*: those on February 6 and 28, 2006, by Randy Kennedy and Hugh Eakin, and that on February 20, 2006, by Hugh Eakin and Elisabeta Povoledo.

[55] That American citizens are being taught that it is alright to steal cultural property from other countries if one can provide that property with a good home is also not considered morally wrong.

[56] Patty Gerstenblith is a cultural property law expert at DePaul University.

[57] Jock Reynolds is the director of the Yale University art gallery.

CHAPTER

Calling for a Code of Ethics in the Indian Art Market

Elizabeth A. Sackler

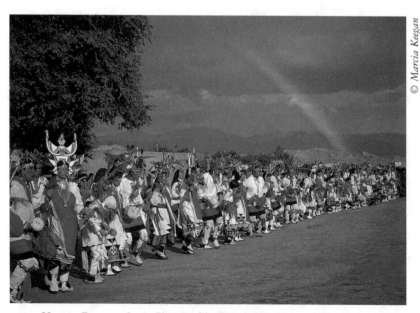

Harvest Dance at Santa Clara Pueblo, New Mexico

Professor Gail Levin moderated *Ethics in the Art World* at the College Art Association Conference on February 22, 2002. "Calling for a Code of Ethics in the Indian Art Market" was the paper from which I expanded remarks as a panelist at that session. The United States was suffering the aftershocks of September 11, 2001. More than four

89

years have passed now, and we are confronted with a constitutional crisis and ethical dilemmas in a multitude of areas.[1] The following introduction was written in the spring of 2005 and serves as a preface for the inclusion of my paper in this anthology.

—November 2005

Introduction

9 April 1954. She said to me today as I was leaving: "And now my dear, when are you going to start writing again?" I might have said, of course, that all this time I've been scribbling off and on in the notebooks but that is not what she meant. I said: "Very likely never. . . ."

"Why can't you understand that," I said, really wanting to make her understand, "I can't pick up a newspaper without what is in it seeming so overwhelmingly terrible that nothing I could write would seem to have any point at all?"

"Then you shouldn't read the newspapers."

I laughed. After awhile she smiled with me.

—From *The Golden Notebook*, Doris Lessing[2]

Being of the mind that sees the world through ethical-colored glasses, I am alarmed by the national changes we are witnessing; fundamental democratic rights are being dissolved without sober discourse. I am feeling more humbled than ever knowing that the American Indian peoples have known human rights abuses ever since Columbus' arrival, and I extend my gratitude to my American Indian friends for the poignant yet ironic reminder that I should not be surprised at the current state of affairs. After all, they have lived at the other end of injustice for a very, very long time— and survived.

That said, at this moment in time we are in dire need of ethical discourse and legal opinions that must include, but hardly be limited to, the significance of the compounded loss of rational thinking and democratic activism by the American public;[3] the significance of unethical, if not illegal, unchecked war-profiteering by the highest elected officials of this administration;[4] the significance of the utilization of electronic devices and ethnic profiling;[5] the significance of the deterioration of our

constitutional rights[6] under the Patriot Act;[7] the significance of the use of the self-proclaimed War on Terror to further the agenda of President George W. Bush and the religious far Right;[8] the significance that, by order of the highest national authorities, people are "disappeared" and men are categorized as enemy combatants to legitimize their being outsourced to countries where torture is legal;[9] the significance of the four years without due process and continual unchecked human rights violations of detainees in Guantánamo Bay;[10] the significance of [the then] House Majority Leader Tom DeLay's statement that "judicial independence does not equal judicial supremacy" in a videotaped speech at an ambiguously described "conservative conference" in Washington, D.C. but entitled "Confronting the Judicial War on Faith;"[11] and the significance of Senate Majority Leader Bill Frist's videotaped speech, simultaneously broadcasted to an estimated sixty million people in the United States the following day, for "Justice Sunday," organized by unnamed "Christian conservative groups" who condemned Democrats as being "against people of faith."[12]

The unchecked political power of the fundamentalist religious far Right, the acquiescence of our legislative branches, the war rhetoric fed to us by a compliant media and mainstream press could be the rain showers before a mighty hurricane if you can imagine the significance of President Bush's precedent of preemptive strikes combining with the fact that he is a born-again commander-in-chief who controls 2,000 intercontinental land-based hydrogen bombs, 3,456 nuclear weapons on submarines roaming the seas fifteen minutes from their targets, and 1,750 nuclear weapons on intercontinental planes ready for delivery. Of these 7,206 weapons, roughly 2,500 remain on hair-trigger alert, ready to be launched at the press of a button . . . enough explosive power in the combined nuclear arsenals of the world to "overkill" every person on earth thirty-two times.[13]

—May 1, 2005

The Paper

What is art? I have been struggling with this rigorous question for more than a decade.

I grew up around important French paintings and sculptures of the nineteenth and twentieth centuries, Ancient Iranian antiquities, Shang Dynasty ritual bronzes, Neolithic jades, and Ming furniture. All were

considered art. I neither questioned nor even thought about this grand, all-encompassing categorization.

Until 1991.

Native American Graves Protection and Repatriation Act

In 1990, the Native American Graves Protection and Repatriation Act (NAGPRA) was passed by the Senate and signed into law by President George H.W. Bush. This legislation was the culmination of ten years of lobbying by American Indian activists, advocates, and lawyers. NAGPRA is a human rights act acknowledging the mostly unscrupulous means of acquisition—looting, grave robbing, and/or sale under duress—of American Indian ancestral human remains, grave goods, cultural patrimony, and ceremonial material. Explicitly, NAGPRA distinguishes the 556 Native American tribes currently recognized by the Bureau of Indian Affairs as sovereign nations and requires all institutions with Native American collections that have ever received federal funding to return items that fall under the above four categories. This has prompted changes in exhibition cases as well as acquisition guidelines in museums, historical societies, and libraries. NAGPRA does not apply to the private sector.

Sotheby's Auction House

One of Sotheby's important and lucrative spring auctions was of "Fine American Indian Art." In May of 1991, more than 290 items were up for sale, including three "masks" consigned by a non-Indian collector; two from the Hopi and one from the Navajo Nations.[14] This often-used English descriptor, "mask," is a deceiving noun as it blurs the distinction between art and ritual objects. "Friends," as they are generally called by the Pueblo peoples of the Southwest, have individual names that indicate the clan or society who care for them or, sometimes, the spirit they hold. Their knowledge and power are activated in ceremonial dance.

Representatives from the Hopi and Navajo Nations came to know that the three were scheduled for sale and contacted Sotheby's, requesting that Koyemsii, Ahola, and Yebeiche, respectively, be removed. The persons who telephoned from Hopi and Navajo explained to the head of the Sotheby's Indian arts department that the "masks" are not art, but essential spirits needed for the continuity of their religious life—they are spiritual entities or

life-spirits. Sotheby's reply was brusque, accurate, and without ethical or moral concern: Auction houses are not bound by NAGPRA.

This "Fine American Indian Art" sale also offered nearly a dozen items (including Cheyenne leggings, a Sioux beaded tobacco bag, and a pair of child's moccasins, described as decorated "with tipis and chevrons") with provenance information reading, "Collected by Captain Alfred Mason Fuller (1852–1902) while serving with the Second Cavalry in Montana and Wyoming between 1876 and 1882."[15] Spoils of war have long been considered the prizes of the victor. Given the specific dates and locations in this instance, anyone even slightly familiar with American history would know that they were "collected" during the Westward Expansion and more than likely taken off dead victims' bodies, picked off a battleground, or confiscated during the Indian Wars.[16] It is doubtful that those particular items would have been sold under duress, as was often the case with jewelry and blankets.

Looking at them, and the provenance labels, at the presale exhibition, I was outraged that people would actually purchase or even want to own them.[17] I began to wonder if auction houses and potential buyers are unconscious, in denial, or basically apathetic about the importance of provenance information. I came to understand that for bottom-line-driven dealers and auction houses, the uninformed are their best customers. That may be so, but it is morally indefensible.

I attended that "Fine American Indian Art" auction the next day and purchased Koyemsii, Ahola, and the Yebeiche, and returned them. It is accurate to say that life changed, as repatriation, the movement, began.[18]

The American Indian Ritual Object Repatriation Foundation

In 1992, I founded the American Indian Ritual Object Repatriation Foundation as a public foundation[19] to assist in the return of ceremonial material from the private sector and to educate the public about the distinction between art and sacred material.

The years since NAGPRA and the Repatriation Foundation's births have been heartening. Museums, historical societies, universities, and other institutions with American Indian collections have, for the most part, gone from shock and confusion to surrender and proactive participation. Nationwide, institutions have inventoried hundreds of thousands of objects in their collections. This process has required an increase in budgets for personnel and legal advice, but museum curators and registrars continue to report that they have emerged with a new knowledge and understanding of

their collections because of the wealth of information shared by visiting Native representatives. Human remains and sensitive material culture have been removed from displays and trustees have learned to balance the repatriation of assets with institutional fiduciary responsibilities. NAGPRA, for America, has been remedial for Natives and non-Natives, alike.

In the beginning, the Repatriation Foundation assisted museums with communications: how and who to contact at hundreds of Native Nations. The Foundation's publication of *Mending the Circle: A Native American Repatriation Guide*[20] in 1996 leveled the playing field and enhanced communications between museums and Native Nation Repatriation Offices. *Mending the Circle* is widely recognized as the definitive repatriation guide and is used, as well, by major law schools as a textbook and by scholars for research.

By the beginning of this year [2002], the Repatriation Foundation has assisted, both as conduit and facilitator, in scores of returns from the private sector, and contributed to last fall's termination of Sotheby's thirty-year-old Indian art department's annual auction.[21]

The foundation takes great pride in having created a new paradigm for museums in Europe as well being as a ray of hope to indigenous peoples around the world. The work of the foundation has inspired and encouraged collectors and individuals to participate in the return of sacred material to American Indians. The foundation has been embraced by the scholarly community and has been at the forefront of discussions about distinguishing ceremonial items from those appropriate for sale, indeed we have insisted that this distinction belongs in ethical dialogs.

Who Are These Things We Call Art?

There is a significant difference between aesthetically pleasing items viewed as inanimate commodities and physical manifestations of life's spirit. "Friends," if you will, as well as many items, including ceremonial regalia, are central to a living culture's spiritual life and continuity—holding knowledge, instructions, and prophecy. This is an indigenous worldview, neither a singular belief system nor primitive superstition nor one with which people in Western cultures are necessarily familiar or comfortable.

For Native Americans, however, intuitive powers and the miraculous event are the very roots of communities and their relationship to the physical world and their spiritual truths.[22] Corn grows where there is no rain when planted in a hole made by a sacred cottonwood prayer stick; stories speak from sacred designs of quills on a belt (wampum) to those trained to

hear. The disintegration of totems on mountains and in caves releases spirits and prayers that preserve life's cycles—that is their purpose, the raison d'être of their existence.

To physically preserve sacred items in a museum case for viewing or to hold them in storage facilities for posterity is, in fact, to destroy them.

History and the Struggle for Human Rights

The facts of the conquest of the Western hemisphere are not taught in most educational institutions, from grade to graduate school. This was not a vacant continent, but one inhabited by a hundred million human beings, and an estimated population of twenty million lived within the borders of what is now the United States. The people were sophisticated in matters of health and healing. They were expert practitioners of nutrition and sustainability, aware of the intricacies of botany and ecological diversity. The encyclopedic knowledge over thousands of years was, and to some extent still is, transmitted orally from one generation to the next. And their exceptional patience and understanding of the need to nurture children and bestow respect accorded their greatest asset—the elders—are still in evidence today.[23]

Before the arrival of Columbus, the people of this hemisphere had never known contagious disease; they were without immunities and scourged by epidemics that were carried by the explorers and conquistadors from the old world. Millions died hideous deaths in less than a century after the arrival of the first landing in the Caribbean. The population of Turtle Island (America) plunged from twenty million people in 1500 to two hundred thousand in 1900,[24] predominantly due to disease, then genocide.[25] It was this attrition, in fact, that ended the Indian slave trade and set the African slave trade in motion. And the first germ warfare began at the end of the eighteenth century when the federal government and United States cavalry distributed blankets contaminated with smallpox and measles to tribes along the East Coast.

In the nineteenth century, the federal government outlawed American Indian ceremonies, and in 1823 Supreme Court Justice John Marshall's ruling, known as the Doctrine of Discovery,[26] in the *Johnson v. McIntosh* case, set the precedent for Indian/federal land disputes on which all private property transfer rests, to this day:

> On the discovery of this immense continent, the great nations of Europe are eager to appropriate to themselves so much of it as they could respectively acquire. Its vast extent offered an ample field to the ambition and enterprise of all; and the

95

character and religion of its inhabitants afforded an apology for considering them as a people over whom the superior genius of Europe might claim ascendancy. The potentates of the old world found no difficulty in convincing themselves that they made ample compensation to the inhabitants of the new, by bestowing on them civilization and Christianity . . . so the Europeans agreed on a principle of law that discovery gave title to the government by whose subjects, or by whose authority, it was made, against all other European governments.[27]

One of the most appalling exploits started in 1868 when the Smithsonian Institution anthropologists set out to "prove" the inferiority of American Indian people and began the cranial studies that resulted in decades of mass murders and grave robbing to decapitate the dead. The United States cavalry enthusiastically participated in brutal slayings, and the boiling and weighing of skulls to be sent by train to Washington, D.C.[28] In 1887, the General Allotment Act diminished communally held tribal lands and between the 1890s and the 1920s tribes were "forced to agree to land cessions."[29]

During the first half of the twentieth century, Indian children were kidnapped and kept in boarding schools against their will, and the 370 treaties between the United States and Sovereign Indian Nations were, and continue to be, summarily ignored, despite their legal standing.[30] Spoils of war, once a curio in the archeological study sector, became part of the art market during the 1970s, blossomed into serious trading as commodities, began breaking records in sales in the Indian art market by the mid-1980s, and has become the lucrative business we know today.[31]

Endless brutalities have hammered away at these eco-oriented, aesthetically brilliant cultures. The Indian peoples' slogan, "Surviving Columbus," is that indeed they have, which in part speaks to the power of spiritual life in Indian communities.

And so it is that those who sell, collect, or study ancestral remains, ceremonial material, and grave goods continue to rob heritage and make precarious the future of Native Americans.

Ethics in the Art Market

Is it inevitable that the creation of an art market, or more precisely the point at which art becomes commodity, results in a loss of ethics? Unfortunately, observations lead to a resounding "yes."

96

The plundering of art and spoils of war is under scrutiny worldwide— by UNESCO, governments, attorneys, and astute museum directors.[32] Sites in South American countries, known as "source nations," continue to be pillaged, but the acquisition of stolen property does not establish legal title, nor does the transfer of stolen property in a good-faith purchase.[33]

As we meet here today [February 22, 2002], Frederick Schultz, a Fifty-seventh Street ancient art dealer who was arrested by federal agents, is on trial for trafficking stolen property. Schultz allegedly baked a fake accession label and contrived a fictional 1920s Englishman's sojourn to Egypt as provenance for a fourteenth-century BCE stone bust of Amenhotep III. This is certainly unsettling, but so is the position of other antiquity dealers who say that federal involvement in this case is contrary to American "notions" of private property. The Antique Art Dealers Association's lawyer William Perlstein remarked, "I think the government is out to squelch the antiquities trade, and no one is taking into account the interest of the public it serves."[34]

In Afghanistan, religious statues have been toppled, and cultural treasures from the country's national museum, the Kabul Museum, have recently been reported as destroyed, melted down, or stolen for black market sale to the West. The latter is in the face of Afghanistan's national laws prohibiting the sale of art from museums, but of interest to this discussion today is all participants' patent disregard for international treaties.[35]

We must extend much gratitude to [co-panelist] Hector Feliciano[36] for his important book, *The Lost Museum*, and for raising awareness of one of the Nazi Party's agendas of confiscation and theft of art belonging to Jewish dealers and families.

Recent legal battles between museums and descendants of Jewish victims of Nazi confiscation are now front-page news stories. These are solid victories for all repatriation efforts.[37] The lawsuits put faces on the reality of the Nazi "art program" and educate people about the law—good title, property rights, and the ethical issues surrounding the spoils of war.

The Wiesbaden Manifesto

A cry of caution had emerged in 1946.

An estimated sixteen million works of art were confiscated and meticulously inventoried by the Nazis[38] from 1934 until the war's end in 1945. The Allies established four "collecting points" in occupied Germany to assemble, inventory, and care for the stolen art in anticipation of restitution and repatriation to Jewish families, descendents, or countries of origin.

At the same time that the late Walter Farmer was director of the Wiesbaden Collecting Point, Harry McBride was administrator of the new National Gallery of Art in Washington, D.C.[39] According to Farmer, McBride recommended, under the guise of security, that the Army transfer two hundred works of art "of the greatest importance" from Wiesbaden to the nascent National Gallery. It was so ordered, and the chosen masterpieces left Wiesbaden for Washington, D.C.[40]

Walter Farmer and his staff of 140 fine arts specialist officers, responsible for the packing and shipping of those great works, were so outraged they composed "the Wiesbaden Manifesto." They sent their bold protest to the United States Senate, where the manifesto was accorded full agreement and a bill went to the Oval Office. President Truman signed orders for the priceless works of art to be returned to the Wiesbaden Collecting Point and their repatriation status.

An excerpt:

> We are unanimously agreed that the transportation of those works of art to Washington, D.C., undertaken by the United States Army, upon direction from the highest national authority, establishes a precedent which is neither morally tenable nor trustworthy. . . . No historical grievance will rankle so long, or be the cause of so much justified bitterness, as the removal, for any reason, of a part of the heritage of any nation, even if that heritage be interpreted as a prize of war. . . . There are yet further obligations to common justice, decency, and the establishment of the power of right, not might, among civilized nations.[41]

Conclusion

The Wiesbaden Manifesto is an outstanding treatise in its call for integrity, ethical standards, and moral obligations when addressing the handling of spoils of war and commitments to restitution.

"It is no exaggeration to describe Paris as the art supermarket for the Nazis . . . [until] the Liberation in August 1944," wrote David D'Arcy in a 1995 issue of *Art & Auction*.[42] I would add that it is not an exaggeration, in this regard, to describe the Wiesbaden Collecting Point as a perceived "art supermarket" by the United States when the war ended but arrested by Walter Farmer's active moral conscience.

There is no conclusion yet for the spoils of war belonging to American Indians or the orphaned Nazi booty. Repatriation and restitution, in both

cases, may go on for a very long time but can only succeed with the vigilant rejection of financial and legal pressures. Our educational institutions must do their part to teach the history of our country. We cannot afford to hide behind reverence of unworthy heroes and legends of glory; indeed that fuels attitudes of superiority and bigotry. Exceptional and credible thinkers need to synthesize information, and strong, truthful voices, be they eloquent or raw, must rise above the clamor of the deceptive guile of those who would oppress.

It is essential to be steadfast—individuals must live and work in a conscious and conscientious manner, and the art market must rise above greedy apathy and accept sound ideals that move toward ethical conduct. If not, there is little to be learned, save that pockets can be lined with the gold of the dead and of the losses of the living.

Endnotes

[1] David M. Potter, *Freedom and Its Limitations in American Life*, ed. Don E. Fehrenbacher (Stanford, CA: Stanford University Press, 1976). Published posthumously, this is an important collection of Dr. Potter's papers on the nature of freedom and control.

[2] Doris Lessing, *The Golden Notebook* (New York: Simon & Schuster, 1962), 240.

[3] Paul Krugman, "Who Gets It?" Op-Ed, *New York Times*, January 16, 2004, A21. Referring to Lesley Clark, who is quoted: "I think we're at risk with our democracy, I think we're dealing with the most closed, imperialistic, nastiest administration in living history."
Sebastian Haffner, *Defying Hitler* (London: Phoenix, 2002). This is a personal memoir recounting the rise of the Nazi Party and Hitler's Germany.

[4] Margie Burns, "The Family's Profiteering Goes Unobserved," *Washington Spectator* 30, No. 3 (February 1, 2004): 1.
Jane Mayer, "Contract Sport: What Did the Vice-President do for Haliburton?" *New Yorker*, February 16–23, 2004, 80–91.

[5] Adam Liptak, "Citizen Watch: In the Name of Security, Privacy for Me Not Thee," *New York Times*, sec. 4, November 24, 2002.
"The New Airport Profiling," Editorial, *New York Times*, March 11, 2003, A4.
"What's Wrong with the Patriot Act and How to Fix It," Center for Democracy & Technology, *www.cdt.org*.

[6] Amendment I: Congress shall make no law respecting an establishment of religion, or prohibiting the free exercise thereof; or abridging the freedom of speech, or of the press; or the right of the people peaceably to assemble, and to petition the government for a redress of grievances.

[7] Patriot Act: "United and Strengthening America by Providing Tools Required to Intercept and Obstruct Terrorism Act."
"Revising the Patriot Act," Editorial, *New York Times*, April 10, 2005, A20.

[8] "The Disappearing Wall," Editorial, *New York Times*, April 26, 2005, A18.

[9] Nina Bernstein, *New York Times*, April 8, 2005, B1.

[10] Katharine O. Seelye, "Some Guantánamo Prisoners Will Be Freed, Rumsfeld Says," *New York Times*, October 22, 2002.
David Rose, *Guantánamo, The War on Human Rights* (New York: The New Press, 2004), 2, 60.
Anthony Lewis, "The Justices Take on the President," Op-Ed, *New York Times*, January 6, 2004, A21.
Jack Begg, "After the Terror Attacks a Secret and Speedy Rewriting of Military Law," *New York Times*, October 24, 2004, A1.
Neal Lewis, "Appeals Court Is Urged to Let Guantánamo Trials Resume," *New York Times*, April 8, 2005, A21.

[11] Carl Hulse and David D. Kirkpatrick, "DeLay Says Federal Judiciary Has 'Run Amok,' Adding Congress Is Partly to Blame," *New York Times*, April 8, 2005, A21.
"Schiavo as Prologue," Editorial, *The Nation* 280, no. 15, (April 18, 2005): 3.

[12] David Kirkpatrick, "In Telecast, Frist Defends His Effort to Stop Filibuster, Seeks Christian Support for Rule Change," *New York Times*, April 25, 2005, A14.

[13] Helen Caldicott, *The New Nuclear Danger: George W. Bush's Military-Industrial Complex* (New York: The New Press, 2002), 3. There are 28,000 nuclear weapons held by eight nation-states worldwide according to Worldwatch Institute, *www.worldwatch.org/press/news/2005/01/11.*

[14] Sotheby's, "New York, Sale 6181, Fine American Indian Art." May 21, 1991, Lots 40, 41, and 42.

[15] Ibid. Lots 126, 131, 270, 273, 282 (4), and 283 (5).

[16] Montana was declared a territory of the United States in 1864 and became a state in 1889. Wyoming became a territory in 1868 and received statehood in 1894. Indian peoples refer to the Indian Wars as the "Indian Massacres."

[17] They sold for a total just shy of $15,000 according to "Sotheby's Sale Results, Fine American Indian Art, May 21, 1991, (Sale number 6181)."

[18] Media coverage included: "Buyer Vows to Return 3 Masks to Indians," *New York Times*, May 22, 1991, C11.

"Dancing with Masks," *New York Times* Editorials/Letters, Topic of the Times, May 26, 1991, E10.

"Ceremonial Masks Return Home," *Christian Science Monitor*, June 12, 1991, 14.

"Returning a Gift; One Not-So-Small Gesture to Right the Past," *Chicago Tribune*, sec. 6, July 28, 1991.

"Indian Art Auction Shows Market Strength–and One Buyer's Character," *Art-Talk*, August/September 1991, 51.

"Sackler Starts Foundation," *Art-Talk*, August/September 1991, 51.

"What's in a Name?" *ARTnews*, September 1991, 36.

"No More Auction Block for 'Life Spirit,'" *New York Newsday*, Interview, November 7, 1991, 113.

Rita Reif, "Antiques/1991; Baseball Cards and Beyond. It Was That Kind of a Year in the Art Market," *New York Times*, December 29, 1991, 33.

[19] The Repatriation Foundation received a New York State Board of Regents Provisional Charter on April 29, 1992, and their Absolute Charter in 1998.

[20] *Mending the Circle: A Native American Repatriation Guide* can be downloaded, all or in part, free of charge, at *www.repatriationfoundation.org*.

[21] Sotheby's resumed its American Indian art auctions in 2004.

[22] David Suzuki and Peter Knudson, *Wisdom of the Elders: Honoring the Sacred Native Visions of Nature* (New York: Bantam Books), 154–157, 168.

[23] Ibid. See also Jack Weatherford, *Indian Givers: How the Indians of the Americas Transformed the World* (New York: Crown Publishers, 1988), 79, 183.

[24] Statistics based on averages from Georges E. Sioui, *For an Amerindian Autohistory*, trans. Sheila Fischman (Montreal: McGill-Queen's University Press, 1992), 3.

James W. Loewen, *Lies My Teacher Told Me* (New York: The New Press, 1995), 74.

Hans Koning, *The Conquest of America: How the Indians Lost Their Continent* (New York: Monthly Review Press, 1993), 26, 47, 54, 58.

Ronald Wright, *Stolen Continents: the "New World" through Indian Eyes* (New York: Houghton Mifflin Co., 1992), 14.

[25] Op. cit., Sioui, xxii–xxiii.

[26] Steven T. Newcomb, "The Evidence of Christian Nationalism in Federal Indian Law; The Doctrine of Discovery, *Johnson v. McIntosh*, and Plenary Power," *Review of Law & Social Change*, "The Native American Struggle: Conquering the Rule of Law, A Colloquium," Vol. XX, No. 2 (New York: New York University, Review of Law & Social Change, 1993), 303–341.

[27] Vine Deloria, Jr., John Mohawk, Oren Lyons, et al., eds. *Exiled in the Land of the Free* (Santa Fe: Clear Light Publishers, 1992), 299. The Doctrine of Discovery transformed the "discovery" of land into "legal dominion" over it and the rights of dominance. Dominion still rests with the federal government of the United States.

[28] Suzanne Harjo, "Introduction," *Mending the Circle: Native American Repatriation Guide* (New York: American Indian Ritual Object Repatriation Foundation, 1996), or at *www.repatriationfoundation.org*.

[29] Vine Deloria, Jr., *Behind the Trail of Broken Treaties* (Austin: University of Texas Press, 1974), 189.

[30] Jerry Mander, *In the Absence of the Sacred* (San Francisco: Sierra Club Books, 1991), 199. "Formal treaties with Indian nations follow[ed] the same procedure of congressional and presidential approval that was followed with France or Great Britain. There were no distinctions between Indian treaties and any other; all became the 'law of the land' as the Constitution requires." Op cit., Deloria, Jr., 250.

[31] Rita Reif, "Sales Records Set at Houses," *New York Times*, December 26, 1980, C28.

[32] Steven Vincent, "Who Owns Arts?" *Art & Auction*, January 1995.

[33] Thomas Kline, panelist, Bard Graduate Center for Studies Conference, "The Spoils of War: World War II and Its Aftermath: The Loss, Reappearance & Recovery of Cultural Property," January 20, 1995. Richard Perez-Pena, "Guggenheim Presses Case on Ownership of a Stolen Painting," *New York Times*, December 27, 1993, B1.

[34] Celestine Bohlen, "Illicit Antiquities and a Case Fit for Solomon," *New York Times*, January 30, 2002, E1.

[35] Celestine Bohlen, "Afghan Art Dispensed by the Winds of War," *New York Times*, November 1, 2001, A1. Since then, the following article indicates a reversal of the previous news item: Carlotta Gall, "Afghan Artifacts, Feared Lost, Are Discovered Safe in Storage," *New York Times*, November 18, 2004, A7.

[36] Hector Feliciano, co-panelist at the *Ethics in the Art World* session (College Art Association, 2002), is the foremost authority on Nazi-era thefts.

[37] The United States is the only nation-state, including all third-world countries, without legal prohibition of the exportation of indigenous material culture; until such time as this is remedied, American Indian material will be sold or transferred to countries without laws such as the NAGPRA.

[38] Sol Chaneles, "The Great Betrayal," *Art & Antiques*, December 1987, 93.

[39] Philip Kopper, *America's National Gallery of Art: A Gift to the Nation* (New York: Harry Abrams, Inc., 1991), 170.

[40] Walter Farmer, panelist, Bard Graduate Center for Studies Conference, "The Spoils of War: World War II and Its Aftermath: The Loss, Reappearance & Recovery of Cultural Property," January 20,1995.

[41] Ibid.

[42] David D'Arcy, "France's War Art Losses: Missing in Inaction," *Art & Auction* XVII, no. 11, (June 1995), 80.

CHAPTER

The Preservation of Iraqi Modern Heritage in the Aftermath of the U.S. Invasion of 2003

Nada Shabout

On April 9, 2003, the past and future of Iraq's visual heritage came under full attack while the world watched in shock and awe. To be fair, this attack had in effect started earlier and in different stages. Many argue that the destruction and alteration of Iraq's history was initiated by Saddam Hussein himself. The "Haussmannization" of Baghdad initiated in 1980 by Saddam Hussein was a large-scale campaign to reconstruct the city of Baghdad in an image suitable for expressing his power and authority.[1] The campaign included reshaping some of Baghdad's historic districts through demolishing certain landmarks, as well as replacing certain iconic monuments. Iraq's Unknown Soldier monument, designed by architect Rifa't Chaderji in 1959–1961, is one of the most visible examples. A simple, symbolic, modernist structure was removed from al-Fardoos Square and eventually replaced by the infamous statue of Saddam Hussein, which was symbolically toppled in full view of the world on April 9, 2003, announcing the end of an era. Another Unknown Soldier monument, designed by the late Iraqi sculptor Khalid al-Rahal, was erected in 1985.

The scale and depth of the cultural destruction of Iraq's institutions following the U.S.-led invasion, along with the sudden disintegration of all structures, register its effect as fatal. While legal responsibilities can be debated and decided in courts, ethical implications are complex and reach beyond the immediate loss and destruction of artifacts. For the purpose of

this essay, the ethical ramifications of the complete failure by the occupy-ing power to protect Iraq's modern heritage will be discussed in relation to two broad categories: the destruction and loss of the collection of the Iraqi Museum of Modern Art; and the spatial reconfiguration of the city of Baghdad in relation to its public monuments while altering the path of the future development of Iraq's contemporary visual production.

The scale and extent of the destruction of Iraq's governmental and civil institutions has been a major obstacle for plans of the reconstruction of Iraq. The ramifications of this destruction of Iraq's modern heritage should be evaluated on two distinct, although arguably interconnected, levels: legal and ethical. The world's archeological community has been quite vocal about the legal responsibility of the United States toward the protection of Iraq's heritage, both movable and immovable. As an occu-pying power and the most dominating member of the coalition forces, the United States has been criticized for its complicity in view of what is seen as its deliberate neglect to stop the looting of Iraqi institutions. Three members of the White House Cultural Advisory Committee, Martin E. Sullivan, Richard S. Lanier, and Gary Vikan, resigned in protest of the U.S. military's conduct and failure to protect Iraq's historical her-itage. The coalition forces have been accused of violating the Hague Convention of 1954 on the protection of cultural heritage in times of war, to which the United States is a non-party, as well as UN Security Council Resolution 1483 of May 22, 2003, reaffirmed on October 16, 2003 in Resolution 1511. Both Resolutions emphasize the temporary role of the coalition authority, as well as the necessity of the protection of Iraq's her-itage through establishing a ban on international trade in Iraqi cultural property.

Politically, heritage is not a neutral subject in view of its immense role in shaping collective memory. Hence, a crucial difficulty arises in regard to the definition of what constitutes heritage and what is worth saving following armed conflicts. For example, on May 19, 2005, President Bush renewed Executive Order 13350 and continued "a nation-al emergency protecting the Development Fund for Iraq and certain other property in which Iraq has an interest, pursuant to the International Emergency Economic Powers Act."[2] In compliance with UN Security Council Resolution 1483, the order prohibits cultural material removed from Iraq after August 1990 from entering the United States.[3] This restriction, however, did not apply to objects specifically brought to be displayed in a new National Infantry Museum at Fort Benning. The report listed specific "historic pieces" as part of "the many items that were

brought from the country" to the museum which had earlier in the week "received ninety artifacts from Lt. Col. Steve Russell of the First Battalion, Twenty-second Infantry Regiment, Fourth Infantry Division at Fort Hood, Texas."[4] The items were collected by Russell, whose appointment by the commanding general at the U.S. Army Center of Military History in Washington, D.C., afforded him the authority to remove artifacts from Iraq. The objects, which included a metal side profile of Saddam's face, and some of Saddam's swords and rifles, collected during Operation Iraqi Freedom in August 2003 in Tikrit, were to be displayed as visual narration of "what soldiers did and how they helped in the War on Terrorism."[5]

The Iraqi Museum of Modern Art

The report on the situation of "Cultural Heritage in Iraq" presented by Stefano Carboni at the Second Annual Convention of Association of Art Museum Curators at the Brooklyn Museum of Art on June 18, 2003, which detailed the situation of Iraq's National Museum, archeological sites, and libraries, briefly listed that "the Pioneers' Museum and the Saddam Center for Modern Art were looted and ransacked."[6] The Saddam Center for the Arts referred to in the report, now renamed the Iraqi Museum of Modern Art, was in fact one of the buildings severely damaged after the U.S.-led bombing raids over Baghdad.[7] The museums' collection of over 7,000 works of art was viciously looted as the Baath regime collapsed, and the occupying power was lax in providing security to protect Iraq's important cultural institutions.[8]

Historical Background

The Saddam Center for the Art, located on Haifa Street in Baghdad, was inaugurated in 1986 as the official home for the collection of modern and contemporary Iraqi paintings, sculptures, drawings, and photography until April 2003. The gigantic structure of five levels in the shape of a ziggurat was divided into several galleries and combined the collections of two earlier museums it replaced.[9] The first was the original National Museum of Modern Art, inaugurated in 1962 as a result of a project that was started under the Iraqi monarchy and was funded by the Gulbenkian Foundation, housed a collection of contemporary Iraqi art. The second was the Museum for Pioneer Artists, established in 1979 by the Ministry of Information and Culture, housed Iraqi works from the late nineteenth century and first half of the twentieth century by the first generations of amateur native artists and Ottoman soldier-artists.[10]

During the second half of the twentieth century, Iraq hosted many important regional and international cultural events, as well as took the lead in providing forums of interaction among artists of the region. As pan-Arabism climaxed during the 1970s, artists of the Arab world felt the necessity to combine their efforts through cultural meetings and joint exhibitions to prepare a shared Arab environment for creativity and art research. Their intention was to explore and define the role of the plastic arts in making the future Arab culture. The first meeting for Arab artists was held in Damascus in 1971 and resulted in forming the Union of Arab Plastic Artists. It held its first conference in 1973 in Baghdad. The conference culminated in the first Arab Biennale in Baghdad in 1974 and was followed by several art exhibitions and festivals that were held in different Arab cities. Intended as an annual festival, the Al-Wassity Festival was organized in Baghdad in 1972. Since promoting an Arab identity in the arts well suited the objectives of the Socialist Arab Baath Party, the government spared no expense in supporting such efforts.

The cultural efflorescence that resulted from these interactions produced invaluable works of art, which became the permanent collection of the Iraqi Museum of Modern Art. Moreover, this unique collection represented the development and evolution of modern Iraqi art in its various movements and stages. Iraqi artists were leading the Arab world in successfully forging a modern national style and provided a model for other Arab artists to follow in forming their own visual identity. The collection included several experiments by Iraqi women artists who introduced unique visual styles in their negotiations of national identities. For example, the work of Madiha Omar of the 1940s was the precursor to the popular trend of modern visual manipulations of the Arabic letter. Suad Al-Attar's work introduced an introspective dimension to visual folkloric investigations partaken by her male colleagues. In addition to Iraqi and other important regional works of art, the museum also held a collection of valuable works by Picasso, Miró, and other modern European masters.

In the Aftermath of the Invasion

Following the looting of April 2003, a number of the works were smuggled outside the country while others are still being traded on the black market in Baghdad. Many organizations and Iraqi individuals, particularly Iraqi artists, petitioned the various offices of the Coalition Provisional Authority (CPA) at the time and the U.S. State Department for help in stopping the pillaging of the museum and the recovery of more

than 5,000 stolen works of modern art, but the official position of the occupying power has always been insistent on the voluntary return of the stolen works and, thus, nothing was done.[11] After an Iraqi police force was formed, the new Iraqi government authorized the repossession of the works by force. No data on the results are available, and no evidence of successful efforts is recorded. Of particular significance to note here is that since the United States is non-party to the 1954 Hague Convention, it claims that it does not have to legally abide by the stipulations specified in Protocol I mandating an occupying state to "pay an indemnity to the holders in good faith of any cultural property which has to be returned."[12]

Few successful individual efforts were taken by concerned Iraqi citizens that helped in locating, acquiring, and protecting some of the missing pieces. Almost immediately after the looting of museums, some works were purchased at personal cost by Iraqi gallery owners with the publicly stated intention of preserving them until they could be returned to a new Iraqi Art Museum. A more efficient effort was organized by the renowned Iraqi sculptor Mohammed Ghani. Ghani returned to Baghdad weeks after the collapse of the former regime and found the Iraqi Museum of Modern Art in ruins with mounds of shattered sculptures and broken or empty frames where canvases were hastily cut out. Enlisting the help of his colleagues and students, he organized and initially funded a campaign of buying back some of the stolen works in the neighborhood surrounding the museum. The group of artists formed a Committee for Recovering Iraq's Culture and was able to recover about 100 important works by renowned artists, starting with Jawad Salim's wooden statue of "Motherhood," purchased for the mere price of $200.[13]

Ghani contacted the CPA, pleading for financial support and help in continuing his endeavor. Failing to secure any aid from the CPA, he approached and solicited funds from friends, personal acquaintances, and other concerned individuals within the Iraqi community. His plan was dependent on the efforts of his eager students and colleagues to locate and purchase the stolen works. Individuals who donated funds for the effort were bound by an agreement, retained by Ghani, establishing them as the temporary custodians of the specific works purchased with their money until the museum is reinstituted. In return, they were promised to be publicly acknowledged as donors for the arts. Ghani has been able to retrieve a considerable number of works that are currently scattered in Iraqi houses. His effort persisted, but, unfortunately, the price of the stolen works continues to rise while his limited funds are depleted, making his task much harder to complete.

Ethical Implications

Good intentions not withstanding, there are several key considerations. First, on the practical side, many of the works have either been already damaged beyond recovery or face the risk of severe damage due to the lack of the controlled environment required for their preservation. The current conditions of a destroyed infrastructure and shortage of resources, particularly during the hot temperatures of summer, translates to only few hours of daily electricity. Second, having a large number of recovered works dispersed at various places inside and outside of Iraq without official documentation through an official body working in collaboration with or under supervision of the Iraqi Ministry of Culture increases risks of their complete loss with time. Many Iraqis simply do not trust the current Iraqi government and without an enforced policy have the option of retaining the work without necessarily reporting it.

Moreover, there is no official or comprehensive catalog of the museum's collection since its archives were destroyed with the building. An immediate grave consequence of this is the inability of the authorities, including the Interpol, to track the stolen works. Thus when information about attempts to sell specific stolen works, such as historically valuable ones by the renowned pioneer artist Faiq Hassan, in Amman, Jordan, were communicated to the Interpol, their response expressed their inability to even include the stolen items in their database of stolen works of art published on their Web site without concise and authenticated full information and images.[14]

Furthermore, several galleries in Amman, Jordan, and the United Kingdom are impudently circulating images of looted works for sale through electronic transmissions.[15] The list of works they offer includes paintings by Abdul Qadir al-Rassam priced at $3,000 and Shakir Hassan Al Said priced at $1,500. While the act itself is treacherous, the ease and freedom through which they accomplish their venture is more troubling and indicative of the world's disregard of Iraqi art's value.

Modern Iraqi works of art, including ones from the Iraqi Museum of Modern Art, have surfaced in the United States and other countries.[16] Unverified rumors alleged that a number of journalists smuggled Iraqi paintings into the United States. This was in fact part of the defense strategy utilized by Mr. Benjamin James Johnson's lawyer: "There were some journalists who brought back some artifacts of substantially greater value who don't face charges."[17] Mr. Johnson, a television engineer for Fox News, was intercepted by customs agents at Dulles International

Airport outside Washington, D.C., carrying twelve stolen Iraqi paintings among other items.[18]

Few were confiscated but more went by unnoticed. For the most part, they were unrecognized as looted works for lack of identification and publicity. On one rare occasion, when Major Gregory McMillion of the U.S. Air Force was caught with what he called "souvenirs of war" and a statue was discovered among the vast collection of weapons, the military case prosecutor investigated the origin of the statue and discovered that it was in fact part of the looted modern collection.[19] It was a wooden statue by the Iraqi artist Mohammed al-Nuaimy, dated 1991 and executed in style reminiscent of that of his teacher Mohammed Ghani. The statue bore an inventory number identifying it as part of a collection, although there was no clear statement that it was part of the collection of the Iraqi Museum of Modern Art. Nevertheless, the story of the statue remained secondary in the press and at best warranted a line, "Other items included a statue looted from an Iraqi museum."[20]

About 1,300 works have been recovered and are in the custody of the Ministry of Culture. Most works are severely damaged and are in desperate need of restoration. While personnel from Iraqi museums were sent for training in restoration and preservation protocols to various European countries on foreign aid grants, there are no funds to actually carry out any restoration. The structure of the museum has been rebuilt, and the Ministry of Culture is scheduled to move into it as soon as it is furnished, but no plans regarding the collection have been discussed yet.[21]

Future Trajectories of Iraq's Contemporary Visual Production

Two years after the fall of the Baath government, the conditions in Iraq have generally not improved for artists. The official administration protecting the arts, weak and corrupt as it was, has been completely shattered. Reports from Iraq in the aftermath of invasion on the situation stated that the president of the Iraqi Artists' Society was assassinated, presumably because of his role in the Sadr City (previously Saddam City and before that al-Thawra City) executions. The president of the Plastic Arts Society fled the country with fifty stolen paintings of key modern Iraqi artists: Faiq Hassan and Ismail al-Shaikhly.[22] Contemporary Iraqi artists today feel rather neglected and secluded. They have no support, financial or otherwise, no available material, and no one to safeguard their creations. Destruction of Iraq's cultural artifacts continues without discrimination

covering all periods of its history: ancient, Islamic, and modern. The Iraqi Museum of Modern Art has not recovered its lost collection nor was an archive of its contents compiled.

Moreover, during the two years of occupation by the United States" troops, conditions did not improve, but rather worsened in many cases. This is a particularly significant fact in relation to Iraq's art market. During the 1990s and under the United Nations–enforced sanctions, the lack of state patronage led to the creation of a private art market in Baghdad. A number of private galleries were founded by artists and entrepreneurs searching for alternative supports. Some reports list more than forty-five galleries established in Baghdad during the 1990s.[23] Sponsorship of these galleries depended highly on foreigners working for the United Nations. For the first year after the 2003 invasion, they were replaced by individuals working at various nongovernmental organizations and the overflow of international journalists and other interested parties. As lack of security and stability increased, resulting in the departure of most nongovernmental organizations and limiting the number of journalists, a specific market catering to American soldiers was created instead. The work commissioned was generally a portrait of the soldier, possibly with his or her family, painted from a photograph supplied by a middleman, for the price of $100.

The deteriorating realities of life in Iraq are forcing many artists who endured with hope the long years of deprivation under the Baath rule and the sanctions to leave Iraq seeking safety in neighboring Jordan and other countries. The situation is further forcing many well-established artists to compromise their artistic integrity and cater to the growing commercial art market in the Arab Gulf region, which favors local versions of Orientalist themes.

Contemporary Iraqi Art

A new danger has arisen insofar as the future development of contemporary Iraqi art is concerned. The Western world, particularly the United States, was suddenly alerted to the existence of a contemporary visual production in what it had long perceived as an ancient land and the cradle of civilization. Awaking to the possibility of a current and thriving culture, the West applied old but persistent formulas of Orientalism to its perception of a modern "East." With complete ignorance of Iraq's modern art history and the dynamics of its changing aesthetics, American media immediately fixed Iraq's contemporary production into particular ideological criteria deemed fitting for the current circumstances. Replacing the

rhetoric of the colonial "modernization project" with the contemporary "democratization project," this criterion first and foremost reflects a convenient political reading of the situation.

Allowing American media to define and dictate the future development of contemporary Iraqi art simply and in one broad stroke risks obliterating a century of aesthetic development and transformation. Of particular peril is applying the policy of de-baathification, modeled after that of denazification and enforced in certain domains by the CPA to the realm of art to determine the value and worth of a visual work of art. An example of this situation is evident in encouraging the destruction and replacement of statues and portraits of Saddam Hussein or those of particular significance to the Baath regime. On its outset, it is of course absurd to label all works of art produced during the reign of Saddam Hussein, including ones personally commissioned by him, as "Baathist" art.[24]

Artistic freedom was greatly restricted during the 1980s in the form of strong governmental patronage and guidance. The ruling party dominated all major cultural centers, fine arts schools, and tolerated only one art association, the Official Iraqi Artists' Society. The innovative experiments of the first half of the twentieth century in modern art were replaced by propaganda art that stylistically favored social realism. That, however, did not preclude many Iraqi artists from continuing many of their experiments in the shadows. Further, the circumstances of the 1990s allowed some artists a degree of independence and limited freedom. Due to the weakness and ineffectiveness of the Ministry of Culture and Information, artists were able to concentrate on their work away from the control of Saddam. Contact with any form of an official body, which regulated contemporary Iraqi art through commissions and exhibitions, such as the Saddam Center for the Arts and the Society, was minimal and formal. Nevertheless, for artists to be granted permission to travel and participate in international exhibitions, they had to participate in an exhibition at or sponsored by the Saddam Center. To avoid such an association most artists opted to abstain. This, in turn, affected the image of Iraqi art insofar as the work of only certain artists, those who complied, became the work promoted by the center as representative of contemporary Iraqi art.

Today, a new image of Iraqi art is being formed by American media by promoting certain examples and artists as quintessentially Iraqi. The direction of their endorsement hints at a wider ideology of structuring and advertising new visual images for the "liberated" Iraq based on the purging of the Baath from Iraq's collective memory. The most pertinent manifestation of this ideology is the highly advertised pulling-down of Saddam's

statue in al-Fardoos Square on April 9, 2003. The created haunting image and act became iconic of "the fall of Baghdad," "the fall of the Baath," and "Iraq's liberation." By the power of the image, the world witnessed the joy of Iraqis celebrating their freedom. The initial overall symbolism persisted even after several reports highlighted the event as staged. While words cannot counter the supremacy of "sensual immediacy" produced by the first encounter with the image, these revelations were not allotted equal coverage in the media to correct the previous image.

Enforcing the intended message, a self-proclaimed group of mainly amateur artists who called themselves Jama't Najeen, the Najeen Group, were allowed to permanently reconfigure a space that had a direct association with the War in Iraq as it was constantly featured in the background of all media coverage.[25] On May 29, 2003 they unveiled the partially completed *Statue of Najeen* in al-Fardoos Square. Western media specifically emphasized the placement of the new statue "atop a pedestal where a statue of Saddam Hussein once stood."[26] The significance of the statue is in its being, timing, iconic positioning, and media acknowledgment. Of particular consequence here is the authority that permitted the statue's construction. Insofar as they embody a reflection of the national collective memory, public monuments are an essential tool for government propaganda that will never be forfeited to the will of the public. A case in point is the action taken by the coalition forces upon their entrance into Baghdad when they immediately seized the sites of Nasb al-Shaheed, the Unknown Soldier, the Victory Arch, and others for fear of becoming public rallying points igniting national pride and thus calling for resistance. Therefore, it was a tactical act to allow al-Najeen statue, which appeared virtually overnight following the well-publicized images celebrating the fall of the Baath regime, to be distinguished in Western media as an example of Iraqi defiance and will to endure.[27]

Ethically questionable in itself, further implications of this policy jeopardize the image and knowledge of the unknown history of modern Iraqi art. While this history presents an ample number of nationally and regionally indispensable artists, any search conducted on cyberspace today pertaining to Iraqi art encounters numerous hits for the newly famed painter Issam al-Azzawy, known as Esam Pasha. Practically unknown in the Baghdad art scene before 2003, and with no formal art education, Pasha has been the one Iraqi artist discovered by Western media. The concern, however, is in the rhetoric and mode of presenting him outside the context of other Iraqi artists. Pasha has been advanced as the most promising contemporary Iraqi artist of the post-Saddam era.[28] "Pasha" made his

début with his thirteen-foot-high colorful mural, *Resilience*, painted over a portrait of Saddam at the entrance of the Ministry of Labor and Social Affairs in the al-Mustansiriya district in Baghdad.[29]

Regardless of its subject, the mural is endowed with abundant political significance as it is the first portrait of Saddam to be painted over and the first official public mural in Baghdad to be executed only six months after the fall of the regime.[30] Particularly significant is that the idea of the mural was initiated and funded by the American military when the sum of $918 was awarded to al-Azzawy from the discretionary fund provided to senior U.S. commanding officers.[31] While al-Azzawy was employed as a translator for the U.S. National Guard, the proposal of replacing the damaged image of Saddam was casually relayed to him.[32] Al-Azzawy found in the suggestion an inspiration for what could instigate a campaign of visually cleaning up the city. He contacted the Ministry of Labor, the lawful owner of the mural, and was granted permission without any financial responsibility.

The legality of the approval of a ministry of an interim government in a country under occupation is certainly questionable. It is foreseeable that future elected Iraqi governments will investigate such actions. Iraqi Culture Minister Noori al-Rawi stressed in an interview on June 8, 2005, that his ministry does not recognize decisions instituted by former governments considered only as "caretakers."[33] The liberty to instigate change by members of the occupying power and deliberate lack of supervision to stop the fulfillment of such initiatives is, however, more alarming.

Conclusion

The cited cases present examples of the occupying force's blatant disregard of UN Security Council Resolutions 1483 and 1511. Their ethical ramifications, however, far precede their illegal misconduct. As a retainer of collective memory, heritage is an important factor in the reconstruction of a nation after armed conflict. With the intensified rhetoric of sectarian divide and national incoherence of the Iraqi nation, emphasizing its artificial construct after World War I, heritage becomes paramount in preserving unity and providing a collective forum of identity negotiations. Modern heritage is specifically significant in the case of Iraq, as Iraqi artists had undergone a similar task of identifying and forming a national visual identity based on reinvestigating their historical patrimony. Thus preserving Iraq's heritage of the twentieth century and allowing for its natural evolution would provide Iraqi society in the aftermath of the U.S.-led invasion a valuable model to consider.

Endnotes

[1] Along with colossal portraits representing him in the persona of different heroes from Iraq's history, the reconstruction of Baghdad included four major redevelopment projects. The goal of Baghdad's reconstruction as stated by the government was twofold: to modernize the city and revive and restore its historic heritage.

[2] Executive Order 13350 is an amendment, extension, and expansion to a number of executive orders by which President Bush declared a national emergency to protect the Development Fund for Iraq created to aid in Iraq's reconstruction through blocking funds and prohibiting the removal of property from Iraq. President George Bush, "Notice: Continuation of the National Emergency Protecting the Development Fund for Iraq and Certain Other Property in Which Iraq Has an Interest," The White House, May 19, 2005, July 5, 2005, *www.whitehouse. gov/news/releases/2005/05/20050519–8.html.*

[3] See Office of Foreign Assets Control, U.S. Department of the Treasury. "Iraq: What You Need To Know About the U.S. Embargo, An overview of the Executive Order 13350 and E.O.s 13315 and 13303." November 30, 2004. *Department of the Treasury*, 9/9/2005, *www.treas.gov/offices/enforcement/ofac/sanctions/ iraq.txt.* "Iraqi Cultural Property-Section 575.533 effective May 23, 2003, prohibits transactions with respect to Iraqi cultural property or other items of archaeological, historical, cultural, rare scientific, and religious importance illegally removed from Iraq since August 6, 1990."

[4] Angelique Soenarie, "Museum Displays Saddam's Sword," *Ledger-Enquirer*, September 25–26, 2004, *www.ledger-enquirer.com/mld/ledgerenquirer/news/local/ 9755953.htm?template=co.* Of importance to mention here is that the information cited in this article was not published again or in other venues.

[5] Ibid.

[6] Stefano Carboni, "Report on the Current Situation of 'Cultural Heritage in Iraq' Presented at the Second Annual Convention of the Association of Art Museum Curators, The Brooklyn Museum of Art, Brooklyn, New York, June 18th, 2003," *Iraq: The Cultural Aftermath*, 2003, January 30, 2005, *www.historiansofislamicart.org/ iraq/carbonireport.htm.*

[7] Further collections of modern Iraqi art were retained in several other venues. A list prepared by several Iraqi artists includes the Al-Rashid Hotel in Baghdad, the Republic Palace (Saddam's residence), and the Conference Palace. No archive of their contents has been found, and reports from artists who had

frequent access to some of these venues are incomprehensive or unreliable. There are, of course, various undocumented private collections as well.

[8] Information cited here was collected by the author through various correspondences with the Iraqi Ministry of Culture.

[9] The structure of the Saddam Center was originally conceived as a mega commercial center as part of the Haifa Street redevelopment project. In the spirit of a "regionalized international style" and in an effort to synthesize modernity and tradition as well as achieve contextual harmony of all parts of the project and their surroundings, traditional Iraqi architectural vocabulary used, including *riwaq* (arches), *shanashil* (courtyards), and ornaments. The shape of the structure with its upper stories stepped back and planted terraces, oscillates between a Mesopotamian ziggurat and Babylon's Hanging Garden. For details see Sohiko Yamada, "Baghdad: Breaking Tides," *Process: Architecture* (Tokyo), no. 58, *Medinat Al Salam: Baghdad 1979–83* (1985): 15–19, and 75.

[10] For details on the history of Iraqi modern art see Shakir Hassan Al Said, *Fussul min Tarikh al-Haraka al-Tashkiliah fi al-Iraq (Chapters from the History of Plastic Art Movement in Iraq)*, part 2 (Baghdad: Ministry of Culture and Information, Dar al-Hurriyah lil Tibaa', 1988).

[11] Attempts included several inquiries by this author to the U.S. State Department. The Iraqi artist Mohammed Ghani contacted various offices of the Coalition Provisional Authority, as well as met with representatives from the Ford Foundation and the Carnegie Corporation who visited Baghdad in 2003 to offer their aid and expertise in saving Iraq's cultural heritage. He also met with Ambassador Pietro Cordone who was the acting Minister of Culture of the provisory coalition government in Iraq until October 2003. He received similar responses from all parties, emphasizing the U.S. legal stand in regard to the necessity of voluntary return of stolen goods without rewarding acts of deliberate cultural destruction. As reported by Mohammed Ghani in an interview by the author, June 2003, in Amman, Jordan.

[12] Protocol for the Protection of Cultural Property in the Event of Armed Conflict, signed May 1954, 249 U.N.T.S. 358. See James A.R. Nafziger, "Protection of Cultural Heritage in Time of War and Its Aftermath," *IFAR: Art Loss in Iraq, Iraq Double Issue* 6, nos. 1 & 2.

[13] The recovery of Salim's statue instigated this collective effort project. The statue was found at one of Baghdad's local markets (*Suq Haraj*) by the artist Salah Abbas who borrowed the $200 at the time from the sculptor Taha Waheeb to purchase it. Upon taking the statue to al-Athar Gallery where it was received by a

number of his colleagues, the need for an active recovery plan to rescue the thousands of looted works was heightened. The group also organized in August 2003 an Iraqi sculpture exhibit where they exhibited some of the recovered works on the ruins of the center under the banner "Yes to Creativity and No to Destruction." Interview of Mohammed Ghani by author and statement and various news article by Salah Abbas.

[14] This was the response communicated to me by Interpol when I relayed the confidential information and forwarded the images I received from two Iraqi artists based in London and Amman, Jordan. The Iraqi artist in Amman had personally photographed the paintings that were brought to him to authenticate, as has become the habit. He then sent the images to the renowned Iraqi artists Dia Azzawi in London, who has been organizing efforts to track stolen works, as well as identify the new trend of forged Iraqi works. Personal electronic mail correspondence with Interpol, August. 8–12, 2004. Electronic mail correspondence with Dia Azzawi, August 7, 2004.

[15] These galleries operate electronically under pseudo names and under personal electronic mail accounts. They generally target wealthy collectors interested in Iraqi art, and would only reveal their identity to conclude a deal. They would send electronic images of the works with alleged authentication. There is, however, an increasing number of forged works attributed to renowned Iraqi artists in circulation, further complicating efforts of documentation. Few of these electronic transmissions were forwarded to me by Salam al-Rawi on June 6, 2005.

[16] Jordanian customs impounded forty-two paintings at al-Karameh border post from "unidentified" journalists entering Jordan from Iraq. See "Jordanian Customs Seize Dozens of Works Stolen from Iraq," April 19, 2003, December 24, 2005, *www.haaretzdaily.com/hasen/pages/ShArt.jhtml?itemNo=285363&contrassID=1&subContrassID=8&sbSubContrassID=0&listSrc=Y.*

"Man Free without Bond in Smuggling of Iraqi Art," *Washington Times*, March 30, 2003, *www.museumsecurity.org/03/066.html#_Toc39461565.*

[18] Terry Frieden, "TV Employee Charged with Smuggling Iraqi Art," *CNN* Washington Bureau, March 23, 2003, December 24, 2005, *www.cnn.com/2003/LAW/04/23/sprj.nilaw.antiquities/.*

[19] *U.S. v. McMillion*, Ft. Walton Beach, Eglin Air Force Base, Florida, where I testified as a national expert. Major Gregory McMillion was found guilty of bringing contraband material from Iraq, including a statue looted from an Iraqi museum. Major McMillion was found guilty on three of the four charges against him and is sentenced to one year confinement and dismissal from active duty.

[20] Bill Kaczor, "Officer Turned Arms Dealer," May 20–21, 2005, *http://loveinwar.bloghorn.com/364c.* Of interest is that in both cases the defense claimed that both defendants were unaware that the objects they carried were stolen or that they were breaking the law by transporting them outside of Iraq. Yet both claimed at first that the objects were given to them, or in the case of Major McMillion that he found it in a field outside of the Baghdad International Airport. This only demonstrates the lack of enforcement of the international laws of protecting cultural heritage.

[21] Information is based on several correspondences with the Iraqi Ministry of Culture.

[22] As reported in an interview by the author with Dr. Shafiq al-Mahdi, assistant dean of the faculty of fine arts at Baghdad University, June, 2003.

[23] For further details see Kim Ghattas, "Baghdad's 'flourishing' art scene," BBC.CO.UK, April 29, 2002, BBC NEWS, October 1, 2003, *http://news.bbc.co.uk/1/hi/world/middle_east/1957596.stm.*

[24] It is of merit to mention at this point that the Iraqi art community in general does distinguish between what it perceives as significant and "museum" worthy art and products of the Saddam glorification policy.

[25] The Najeen defined themselves as "an artistic and literary group of Iraqi professional artists and art students in Baghdad that survived the past and the war" (hence the name *najeen* [survivors], from the Arabic root *naja*, to survive).

[26] Photo Ap, *Taipei Times.com*, June 2, 2003, July 15, 2003, *www.taipeitimes.com/News/photo/2003/06/02*

[27] The Coalition Authority later funded a bronze cast of the statue a few months following its creation.

[28] See *Art Vitae.com*, September 2, 2004, *www.artvitae.com/artist_portfolio.asp?aist_id=217.*

[29] It is also interesting to note that Mr. al-Azzawy's fame was further amplified by his purchase of a Joan Miró aquatint stolen from the Iraqi Museum of Modern Art for $90. See Beth Potter, "Artwork Looted from Iraq Gallery Is Real," *Washington Times*, March 10, 2003, September 2, 2004, *www.washingtontimes.com/upi-breaking/20050310–123651–1708r.htm.*

[30] Of interest to note here is that al-Azzawy's claimed pedigree, as the grandson of Nuri al-Said, provided additional opportunities for promoting and legitimizing him by emphasizing the link of the post-Saddam era with one of today's most idealized pre-Saddam eras, the period of the Iraqi monarchy portrayed by many as the only rightful national Iraqi government.

[31] See Scott Peterson, "An Iraqi Whose Art Spans Worlds," *Christian Science Monitor*, August 29, 2003, May 6, 2004, *http://csmonitor.com/2003/0829/p06s01-woiq.htm.*

[32] Issam al-Azzawy, Telephone interview by author, Aug. 11, 2005.

[33] See "Culture Ministry to Target Corruption," *Iraqi Press Monitor*, The Institute for War & Peace Reporting, June 8, 2005, July 10, 2005, *www.iwpr.net/archive/ipm/ipm_258.html.*

Ethics of Appraising Fine Art

Alex Rosenberg

In any successful society, as many people as possible must understand the laws and customs that govern that society. These common denominators include not only laws and customs, but also language and ethics.

To achieve the required consensus, we see that the most successful and democratic governments are those in nations with the highest degree of literacy. Literacy allows us to understand and digest the events occurring around and to us and to rally either support or opposition to these events. In nations with a high degree of literacy, governments feel compelled to explain or attempt to rationalize their actions, while in nations where literacy is low, force and not logic, is used to make citizens comply.

As appraisers seeking to make ours a more effective profession, we have created a methodology, glossary, and a set of ethics that govern our activities. Modern appraising is rather recent. Being an organic field, it is subject to constant reevaluation and resultant change and addition. This clinical approach and the emphasis upon education involving a number of institutions of higher learning has changed appraising from a trade to a profession in less than twenty years. Not too long ago, attorneys employed appraisers to buttress the theories they created. Now they employ appraisers to help create their cases and are dependent upon the appraisers not only for original ideas, but to appear in court as expert witnesses.

However, it remains an unchallenged fact that the single most important factor in appraising is the ethics of the appraiser. While various appraisal groups, including IRS and USPAP (Uniform Standards for Professional Appraisal Practice), all have certain common denominators

that govern our activities, many of these rules are now part of law while others originate from a sense of fairness and still others from our cultural and religious backgrounds.

Operating against this is the visible lowering of the moral and ethical standards governing the behavior of our leaders in both the public and private sectors. No longer do the classical definitions of honesty, truth, and fair play govern these leaders. The bottom line has become the only truth and this thinking allows the heads of many major corporations to falsify statements, steal from the stockholders, and grant themselves outrageous salaries. Governments, likewise, tell us whatever they feel will cause us to support their actions. The assurances of the president that allowed us to go to war in Iraq are a perfect example.

This behavior, when repeated often enough, must have an effect on the average person. While most people are honest as a result of their upbringing, the constant lowering of the ethical standards employed by our leaders must cause the ethical standards of most people, from the least to the most educated, to undergo change and to be eroded gradually. The best example of this occurred during the period the Nazis ruled Germany. The inhuman behavior of the vast majority of the German people was the result of an immoral leadership hacking away at the ethics of a people until they had convinced most of the German people that it was ethical and moral to kill six million Jews in order to defend Germany. The mass of the German people were not aware that their standards of right and wrong were being altered as they sank further and further into an abyss of substandard behavior while still going regularly to church and seeing themselves as good, God-fearing people.

Some appraisers have not been immune to the examples set by our leaders. While the quality of the work done by most appraisers has improved greatly in recent years, a minority has taken to violating the codes of ethics of the profession by making untruthful statements or representations.

This process by which standards are gradually lowered almost imperceptibly is the danger we face and must avoid at all costs.

If our ethical standards are lowered, we will have broken the quartet consisting of connoisseurship, language, methodology, and ethics, and in doing so destroy the necessary equilibrium required by a stable and democratic society. Without a clear understanding of any of the above four, there can be no clear understanding or definition of the work being performed, and the resultant findings of the appraiser will take on different meanings to different people. The result will be confusion and the

lessening in importance of the appraiser's findings and then finally the destruction of the reputation of appraisers, first individually and ultimately as a profession.

In this connection, we face an additional problem. Just as ethical standards changed dramatically to meet the needs of the German government during the Nazi period, to a lesser extent, law, morality, customs, and ethics have changed to meet the needs of the governing class during our entire history. This has created monumental problems for those who wish to maintain former standards or those standards that went unchanged or were the least changed over the years.

In dealing with this, we must determine which standards are basic and which peripheral. It is the core, basic standards that will invariably be the oldest and those that have undergone the least modification. These are the standards we must preserve if we are to have an ethical code that is not merely a justification of the behavior of the period.

In appraising we are taught we must only work for the truth. We must at all times be impartial, honest, and accurate. Even though we are being hired and paid by a client, our results cannot and should not be influenced by the apparent needs of the client. The client's attorney or accountant seeks a certain conclusion from the appraiser or expert and usually will try hard to get the professional to alter or modify an opinion to meet the client's need. Often the client is one whose case commands sympathy, making it very difficult for the expert or professional to stick to the truth, as he or she sees it, and not to be affected by the needs of the client. A small alteration of opinion brought about by one desiring to be helpful is the beginning of an often-imperceptible road to changing one's ethical standards.

One need only examine the history of the unholy professional relationship between Lord Duveen and Bernard Berenson to see how one can be compromised gradually over a period of time and still see himself as an impartial expert. Even when Berenson was receiving a percentage from each sale made by Duveen as a result of Berenson's dubious authentications and advice to Duveen's clients, Berenson saw himself as honest and his advice as impartial. Berenson's need for money allowed him to continue to live at I Tati and to work with Duveen. Duveen's understanding of Berenson's weakness and needs allowed him to exploit and demoralize Berenson.

The exercise of due diligence is a weapon with which appraisers can help maintain their sense of ethics. In doing an appraisal, certain work is mandatory and must be performed honestly and impartially. These activities

are reported in the appraisal and allow the appraiser to withstand any pressures brought against him by either clients or other professionals. Due diligence further prods appraisers to work in an honest fashion, as disclosed violations can not only lose a case for the appraiser, but under certain circumstances may lead to civil or criminal action against the appraiser.

From this, we must conclude that maintaining good ethics requires a zero degree of tolerance. Once we lower our ethical standards, it becomes easier to do so a second time and the times thereafter. Only by applying zero tolerance can we remain ethical. It is very difficult for the average person to separate himself from the unethical examples of his leaders, to refuse the demands of an unscrupulous (though much-needed) client, or not to go along with a peer's dishonest behavior. But, only in this fashion can we prevent our profession from undergoing a further erosion of ethics.

9

Artists' Estates: When Trust Is Betrayed

Gail Levin

In recent decades, the market has generated dramatic gains in value for certain modern and contemporary artists, multiplying the incentive to exploit and pillage their estates with a disregard for their wishes. This nearly always stems from old-fashioned greed. The stories of frustrated hopes artists have for their legacies merit telling, if only to help forestall future betrayals. The false executors who have engineered or countenanced theft include fellow artists and friends as well as attorneys and accountants, employees both of banks and of commercial galleries and museums. Sometimes mere ineptitude allows exploiters to help themselves to art that they view as a mere commodity to be exchanged on the marketplace.

Given the scant attention paid to the matter, I looked forward to *Artists' Estates: Reputations in Trust*, edited by Magda Salvesen and Diane Cousineau.[1] It includes interviews mainly with managers of the estates of particular artists, especially their widows and children, but also a prominent biographer and former museum trustee, art dealers, heads of foundations, lawyers, and several others, all of whom share specialized knowledge and experience. Most suggest that things usually go as planned, reporting positive histories in dealing with artists' estates as well as challenges.

Evoking an exception that is notorious, the children of Mark Rothko report how they had to sue to obtain their rights. After the artist's suicide in 1970, Rothko's executors, all of whom he had considered to be his trusted friends, conspired to bilk his estate. Their collusion with his dealer, Frank Lloyd of the Marlborough Galleries, is well documented in the records of the four-year lawsuit and the eight-month trial of the suit

brought by his daughter, Kate, who was only nineteen at her father's death, as recounted in *The Legacy of Mark Rothko: An Exposé of the Greatest Art Scandal of Our Century* by Lee Seldes.[2]

Although not treated by Salvesen and Cosineau, ethical if not legal issues have been posed with respect to the estates of the Kurt Schwitters and Francis Bacon, both involving a commercial gallery, and of Edward Hopper and his widow, Josephine Nivison Hopper, involving a museum operating as a public trust.

To be ethical, transactions regarding an estate should be coherent and transparent. There should be such careful documentation that the management of an artist's work would give no cause for inquiry either before or after death. Yet suspicions arose regarding Schwitters and Bacon, perhaps triggered by the publicity surrounding the Marlborough Gallery and the Rothko estate.

In the case of Schwitters, decided by Norway's High Court in January 2005, two members of the artist's family (his son Ernst's estranged wife, Lola, and his grandson, Bengt) sued Marlborough Gallery, charging that it bought works from the estate at below market value, underinsured some works, and withheld money from the estate. The Supreme Court ruled on appeal that the charges were unfounded and awarded damages and costs to Marlborough.[3]

In another case, again with the Marlborough Gallery, the estate of Francis Bacon accused the gallery of systematically defrauding the late painter and of being unable to account for the whereabouts of thirty-three works worth as much as £30 million. The executor, Professor Brian Clarke, was reported to have initiated the case because of concerns that the London gallery and its Liechtenstein subsidiary had both failed to pay Francis Bacon properly during his lifetime and had "blackmailed" him to keep him from changing galleries. For its part, Marlborough claimed that Bacon himself sold or gave away the missing works. In this case, Bacon's own failure to keep clear records and his preference for putting pre-tax money in a Swiss bank account complicated matters.[4] Days before the full hearing was to begin, Marlborough Gallery and the Bacon estate announced that they had settled out of court, and the estate dropped its legal action against the gallery.[5] Since the gallery had maintained an archive of photographs and other records, the two parties needed to cooperate to complete a *catalogue raisonné* of Bacon's work.

A different kind of ethical challenge arose in the case of Edward Hopper and his wife, Josephine, because their entire artistic estates were willed directly to a tax-exempt museum, which holds art in trust for the

public good. According to the Code of Ethics of the International Council of Museums (ICOM):

> Museums have the duty to acquire, preserve and promote their collections as a contribution to safeguarding the natural, cultural and scientific heritage. Their collections are a significant public inheritance, have a special position in law and are protected by international legislation. Inherent in this public trust is the notion of stewardship that includes rightful ownership, permanence, documentation, accessibility and responsible disposal.[6]

The affiliated American Association of Museums decrees in its own Code of Ethics that "acquisition, disposal, and loan activities are conducted in a manner that respects the protection and preservation of natural and cultural resources" and that "disposal, and loan activities conform to its mission and public trust responsibilities."[7] In the case of the Hoppers' artistic estates, close review suggests that their legatee, the Whitney Museum of American Art, failed to meet such stringent standards of accountability to its public trust, indeed that it failed to secure for itself all of the legacy to which it was entitled.

The Hoppers were especially vulnerable to abuse because at their deaths they were elderly, isolated, and lacking both family and trusted friends. When Edward Hopper died in his New York studio on May 15, 1967, slightly before his eighty-fifth birthday, his widow, Jo, who was less than a year younger, inherited everything. The couple was not only childless, but each had only one sibling who had predeceased them; and neither sibling bore any children. Ill, nearly blind, and entirely alone, the widowed Jo was left to fend for herself. At her death in 1968, she left Edward's entire artistic estate to the Whitney, following his desire that his legacy find a permanent home in the museum that had long fostered his work.

Lacking alternatives and mindful that the Whitney had included her in several group shows over the years, Jo also willed her own work to the museum, except for two canvases, one bequeathed to a friend and the other to the Cobb Library in South Truro, near the Hoppers' beloved home on Cape Cod. Since their marriage in 1924, she had meticulously recorded whatever art left the studio for exhibitions, sales, or gifts. Jo left the record books to Lloyd Goodrich, who had given Hopper important early critical support, first writing about his work in 1926, and later serving as the curator of Hopper's two major retrospective exhibitions at the Whitney.

The Josephine N. Hopper Bequest—more than three thousand paintings, drawings, watercolors, and prints by Edward, to say nothing of Jo's own art—took the museum by surprise. Almost three years passed from the time of Jo's death until March 19, 1971, when a Whitney press release announced the gift of "the entire artistic estate of the late Edward Hopper"—with no mention of Jo's work. The museum's director, John I. H. Baur, was quoted as calling the collection "an asset beyond valuation."[8] Plans for the future of the bequest soon emerged.

In the matter of the Hopper Bequest, Goodrich served as the museum's advisory director. Despite the artists' desire to find a permanent home at the Whitney, Goodrich told the *New York Times*, "We want collectors and other museums to have access to it, so we'll put it on the market eventually."[9] Denouncing in the *New York Times* this "contemplated disposal of the Hopper bequest" as a scandal, Hilton Kramer called the museum "a major institution suffering from . . . a feeble sense of its own identity and purpose." Kramer accused the Whitney of trying to destroy the value of the bequest as a permanent archive.[10] Baur retorted that the Whitney had itself not yet reached a decision on what part of the bequest it would keep.[11] Some sales did take place, including etchings and watercolors. A list drawn up by Lloyd Goodrich as late as June 6, 1974, indicates that he recommended selling twenty-five drawings, even though Hopper produced them during the 1920s at the museum's forerunner, the Whitney Studio Club. Eventually, under the pressure of intense public scrutiny and growing indignation, the museum stopped selling items from the bequest.

But the works that made it to the Whitney were not the "entire artistic estate" that Jo and Edward had intended to find a home there. Following the artists' deaths, works from Edward's formative years and sketches for his mature canvases flooded the art market, although no one has ever told how they got there, formally documenting or tracing these objects step by step back to the artist. Even one major canvas of Hopper's maturity, which is clearly documented in the record books and marked in pencil in Jo's hand as "Here in Studio," mysteriously appeared on the market.

Neither Hopper's legitimate heir nor others have bothered to question how the childhood sketches of an artist of Edward Hopper's distinction made it to the marketplace. It seems hard to believe that an artist, who never liked to exhibit his drawings, would have intended for sketches on paper, some made when he was only age ten or eleven, to be sold after his death. Why did no one ask the pertinent questions about this part of the Hopper estate?

Before Edward died in 1967, both he and Jo had been hospitalized and were released in early December 1966. After breaking both her hip and her leg, Jo was only able to get around their home, a walk-up apartment on New York's Washington Square, with the use of a walker. She had cataracts in both eyes, with glaucoma that rendered her eyes inoperable.

In a letter to her friend Emeline Paige, Jo reported as present at Edward's modest funeral in Nyack: John Clancy (his dealer at the Rehn Gallery); the artists Henry Varnum Poor (1888–1970), with his daughter Anne Poor; Peggy Day (widow of the writer and cartoonist Clarence Day); the critic Brian O'Doherty with his wife, the art historian Barbara Novak; and Lloyd Goodrich (1897–1987), the past director of the Whitney Museum of American Art. But she never recorded any further effort by any of them to see how she was coping.[12] The only person at the funeral who would see Jo again was the Baptist minister who conducted the service, Arthayer Sanborn, who served the Nyack church that Hopper's spinster sister and only sibling, Marion (1880–1965), attended until her death.

Toward religion in general and this minister in particular, Edward had not been well disposed. Just before his last retrospective opened at the Whitney Museum in late September 1964, he wrote his sister, warning her not to even think of attending the opening party: "This is one time in the year when I can meet museum directors, critics, and collectors of importance and I shall have to devote all my time to them (and will have no time for you, Dr. Sanborn and Beatrice [Sanborn's wife])."[13]

Moreover, Hopper was notorious for his lack of friendships, yet Sanborn has tried to establish that he enjoyed the painter's friendship. When Sanborn put on display a miscellany of Hopper "drawings, prints, watercolors, photographs and memorabilia" at the Brevard Art Center and Museum in Melbourne, Florida in 1980, its "executive director," Robert Gabriel, described Sanborn in the catalog as "a longtime friend of Edward Hopper."[14]

The title of Sanborn's own essay in the Brevard Art Center and Museum catalog is "Reflections of a Friend." He wrote that his relationship with the Hopper family began when he became the minister of the Nyack Baptist Church in 1953. At that time, Marion lived alone in Hopper's boyhood home. Sanborn did in fact get to know Marion and he claims only that Edward and Jo "in the latter years of their lives . . . became more and more dependent on me for varied services." Certainly officiating at the funerals of both Marion and Edward was paramount among the services he offered.

He also looked in on Marion and, on at least one occasion, when Marion was sick and her housekeeper was away on vacation, drove to New York and brought Edward and Jo to Nyack.[15]

Sanborn first contacted me in the summer of 1976, shortly after I began that June at the Whitney as the first curator of the Hopper Collection. My chief assignment was to write a *catalogue raisonné* of Edward Hopper's work and to organize related exhibitions. By definition, a *catalogue raisonné* employs methodical scholarship to gather and digest in systematic form all that can be known of an artist's work and life. Naturally, I was interested in Sanborn's story and in gaining access to whatever art and documents he owned. I only gradually came to see that he had many works; he never revealed the full extent of his collection to me. In the course of various interviews, he eventually told me that Jo and Edward never gave him anything. He said that he had had to fly home from Pittsburgh to conduct Edward's funeral, but that Jo had not reimbursed his expenses or ever compensated him then or at any other time.

His account conflicts, however, with what I discovered years later, when I was conducting research for Hopper's biography. In Jo's diary for 1965 (one of sixty-odd notebooks located in another private collection), she wrote that she and Edward had paid Sanborn, who had conducted Marion's funeral, "five hundred dollars from the estate." In Sanborn's Brevard catalog essay, he wrote that the couple "shared bits and pieces of their life as well as giving to me much of the family treasures in memorabilia." Nowhere does he explain how he came to possess so many works of art. None were left to him in the will of either Edward or Jo. Edward's will, signed June 18, 1964, left everything to Jo, but in the event that she might die before him, he named a group of friends as legatees, making no mention of Sanborn.

From the Hopper family house in Nyack, where Hopper stored the art of his formative years (made well before the art market responded to his work), many early works found their way into Sanborn's possession, all by means of transfers that remain without formal documentation. Yet none of these works was Marion's to give away. During her illness and after her death in 1965, Sanborn had the key to the Nyack house. From the 1950s, when Sanborn came on the scene in Nyack, Hopper neither sold nor gave away any of this work from his early years. To date, Sanborn has produced no documents showing how he came to possess so many works of art by Edward Hopper. There is no entry of such a transfer in either Jo's diaries or in the record books that she kept so carefully. Had numbers of these early works been given to Sanborn either by Edward or Jo, surely there

would be some document showing the transfer of title. In short, Sanborn has not demonstrated clear title.

The Brevard catalog alone lists around ninety original artworks from Hopper's boyhood years, including a sketch Hopper signed and dated 1894. There are also more than thirty drawings dated from the years of Hopper's maturity, including sketches for such paintings as *Hotel by the Railroad* (1952), *Sunlight on Brownstones* (1956), *Sunlight in a Cafeteria* (1958), and *People in the Sun* (1960). Once again, there has been no documentation on how these got from Hopper's studio on Washington Square to Sanborn's possession. Nor is there any documentation of previous title transfer for other works by Hopper that Sanborn has given to friends and family members or sold at auction and through galleries, including Hirschl & Adler Galleries and Kennedy Galleries in New York.

Could these works have been gifts? During his long life, Edward Hopper gave away very few gifts of his art. With the exception of an occasional gift to his wife, he never gave away a major canvas. He did give away a few watercolors, some drawings, and some prints to various people during his lifetime. He gave one watercolor to his nurse, who also happened to be his physician's daughter; another watercolor to the mother of his early patron Bee Blanchard; and to his Cape neighbor Harriet Jenness, a watercolor in exchange for borrowing her house while constructing theirs. Almost all of Hopper's gifts were inscribed to their recipients, and most are listed in the record books.[16]

Moreover, Jo, as she had for the forty-three years of their marriage, continued to keep meticulous track of the whereabouts of Edward's work. Despite this, at least one major canvas, *City Roofs* (1932), which is clearly listed in Jo's hand as "Here in Studio," turned up inexplicably and without documentation in Sanborn's possession.[17] Strangely, Deborah Lyons, whom the Whitney hired to transcribe the record books' entries for the *catalogue raisonné*, omitted this note, "Here in Studio." Yet, it is clearly visible on the reproduction of the Record Book page in the published edition of the Record Books that Lyons produced for the Whitney.[18] According to expert opinion, this work alone is worth at least $6 million in today's art market, where one of Hopper's paintings recently sold for more than $12 million.

Why, then, have no questions been raised? A partial answer may be inferred from circumstances surrounding my *catalogue raisonné* of Hopper's work—a project I began in 1976 as curator of the Hopper Collection at the Whitney Museum, but which was only published in 1995 by W.W. Norton & Company for the Whitney. My employment at the museum ended in 1984, although I continued to update the manuscript of

the *catalogue raisonné* until the final manuscript was submitted for publication. Without consulting me, others decided to exclude information about the provenance of each work from the three printed volumes and relegate it to an accompanying CD-ROM. Furthermore it was decided, again without consulting me, not to allow global searches on ownership, although searches are possible on title, date, and media. Thus, research into provenance is impeded: Except by checking each work manually, it is not possible to produce a list of artworks that passed through the same owner.

To add to all this, I was not allowed to address the major problem in the listing of provenance, which should have questioned how each individual work got from Hopper's possession to Sanborn's, this despite the fact that I had long since made a full report in writing about the matter to the museum's administration. In effect, when I sought to blow the whistle, the museum muffled the sound. It seems clear in retrospect that the Whitney tried and continues to try to suppress the whole story of the bequest of Josephine N. Hopper.

The public protests at the sales of Hopper's work by the Whitney only scratched the surface of the museum's disregard for the nature and value of the bequest as a permanent archive. To this day, the public record gives no hint of the full extent of history's loss. My own awareness grew gradually from the moment I began work on the bequest in 1976. Inaugurating the *catalogue raisonné*, I expected to find Hopper's papers, including the letters he kept and the photographs, books, and phonograph records that he and his wife owned; in short, the evidence of his intellectual and cultural scope. I searched in vain. Soon I learned that neither Goodrich nor anyone else from the museum had sought to obtain this archival material, either directly from Jo after Edward's death, or, later, from the executor of her estate, the Bank of New York. It is not clear whether no one from the bank had invited the museum, as principal legatee in Jo's will, to claim or buy the contents of Hopper's New York studio or if no one from the museum took the trouble to show up.

But, according to what Sanborn told me, the bank invited him, as a legatee. Along with a number of other individuals named by Jo, Sanborn received an equal portion of the division of the cash residue of her estate, but no art or documents. Sanborn recounted to me that he was allowed to purchase antique furniture that had belonged to the Hoppers and that the entire contents of their New York studio and home (three rooms in total) was valued at less than $100. In a joint interview with me, Sanborn's wife claimed that they had found stacks of Hopper's drawings beneath the paper liners in dresser drawers of furniture that they purchased from

the studio. If this is true, then there is no question that these drawings should have gone to the Whitney as part of the Hoppers' artistic estate. The executor had neither the right to sell the drawings to Sanborn, nor to give them away.

With his newly acquired treasure, Sanborn contacted the Kennedy Galleries in New York. Lawrence Fleischman, the gallery's owner, sent his employee, Milton Esterow, to Nyack to look at the artwork then being offered for sale to the gallery. Esterow, who had been a staff reporter on the *New York Times*, was then best known as the author of a book called *The Art Stealers*, the dust jacket of which promotes the book as "a lively history of certain fabulous art thefts—and the strange breed of thieves who perpetrated them."[19] Deciding that the work was authentic, Esterow immediately offered Sanborn a consignment deal for what he was shown, which was actually just a small part of what Sanborn had amassed. I recall that Sanborn told me that as soon as the initial check from Kennedy Galleries cleared, he resigned from his position at the Baptist church. I believe that he said that he was then fifty-six years old.

Acquiring Sanborn's collection of Hopper's early work represented a coup for the Kennedy Galleries. Fleischman later told me that at the time he had mistakenly believed that he had gotten all of the art by Hopper that Sanborn had. Fleischman asked both Lloyd Goodrich and me, as the newly appointed curator of the Hopper Collection, to write brief essays for a show of art by Hopper that took place at the Kennedy Galleries in the spring of 1977.[20] This show featured some of the early works he had acquired from Sanborn, along with six etchings and at least a dozen watercolors and oils from Hopper's maturity that came from other private collections. With the possible exception of some of the etchings (which may have sold before 1924), these works had passed through the Frank K.M. Rehn Gallery in New York, which served as Hopper's dealer from 1924 until his death in 1967.

Fleischman added to the catalog of his show his "Personal Remembrance" of his acquaintance with Hopper. In my task of compiling records of Hopper's work for a *catalogue raisonné*, I knew that I needed both the cooperation of Lloyd Goodrich, to whom I dedicated my essay, and Kennedy Galleries, which by then had been dealing in the resale of many works by Edward Hopper. I also needed Sanborn's cooperation, for he, it turned out, had in his possession documents essential to the writing of the *catalogue raisonné*, including Hopper's letters home to his family from Paris. It seemed like an invitation that I could not refuse, and I wrote my essay with the Whitney's full encouragement.

Yet no mention of Sanborn or the provenance of any of the works in the Kennedy exhibition appeared in any of the three brief essays in the gallery's catalog or with the objects' reproductions. Nor is there a checklist, where such information might be expected. A neophyte in the museum world, I did not yet fully understand what was implied by the presence of Hopper's work in Sanborn's possession. Nor do I know now what Fleischman might then have realized or suspected about their provenance.

Recently, however, doubts about provenance have surfaced in connection with some of the ancient works of art from Greece and Rome that Fleischman had already begun to amass by 1976 when he was doing business with Sanborn. It is now alleged that some of these works came from clandestine excavations and were exported from Italy in violation of Italian and U.S. law. *The New York Times* chief art critic, Michael Kimmelman, has just written: "And if the Getty's former antiquities curator, Marion True, and her bosses at the museum did not suspect that some of the objects they acquired from a trustee, Barbara Fleischman, and her late husband, Lawrence, were hot, then they were just about the only people in the art world who didn't."[21] No one, however, seems to have questioned the provenance of these early works by Hopper, either when they first hit the art market in 1976, or in the thirty years since then.

By the time I first heard from Sanborn in June 1976, he had already given away an early Hopper self-portrait to a friend and fellow preacher, who that year sold it to the Boston Museum of Fine Arts for about $65,000.[22] The high price paid for this portrait took Sanborn by surprise as he himself later told me. He then started paying close attention to market prices for Hopper's work. When the museum's project for a *catalogue raisonné* of Hopper was announced in the *New York Times*, Sanborn understood the importance it had for his future income. He needed to establish that all of the works in his possession were authentic and thus contacted me in my new job as curator of the Hopper Collection at the Whitney.

I soon learned from Sanborn that he not only possessed works of art by Hopper, but also many invaluable documents. Not only had the Whitney lost art that rightfully belonged to it (and therefore to the public), but the museum also had missed the opportunity to conserve basic materials for a history of the Edward Hopper and his production. This, despite the fact that in 1964, Jo wrote on the subject of "pack rats" to Margaret McKellar, a staff member at the Whitney at the time when the museum was producing the catalog for the last retrospective exhibition held during Edward's life: "Pack rats might not like to be associated with the Rat Family even, however honorably antiquarian. Of course I keep

everything from way, way back—letters to his mother from French people E. stayed with when in Paris to say E. such a very good boy in 1906. His mother gave them to me. She a pack rat too."[23] If the Hoppers wanted their legacy preserved enough to bequeath their entire artistic estate to the Whitney Museum, it seems clear that they would have wanted the related documentation to be preserved in an institution, not hoarded by a retired preacher living off their legacy. Surely this was the unstated goal of Jo's letter to Margaret McKellar, telling her about letters written to Hopper's family from Paris.

The Whitney has never pursued its claim to all of Edward Hopper's artworks that were bequeathed to it. Nor did the museum seek out any documentation at the time of Jo Hopper's death. When I arrived on the scene in 1976, I discovered not only the dearth of expected documents, but a different absence. In going through the Hopper collection, I expected to see Jo's art as well as Edward's. I had read James Mellow's article in the *Times*, describing canvases by Jo in the bequest as "generally pleasant, lightweight works: flowers, sweet-faced children, gaily colored scenic views."[24] Instead I found no canvases. Only some overlooked watercolors, drawings, and a handful of tiny paintings on canvas board painted during her student years. All of these escaped being discarded by passing as Edward's work.

In evaluating Jo's work in the bequest, Baur naturally looked for advice to Goodrich. Together Baur and Goodrich rejected Jo's work as unworthy of the museum. Unfortunately for history, they ignored the basic tenet of the ICOM Code of Ethics: "There will be a strong presumption that a deaccessioned item should first be offered to another museum."[25] The Whitney failed to offer Jo's work to other museums; instead, it arranged for some of her paintings to be given away, mostly to local hospitals that keep no records. Ironically, the only paintings from this group that can now be traced are four that went to New York University, which had troubled the Hoppers for years with efforts to evict them from their home, after the university purchased the building in which they lived.[26] The Whitney simply discarded the rest of Jo's canvases without investing in even archival photographs.

In all, only three canvases by Jo Hopper were saved for the Whitney's permanent collection. None was ever exhibited. All three had disappeared by the time I began work there in 1976. To my knowledge, none has since turned up, though ironically, about a decade after the Whitney discarded Jo's paintings, her friend, Felicia Meyer Marsh, the widow of Reginald Marsh, bequeathed a number of Jo's other small pictures to the Whitney.

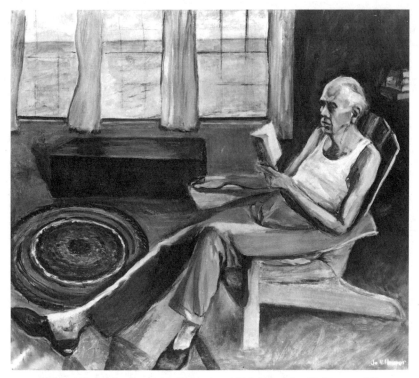

Edward Hopper Reading Robert Frost, circa 1955, Josephine N. Hopper. Oil on canvas, 25 inches × 30 inches. Lost or destroyed.

The museum also received Jo's portrait of Edward that I, as curator of the Hopper Collection, convinced Hopper's dealer, John Clancy, to donate. This picture, now the only major oil painting of Jo Hopper's at the museum, has never been accessioned for the permanent collection. Today, we know most of Jo's paintings only by the professional black-and-white photographs that she had taken during her lifetime.[27] The sole survivors are a few works she sold or gave away.

The Whitney took for granted that Jo's work had no significance. Not all opinion was so shortsighted. Her qualities had not escaped the one interviewer who also became a friend in the last years. Concerning her, Brian O'Doherty argued in a 1971 review of the first exhibit from the Hopper bequest that Jo "must receive considerable attention in future Hopper studies."[28] This prescription for Hopper studies proved more prescient than anyone then imagined. My research went on to show for the first time how Jo's role as an artist intertwined with Edward's work. Starting in courtship,

they made art together. Often they used the same studio or worked at the same locations. When he suffered from painter's block, as frequently happened, she would goad him into action by starting to paint first. They shared the routines of every day and the heroic automobile journeys questing for subjects. They absorbed and discussed the same books, plays, and films, exchanging *billets* in French. With her help, his career took wing. Even though her career withered, ignored, when not discouraged by him, her work is essential for anyone seriously interested in understanding the art and life of her husband.

Not only would Jo's destroyed paintings, such as *Edward Hopper Reading Robert Frost*, be of value today, but her entire body of work deserved to survive so that it could now be judged in a world much changed by both the women's movement and the feminist art movement of the 1970s. Instead her work was almost entirely erased by the very institution she entrusted with the legacy of both her work and that of her husband.

Ironically for the Hoppers, it seems that their trust in the Metropolitan Museum was also misplaced. The only work not by themselves that the Hoppers named in their wills was an anonymous American folk painting, *Calvin Howe and His Two Sisters*, which Jo bequeathed to the Metropolitan Museum. The Hoppers knew, of course, that the Whitney had sold off its collection of pre-twentieth-century American art in 1949 in order to raise funds to collect contemporary art.[29] So it was unlikely that they would have chosen to leave the folk treasure that they had collected to the Whitney.

Hopper discovered this folk painting in 1929 on view in a jeweler's shop on West Forty-fourth Street in New York. He was so taken by it that he immediately described it (January 22, 1929) to the critic Forbes Watson: "It is American of the 1830s I should say. A portrait of three children done with a simplicity and honesty that is striking. Very large in values and unaffected in its design. It is not at all naïve but done with experience and understanding. I think that it's quite a fine thing."[30]

Hopper bought this work, making it the only historic painting that he or his wife ever purchased. They demonstrated their estimate of its value, when they posed in front of it for a portrait photograph taken in 1932 by Louise Dahl-Wolfe.[31] Years later, on May 4, 1959, the Hoppers invited the Metropolitan Museum curator, Theodore Rousseau, to see their treasured painting. He subsequently sent Albert Gardiner, the curator for American art, to see the Hoppers' picture.[32] Jo's will, signed September 1, 1967, states that this painting was "heretofore found acceptable by James R. Rorimer, director [of the Metropolitan]." Thus, confident of the Metropolitan's approval, the Hoppers bequeathed their treasure to the museum at Jo's death in 1968.

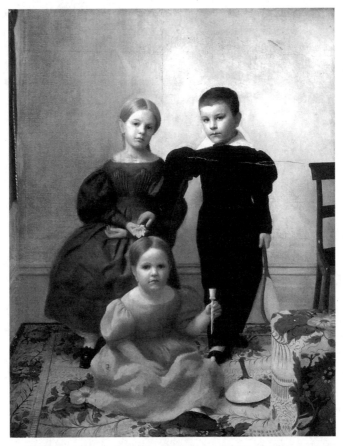

Calvin Howe and His Two Sisters, circa 1830s, American Folk Painting. Private Collection, Courtesy Sotheby's, Inc. Formerly in the collection of Edward and Josephine Hopper.

Despite the fact that Hopper would not even restore damage to his own paintings, the Metropolitan's curators decided in the 1990s that this picture was "overcleaned" and probably by him. The curators decided not to include this work in the catalog of its American collection. The museum offered the painting for $1 to the Hopper House, a local art center operating out of Hopper's boyhood home in Nyack, New York. After the Hopper House foolishly turned down this unique opportunity to own a painting purchased by Hopper, the museum sold the Hoppers' beloved picture, bequeathed for the public's enjoyment, to a private collector in a Sotheby's auction on October 23, 1994, for about $7,000.

If they really wanted to insure that the public could enjoy the art that they valued, the Hoppers should have required that if the art that they left to museums was later deaccessioned or even immediately refused, the entire bequest should go to another named museum. Institutions, we must recognize, are only as good as the leadership and staff at any particular moment. Museums constantly change, depending on who is running them at a given time. As institutional values, goals, and tastes evolve, collections expand and contract. Thus, some artists' works are relegated to deep storage for years, even decades on end; the works of others less lucky are consigned to the auction block or even the trash heap. The Hoppers would have been wiser to divide the bequest of their own work among several institutions. Had they done that, chances are that not all of the museums would have betrayed the artists' trust as the Whitney and the Metropolitan did.

Endnotes

[1] Magda Salveson and Diane Cousineau, eds., *Artists' Estates: Reputations in Trust* (New Brunswick, NJ: Rutgers University Press, 2005). For guidance on (rather than a history of) estate planning for artists, readers will want to consult the helpful book, *Visual Artist's Guide to Estate Planning*, edited by Barbara T. Hoffman, Esq. It is available for free downloading at *www.sharpeartfdn.org/ estateplnbook/download_page.htm*.

[2] Lee Seldes, *The Legacy of Mark Rothko: An Exposé of the Greatest Art Scandal of Our Century* (New York: Holt Rinehart and Winston, 1978).

[3] The Schwitters case (January 2005), *http://64.233.161.104/search?q= cache:5b7D4w8if1wJ:www.theartnewspaper.com/news/article.asp%3Fidart%3D4399+ %22Kurt+Schwitters%22+%2B+estate+%2B+%22Marlborough+Gallery% 22&hl=en*.

[4] "Bacon Estate Alleges Artist Was Blackmailed by Marlborough," *Art Newspaper*, no. 121 (January 2002): 3.

[5] Martin Bailey, "The Estate of Francis Bacon Drops Legal Action against Marlborough," *Art Newspaper* 13, no. 123 (March 2002): 7.
Michael Glover, "Bacon Estate Settled," *Art News* 101, no. 3 (March 2002): 70.

[6] See ICOM Code of Ethics for Museums at *http://icom.museum/ethics.html# section2*. In the United States, the National Committee is housed with the

American Association of Museums (AAM) forming AAM/ICOM, so that this Code of Ethics applies to American museums.

[7] *www.aam-us.org/museumresources/ethics/coe.cfm.*

[8] Grace Glueck, "Art Is Left by Hopper to the Whitney," *New York Times*, March 19, 1971.

[9] Ibid.

[10] Hilton Kramer, "The Hopper Bequest: Selling a Windfall," *New York Times*, March 28, 1971.

[11] John I.H. Baur to the Editor, Art Department, *New York Times*, April 9, 1971, draft in Whitney Museum archives.

[12] In interviews by the author with Brian O'Doherty and Barbara Novak, they confirmed that they never again saw Jo. See Gail Levin, *Edward Hopper: An Intimate Biography* (New York: Alfred A. Knopf, 1995), 578–579.

[13] Ibid., 565. Edward Hopper to Marion Hopper, letter in Hopper's hand, September 14, 1964, copy at Whitney Museum of American Art in Hopper Archives, which were compiled by Gail Levin.

[14] Robert Gabriel, "Foreword," in *Edward Hopper: The Early Years* (Melbourne, FL: Brevard Art Center and Museum, 1980).

[15] See Levin, *Edward Hopper: An Intimate Biography*, 570.

[16] See the partial reproduction of the record books left to Goodrich: Deborah Lyons, ed., *Edward Hopper: A Journal of His Work* (New York: W.W. Norton & Company, 1997), 66, which reproduces one of Jo's lists of gifts from Record Book, volume III.

[17] See Lyons, ed. *Edward Hopper: A Journal of His Work*, 45, which reproduces volume II, 3.

[18] Ibid.

[19] Milton Esterow, *The Art Stealers* (New York: Macmillan, 1966).

[20] Lloyd Goodrich and Gail Levin, *Edward Hopper at Kennedy Galleries* (New York: Kennedy Galleries, 1977).

[21] Michael Kimmelman, "Regarding Antiquities, Some Changes, Please," *New York Times*, sec. E4, December 8, 2005.

[22] The Boston Museum of Fine Arts gives as the provenance for this work: the artist, his mother, his sister Marion, Rev. Arthayer R. Sanborn, Rev. and Mrs. William H. Britain, but there is no evidence whatsoever that this particular painting belonged to anyone but Edward Hopper, who stored all his early art work in the attic of his family's home in Nyack. Nor is there any evidence that Marion Hopper gave this work to Sanborn.

[23] Josephine N. Hopper to Margaret McKellar, January 20, 1964.

[24] James R. Mellow, "The World of Edward Hopper," *New York Times Magazine*, September 6, 1971, 21.

[25] See ICOM Code, 2.15 Disposal of Objects Removed from the Collections.

[26] See Levin, *Edward Hopper: An Intimate Biography*, 394–395 and 545–546. Ironically, due to a historically minded dean in New York University's School of Social Work, the space of Hopper's studio has been preserved, although it currently houses faculty offices.

[27] Fortunately, during her lifetime, Jo had the same professional photographer who recorded Edward's work take photographs of some of her canvases. Many of these black-and-white photographs have survived, and I collected them and had them copied by Geoffrey Clements for the Hopper Archive.

[28] Brian O'Doherty, "The Hopper Bequest at the Whitney," *Art in America* 59 (Summer 1971): 69.

[29] "Whitney Museum Will Replace Art: 200 Works of 19th Century Art to Be Sold, and Proceeds Will Buy Modern Pieces," *New York Times*, December 9, 1949, 33. See also Richard F. Shepard, "Whitney Museum Lists New Goals; Earlier American Art Will Be Collected Once More," *New York Times*, December 15, 1964, 51. This turned out not to be true, but then who would have believed it anyway?

[30] Levin, *Edward Hopper: An Intimate Biography*, 220–221 and 605.

[31] Ibid., 245.

[32] Ibid., 522.

CHAPTER

The Moral Case for Restoring Artworks

James Janowski

Imagine that aesthetic terrorists were to disfigure the *Mona Lisa*. Or that members of the Lazlo Toth League, undaunted by security measures taken to foil actions like that of their wild-eyed leader, were to pulverize the *other* arm on Michelangelo's *Pieta*. The loss would be huge in both cases. But would it be appropriate to restore these art objects—or not? The focal questions of my paper are these: When, if ever, is it appropriate to intervene on behalf of an artwork in the interest of restoring it? And, assuming intervention is at times appropriate, what sorts of restoration are justified? What sorts misguided? And why?

Artworks, Restoration, and Identity

In a pair of provocative papers, Mark Sagoff and Michael Wreen investigate the appropriateness, metaphysically, of restoring artworks. Both address the restoration of Michelangelo's *Pieta*—a sculpture that was horribly damaged by a hammer-wielding Lazlo Toth in May 1972 and restored by Vatican conservators later that year. Presumably the attack on Michelangelo's sculpture was a onetime event—let us hope together that there is no Lazlo Toth League—and most artworks do not suffer such cataclysmic harm. But while the case of the *Pieta* is especially dramatic, thinking it through will serve to guide us in more mundane circumstances as well. Indeed, I aim to ferret out principles that apply to the restoration of all artworks, whatever the source of degradation.

Sagoff and Wreen mark off starkly opposed positions in the debate. Sagoff defends "purist restoration," which he characterizes as follows: "A purist

restoration limits itself to cleaning works of art and to reattaching pieces that may have fallen. Purists contend that nothing inauthentic— nothing not produced by the original artist—may be shown."[1] Put simply, purist restoration demands that no new material be added to the original artifact. And with this standard in mind, Sagoff argues that the Vatican Museum's efforts to resuscitate the sculpture were misguided.

By way of contrast, Wreen defends "integral restoration," a process that seeks "to return an artwork to its predamaged condition . . . even though at least some of the material used to do so is not material from the original work. Restoring the original look of the work is the primary value guiding such restoration, its aim being to create . . . a work perceptually indistinguishable from the predamaged work."[2] Put simply, integral restoration focuses on appearance; it aims to replicate the artist's original efforts. And with this understanding of restoration in mind, Wreen argues that the work on Michelangelo's *Pieta* was entirely appropriate.

Sagoff and Wreen advance different understandings of "the artwork." For Sagoff, the artwork is an ideal object. An art object is a static and timeless thing, brought into being once and for all via the artist's creative activity. For Wreen the artwork is a perceptual object. It is constituted by an object's surface appearance—by its propensity to induce a particular set of sensory impressions. This difference aside, both Sagoff and Wreen hold that the *identity* of an artwork is a sensible, important notion. In fact, part of their dispute can be understood as a difference about exactly what this identity involves. For Sagoff, the identity in question is a matter of the object's unsullied materiality; where something non-original is added, the artwork has been fundamentally altered. Indeed, the allied notion of "authenticity" carries much of the load in Sagoff's argument: Where integral restoration occurs, authenticity is compromised and the artwork is *no longer the same artwork*. In contrast, Wreen argues that the identity of the artwork is constituted by its "phenomenological payload." It is sameness of perceptual experience that makes an artwork one thing. Thus Wreen differs from Sagoff in holding that the identity in question is a matter of the object's "visual freight"— the experience it occasions—rather than its particular materiality.

How should we think about the turf marked off by Sagoff and Wreen? I want to evaluate their respective views. My larger aim, however, is to both mark off a position of my own in the debate, arguing for what seems to me the truth about the restoration of artworks, and to spell out what neither author discusses sufficiently: the *moral* implications of their stances. The felt imperative to restore artworks has its source in normative

considerations, and any analysis of the appropriateness of restoration needs to go beyond metaphysics to take this into account.

A Point against Sagoff

Sagoff subscribes to an exacting criterion of authenticity. Is the restored *Pieta* the same artwork it was prior to Toth's hammer-blows? Sagoff says no. In his view, integral restoration makes Redig de Campos (the Vatican Museum's director in 1972) and his team of conservators a sort of co-artist, and it gives rise to a new artwork—one that has bastardized the sculpture. Indeed, restoration fundamentally alters a time-less and unchanging thing that was brought into being, "once and for all," by Michelangelo.

In my view this is too static and rarefied a conception of "the artwork." I agree that the restored *Pieta* is not the same artwork Michelangelo rendered—though not for the reason Sagoff articulates. What I would like to urge here is that Sagoff's concern with the art object's *time-less ontological identity* is misguided. And I believe that some of Derek Parfit's thinking about identity in the human context can help show this.[3] In brief, Parfit holds that "personal identity" is a fiction—and that we would do better to talk about the *continuity* or *survival* of the person. Parfit argues that there is nothing—no *thing*—that underlies the various tempo-ral instances of a person. Thus he asks if I am identical to, or ontologically one and the same with, the person I was when I was five. And bucking the received (Cartesian) wisdom, Parfit argues no. Something survives across the years, Parfit claims, but with a difference; he advances a *relative* or *loose* sense of personal identity based on psychological continuity rather than a purported ontological unity. Put most simply, Parfit's point— obviously only sketched here—is that *we are changing all the time*.

Why discuss Parfit? Well, it seems we might extend Parfitian think-ing about personal identity to our thinking about the identity of art objects. Is the artwork fresh out of the studio ontologically one and the same with the artwork 500 years later? Contra Sagoff, the answer is not an obvious "yes"; one *could* argue that the being of an artwork changes over time. Indeed, one might urge that an artwork survives not as a timeless ontological singleton, but rather in a looser sense—in terms of its conti-nuity with, its close relationship to, its "predecessor." This view stresses malleability over constancy. Artworks persist, but, like people, they are changing all the time. And the idea that some mysterious metaphysical constant cuts across the artwork at all times—something that makes it the

same (ideal) thing through the various changes it undergoes—is quite misguided. If we come to think like this, obviously we will not be so tempted to talk about "the identity" of the artwork. In fact Sagoff's question, "Is the restored artwork *the same* artwork?" might come to sound funny—like the wrong question to ask.

While the ways in which artworks change requires unpacking, space limitations preclude doing so here. For now I simply note that this understanding of the artwork squares with experience. Sagoff argues that the aesthetic object is a timeless ideal object. But this is empirically disconfirmed. Art is subject to many forms of modification. Indeed, against Sagoff and with common sense, artworks are in time and affected by the same. Artworks decay.[4] Thus it seems to me that the materiality of the object is a condition of the continued existence of the artwork. In fact, like Sagoff and Wreen, I too am committed to the *identity* of the artwork—but in a sense that splits the difference between them and depends essentially on the continued physicality of *the artifact*.

A Point against Wreen

If Sagoff goes astray in appealing to the timeless identity of the artwork, what should we say about Wreen? Again, for Wreen, surface appearance constitutes the aesthetic object—and thus objects perceptually indistinguishable from the original *are the same artwork*. Wreen intends this quite literally. And this naturally invites the question: What about perfect copies—copies produced, say, molecule-for-molecule in an art-replicating lab? Any aesthetic sense theorist, it seems, would support such a lab's efforts. And so Wreen does: "I see no reason to preclude multiple instances of one and the same painting, if multiple instances of one and the same novel, poem, photograph, cast sculpture, or print are possible. The only thing currently lacking for its actuality . . . is the relevant technology."[5]

In fact Wreen's argument vindicates both replicas and reproductions. He follows M. Pabst Battin in imagining an art replicator churning out a *Mona Lisa* for every living room, and he seconds Battin's claim that this would be a good thing.[6] And, we might wonder, why not? If art is desirable—if it is, as Wreen (rightly) assumes, edifying and educational and constitutive of the human good—then this happy egalitarianism of *Mona Lisas* would seem a splendid thing, the world a much better place for it and people much better off. Thus Wreen says: "Is a world with a great work of art, or at least an exact replica thereof, on every wall a desirable world? My own answer is simplicity itself: Sure, other things being equal."[7]

Wreen's tone is refreshing. But what is one to make of his argument? What, for example, should we say about his claims concerning the art replicator? While there is something right in Wreen's appeal to "surface," I believe that understanding the artwork as merely a perceptual object, and hence as something in principle infinitely replicable, is misguided. Phenomenological payload is not the *only* thing that is important.

To see this, let's think briefly about Robert Nozick's "experience machine."[8] Nozick asks us to imagine a contraption that serves up any and all experiences. One simply chooses one's favorite, hooks up, and enjoys the ride. So, say that I wanted to see the *Pieta* but could not get to Italy. Well, plugging into the experience machine, I can have all the "Pieta-experience" I want. *From the inside* I cannot tell whether my sensations are veridical or the product of the machine. Indeed, in terms of the felt quality of consciousness, the distinction makes no sense: In both instances I am moved, whether cognitively or emotionally, in exactly the same way. Moreover, if what matters is being moved, rather than what occasions the movement, it seems plain that hooking up is perfectly fine. (Thus Nozick's hard question: "Would you plug in? What else can matter to us, other than how our lives feel from the inside?"[9])

Persuasive? Well, Nozick himself urges that there is something deeply amiss about machine-generated experience. In brief, he suggests that human beings care not only about *having* experiences but also about *doing* certain things—and, in particular, those things that give rise to the desired concomitant experience. Moreover, they care about *being* a certain way—a way other than the way of "the indeterminate blob" hooked up to the machine.

Unless I'm hopelessly naïve, Nozick seems to have (at least most) human beings pegged. And there is a lesson here for our thinking about Wreen. Indeed, I believe we have Nozickian considered judgments about our experience in front of a lab-generated replica of the *Pieta*. Wreen happily sanctions the replica: A replicated experience is every bit as genuine as a "real" experience (in fact there is no distinction between the two).[10] But it seems to me, as it would to Nozick, that there is something inapposite about one's experience in front of a machine-generated *Mona Lisa* or a machine-generated *Pieta*. And Sagoff captures this well: "People go to the Vatican Museum to see the *Pieta* of Michelangelo and not simply to have a certain [Pieta-] experience."[11]

In fact there is something deeply right in Sagoff's principled appeal to authenticity, even if, as I have argued, he miscasts the idea. Wreen follows Battin in arguing that a perfect replica of the *Mona Lisa* in every

living room would be a good thing. But in my view these lab-generated replicas would be inauthentic—and it would be a mistake to put one in everybody's house. Against Wreen, there is *only one Mona Lisa*, and *only one Pieta*.[12] The Battin/Wreen copies, at least where they were acknowledged to be copies, would not in fact have the same phenomenological payload as the "real deal." We would not sign on to the Battin/Wreen program for precisely the reason we would not connect to Nozick's machine: We would know, antecedently, that the experience was simulated—and less valuable owing to its inauthenticity. Put simply, knowledge affects the aesthetic experience itself, and knowing this, we would, or certainly should, act accordingly.

A Point against Sagoff *and* Wreen

Sagoff suggests that "[W]e value one object way above another because it is the product of a different process."[13] He means that we value the original over the replica, even the perfect replica, because the former is the product of a creative process—the bringing into being of something good in accord with intention. Put simply, it is art.

But to show that authenticity involves more than this, imagine we were to discover "a second *Pieta*," this one the product of Michelangelo's own hand. Imagine, say, that Michelangelo had had a premonition that his sculpture would be attacked and, accordingly, had labored to "replicate" the original. Imagine further that he had done such a marvelous job that his pieces were perceptually indistinguishable. Develop the story: Imagine Michelangelo had wanted the two *Pietas* to be *different* and thus buried some materials inside the second. (This does not affect the appearance.) He then records in his diary, which we discover alongside the second sculpture, that though he intentionally affected exactly similar surfaces, he nonetheless understood—and intended—the two sculptures as *different artworks*. Each sought "to solve a different problem" (one of Sagoff's criteria for an artwork), and thus Michelangelo neither took himself to be making a (mere) copy nor wanted us to understand his project in *Pieta #2* in this way.

Given Lazlo Toth's act, what should be done with *Pieta #2*? Wreen, focusing on the artwork's surface, would argue that we have very good reason to replace the original with *Pieta #2*. (No more reason than we have to replace it with a lab-generated copy—but no less, either.) Integral restoration will be difficult. And where we can get the same perceptual payoff without laboring, why not? Sagoff, for his part, might urge that we maintain the status quo, leaving the original in its damaged state and *Pieta #2* in

the Vatican's just-discovered cellar. On the other hand, there is some reason to think that Sagoff would argue that we prop up *Pieta #2*—precisely because Michelangelo himself has reported that its production was a genuinely creative act, resulting in a different piece of art. Recall Sagoff's insistence that an artwork is rightly understood as something over and above, indeed something beyond, its perceptual properties. Well, in *Pieta #2* we do have something over and above, something beyond, the perceptual properties. We have Michelangelo's *word*—something that would seem to oblige Sagoff to second the master's understanding of *Pieta #2*.

These responses seem wrong. I believe it would be better, metaphysically and morally, to integrally restore the damaged *Pieta* than to prop up *Pieta #2*, the fact that the latter is Michelangelo's work and visually indiscernible from his first sculpture notwithstanding. Why? Because *Pieta #2* is *not the real thing*. And what makes the original *Pieta* the real thing, damaged or not, is its place in the space-time continuum: It is the self-same artifact, the particular physical token, which has been on display all these years. Indeed, there is only one *Pieta* (or one *Mona Lisa*). And this not in Sagoff's misguided ontological sense—again, there is no timeless, ideal substance here—but rather in the very important sense that there is only one—*can be* only one—material object capable of harboring aesthetic value and relaying aesthetic meaning. (Thus so also does Wreen err in arguing that art objects are infinitely replicable.) In the present case, this is Michelangelo's original sculpture—the artifact that has occupied the frontlines in Italy for centuries. And the general idea here is straightforward: Properly understood, an artwork is a *particular physical object—changeable and informed by history*. (Thus we do a genuine disservice to history—as well as to our contemporaries and future generations—if we replace the original with *Pieta #2*. And this because the latter is not the *Pieta* at all—*in the sense of the thing that is able to transfer value and meaning*. It is not the thing that gives rise to semantic properties, which will be something more than perceptual properties, even if they are also, as they are, partly perceptual properties.[14])

The point against Sagoff, then, is that the generation of aesthetic value is not merely a matter of the creativity of an artist; it is also a matter of the creativity of time. That is, generating aesthetic value is, in part, a matter of history as well. And the point against Wreen is that the production of aesthetic value is not merely a matter of perceptual payoff. Indeed, *Pieta #2*, though Michelangelo's work and though Michelangelo himself wanted it displayed should his nightmare come true (again, the second piece "solves a different problem"), is no better than the art replicator's perfect copy. Or, more safely, I think we have a continuum: Best is the original *Pieta*,

damaged and integrally restored; second best, *Pieta #2*, a product of Michelangelo's chisel and intention; and worst, the replicated "*Pieta.*" Thus, I believe we need to challenge the master's (hypothetical) reading of art—which neglects the importance of history. What my imaginary Michelangelo failed to recognize is this: Once out of his hands, the original *Pieta* becomes common property, even a sort of collective and ongoing cultural project. And this is true of art objects quite generally.[15]

Conclusion: The Moral Implications

In my view, both Sagoff and Wreen violate our considered judgments about artworks. I believe we would rather experience an integrally restored *Pieta* than either the *Pieta* severely damaged (the risk we run if we buy Sagoff's view) or a brand-new "*Pieta*"—whether the product of an art replicator or Michelangelo's hand and prescient mind (the risk we run if we accept Wreen's happy egalitarianism). But why?

Ultimately for *moral* reasons. Indeed, the positions advanced by Sagoff and Wreen have significant moral implications—implications not adequately explored by either author. I want to suggest that Sagoff and Wreen proffer misguided readings of the identity of an artwork that, were they to be followed, would lead to moral mistakes. Their views do not square with what reflection suggests about the morality of art conservation.[16] (It seems to me that the injunction to conserve and restore artworks is ultimately a normative one. And intuitive dissatisfaction with the moral implications of a theory should force one to rethink the theory—in the way I have done here.[17]) Put simply, morally speaking, both go astray. How so?

Sagoff first: An unflinching commitment to purist restoration consigns artworks to the dustbin. Put into practice, Sagoff's view would allow artworks to *wither*. Witness: "The purist believes a work of art may be so valuable that it is worse to repair it integrally than to let damage to it stand."[18] I disagree. Abstract metaphysical principle is one thing; real-world moral practice is another. Purism makes both a backward- and forward-looking mistake. First, it fails to recognize how much we owe to artists and to those, whether individuals or cultures, that have maintained their works. To allow an artwork to wither is to disrespect its creators and its guardians. Indeed, we have a debt of gratitude to both; and purism, focusing too narrowly on the artwork per se, misses this. Second, purism breaks the moral link between us and our progeny. To fail to restore artworks is to neglect our stewardship obligation and to abdicate our responsibility to future generations. The purist's unyielding commitment

to principle leads to the *disabling* of an artwork as a repository of meaning and value. Indeed, it renders artworks incapable of influencing people's lives for the good. Sagoff, of course, urges that in taking this stance I misunderstand art, which is "above all price" and valuable in itself. I plead guilty—without apology—to his charge that I am an instrumentalist about the value of art. Sagoff treats the artwork as morally prior; but I believe this gets morality backward and leads to conclusions about art conservation that are simply unacceptable.

Wreen's view, too, has untoward moral implications. While Wreen is correct to defend integral restoration, he errs in affirming that artworks can be reproduced at will and disseminated after the fashion of a garden-variety consumer product.[19] Indeed, Wreen's promiscuous reading of integral restoration goes (way) overboard, neglecting the importance of the particular artwork's particular history. Followed to its conclusion, his view licenses—even encourages—deception. Staring at a replicated *Pieta* is analogous to being told a lie. (Sagoff is exactly right about this.) Thus, in treating art objects as effectively interchangeable, Wreen advances a position that disrespects artworks and people. It misses the value in the original. And it cheapens human beings as well. It implies that our appreciation of authenticity—understood in my way, not Sagoff's—is somehow illusory or unimportant. But this seems quite wrong. Indeed, our rational attunement to the authentic, historically informed object highlights a basic fact about our nature. We are right to feel an affront at a replicated *Pieta*, and any view that denies this glosses over something important about us. Thus my critique of Wreen, too, focuses ultimately on people and their interests. Where we are duped or deceived we are made worse off; and carried to its extreme, Wreen's position permits—even promotes—just this.

In my view, then, art is too important, morally speaking, to allow either of these extreme positions to hold. But all is not lost. Integral restoration, *rightly understood* (i.e., not in Wreen's way), splits the difference between Sagoff's overly-principled respect for the artwork and Wreen's glib, facile, and promiscuous understanding of the same. And perhaps these theoretical considerations can be bolstered by reflection on the actual *practice* of art conservation. Wreen argues that "the primary aim" of integral restoration is to "create . . . a work perceptually indistinguishable from the predamaged work." But this is not how professional conservators would describe their vocation. In the conservator's studio (as opposed to the philosopher's study), the primary aim of integral restoration is to make a damaged artwork whole, to rehabilitate its values and restore its integrity.

Sometimes this will involve a concern with "surface." Sometimes it will abstract from this concern entirely, or attend to it only in part. But in any case it is the *particular art object*, and not mere "appearance," that is the conservator's overriding concern. Above all, conservators seek to treat the artwork in ways that will enable it to continue to (non-deceptively) translate meaning and value to perceivers.

And thus it seems to me that integral restoration—where this means using and displaying material that is not original, cost to beauty, "original look," and stylistic unity notwithstanding—is morally justified. It treats the objects, understood as rich repositories of creativity and historical meaning as well as the values that supervene on each of these things, with the respect that they are due. It also treats human beings—past, present, and future—with the respect they deserve. Of course, to say all of this is not to say that integral restoration is cost-free, or does not leave us with a moral remainder. Adding non-original material, even where this process is reversible, is a cost; so, too, is the absence of stylistic unity—something that the conservator will readily forgo in the interest of integrity. Thus, not surprisingly, integral restoration is not a "perfect solution." But of course to expect a perfect solution is quixotic; it is to expect too much.

Doing the right thing is often a matter of sorting through conflicting intuitions and making compromises. Sagoff's view, though well-motivated (all else equal, of course we want to acknowledge and maintain the value of art), is quite *un*compromising. And Wreen's view, though once again well-motivated (all else equal, of course we want more people, not less, to be edified by artworks), is *too* compromising. Where we allow our thinking about art restoration to be informed by the moral implications of that same thinking—where we allow, as I believe we should, that there is a feedback loop from metaphysics through morality and back again—I think we will seek to split the difference between Sagoff and Wreen by endorsing (the conservator's understanding of) integral restoration. In the real world, with real interests at stake, a balance needs to be struck. Understood rightly, integral restoration does exactly this. It is the correct approach to compromised artworks and, morally speaking, the right thing to do.

Endnotes

[1] Mark Sagoff, "On Restoring and Reproducing Art," *Journal of Philosophy* 75, no. 9 (September 1978), 457; hereafter "RRA."

[2] Michael Wreen, "The Restoration and Reproduction of Works of Art," *Dialogue* 24 (1985), 91; hereafter "RRWA."

[3] See Parfit's "Personal Identity" in *Personal Identity*, ed., John Perry, (Berkeley: University of California Press, 1975), 199–223.

[4] Subscribing to Richard Wollheim's "physical object hypothesis," this seems to me obvious. See Wollheim, *Art and Its Objects* (New York: Cambridge University Press, 1980).

[5] Wreen, "RRWA," 98.

[6] See M. Pabst Battin, "Exact Replication in the Visual Arts," *The Journal of Aesthetics and Art Criticism*, 38 (1979): 153–158; hereafter *JAAC*.

[7] Wreen, "RRWA," 99.

[8] See Robert Nozick, *Anarchy, State, and Utopia* (New York: Basic Books, 1974), 42–45; hereafter *ASU*.

[9] Ibid., 43.

[10] Again, if qualia is all that matters, the art replicator is a boon. Wreen's thinking echos the view Ross Bowden imputes to the Kwoma, a "nonliterate" society in Papua New Guinea. See Bowden's "What Is Wrong with an Art Forgery?" *JAAC* 57, no. 3 (Summer 1999): 333–344; hereafter "WWAF." Bowden says (p. 335): "Kwoma believe that a copy . . . possesses all of the culturally and aesthetically significant features of an 'original'. . . . An original . . . possesses nothing that a well-made copy does not also possess."

[11] Sagoff, "RRA," 467. Nelson Goodman's discussion of Rembrandt's *Lucretia* and "a superlative imitation of it" is instructive here. See Goodman, *Languages of Art* (Indianapolis: Bobbs-Merrill, 1968), 99.

[12] Walter Benjamin would agree. See his discussion of the "aura" in "The Work of Art in the Age of Mechanical Reproduction," in *Illuminations*, ed. H. Arendt, (New York: Harcourt, 1968), 219–253.

[13] Sagoff, "RRA," 456.

[14] Put differently, aesthetic value is not merely a matter of an artwork's directly observable qualities. Aesthetic value is partly determined by an artwork's non-exhibited or institutional features. See Bowden, "WWAF," 333–343.

[15] Whereas Sagoff claims the artist makes something "once and for all," there is an important sense in which the artist simply relinquishes control once the artwork, understood here as a *gift*, is in the world. While this idea needs to be unpacked, space constraints preclude doing so here.

[16] There is a complex relation between restoration and two allied activities—conservation and preservation. Thus I have argued that the values and semantic meanings in the *Pieta* could not be conserved, indeed could not be preserved, without some restorative work. In this respect conservation, preservation, and restoration, though conceptually distinct, will in practice often overlap. For a discussion of this relation, see Antony Savile's "The Rationale of Restoration," *JAAC* 51, no. 3 (Summer 1993), 463–473.

[17] Cf. John Rawls's method of reflective equilibrium.

[18] Sagoff, "RRA," 461.

[19] A comment by Thomas Nagel, made in another context, is relevant: "Some of the most wonderful things in the world just are rare: There is no way around it." See Nagel's *Equality and Partiality* (New York: Oxford University Press, 1991), 138. Artworks cannot be infinitely replicated and radically democratized—and then appreciated after the fashion of a candy bar. This seems to me just a fact about the world.

Ethical Issues and Curatorial Practices

Joan Marter

Often museums hire scholars as outside contractors or guest curators to work on specific projects that might fall outside the expertise of staff members. These assignments sometimes come about because curators are too busy to support a full schedule of temporary exhibitions. In any case, guest curators often bring innovative ideas as well as substantive expertise and knowledge to a museum project. For the guest curator, however, the collaboration with a museum staff can result in infractions that compromise the intellectual integrity of the contractor's work. The most egregious of these infractions is scholarly erasure, but there are other situations that can seriously affect the proper acknowledgment of a scholar's contributions to a project.

Although a guest curator may bring intellectual resources of unparalleled importance to a museum project, it is the museum that has the necessary financial resources for arranging loans, organizing an exhibition, and publishing a catalog. These realities lead to possible abuses by museum personnel as they consider financial supremacy as a guarantee for authority that cannot be challenged over the conduct of a project. It is essential that a guest curator sign a contract with the museum to guarantee his or her rights. A few examples can be cited to indicate the dangers to scholarly practice when a major institution uses the power of its substantial operating budget to intimidate a guest scholar or author.

Without going into too many specifics, I can attest to the following: a museum organizing an exhibition, which was based on a scholar's doctoral dissertation, but erasing the scholar's name from any acknowledgment and giving full credit for the research to the curator alone.

The scholar was not consulted or contacted in any way while the exhibition was being planned, and the appropriation of her research was taken from the dissertation that was made available through UMI Press in Ann Arbor, Michigan. There have been several instances that I know of first-hand where the identification of the guest curator is dropped from the exhibition when the show travels to other museums, or the title pages of catalogs have failed to acknowledge a guest curator or outside contractor.

In my personal experience, a major museum insisted on crediting a curator on staff with a two-volume publication devoted to a comprehensive study of the museum's sculpture collection while other authors received secondary acknowledgment. Two volumes were published, and the "in-house" curator's work was almost exclusively on the first volume. Her name was also given top billing on the second volume, although I had written individual entries totaling 195 pages, and the curator wrote only thirty pages in that volume (see *American Sculpture in the Metropolitan Museum*, vol. II [New Haven: Yale University Press, 2001.]).

In other cases, exhibitions were cancelled or seriously modified after an agreement was signed with an outside contractor. Some scholars have found that they were not consulted regarding the selection of works for an exhibition, even though the works were to be included in their "section" of an exhibition. My experience has included a request to "curate" an exhibition entitled *American Sculpture from the Zimmerli Art Museum: New Dimensions* (September–October 2003) that involved trips to storage to examine works and a serious effort to include only the most appropriate examples. Subsequently these choices were ignored by the staff curator who made the decision to show all of the works in the museum's collection. Curators on staff have appropriated previously published material by scholars, and claimed this research as their own in connection with a collaborative publication with that scholar. In many instances the outside contractor was excluded from the examination and approval of a checklist for an exhibition, or even the page proofs of a publication. No recourse was possible once the publication appeared in print.

In my own contractual arrangements with museums—and those of several of my colleagues—the role of guest curator is a precarious one, where ethical standards that a museum would observe for its own staff are ignored for an outside contractor. To avoid violations of the intellectual rights of scholars working on projects with museums, it is advisable to follow certain guidelines, such as those available on the Web site of the College Art Association. The possibility of entering into litigation with a major institution is all but impossible for the scholar, and museums take

advantage of this inequity by setting the terms of any agreement to the advantage of the institution.

I would like to consider some of the ethical issues that roil the collaboration of curators/museums with outside contractors and suggest some remedies. Scholarly erasure is one of the most serious offenses against a researcher. This violation involves the theft of intellectual property, in this case by a curator who publishes the findings as his own, or by an institution that claims credit for ideas leading to an exhibition and/or publication that originated with a scholar that is not affiliated with the institution. If the scholar has been asked to collaborate with an institution on the planning of an exhibition or publication, I suggest that a contract be prepared so that scholarly erasure can be avoided. In such a contract, the scholar needs to have it specified that he or she is entitled to read the final copy of the catalog manuscript prior to going into final draft for printing. However, if the scholar discovers that his or her research (published or unpublished) has been used without authorization by a museum for an exhibition and publication, there may be no recourse but litigation.

When a scholar is engaged as a guest curator for an exhibition, a contract or letter of agreement is necessary. This contract will outline the allocation of responsibilities, and, most importantly, the document will indicate the credits and intellectual property rights that will be acknowledged in all publicity for the exhibition and any published materials. The scholar needs to specify where and in what manner this acknowledgment should appear. The outside contractor must have the right to examine press releases, the title page, and table of contents page of the exhibition catalog to determine if the credit has been properly cited. Copyright issues are also a factor. Ownership of any written essay should remain with the author, who licenses the museum to publish the research. If the essay is written as a work-for-hire, the ownership should return to the author for purposes other than the museum's publication.

Outside contractors often find that they are effectively excluded from the preparation of the exhibition, including key decisions about works to be included, the selection of reproductions for the publication, and any educational materials to be created. A guest curator needs to ensure that the exhibition is indeed a collaboration between the scholar and the institution. A work schedule needs to be agreed upon, and an agreement by all parties should be reached on the responsibilities for grant proposal writing, selection of objects, wall copy, and the decision-making process.

Financial compensation should be determined at the time of the contract. Researchers will want to assure that their expenses will be paid

for travel related to their work. Breach of contract by the institution needs to be discussed. The guest curator is advised to assure that there is a mechanism for the consultation and approval of the contents of the catalog. Guest curators are entitled to appropriate credit for all contributions to an exhibition. Any written agreement should explain that the guest curator will be acknowledged as "curator" in all press releases and in the publications.

If the exhibition is expected to travel to other venues, the guest curator should confirm that his or her name continues to be used in all publicity for the exhibition. The contract should specify the location and extent of the credit to be given the guest curator. In addition, the museum and all participating venues should acknowledge the full professional title and affiliation of the guest curator.

Often museum personnel object to the preparation of a contract, particularly one involving legal counsel. However, it is my opinion that the friendly handshake never suffices to assure a satisfactory working relationship between the outside contractor and the institution. Even within my own university, I find it necessary to prepare a letter of agreement with the staff of our university museum. An awareness of ethical standards is an indication of the professionalism involved in the collaboration among all parties engaged in curatorial practices. For details relevant to contracts for guest curators, information is available on the Web site of the College Art Association (see *www.collegeart.org*). Mutual respect is best assured by working out all of the details in advance of any problems that may develop. Ethics in curatorial practices can be affirmed for all parties by the careful preparation of an agreement to assure equitable treatment.

Fair Use and the Visual Arts: Please Leave Some Room for Robin Hood

Stephen E. Weil

My argument in this chapter rests on two foundations. One is the conception of fair use that Federal Judge Pierre N. Leval has so eloquently articulated over recent years—that is, that fair use is not an *exception* to copyright's overall objective but, rather, wholly *consistent* with that objective.[1] If copyright's initial purpose was, as Leval has argued, to be an incentive that would stimulate progress in the arts for the intellectual enrichment of the public, then what is basically required in order to determine whether any particular use is or is not a fair one is a two-pronged inquiry. First, is the use consistent with copyright's underlying purpose of stimulating further productive thought and public instruction?[2] Second, if so, does it then do so without unduly dampening copyright's incentive for creativity?

The other foundation upon which my argument in this chapter rests is the proposition that the realms of verbal and the visual are so fundamentally different that the rules developed to govern fair use in one realm—language-based rules developed primarily in the context of the printed word—are not necessarily the most productive rules by which to govern fair use in the other. I will argue here that the objective of copyright would better be achieved if the visual arts had a distinct and separate fair use regime of their own. In considering the outlines of such a regime, regard must be given not only to the ways in which the visual arts, taken as a whole, differ from their creative counterparts in other realms and most especially from the domain of the printed word, but also to the ways in which the various genres within the visual arts differ from one another. I consider four such differences below.

Appropriation

In contrast to its relatively infrequent use in literature, appropriation has played and continues to play an important role in many of the most significant visual art movements of the past century. On a recent visit to the Hirshhorn Museum and Sculpture Garden, I was struck by how many of the objects there were on view in which one artist made reference to the work of another.[3] In the museum's then-ongoing special exhibition, "Regarding Beauty," the first six works of art that a visitor encountered—works by artists as diverse as Jannis Kounellis, Michelangelo Pistoletto, Yasumasa Morimura, and Cindy Sherman—all incorporated, in part or in whole, other works of art: casts of antique sculpture, a series of portraits from the Renaissance, and, in one instance, Manet's great painting, *Olympia,* in its entirety.[4]

On another floor, Nam June Paik's *Video Flag*—its seventy thirteen-inch monitors arranged in the familiar format of the American flag—was pulsing out a barrage of microsecond-long snippets culled from television newscasts, documentaries, commercials, and films. Elsewhere were Larry Rivers's witty reprises of Cezanne's *Cardplayers* and David's standing portrait of Napoleon together with Gerhard Richter's sumptuous repainting of Titian's *Annunciation* and Andy Warhol's own idiosyncratic version of the *Mona Lisa.* Outside the museum, in shimmering stainless steel, stood Jeff Koons's six-foot-high *Kiepenkerl,* a work cast directly from a twentieth-century replica of a nineteenth-century bronze sculpture depicting a local tenant farmer that once stood in a square in Munster, Germany.

All this is more than coincidence. As the California-based experimental music and art collective Negativland has said:

> Artists have always perceived the environment around them as both inspiration to act and as raw material to mold and remold. However, this particular century has presented us with a new kind of . . . human environment. We are now all immersed in an ever-growing media environment—an environment as real and just as affecting as the natural one from which it sprang.[5]

In tandem with the emergence of this "ever-growing media environment" has been the emergence, not surprisingly, of a new legal environment, as well. The environment artists were once surrounded by was a freely usable one of landscapes, seascapes, and townscapes, of cottages and cows. This new environment—the one that artists today are seeking to mold and remold—consists of an ever-greater measure of media and other human creations in which intellectual property rights generally subsist. A contemporary artist

who today seeks to portray aspects of everyday life must, in the course of doing so, almost inescapably bump up against somebody else's copyrighted material.

Beyond this change in subject matter, the repertory of techniques available to contemporary artists has also expanded. One important early-twentieth-century development was the emergence of collage, a technique that frequently depends on all use of previously printed materials. A corollary technique—common to virtually all of the photography-based arts—is montage, which, again, may rely heavily on preexisting films, photographs, or video.[6] Artists who would avoid complications by limiting their appropriations to material in the public domain find that the public domain itself has shrunk and continues to shrink. The American artist Cindy Sherman, for example, is not yet fifty years old. If the artists of some future generation should choose to build upon her in the same manner that she herself has chosen to build upon the work of still earlier artists, it could well be another one hundred years or more before her work is safely in the public domain and those of artists of the future are clearly at liberty to do so.

If our society is to continue to be enriched by the vigorous production and distribution of original works of visual art, then visual artists need a license to forage widely—far more widely than conventionally interpreted copyright law might permit—in gathering the raw materials out of which to compose their work. In *Campbell v. Acuff-Rose Music*, the U.S. Supreme Court unanimously ruled that the rap group 2 Live Crew's 1989 version of Roy Orbison's 1964 hit song "Pretty Woman" could be characterized as a parody and that, accordingly—under a judicially crafted exception to the copyright law—it did not constitute an infringement of the original.[7] Although the *2 Live Crew* case might be read as a promising step in the right direction, it should be viewed with great caution. In the end, 2 Live Crew's in-your-face rap music proved so outrageous that the Supreme Court could not escape its parodic element.[8]

That the deadpan and often elusive ironies of postmodernist visual art are also parodies may not be quite so clear. *Rogers v. Koons*, a case in which the court never really *got* what the artist intended, clearly seems a case in point.[9] Even had the *Koons* case been decided otherwise, it would still have left visual artists with a remarkably narrow fair use opening to wiggle through. Parody is by no means the only mode by which one work of art may refer to another in order to achieve a desired artistic effect.

The American literary critic R.P. Blackmur once observed that poetry has the capacity to add to our "stock of available reality."[10] Works of visual art share that same capacity. When the copyright law is used—as it was in *Koons*—not merely to award damages but actually to suppress a work of art, then its effect is to diminish the stock of reality available to all those who might one day have come into contact with that work. Or worse, as Louise Harmon points out in an article that raises questions about the *Koons* decision, the loss to the public in such an instance may go far beyond just that one particular work of art. "Other artworks," she writes, "may never reach maturation; some may never be conceived. There is much to mourn in Jeff Koons' defeat. Little unseen deaths inside you, inside me."[11]

In terms of the public's enrichment, the benefits to be expected from permitting visual artists to work at their imaginative fullest would seem to outweigh by far any resulting disincentives to creativity. Visual artists, above all, need a fair use rule that is both flexible enough and spacious enough to permit them a considerable degree of appropriation. To the extent that they might abuse such a privilege, remedies less drastic than to deprive the public of their work might better be established elsewhere than under the copyright law.

Reproduction

For the visual arts to achieve their maximum vigor, artists require not only the freedom to work at their imaginative fullest, but also the support provided by an "art world" of collectors, curators, critics, and others. Such an art world cannot function properly, however, without the relatively unimpeded circulation within it of images of contemporary art in forms such as slides, transparencies, and printed illustrations. Of the several sensory dominions we inhabit, that of the visual is arguably the most complex—both in the richness of the elements by which it is composed and in the simultaneity with which those elements may be apprehended. At any given moment, an individual's visual field can encompass hundreds or even thousands of these elements, each of a distinctive color, contour, and texture. In terms of color alone, the appearance of any single element may change from moment to moment, depending on the distance from which it is seen, the light by which it is illuminated, and the proximity it has to one or more other elements. If Eskimos truly do have thirty words for snow, that number pales by comparison to the vocabulary that would be required—perhaps a million

words or more—to name all the distinct colors the human eye can pur-portedly differentiate. The computer does even better. A twenty-four-bit monitor has the capacity to produce more than sixteen million different colors.

Regard must be given here to those differences alluded to earlier between the realms of the verbal and the visual. That words can be adequately defined by other words is what makes a dictionary possible. By the same token, most verbal compositions—novels, plays, and even narrative poems—can be effectively summarized or even paraphrased. A reviewer, for example, might write a perfectly intelligible review of a new novel or play without even actually quoting a single line of text.

In general, however, images cannot be defined adequately at all, either by words or by the other images. Likewise, works of visual art—because they partake of the simultaneity and infinite complexity for the visual realm—cannot be adequately summarized or paraphrased. Neither can they be accurately described. Imagine trying to provide an adequate verbal count of Botticelli's *Primavera* or Rembrandt's *Night Watch*.[12] Unlike the situation of the literary critic, it would be virtually impossible for an art reviewer to write an intelligible review of a new painting with-out providing the reader with some pictorial notion of what the painting itself looks like. Not even quotations can help. A work of visual art, unlike a literary work, is incapable of yielding up a quotable extract—some small detail that might give a better sense of the whole. If the works of contem-porary visual art are to be discussed, analyzed, debated, compared, cham-pioned, criticized, or demonized, or otherwise to serve as the center of any serious discourse, then images of those works—images of them in full, not just details—must be available to circulate among those who participate in that discourse and who ultimately provide a support system for the cre-ators of those works.

Just as it might be sound copyright policy to provide contemporary visual artists with greater latitude than other creative practitioners as to what they may incorporate into their own work, it may also be sound pol-icy to limit the ability of such artists to use copyright to impede the free circulation of images of that work within the cultural and commercial mar-ketplaces. It is also important that artists (or, as may be more frequently the case in actual practice, the surviving spouses or other heirs of artists) not be able to use copyright in wholly arbitrary ways as a means to stifle and/or control the views expressed by others with respect to their work. To put too great an emphasis on the exclusionary aspects of copyright is to undermine its fundamental public service objective.

Section 107 of the Copyright Act provides the factors to be considered in any particular case in determining whether certain uses for purposes such as criticism, comment, news reporting, teaching, scholarship, and research might be "fair uses" and consequently non-infringing:

> (1) the purpose and character of the use, including whether such use is of a commercial nature or is for nonprofit educational purposes; (2) the nature of the copyrighted work; (3) the amount and substantiality of the portion used in relation to the copyrighted work as a whole; and (4) the effect of the use upon the potential market for or value of copyrighted work.[13]

Arguably, then, in determining the fairness or unfairness of producing and distributing photographic and/or printed copies of a work of art for educational purposes or for comment and criticism, one should give little or no weight to the third of section 107's four fair use factors—the amount and substantiality of the portion used in relation to the copyrighted work as a whole.[14] Because visual images cannot be summarized, paraphrased, described, or even quoted from, it follows that uses intended for the purposes of education, criticism, and comment must—if they are to engender the meaningful discourse essential to the ongoing well-being of the visual arts—necessarily include some greater "amount and substantiality" of the copyrighted original than might be the case for some other kind of a use or in some other area of creativity. Instead, added weight must go to factor 1—the purpose and character of such a use.[15]

Thus approached, a use that is truly aimed at encouraging a broader and/or more discriminating appreciation of a work of visual art should, absent some fatal problem under factor 4, per se qualify as a fair use. Factor 3, then, might regain some greater weight only when the purpose of the use does not pertain to education, criticism, or comment.

Business Models

The extent to which strong copyright protection is warranted for a work of visual art may depend upon the business model by which it is distributed to the public and the medium in which it was originally created. Works of visual art are distributed to the public through a broader variety of business models than are the products of other creative domains. Consider the spectrum along which these might be arrayed.

At one extreme is the model employed by Thomas Kinkade, the California painter of sentimental landscapes and rain-glittering city scenes whom the *New York Times* described in 1999 as this country's most commercially successful artist.[16] Kinkade reportedly does not sell his original paintings at all. What he sells instead are prints made from the original. Distributed by a captive network of more than two hundred galleries (the "signature" galleries), these prints are offered in a dazzling variety of formats: "Studio Proofs," "Gallery Proofs," "Renaissance Editions," versions touched up with a little paint by the studio assistants, and versions touched up with quite a bit more paint by the artist himself. Prices can range from the $35 for a small, framed gift card to $10,000 or more for a large hand-touched paper print mounted on canvas. Although some editions are limited, the limits can run up to several thousands for each size of each image. For the 1999 fiscal year, Kinkade's publisher—the New York Stock Exchange-listed Media Arts Group, Inc.—reported net revenues of $126 million. Assuming that half the retail sales proceeds were retained by the galleries, that would suggest that the volume of Kinkade sales to the public was then in the vicinity of $250 million annually.

At the Kinkade end of the spectrum, then, what we have is the work of art as the source of a valuable image. At the other end of the spectrum—in total contrast—is the work of art as a precious object. The most familiar example of a work of art of this latter type is the hand-painted canvas that an artist has personally created in a single copy—a copy that he or she hopes to sell for a price that will generally constitute the entire income ever to be realized from its production. As a specific example, consider a work by the contemporary British figurative painter Lucian Freud, who has reportedly sold several of his most recent paintings for prices up to $2 million each.

Let us now suppose, first, that each of these artists still retains copyright to his work and, second, that an art museum—the Philadelphia Museum of Art, for example—without the authorization of either artist, produces and offers for sale in its onsite gift shop a set of full-color postcards of paintings by both these artists, Kinkade and Freud. Assuming that the museum can successfully argue that its distribution and sale of postcards is at bottom educational, thereby meeting the threshold test of section 107, and assuming that the third section of 107 fair use factor is not to be given any weight, how confidently can we proceed to apply the fourth fair use factor—the one that addresses the effect of this use on the market?

In the case of Kinkade, the fourth factor makes an excellent fit. Kinkade's business model is essentially that of a book publisher who, without ever attempting to sell the underlying manuscript itself, simultaneously offers deluxe clothbound and paperbound editions of the text. Under those circumstances, the unauthorized Kinkade postcards might compete directly with the small, framed gift cards that Kinkade's galleries themselves offer for $35. An attempt to defend such a use as fair under section 107 might very well founder over this fourth factor, potentially having an effect on the market for or value of the copyrighted work. To permit the manufacture and distribution of such postcards could only, in Judge Leval's analysis, diminish the artist's incentive for the creativity without providing the public with any substantial benefit beyond that which it already enjoys.

The case of the Freudian postcards is different. Freud's business model—a very traditional model for painters—is to sell his original paintings and to suppress whatever urge he may otherwise feel to traffic in printed copies of these. The fourth factor of section 107 scarcely fits his situation at all. Assuming in the first place that the paintings depicted on the postcards were for sale—they might not be; they might be in the hands of museums that never dispose of the works of art from their collections—it would still be ludicrous to contend that these postcards might adversely affect the artist's market because a potential purchaser of one of his paintings would not likely be tempted to acquire a postcard as a substitute.

Alternatively, although such an unauthorized postcard might be competitive with an *authorized* small-scale printed version of the painting—in which case its manufacture and distribution might be palpably unfair—what if no such authorized small-scale version is to be anticipated? The *2 Live Crew* case discussed earlier suggests that an unauthorized derivative work may constitute a fair use when there is little likelihood of a similar version ever appearing with the copyright owner's authorization.[17] If these postcards and other small-scale printed versions are unauthorized derivative works, then it might be arguable, again in Levallian terms, that the museum's production and distribution of these Freudian postcards is enriching to the public without diminishing the artist's incentive for continued creativity in any substantial way.[18]

Between these Kinkadian and Freudian extremes are a host of other business models, each with its own following among visual artists. In every instance, to what extent and how the section 107 factors can be applied to even so seemingly simple a copy as a postcard will depend on very specific facts and circumstances. And picture postcards, in turn, are

only the tip of the complexity. Offered within every museum shop, beyond those postcards, are a host of other art-derived products, some of such hefty and indisputable educational value as scholarly catalogs, and some of such tangential or even dubious educational value as coffee cups and T-shirts. Notwithstanding the fantasies of those who hope that copyright law might be smoothed out to an easy, uniform application, each of these many uses might still require a separate determination, on the basis of all of its particular facts and circumstances, of whether or not it is a fair one.

Further complicating the application of the fourth fair use factor in section 107 is that the range of materials and techniques employed to create both original works of visual art and copies of those works is also far broader than that to be found in other creative domains. Notwithstanding the variety of forms they may take, literary works are invariably embodied in language. Determining whether, and to what degree, any particular text may be a copy of some other—even when the language of the original has been changed through translation—may be little more, at least conceptually, than a case of comparing apples with apples. Within the visual arts, however, comparison can rapidly escalate to the level of apples and oranges.

Until late in the nineteenth century, the visual fine arts largely consisted of painting in a variety of media and on a variety of surfaces, sculpture (both cast metal and carved wood or stone), printmaking, and drawing. In the years since, however, that list has expanded to include collage; constructed sculpture; sculpture cast or otherwise fabricated in glass, plastic, and ceramic; conceptual art; fabric art; earth art; and, perhaps most important, the whole and still-expanding range of photography-based fine art forms, including still photography, motion pictures, video art, and, now just emerging, Internet art. Also expanded has been the range of materials and techniques by which these original works of art may be copied, sometimes in their original media, sometimes in other media altogether.

Returning to our hypothetical onsite museum store—the one that specializes in unauthorized copies—the least perplexing cases for fair use purposes might be those in which an original work of art was copied so exactly in terms of both its medium and its appearance as to be virtually indistinguishable from the original. That might be the case, for example, with a minimalist sculpture by Donald Judd or Carl Andre, a black-and-white photograph by Robert Mapplethorpe, or a work of digitized video art by Bruce Nauman. In those instances, the fourth fair use factor of section 107 again appears to make an easy fit. Setting aside their lack of

appeal to that perhaps handful of collectors with the means to pay a premium price for a real Judd, Andre, Mapplethorpe, or Nauman original, the production and distribution of these copies might readily be enjoined on competitive grounds, that is, that—to use another Levallian term—they are wholly duplicative rather than in any sense transformative.[19] Here the balance tips toward protection. For the public, no gain. For the artists, some pain.

Not so obvious, however, might be the outcome when the copy is in a different medium: a small black-and-white photograph of a monumental and brilliantly colored kinetic sculpture, for instance, or a videotape of the works hung in a painting exhibition. Consider the case of the sculpture. Even if the assertion that the photograph of the sculpture is fundamentally educational in purpose fails to eliminate the third fair use factor from consideration, it would by no means be clear how the "amount and substantiality" of the portion used in the photograph would weigh in relation to the monumental sculpture as a whole. As for the fourth fair use factor, its application to the museum-made photograph might, in turn, depend on whether the sculptor herself is seeking to exploit a market in such a derivative. At a policy level, this photographic copy—more transformative, less duplicative—might be understood as providing the public with a benefit beyond that furnished by the original without unduly penalizing the copyright owner in the course of doing so. Thus understood, such a use might, on balance, qualify as a fair one.

Again, as in the case of the different business models, generalities may be misleading. The determination of whether any particular unauthorized copy does or does not qualify as a fair use requires a careful examination of all facts and circumstances surrounding both the original and that copy.

Copies and Quotations

Particularly applicable to works of visual art is Susan Sontag's dictum that "art is not only about something; it is something."[20] It is here that the situation of the visual arts diverges most radically from that of the literary ones. With the possible exception of the lyric poetry, literary works are primarily *about* something. This is not so for works of visual arts. They are about, but they also *are*.

The distinction has not always been recognized. In the second of his *Bridgeman Art Library* opinions, for example, Judge Lewis A. Kaplan observed that photographic "transparencies stand in the same relation to

the original works of art as a photocopy stands to a page of typescript." Notwithstanding whatever accuracy that analogy might have had in the particularly narrow context in which he invoked it—the question before Judge Kaplan concerned the degree of originality involved in making photographs of paintings—beyond that context the analogy he offered is wholly misleading. A transparency or other photograph of a work of art most emphatically does *not* bear the same relation to such work as does a photocopy to a page of typescript.[21] The photocopy is literally a reproduction. It includes virtually everything of importance about the typescript except perhaps the watermark, weight, weave, and finish of the paper on which it was originally typed. In terms of the information it conveys about the text, however, it can readily be considered complete.

By contrast, the transparency of the painting is anything but complete. A confection of celluloid and colored dyes, it may capture the painting's informational content—in essence, what it is about—but in no way does it reflect what the painting is: that it is a tangible object with a physical scale and presence, a canvas support or other surface encrusted and/or stained with a distinctively applied coat of paint in a range of pigment-based colors that in the depth of their hues and subtle interplay far exceed anything that a camera might possibly record. That the various paper products commonly generated from such transparencies—catalog and book illustrations, postcards, posters, and various-size prints suitable for framing—are so frequently referred to as "reproductions" seems unfortunately imprecise and misleading. If Judge Kaplan's photocopy is what counts as a reproduction of the typescript from which it was made, then the only thing that ought comparably to count as a reproduction of a six-foot-square, heavily impastoed abstract expressionist canvas would be another six-foot-square canvas—a full-scale and just as heavily impastoed copy of the original. The transparency and its progeny are not reproductions. A more accurate term for them might be *photoreductions*.

Here again, the third section of 107's fair use factors comes into play. The degree to which these photo reductions omit substantial parts of what a painting "is" may arguably have implications for the application of this third factor. In dealing with such a photo reduction, what is the "portion used" that is to be compared in "amount and substantiality" with the copyrighted work as a whole? For example, in the case of one of our Freudian postcards, might we not appropriately think of such a postcard as little more than a thin, pale reflection of the larger and more imposing original? Might we not even analogize such a postcard to the quotation of a brief passage excerpted from a longer text?

Such an interpretation would, of course, provide a further degree of fair use protection to many of the photo reduction–based images in which museum shops traditionally deal. As a possible improvement on Judge Kaplan's photocopier analogy, consider this: A photograph has the same relation to an original painting as the literal translation of a palindrome might have to a palindrome itself. "*Madame, Je suis Adam*" may certainly catch the literal sense of "Madam, I am Adam." With equal certainty, however, what it has lost in translation is everything that made the original a palindrome, and also that which made it interesting in the first place.

Conclusion

Fair use has so integral a connection to the maintenance of a robust visual creativity in our society that we can ill afford even to limit its application, no less to lose it completely. Of the several threats it faces, two seem particularly noteworthy. The first threat is any effort to simplify its application—to formulate a one-size-fits-all rule that might be incorporated into software and provide prompt, clear, and reliable answers as to which proposed uses are and are not fair ones. For better or for worse, fair use in the visual realm—with its extreme reliance on particular facts and circumstances—may never be a neat and tidy affair. The other threat, perhaps equally dangerous, might be the restriction of access to copyrighted materials in cyberspace. That could be particularly damaging in the case of artists.

Fair use is quintessentially a "don't ask" practice. First comes the use, and the discussion of whether or not it was the fair use follows only if the original copyright owner objects. A use authorized in advance is only an authorized use, not a fair one. The authors of a 1995 report for the U.S. Patent and Trademark Office speculated in an ominous footnote that fair use might be an "anachronism with no role to play" in the age of electronic commerce. What they presumably meant was that fair use is a potential stumbling block.[22] Fair use is far too fact-specific to make an easy fit with a seamlessly functioning, self-regulating, and encryption-guarded system in which all the aspects of a copyright negotiation—the scope and terms of a proposed use, the fee to be paid, and perhaps even the payment itself—might be wholly integrated into one smooth process.

Whatever the advantages of such a system in commercial convenience, the potential threat to creative freedom could be considerable. If visual artists are to enrich our society by "molding and remolding" the environment in which we live, they require unfettered access to all the aspects of that environment—including however much thereof may

happen to consist of materials copyrighted by others—so that they can do their work and so that we may have its ultimate benefit. In its way, fair use is the "Robin Hood" provision of copyright. Within limits, it permits the artist—not infrequently envisioned as a sort of rogue—to poach on the content-rich so long as excessive harm is not done and so long as something with a value beyond that of the original is thereby made available to everybody else. Even now as the lush and enchanted forest of cyberspace springs up all about us, room—some place for play, some proper clearing in the woods—still needs to be left for Robin Hood.

Endnotes

[1] Judge Leval was first appointed to the District Court for the Southern District of New York in 1977 and subsequently elevated to the U.S. Court of Appeals for the Second Circuit in 1993. See Pierre N. Leval, *Toward a Fair Use Standard*, 103 Harv. L. Rev. 1105 (1990).

[2] Judge Leval refers to uses that meet this first test (i.e., uses that introduce additional creative elements rather than simply duplicate the original copyrighted material) as "transformative" uses. He has set forth his views on fair use, which have proven highly influential, in an extensive series of opinions, speeches, and law review articles.

[3] The Hirshhorn Museum and Sculpture Garden is the Smithsonian Institution's museum of modern and contemporary art. Located on the National Mall in Washington, D.C., between Seventh and Ninth Streets Southwest, it first opened to the public in October 1974.

[4] *Regarding Beauty: A View of the Twentieth Century* was a group exhibition organized by the Hirshhorn Museum and Sculpture Garden and shown in Washington from October 7, 1999, through January 17, 2000. It was subsequently shown at the Haus der Kunst in Munich from February 11 through April 30, 2000.

[5] Negativland, *Fair Use*, online at *www.negativland.com/fairuse.html* (last visited January 11, 2003).

[6] A montage is "the combining of pictorial elements from different sources in a single composition." *Webster's College Dictionary* (1991): 878.

[7] *Campbell v. Acuff-Rose Music,* 510 U.S. 569 (1994).

[8] Ibid., 578–85. Further details concerning this case, together with samples from the two musical versions, can be found at the copyright Web site, *Finally, Fair Use,* at *www.benedict.com/audio/crew/crew.asp* (last visited January 12, 2003).

[9] *Rogers v. Koons*, 960 F2d 301 (2d Cir. 1992). The work of art at issue was a sculpture titled *String of Puppies* that the well-known New York artist Jeff Koons had based directly (and without authority) on an image by the relatively lesser-known California photographer Art Rogers. Rogers sued for copyright infringement. Koons's defense was that his sculpture was essentially satiric or parodic in nature and, accordingly, was immune from any charge of infringement as a form of fair use. In rejecting that claim and finding for Rogers, the court noted that parody can function as such only when the work subject to parody is already familiar to the audience for the parodic version and found that such was not the case in this situation. Ibid. at 310.

[10] James D. Bloom, *The Stock of Available Reality: R. P. Blackmur and John Berryman* (Lewisburg, PA: University Press, 1984).

[11] See Louise Harmon, *Law, Art, and the Killing Jar*, 79 Iowa L. Rev. 367, 412 (1994).

[12] Sandro Botticelli (1445–1510), *Primavera* (c. 1477–78), Uffizi Gallery, Florence; Rembrandt van Rijn (1606–69), *The Militia Company of Captain Frans Banning Cocq* ("*Night Watch*") (1642), Rijksmuseum, Amsterdam.

[13] 17 U.S.C. S 107 (1994).

[14] S 107(3).

[15] S 107(1).

[16] Tessa DeCarlo, "Landscapes by the Carload: Art or Kitsch?" *New York Times*, November 7, 1999, 51 (describing Kinkade's working methods, marketing strategy, philosophy, and audience).

[17] *Campbell*, 510 U.S. 569.

[18] In other words, it is arguable that such a use might tend to be of benefit to the public without unduly discouraging the artist from further production. See note 1 and accompanying text (discussing the two-pronged test proposed by Judge Leval).

[19] See note 2 (discussing Leval's concept of "transformative").

[20] Susan Sontag, "On Style," in *Against Interpretation 39* (Farrar, Straus & Giroux, 1969).

[21] *Bridgeman Art Library, Ltd. v Corel Corp., 36* F. Supp. 2d 191, 198 (S.D.N.Y. 1999). The principle question in *Bridgeman* was whether meticulously prepared color transparencies of two-dimensional works of art that were themselves in the public domain contained a sufficient degree of originality to entitle such transparencies to independent copyright protection. The court held that they did not.

[22] U.S. Patent and Trademark Office, U.S. Information Infrastructure Task Force, *Intellectual Property and National Information Infrastructure: The Report of the Working Group on Intellectual Property Rights*, 73 n. 227 (U.S. Patent and Trademark Office, 1995).

CHAPTER

Interrogating New Media: A Conversation with Joyce Cutler-Shaw and Margot Lovejoy

Deborah J. Haynes

We live in a poly-centered world, where virtual technologies have created new definitions of self, place, and community. The boundaries between disciplines are breaking down, creating crossovers between art and science, art and natural history, art and the media, and crossovers among the arts themselves. Traditional definitions of the so-called high arts and mass culture are blending. A continuum exists between artists who use new media as a tool for scanning, experimenting with images, and the like, and those who use new technologies as an art medium, exploring the potential and using it in innovative ways. New digital technologies lead to both optimism and deep concern about our future. They offer artists and others unique access to vast amounts of information, as well as opportunities for participation in a much wider world than artists even twenty years ago could imagine. Yet these technologies also may result in ethical problems and paradoxes that we would do well to confront directly.

This text evolved as a series of e-mail dialogues, enriched by in-person real-time conversation. Because the arena of the visual arts, ethics, and technology is so broad, our discussion focuses on the role of the artist, the function of art itself, the meaning and evolution of identity in this era of avatars, cyborgs, androids—the post-human—and particular ethical issues raised by artists' engagement with technology.

Deborah Haynes (DH): I would like to begin by asking you to consider how the artist's cultural role is evolving. How does artists' engagement with new technologies encourage reflection about the ethical issues and dilemmas of our time?

Margot Lovejoy (ML): Our choices about how technologies are used influence the future of human and cultural development. While scientists and technologists believe that advances in technology allow for progress in understanding, unlocking worlds of knowledge, allowing for new forms of empowerment and opportunities for human development, the role of critics and artists has always been to challenge its effects on society. Critics are concerned about the potential manipulation of public consciousness implied by uses of new media and the many cultural losses that come with it. However, for artists there is a paradox: Those who wish to comment on the contemporary are also bound to use the new media tools that are available to them because these are expressive of our time. Today they allow artists' works to be disseminated to larger audiences. In seeking to develop new forms of expression, many artists are deeply influenced by the potential of new media to seek direct public participation as essential to the meaning of their work.

Access to the Web throughout the developed and developing world is growing rapidly. By using the Web as a medium, artists are being challenged to change their language from a "high art" vocabulary to one that may reach extended mass culture audiences. The artists' role in this extreme moment of change has also shifted in many ways. There are many examples of public art that speak to social and environmental problems, such as global warming, the pollution and disappearance of aquifers, the preponderance of cancers. Mel Chin, working with scientist Rufus Cheney, created *Revival Fields* and other ongoing experimental environmental installations, which use plants to absorb toxic metals from the soil to return landscapes devastated by pollution to life (*http://greenmuseum.org/ c/ecovention/sect1.html*). The Critical Art Ensemble examines issues such as reproduction and who owns the Internet (*www.critical-art.net*). New electronic media makes it possible to literally expand artists' ability to reach out within the larger culture. Those using new media seek to find the means to raise ethical questions about significant issues we face in contemporary society.

Joyce Cutler-Shaw (JCS): I tend to consider virtual technologies as disconnected from particular moral values. It seems that groups and individuals use virtual technologies for whatever they consider most important. These technologies can be used by those with right-to-life

perspectives, with anti-evolutionary positions that are faith-based, or by those who want to promote pornography. I see virtual technologies as instruments for value persuasion, either intentionally or not.

I am most involved at present with medical uses of virtual reality. In the medical field, fascination with the imaging potentials of new technologies is a driving force. An example is the newest development in sonography. Images created through sonography surpass the earlier hazy, hard-to-read fetal images that float in a pyramidal structure. The newest images are closer to the precise representational renderings of a Leonardo da Vinci fetal drawing, but in three dimensions.

Such virtual images, however, tend to eliminate the woman's containing body and diminish the significance of the umbilical cord. Instead of identifying the fetus as a connected, dependent pre-person, such images can reinforce a visual argument for the fetus as a person. This, of course, has significant political and personal repercussions for women who advocate for our primary ownership of and responsibility for our own bodies. The imaging technology is not consciously designed to reinforce a political perspective. But its representational forms can reenforce a particular interpretation with moral implications.

I recently experienced a vivid example of how imaging technology shapes our behavior and interpretation of an event when I was privileged to witness a birth. The woman was in near term labor with her fifth child. No family members were present. Her vital signs were continuously monitored and displayed on a screen. The attending nurse moved a computer mouse across her abdomen to watch the movements of the fetus on another screen, but the woman herself was ignored. There are serious questions about the human consequences of technological advances. What was on the screen was medically vital, but it was not the pending newborn. It was an image, immediate but virtual. The woman was present and real.

DH: You seem to suggest that the technology acts to dehumanize us, just as it simultaneously is useful. Could you say more about this paradox?

JCS: Internet and Web-based dialogs such as listserv conversations have great potential. I am part of an eco-dialog with an expanding group of invited participants. It began with about ten or twelve of us and was dynamic and intimate. Although specific issues now generate useful and informative exchanges and a greater diversity of viewpoints, the group has grown to a point where we do not all know each other. This has to some degree diminished the original sense of intimacy, but issues still stimulate immediate and thoughtful responses. The nature of this medium as we are

using it now encourages, and can over-encourage, spontaneous exchange. The speed of its network potential can be valuable. It can also be embarrassing if we respond too quickly without thinking.

Another example of the potential of this medium for reflection is the emergence of alternative political sites, such as Bagnews.com. Bagnews features political cartoons from the left, blogs that offer visual analysis of current news images, and links for response to other left-leaning political sites. With the technological potential for manipulating images, and the increasing sophistication of public persuasion by manipulated images—from clothing to models to politicians, cars, and cereal—our ability to read, analyze, and respond to the virtual is increasingly challenged.

DH: Do you mean that we must be especially sensitive to this capacity for manipulation and even seduction by new media? And how do issues of the digital divide and unequal access to new technologies relate to this issue?

JCS: I believe that these divisions of generation, age, and class are crucial. We are increasingly divided by extremes of wealth and poverty, education, race, and ethnicity. If we believe in social justice, equality of opportunity, and the underlying principles of a democratic society, then such issues are important for artistic investigation. At the most basic and obvious level, unequal access divides us and is basically unfair and unethical in a purportedly democratic, constitutionally based society such as ours.

It is more imperative than ever that we become visually literate. For example, we used to speak of the president or others in public life as persons, and to identify them as particular, existing, physical selves. At some point in the not-too-distant past we started to refer to the image of the person, and to hear news analyses about their presentational qualities, as if of an obscured or concealed person. We are encouraged, if covertly, to present ourselves persona to persona, rather than as a "real" self to another self. I stress this phenomenon because I identify the ethical with the authentic and with social responsibility. Communication technologies have great potential for the groundswell of engagement by the like-minded. We see this with the coalitions of the religious right, the pro-choice and anti-abortion movements, the political activism surrounding Howard Dean's early presidential campaign in 2004, and anti-war demonstrations organized on the Internet.

ML: Artists without access to the Internet are at an increasing disadvantage because it is now the prime method of communication within programs of educational and art institutions. Especially if they are designers, artists will be left "out of the loop," unable to compete in contemporary

commercial spheres, because they don't have access to what is widely available to others: timesaving text-and-image software where new visual languages and forms are being developed. In the 1990s, industrialist George Soros recognized the importance of founding programs for electronic development in Eastern Europe. He understood that cultures lacking artists and scientists trained in the use of new technologies would fall far behind. While there is an effort to provide some access for Third-World countries, it is clear that this digital divide has major ethical dimensions.

The ethical dimensions you speak of are also defined by the extremely open nature of the Internet. In his essays about the relationship between art and technology, Walter Benjamin warned that new mediums could be used for fascistic purposes just as much as they can be used for progressive thinking and analysis.[1] We are clearly seeing today how TV can distort the news. However, we know that challenges and responses to these forms of misinformation can be broadcast immediately online by anyone with an Internet connection. We live in a time when these battles are multiplying and occur daily because of the technological potential. Yet, this potential allows for the short-circuiting of institutional control. Television, museums, and galleries can no longer limit access to exhibiting or transmitting one's work, one's ideas, and one's political views. It remains to be seen how the general public will be able to confront the ethical issues that will continue to arise, as there are many dangers, including hacking and identity theft, which must be faced.

DH: But this freedom you are talking about can also become addictive. The addiction to virtual technologies seduces and controls artists, as well as the general public, through creating pleasurable and entertaining experiences. Social issues can be manipulated to create a culture of fear, which is immensely dangerous. Life in what I call "actual phenomenological reality" may seem more difficult and conflicted than life on the screen. What do you see as the broader ramifications for our lives?

ML: Technology is not going away. We must learn to live with its prevalent dangers in increasingly urgent and complex ways. Although it seems slow, the public is becoming more and more educated about the dangers of political rhetoric and misinformation, particularly in Europe where the media is not so controlled by corporations.

Regarding artists, significant work by the best artists encourages exploration of one's values and encourages public responses of all kinds, including a critique of the media itself. Net art covers a wide range of complex projects that require viewer participation and collaboration.

Digital media provide easy access to research and knowledge, faster and wider dissemination for artists' work, as well as the ability to communicate easily in their daily lives. These media encourage creation of community, including the growth of artists' connections to one another through home page links.

JCS: Yet, it also becomes easy to enter the virtual realm and to respond as if to the actual. I believe there is a connection to the recent phenomenon of scale escalation in imaging. Newspaper and magazine ads for rings and bracelets and watches show them in the wrist and hand size of giants. Technological models of the human body are escalated in scale, as the walk-through heart in the Museum of Science and Industry in Chicago. This is so different from my experience of holding a human heart in my hand or witnessing a heart transplant. When the surgeon held the newly severed heart in his hand, so disciplined was its human function of continuously pumping blood that, even severed, for some moments it continued to beat. The sight took my breath away.

Or, there is an anatomical model in the Science Museum in Los Angeles, about fifty feet long with visible, light-flashing, internally-motorized moving parts. One hundred twenty people can surround her. I am about the size of a big tumor in her body. How can one relate such a sophisticated and entertaining display to one's physical self? In many cases the ramifications are a distancing from phenomenological reality. In the medical field we are increasingly identified as graphs and scans and high-key colored plasticized parts. The human person is losing out as a primary determinant of scale.

DH: You are talking about the dehumanization of the human, or transformation of the human. Indeed, the meaning and evolution of individual identity is changing in this era of avatars, cyborgs, robots, and the "post-human." We can manipulate ourselves—as images, persons, a species. What are the ethical implications of artists undertaking bionic changes, becoming cyborgs, or exploring robotics?

JCS: This is an area of particular interest to me, given my role as artist-in-residence at the School of Medicine at UC-SD. The underlying first question for me is, what does it mean to be human? What are the parameters of the "normal"? New technologies, for facial and body reconstruction, for addressing physical deformity as well as responding to personal vanity, make possible a physical transformation that is always calibrated against an imagined ideal and/or a projection of physical advance. Consider Michael Jackson's physical transformation. Dissatisfied with his natural self,

at a certain midpoint he transformed into an attractive, light-skinned African American. Pushing his visage to an extreme, he is at the more radical edge of what is possible in individual body re-imaging. Having visited many medical and anatomical museums, including those of teratology (i.e., of the aberrations of the human form), I believe there is a certain range of variation in characteristics of Homo sapiens that are considered normal. These shift from culture group to culture group, depending on the particular accepted range of physical and cultural characteristics or features. Then there is the projected group "ideal" or range of "ideals" that make many hearts beat faster. In the United States these ideals are inventions of advertising, fashion media, and notions of Hollywood glamour. For me the ethical implications are contingent upon understanding what we consider to be within the range of the normal. This is a large arena for artists' exploration.

ML: In her 1995 book, *Life on the Screen: Identity in the Age of the Internet*, Sherry Turkle speaks about how the Internet allows for free and hidden experimentation with different identities or avatars, and how necessary this can be especially to young people in a new age living between the real and the virtual.[2] Other sociologists comment that new generations, always driven to develop their own identities within their particular generational time frame, must experiment in ways that sometimes seem too expansive and extreme. Nevertheless, this is understandable, given the rapid change in technological standards that we are experiencing with their inevitable social and psychological effects.

On one level, science-fiction films such as *Blade Runner* (1982) with its android population or *Gattaca* (1997), which deals with genetic tinkering of offspring DNA, allow for investigation of what it means to be human or for experimentation about the form of future societies. The same is true of other films, such as *2001* (1968), *A.I.* (2001), and *Minority Report* (2002).

On another level, the dramatic works that artists such as Eduardo Kac (*www.eduardokac.com*), Stelarc (*www.stelarc.va.com.au*), and Orlan (*www.orlan. net*) are creating offer powerful and thoughtful critiques of the ethical dangers we face. Artists, fascinated with the growth of artificial intelligence and robotics, are creating not only new kinds of art experiences, but they are also using these technologies to engender serious commentaries about their misuse.

To this list, I would add the following Web artists. Nomeda and Gediminas Urbonas developed a project in 2002 titled "Transaction," which examines media politics (*www.transaction.lt*). Wayne Dunkley maintains a site titled "The Degradation and Removal of the/a Black Male"

(*www.sharemyworld.net*). And Josh On and the Future Farmers developed a project dealing with technology and social issues (*www.theyrule.net*). All of these artists, and certainly many others, urge us to reconsider definitions of and cultural values around identity and power relations.

DH: Given these challenges to traditionally defined identity, what then is the nature of the artist's ethical responsibility in a networked culture? Or, phrased another way, for what is the artist responsible and to what community?

ML: On the Web, artists are responsible not only to themselves and their community, but to a global audience outside of the usual cultural communities, to a popular mass circulation of images and projects without regard to traditional "high culture" language and control. This is territory where they may turn spectators into collaborators. In my own Web works, this principle has grown in importance. For example, my TURNS project (*www.myturningpoint.com*) asks you to participate by submitting a narrative about yourself in response to the question it asks: "What event changed your life?" The work can't exist without the authentic participation of others. To paraphrase Stephen Willats in *Art and Social Function*, our emerging collaborative culture should be founded on networks that encourage exchange and mutuality, fluidity and transience. As he wrote, "The realization that all 'art' is dependent on society—dependent on relationships between people and not the sole product of any one person—is becoming increasingly important in the shaping of future culture."[3]

JCS: I think this is a hard question to answer, especially to the degree that an artist works out of individual intent. Ethical responsibility involves social responsibility, which links one's local context to a larger global one. Many of our cities and even local communities are composed of diverse cultural groups. But in some cases we are disconnected geographically and socially from those who are different from ourselves. If one believes, as I do, that primary artistic expression involves one's authentic voice whatever the medium, and that this is the voice of one's truth, then one way or another it is a human and communicable expression that can be shared and widely understood. This ideal, of course, is far from much of what is being expressed. There is a pervasive attitude that new media is exploitable—a medium of disguise, subterfuge, and cooption. We see the visual dazzle of surface rather than substance. Temporality is crucial. If you time images on the TV screen, there is rarely one without movement for more than a few seconds, if that. Speed and swift movement characterize our commercially

mediated world, and TV is the source of most people's news. Screens now feature two, three, and four centers of interest with continuously moving text lines. However, these characteristics can be serious impediments to contemplation, critical thinking, and interpersonal connection.

DH: What you have said suggests that we all must consider how virtual technologies create consumers who buy first and think later. In addition, we have barely touched on some of the other challenges of a culture that is so wedded to the ubiquitous screen, such as physiological changes, effects on our mental functioning, and on the sense of touch. Some of us wonder if problems such as short attention spans in young people are related to the speed of television images, computer games, and the ease of cut-and-paste. Clearly, we have to learn and to teach others to see. Though we live in a context where visual images are ubiquitous, we are not visually literate or critical enough.

ML: Yes, we do have huge challenges to face in a society that is so invaded by consciousness transforming media. So far, most attempts to bring awareness of these problems into focus for the general public have been restricted to university courses in sociology, psychology, and film studies, where students learn to critique and analyze media. In England, education about TV and film analysis started in high school years ago. We need to encourage dialogue and debate about significant current issues in early childhood education, along with training in the ability to analyze and problem solve. A few children's games on the Internet, such as those by feminist Mary Flanagan (*www.maryflanagan.com*), are focused on building this kind of ability.

What we face is a question of political resolve and financing that will be difficult to achieve, given the present political climate. The potential to educate the public in these issues lies paradoxically with use of the media itself. However, this requires either wresting control of the media from the corporate sphere or showing how companies can benefit from supporting vital forms of public education. Ethical values that we claim to have today should not just become captive to the political rhetoric we are currently experiencing.

JCS: Visual literacy takes time, training, perceptual acuity, and a critical perspective. It is a necessary educational challenge, if we truly value depth in our understanding of the world around us, our place in it, as well as an ability to respond critically to our visually saturated, commercially co-opted environment. I find increasing evidence of visual intelligence and ethical perspectives in artists' new media work that is refreshing and hopeful.

DH: It is, of course, difficult to summarize such complex ideas as we have discussed here. Definitions of art, interpretations of the cultural function of the artist, and even the meaning of the self are changing rapidly under the influence of new technologies. We have tried to elucidate some of the ethical issues that arise when such fundamental categories are transformed. New technologies have the potential to be consciousness transforming, but they can also function to diminish the critical and analytical abilities of the viewer and user. Ultimately, the direction of the future will depend upon our collective and collaborative efforts to address the ethical dilemmas posed by technology in its many guises.

Endnotes

[1] See especially Walter Benjamin, "Author as Producer," in *Reflections: Essays, Aphorisms, Autobiographical Writing*, trans. Edmund Jephcott, ed. Peter Demetz (New York: Schocken, 1986), 220–238. A comprehensive resource list about these issues is also available in Margot Lovejoy, *Digital Currents: Art in the Electronic Age* (New York and London: Routledge, 2004).

[2] In Sherry Turkle, *Life on the Screen: Identity in the Age of the Internet* (New York: Simon and Schuster, 1995), 10.

[3] Stephen Willats, *Art and Social Function* (London: Ellipsis, 2000), 7.

CHAPTER

Art and Censorship

Richard Serra

The United States government destroyed *Tilted Arc* on March 15, 1989.[1] Exercising proprietary rights, authorities of the General Services Administration (GSA) ordered the destruction of the public sculpture that their own agency had commissioned ten years earlier.[2] The government's position, which was affirmed by the courts, was that "as a threshold matter, Serra sold his 'speech' to the Government. . . . As such, his 'speech' became Government property in 1981, when he received full payment for his work. . . . An owner's '[p]roperty rights in a physical thing [allow him] to possess, use and dispose of it.'"[3] This is an incredible statement by the government. If nothing else, it affirms the government's commitment to private property over the interests of art or free expression. It means that if the government owns the book, it can burn it; if the government has bought your speech, it can mutilate, modify, censor, or even destroy it. The right to property supersedes all other rights: the right to freedom of speech, the right to freedom of expression, the right to protection of one's creative work.

In the United States, property rights are afforded protection, but moral rights are not. Up until 1989, the United States adamantly refused to join the Berne Copyright Convention, the first multilateral copyright treaty, now ratified by seventy-eight countries. The American government refused to comply because the Berne Convention grants moral rights to authors. This international policy was—and is—incompatible with United States copyright law, which recognizes only economic rights. Although ten states have enacted some form of moral rights legislation, federal copyright laws tend to prevail, and those are still wholly economic in their motivation. Indeed, the recent pressure for the United States to agree, at least in part, to the terms of the Berne Convention came only as

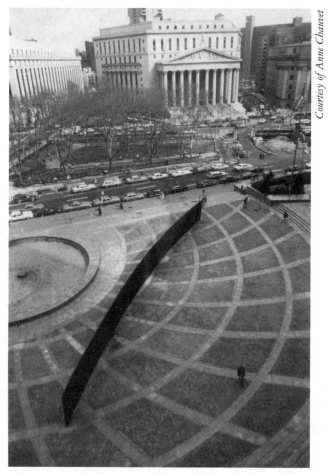

Courtesy of Anne Chauvet

Tilted Arc, 1981, Richard Serra. Weatherproof steel, 12 feet × 120 feet × 2 ½ feet. Collection: General Services Administration. Installed at Federal Plaza, New York City; destroyed by U.S. government on March 15, 1989.

a result of a dramatic increase in the international piracy of American records and films.

In September 1986, Senator Edward M. Kennedy of Massachusetts first introduced a bill called the Visual Artists Rights Act. This bill attempts to amend federal copyright laws to incorporate some aspects of international moral rights protection. The Kennedy bill would prohibit the intentional distortion, mutilation, or destruction of works of art after they have been sold. Moreover, the act would empower artists to claim authorship, to receive

royalties on subsequent sales, and to disclaim their authorship if the work were distorted.[4] This legislation would have prevented Clement Greenberg and the other executors of David Smith's estate from authorizing the stripping of paint from several of Smith's later sculptures so that they would resemble his earlier—and more marketable—unpainted sculptures. Such moral rights legislation would have prevented a Japanese bank in New York from removing and destroying a sculpture by Isamu Noguchi simply because the bank president did not like it. And such legislation would have prevented the United States government from destroying *Tilted Arc*.

If Senator Kennedy's bill were enacted, it would be a legal acknowledgement that art can be something other than a mere commercial product. The bill makes clear that the basic economic protection now offered by United States copyright law is insufficient. The bill recognizes that moral rights are independent from the work as property and these rights supersede—or at least coincide with—any pecuniary interest in the work. Moreover, the bill acknowledges that granting protection to moral rights serves society's interests in maintaining the integrity of its artworks and in promoting accurate information about authorship and art.

On March 1, 1989, the Berne Convention Implementation Act became U.S. law.[5] On March 13, 1989, on learning that the government had started to dismantle *Tilted Arc*, I went before the United States District Court in New York City, seeking a stay for the destruction so that my lawyers would have time to study the applicability of the Berne Convention to my case. I expected—as would be the case in other countries that were signatories to the treaty—to be protected by the moral rights clause, which gives an artist the right to object to "any distortion, mutilation or other modification" that is "prejudicial to his honor and reputation," even after his work is sold. I learned, however, that in my case—and others like it—the treaty ratified by Congress is a virtually meaningless piece of paper in that it excludes the key moral rights clause. Those responsible for the censorship of the treaty are the powerful lobbies of magazine, newspaper, and book publishers. Fearful of losing economic control over authors and faced with the probability of numerous copyright suits, these lobbies pressured Congress into omitting the part of the Berne Convention Implementation Act that provided moral rights protection.[6] Thus, publishers can continue to crop photographs, magazine and book publishers can continue to mutilate manuscripts, black-and-white films can continue to be colorized, and the federal government can destroy art.

A key issue in my case, as in all First Amendment cases, was the right of the defendant to curtail free speech based on dislike of the content.[7] Here

the court stated that the aesthetic dislike is sufficient reason to destroy a work of art: "To the extent that GSA's decision may have been motivated by the sculpture's lack of aesthetic appeal, the decision was entirely permissible."[8] Hilton Kramer has asked, "Should public standards of decency and civility be observed in determining which works of art or art events are to be selected for the Government's support?"[9] He answers his rhetorical question affirmatively and insinuates that *Tilted Arc* was uncivil and comes to the conclusion that it was rightfully destroyed:

> What proved to be so bitterly offensive to the community that *Tilted Arc* was commissioned to serve was its total lack of amenity—indeed, its stated goal of provoking the most negative and disruptive response to the site the sculpture dominated with an arrogant disregard for the mental well-being and physical convenience of the people who were obliged to come into contact with the work in the course of their daily employment.

Kramer goes on to say that it was my wish to "deconstruct and otherwise render uninhabitable the public site the sculpture was designed to occupy" ("A," p. 7).

All of Kramer's statements concerning my intentions and the effect of the sculpture are fabricated so that he can place blame on me for having violated an equally fabricated standard of civility. *Tilted Arc* was not destroyed because the sculpture was uncivil but because the government wanted to set a precedent in which it could demonstrate its right to censor and destroy speech. What Kramer conveniently sweeps under the rug is the important fact that *Tilted Arc* was a First Amendment case and that the government, by destroying *Tilted Arc*, violated my right to free speech.

In the same *New York Times* article, Kramer applauds the Corcoran Gallery for having cancelled an exhibition of Mapplethorpe photographs. The photos Kramer objects to render men, in Kramer's words, "as nothing but sexual—which is to say, homosexual—objects." Images of this sort, according to Kramer, "cannot be regarded as anything but a violation of public decency." For those reasons, Kramer concludes, the National Endowment for the Arts (NEA) should not have contributed its funds to support its public exhibition ("A," p. 7). Once again he accused the artist of having violated a public standard, which in Mapplethorpe's case is the standard of decency. The penalty for this violation is the exclusion of his

speech from public viewing and the withdrawal of public funds to make the work available to the public.

Kramer's article is part of a larger radical conservative agenda. The initiative Kramer took in the *New York Times* was called for by Patrick Buchanan in May and June of 1989 in the *New York Post* and the *Washington Times* where he announced "a cultural revolution in the 90s as sweeping as the political revolution of the 80s." It's worth quoting Buchanan at length:

> Culture—music, literature, art—is the visible expression of what is within a nation's soul, its deepest values, its cherished beliefs. America's soul simply cannot be so far gone in corruption as the trash and junk filling so many museums and defacing so many buildings would suggest. As with our rivers and lakes, we need to clean up our culture; for it is a well from which we all must drink. Just as poisoned land will yield up poisonous fruit, so a polluted culture, left to fester and stink can destroy a nation's soul. . . . We should not subsidize decadence.[10]

Let me quote another leader of a cultural revolution:

> It is not only the task of art and artists to communicate, more than that it is their task to form and create, to eradicate the sick and to pave the way for the healthy. Art should not only be good art, art must reflect our national soul. In the end, art can only be good if it means something to the people for which it is made.[11]

What Buchanan called for and what Kramer helped to justify, Senator Jesse Helms brought in front of the Senate. He asked the Senate to accept an amendment that would bar federal arts funds from being used "to promote, disseminate, or produce indecent or obscene materials, including but not limited to depictions of sadomasochism, homo-eroticism, the exploitation of children, or individuals engaged in sex acts."[12] The Helms amendment was replaced by the supposedly more moderate Yates amendment.[13] Nonetheless, Helms's fundamental diatribe was successful in that the Senate passed an amendment that gives the government the right to judge the content of art.

The Yates amendment, which was approved by the Senate, calls for denying federal money for art deemed obscene. It is based on a definition of obscenity as given by a 1973 Supreme Court decision in *Miller v. California*.[14] In *Miller*, the Supreme Court prescribed three tests for obscenity: a work must appeal to prurient interests, contain patently

offensive portrayals of specific sexual conduct, and lack serious literary, artistic, political, or scientific value.[15] The decision about whether something is obscene is to be made by a local jury, applying community standards. Does this mean that the material in question can be tolerated by one community and another community will criminalize its author? What about Salman Rushdie?

Conservatives and Democrats agree that taxpayers' money should not be spent on art that carries an obscene content; Kramer wants publicly funded art to conform to the standards of decency and civility; Helms does not want the NEA to fund indecency and obscenity; and the Democratic majority in the Senate supported an amendment that will enable the government to deny federal money for art deemed obscene. The central premise in all these statements, proposals, and amendments is that obscenity can be defined—that there is actually a standard of decency that excludes obscenity. The assumption of a universal standard is presumptuous. There aren't any homogeneous standards in a heterogeneous society. There is no univocal voice. Whose standards are we talking about? Who dictates these standards?

It seems a rather extreme measure to impose an arbitrary standard of obscenity on the whole of society. Gays, as one group of this heterogeneous society, for example, have the right to recognize themselves in any art form or manner they choose. Gays cannot be denied their images of sexuality, and they cannot be denied public funds to support the public presentation of these images. Gays are a part of this public. Why should heterosexuals impose their standard of "decency" or "obscenity" on homosexuals? The history of art is filled with images of the debasement, torture, and rape of women. Is that part of the accepted heterosexual definition of decency? It is obvious that the initiative against obscenity in the arts is not directed against heterosexual indecencies but that its sub-context is homophobia. Jesse Helms, in particular, makes no effort to hide the fact that part of his political program is based on homophobia. In an earlier amendment Helms wanted to prohibit federal funds from being used for AIDS education; he argued that the government would thereby encourage or condone homosexual acts. He also stated publicly that no matter what issue comes up, if you attack homosexuals, you can't lose.

The position I am advocating is the same as Floyd Abrams, a noted constitutional lawyer, who stated:

> While Congress is legally entitled to withdraw endowment funding, the First Amendment doesn't allow Congress to pick and choose who gets money and who doesn't. You can't punish people

who don't adhere to Congress's version of art they like. Even if they want to protect the public, the basic legal reality is that funding may not exclude constitutionally protected speech.[16]

The argument ought not to be about assumed standards. We should not get involved in line drawing and definitions of decency and obscenity. There is no reason to participate in this fundamentalist discourse. Taxpayers' dollars ought to support all forms of expression as guaranteed by the First Amendment. Gays pay taxes. Taxation must include the right to representation. Ideas, images, descriptions of realities that are part of everyday language cannot be forbidden from entering into the discourse of art. All decisions regarding speech ought to be made in a nondiscriminatory manner. Government agencies allocating funds for art cannot favor one form of speech over another. Preferences or opinions, even if shared by a majority, are nonrelevant judgments and improper grounds for exclusion. To repeat: If government only allocates dollars for certain forms of art and not others, the government abolishes the First Amendment. If anything, the First Amendment protects the diversity of speech. Government cannot exclude because to exclude is to censor.

Kramer, as well as Helms and Yates, argued that the introduction of obscenity clauses into the NEA funding guidelines was not an attempt at censorship because there was no effort to prevent publication or distribution of obscene material. Instead, they argued that they were merely barring the use of taxpayers' money for such projects. Taxpayers' money ought to be spent to protect the standards of the Constitution and not to protect bogus standards of decency and civility.

Previously the NEA panels were required only to recognize "artistic and cultural significance" and "professional excellence." Now the head of the NEA must add to these intentionally and exclusively art-related criteria the politically charged criterion of obscenity. I question that obscenity is a matter for the judicial system, but I am certain that it is not for the NEA and politicians to determine. The NEA is no longer politically independent, and there is no doubt that its independence will erode even further once the Senate's commission begins to review the NEA's grant-making procedure and determine whether there should be standards in addition to the new obscenity standard that has been forced on the NEA. The twelve-member commission reviewing the NEA guidelines is a purely political commission. It consists of four members appointed by the Speaker of the House, four by the president pro tempore of the Senate, and four by the president. For the time being, John E. Frohnmayer,

chairman of the NEA, has taken it upon himself to reverse peer panel recommendations on grants to artists who might use the grant money to produce potentially obscene material. Those artists considered "harmless" and worthy of NEA funding are asked to sign away their right to free speech by signing a guarantee that they will not use the NEA monies to produce obscenities.

It is obvious that the Mapplethorpe case set in motion for the NEA what the *Tilted Arc* case set in motion for the GSA. The *Tilted Arc* case was used to fundamentally change the guidelines of the GSA's Art-in-Architecture Program. The peer panel selection was weakened because every panel will now select under community pressures or will try to avoid community protest. The contract between the artist and the GSA was changed. The new guidelines now overtly favor the government, which can cancel the contract at any stage of the planning process, and it excludes the realization of site-specific projects in that it explicitly states that artworks commissioned by the GSA can be removed from their federal sites at any time. Every artist who agrees to have a work commissioned by the GSA or funded by the NEA will thereby become a collaborator and active agent of governmental censorship.

This article is based on a speech given in Des Moines, Iowa on October 25, 1989.

Endnotes

[1] On March 15, 1989, *Tilted Arc* was dismantled and removed from its site at the Federal Plaza in New York City. *Tilted Arc* was specifically created for this site, and its removal from this location resulted in the work's destruction.

> Site-specific works are determined by the topography of the site, whether it is urban, landscape or an architectural enclosure. My works become part of and are built into the structure of the site, and often restructure, both conceptually and perceptually, the organization of the site. . . . The historical concept of placing sculpture on a pedestal was to establish a separation between the sculpture and the viewer. I am interested in a behavioral space in which the viewer interacts with the sculpture in its context. . . . Space becomes the sum of successive perceptions of the place. The viewer becomes the subject.

Richard Serra, "Selected Statements Arguing in Support of *Tilted Arc*," in *Richard Serra's Tilted Arc*, ed., Clara Weyergraf-Serra and Martha Buskirk, (Eindhoven: Van Abbemuseum, 1988), 64–65.

[2] For the court's affirmation of the government's proprietary rights, see *Serra v. United States General Services Administration* 847 F.2d 1045, 1051 (2d Cir. 1988); reported in *Richard Serra's Tilted Arc*, 259–68. The court's position turns in part on an understanding of the contract for *Tilted Arc's* commission. For additional information on this contract, see Serra, "Selected Statements Arguing in Support of *Tilted Arc*," 66. The inadequacies of the GSA's contract are detailed in Barbara Hoffman's complete legal analysis of the case, *"Tilted Arc:* The Legal Angle," in *Public Art, Public Controversy: The Tilted Arc on Trial*, ed., Sherrill Jordan, et. al., (New York: Americans for the Arts, 1987), 35–37. For a history of the GSA's Art-in-Architecture Program, see Judith H. Balfe and Margaret J. Wyszomirski, "The Commissioning of a Work of Public Sculpture," in *Public Art, Public Controversy*, 18–27. See also "General Services Administration Factsheet Concerning the Art-in-Architecture Program for Federal Programs," in *Richard Serra's Tilted Arc*, 21–22.

[3] "Brief Filed by the Defendants, United States Court of Appeals for the Second Circuit, January 26, 1988 (edited)," in *Richard Serra's Tilted Arc*, 253.

[4] Although this section appeared in the original version of Kennedy's bill, the current version provides for a study of resale royalties.

[5] In October 1988, both the United States Senate and the House of Representatives passed the Berne Convention Implementation Act of 1988 (P. L. 100–568), which made the necessary changes in the United States copyright law (17 USC §§ J 01–914 [1978]) for adherence to the Berne Convention. On October 20, 1988, the Berne Convention was ratified, and on October 31, 1988 President Reagan signed into law the copyright amendments, making the United States the seventy-eighth member of the Convention.

[6] The moral rights provision of the Berne Convention states: Article 6bis.

1) Independently of the author's economic rights, and even after the transfer of the said rights, the author shall have the right to claim authorship of the work and to object to any distortion, mutilation or other modification of, or other derogatory action in relation to, the said work, which would be prejudicial to his honor or reputation.

2) The rights granted to the author in accordance with the preceding paragraph shall, after his death, be maintained, at least until the expiry of the economic rights.

3) The means of redress for safeguarding the rights granted by this Article shall be governed by the legislation of the country where protection is claimed.

This section (P. L. 100–568, §3) of the Berne Convention was ratified by Congress in this fashion:

> The provisions of the Berne Convention, the adherence of the United States thereto, and satisfaction of the United States obligations thereunder, do not expand or reduce any right of an author of a work, whether claimed under Federal, State, or the common law— (1) to claim authorship of the work; or (2) to object to any distortion, mutilation, or other modification of, or other derogatory action in relation to, the work, that would prejudice the author's honor or reputation.

[7] See "Appeal Filed by Richard Serra in the United States Court of Appeals for the Second Circuit, December 15, 1987," in *Richard Serra's Tilted Arc*, 225–50. For example, counsel drew an analogy to *Board of Education, Island Trees Union Free School District v. Pico* (1982), which held that library books could not be removed simply because the board disliked the content of the texts (ibid., 243–45).

[8] *Serra v. United States General Services Administration*, in *Richard Serra's Tilted Arc*, 266.

[9] Hilton Kramer, "Is Art Above the Laws of Decency?" *New York Times*, sec. 2, July 2, 1989.

[10] Patrick Buchanan, "Losing the War for America's Culture?" *Washington Times*, sec. D, May 22, 1989.

[11] Joseph Goebbels to Wilhelm Furtwangler, II April 1933, in Hildegard Qrenner. *Die Kunstpolitik des Nationalsozialismus* (Hamburg, 1963), 178–79; my translation.

[12] 135 Cong. Rec, 101st Cong., 1st sess., September 29, 1989, S12210.

[13] Ibid., S1221I.

[14] *Miller v. California*, 413 U.S. 15 (1973).

[15] Ibid.

[16] Grace Glueck, "A Congressman Confronts a Hostile Art World," *New York Times*, September 16, 1989.

CHAPTER

The Trauma of 9/11 and Its Impact on Artists

Eric Fischl

In this country, all the images of the dead and dying, of those who jumped or fell, have been suppressed. Because there were no bodies to be seen, we have been left with an unrealistic sense of what happened on September 11. The trauma of the attack has produced some hysterical reactions. When my sculpture, *Tumbling Woman*, was shown at Rockefeller Center, bomb threats were received. "Too soon to be seen" is what I was told as the piece was being draped and taken away. Perhaps. As you can imagine, this experience caused me to reflect on what

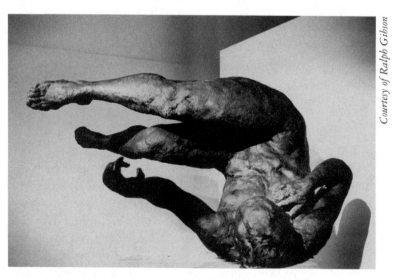

Tumbling Woman, 2001, Eric Fischl. Bronze, edition of five.

constitutes an appropriate expression for tragedy. If we cannot face what happened, how can we move past it?

At any moment the decision will be made as to who is chosen to design the memorial at the World Trade Center site. Based on what I have seen, these proposals fall well short of inspiration. I don't know if those who made the winning proposals for the 9/11 Memorial were overwhelmed by the success of the Vietnam Memorial or if their modernist sensibility could not tolerate the messiness of this human tragedy. What is clear is that something has inhibited them from designing a truly moving and expressive memorial.

My experience of that tragedy is not reflected enough in their proposals. They do not tell me what happened to people I knew and loved. They do not speak of the vulnerability or the cruelty, of the desperation and the horror, of the valor and the sacrifice, of the destruction and above all, the injustice. They do not acknowledge in their designs what happened on that site on that day. In fact, these sanitized designs could be sited almost anywhere.

Perhaps because they did not see the human destruction it inhibited their ability to imagine what the experience was like for those who died. Perhaps that is why they put too much emphasis on the towers themselves. By highlighting them, literally trying to preserve their footprints, and by placing the intimate and sacred memorial spaces underground, covered with a false sense of tranquility, they are ironically doing what the bombing did to the people inside; making them disappear. Not only is the coffin being put in the ground but also the tombstone is being buried along with it. This is wrong. We need to make a vivid, moving, and graspable representation of what happened, and we should demand that the art and architecture express this.

Frankly, I am not sure we are ready to finalize the design of the memorial. Not enough time has passed to absorb the experience and come to terms with our loss. We need to learn how to tell the story. September 11 is more than a gravesite; it is a narrative. It is The Narrative for us now. Imagine if the site of the battle of Gettysburg were a sound and light show, or if the Alamo were a park with reflecting ponds? How ludicrous that would be. Narratives are essential to remembering. They keep the meaning and significance of great historical events vital. They inspire us in their retelling. They reinforce our resolve. I am convinced that the people who died on September 11 would want history to record the horror of what happened to them. They wouldn't want us to suffer with them, but they

would want us to know how terrible it was and how hard they struggled to stay alive, to stay with us.

The site is big enough to contain several different kinds of memorials. Attention must be paid to the things that really symbolize the destruction. Reconstruct the twisted and charred steel facade of One World Trade, return the battered bronze globe that now sits in Battery Park to the center of the plaza where it once stood, and keep the slurry wall exposed. Allow space for monuments that capture the drama, images that haunt us, representations that inspire us, and objects that carry the scars of their survival. In other words, make a real memorial to the events of 9/11.

CHAPTER

Art Enters the Biotechnology Debate: Questions of Ethics

Ellen K. Levy

Recent professional art practices now encompass "evolutionary" design, artificial life art, and "bioart" practices in which artists simulate life and model living systems. Some of these practices involve the production of new life forms in laboratory settings. We are bound to see art differently in the midst of these changes. This essay focuses on new ethical concerns raised by artists using "wet lab" techniques associated with biotechnology.

Before the completion of the first draft of the Human Genome Project in 2000, the public had relatively few opportunities to see or read about art involved with the techniques of genetic engineering. Much of this art was initially exhibited and discussed in alternative spaces and locations then considered to be somewhat removed from the mainstream art world. For example, *Ars Electronica*, held each year as a recurring event in Linz, Austria, since 1979, included relevant work by David Kremers in 1993[1] and Eduardo Kac in 1999.[2] *Art Journal* (1996)[3] introduced Kremers and Joe Davis to its largely academic readership and along with a later issue (2000)[4] provided a forum for discussions about biotechnology and art.[5] Both the catalog for Inigo Manglano-Ovalle's show at the Southeastern Center for Contemporary Art and George Gessert's display at the Exploratorium called attention to plant breeding as a low-tech predecessor of genetic engineering.[6] Regular readers of *Leonardo: Journal of the International Society for the Arts, Sciences and Technology* would also have been informed of artistic developments involving "living" art.[7] The formal announcement in 2000 changed the relative obscurity of the Human

199

Genome Project and publicized many forthcoming issues of biotechnology to the general public. Since then numerous pertinent exhibitions have been held, some of which highlight "transgenic" art made by genetic engineering (also known as "gene splicing").[8] It is in no way predictable what forms this art will assume in the future.

As increasing numbers of artists use or purport to use recombinant DNA (rDNA) technology to make art, questions of significant ethical dimensions arise from these novel artistic practices. Should artists be allowed to create new life forms? Should artists necessarily disclose whether their methods are real or simulated? What are the possible consequences of artists letting new life forms into the environment? Should there be constraints on the artistic use of such technology and, if so, under what circumstances? Should all artists be afforded access to the necessary equipment? What is the proper role of the university with regard to monitoring wet labs? These developments also have implications for the role of museums and galleries that exhibit transgenic art. They will increasingly need to cope with problems of liability, the shipping of biological artworks, and new ethical concerns.[9]

Artists Enter the Biotechnology Debate

Numerous artists are responding to issues raised by biotechnology. Supporters focus on the potential to enhance medical well-being and increase food resources. Pessimists see the possibility of a new eugenics ethos and simultaneously fear an environment both of control and out of control. The debate encompasses medical benefits, fears with regard to reproductive technologies, stem-cell research, academic and industrial relationships, the ethics of introducing new life forms into the environment, and the proper role of the government with regard to establishing regulatory controls. One group of artists critiques politico-economic applications of biotechnology (and may or may not use techniques of biotechnology to do so). Another group believes it essential to engage with current scientific technology, creating living art forms. These living forms can encompass mutations (sometimes caused by chemicals or radiation) and the "partial-living art" forms that result from tissue culture engineering (but do not derive from gene manipulation). It is the creation of transgenic art that has primarily elicited public concern.

In October 2004, Ernestine Daubner and Louise Poissant held a colloquium in Montreal, inviting thirty artists and writers (including me) to explore these subjects in depth.[10] It became apparent that artists with

university affiliations are relatively well situated to gain access to scientists, laboratories, and expertise. Experts and programs from whom artists can now receive scientific training include Arthur and Marilouise Kroker at the University of Victoria,[11] Nathalie Jeremijenko at UC San Diego,[12] David Kremers at Caltech,[13] Victoria Vesna's new Art/Science Center at two locations at UCLA,[14] Jill Scott and René Stettler at the University of Applied Sciences and Arts in Zurich,[15] and Miriam van Rijsingen and Helen Chandler at the Arts & Genomics Center in Amsterdam.[16] Ionat Zurr and Oron Catts offer a postgraduate degree in biological arts designed for art practitioners, scientists, and humanities scholars who wish to engage with bioresearch.[17] Catts founded the Tissue Culture & Art project (TC&A) in 1996. With Dr. Stuart Bunt he also co-founded SymbioticA, the Art and Science Collaborative Research Laboratory (School of Anatomy and Human Biology) at the University of Western Australia in Perth to enable artists to engage in wet biology practices in a science department. MIT has also offered expertise to non-specialists. Artist Joe Davis has worked in Alexander Rich's lab in the department of biology at MIT since 1992.[18] Rich is known for his discovery of left-handed DNA or Z-DNA and the three-dimensional structure of transfer RNA. While at MIT, Davis has conducted research and pioneered the production of biological art forms. Although not providing financial support, the position grants Davis a space in which to work and access to the lab's tools. Davis and other artists embrace the challenge presented by unfamiliar media, often identify with scientists, collaborate with them, and share their sense of discovery.

Transgenic Art Procedures

Trangenic artists insert foreign DNA into a host bacterium where the inserted material can be "expressed" in the phenotype. The DNA of the desired gene is generally inserted into the host by means of a plasmid (an agent that transfers genetic material from one cell to another). The new genetic material then reproduces itself, yielding more of the desired gene. As an example, Joe Davis coded a message into a strip of bacterial DNA for his "Microvenus" project of 1986. He worked collaboratively with molecular geneticist Dana Boyd, using genomic tools of restriction enzymes, vectors, and plasmids to "cut-and-paste" the new genetic material.[19] Davis's initial concept involved supplying information embedded in genetically-modified E. coli bacteria to aliens that had been censored from the NASA Voyager.[20] His intent was also to air an

important ethical issue, asking whether genetically modified bacteria should be sent into space. In fact, Davis's bacterial artwork is securely contained within the lab.

Artworks like "Microvenus" are invisible. Artists who encrypt messages must also devise a way to make their genetic modification known in order to communicate with an audience. Artists can expect that the relative novelty of genetic techniques will single out their work, air their questions publicly, and help them reach their target audience. Davis typically relies on photographic documentation, integrated installations, and publications to illuminate his work, as does Eduardo Kac. Arguably, Kac's most controversial work to date has been "GFP Bunny." This project concerned the production in 2000 of Alba, a "glowing," genetically engineered rabbit that involved scientists at a lab in France transferring a fluorescent gene into the cells of the host rabbit.[21]

Testing Artistic Claims of Genetic Engineering

As a by-product of this way of working, the public must generally take it on faith that the genetic engineering has actually been carried out as claimed. Kac states that the process of creating "GFP Bunny" was accomplished through direct microinjection of DNA into the male pronucleus of a rabbit zygote at a laboratory in France.[22] With this method, transgene sequences from a variety of sources can be introduced into the mammalian genome.[23] Although I was initially skeptical that Alba had been genetically engineered because the widely circulated poster of Alba appeared contrived, the actual scientific methodology involved in carrying out this ambitious work was well within the realm of scientific capability in 2000. As additional proof, cells containing the green fluorescent protein would, if examined, be visible under ultraviolet light. Theoretically, even apart from the easy detection of a luminescent protein within the cells, tests are available to detect the insertion of foreign DNA to determine if genetic engineering has occurred in an organism. However, the testing is far from simple, and it is possible that even with analysis one might not be able to tell that the insertion of foreign DNA has taken place. For example, suppression and natural genetic variance might account for a genome that departs from the norm of a particular animal.[24] From an ethical point of view it still matters whether genetic engineering has actually occurred and, if so, documentation should clearly identify those individuals carrying out the procedures. As things stand, it is hard to assess from his Web site just what Kac's role

in this project involved. Was his primarily an act of artistic appropriation or did the artist himself perform the genetic engineering? Does it matter?

Morality of Producing Transgenic Animals

Genetic manipulation touches on the public's fundamental conceptions of science, religion, and philosophy. Many view the morality of creating animal freaks that would not be likely to be accepted by other animals as highly questionable. Novelty seems an inadequate reason to produce a transgenic pet. Those favoring artistic practices such as Kac's believe that valuable research is conducted through examining new kinds of bonds between animals and people. Kac himself suggests that he produces transgenic animals to examine society's "notions of normalcy, heterogeneity, purity, hybridity, and otherness."[25] (Bear in mind that the concept of the "norm" has at times succeeded in labeling a class as being defective and thus is politically charged.) Kac also states that his project encompassed not just the production but the social integration of the transgenic animal and emphasizes his "commitment to respect, nurture, and love the life thus created."[26]

Ambiguities of Artistic Production

Plant breeding, tissue culture engineering, and genetic engineering offer artists ways to embody their concepts and catch the public's eye. It is not clear to what extent certain artistic proposals have actually been carried out, and this ambiguity may itself pose an ethical problem. Unless directly stated, an artist may be encouraging others to perform genetic manipulations that he, himself, has neither commissioned nor undertaken.[27] The following examples will give you an idea of the range of artistic invention (many proposals do not involve gene splicing but engage other techniques like tissue culture engineering): Marta de Menezes describes how she creates butterflies with new wing patterns by manipulating the chemical micro-environments of chrysalises (the process does not affect the genes themselves);[28] Zurr and Catts's project is to create "pigs with wings" through tissue culture techniques;[29] and Julia Reodica has developed what she refers to as tissue cultured "hymens" in a lab at RPI Biomedical Engineering.[30] The latter artists do not claim that the tissues are meant to be functional.

Another artist, Laura Cinti, states that she used techniques of genetic engineering to create a cactus with "human hair."[31] This seems

unlikely, since there are significant obstacles involved in insuring the expression of the gene that is introduced (i.e., being sure that hair would be produced).[32] Upon first learning of the project, Robert Shapiro (professor emeritus of chemistry and senior research scientist at New York University) stated that "the introduction of the genes that control human hair growth into a cactus should be worthy of a technical article of length in *Nature* or *Science*. One wonders why few papers have appeared in scientific journals to announce such events. If genes responsible for human hair growth have been identified, I have not seen any genetic cures for baldness offered on the market." Shapiro continued to say that one could, however, likely use an older technique like grafting to create such a cactus. As a general observation, I think it healthy to retain some skepticism about whether some artists are actually carrying out the procedures they claim since, even if they have access to scientists and laboratories, the costs may be prohibitive.

Biotechnology, Patents, and Ethics

Today, techniques of rDNA, stem cell research, and cloning pose basic ethical issues with respect to altering our ideas of life and life, itself. One important concern is that non-specialists may release a small amount of genetically modified (GM) organisms into the environment. Significant political activism has played out during the process of seeking biotechnology patent approvals, and ethical debates have often taken place during congressional hearings on patents. A memorable controversy developed in 2002. Genes from a coral species of fish were added to the genome of the common black-and-white zebra fish. This combination produced a pet toy that glowed much like Kac's pet rabbit. "GloFish" were intended for commercial sale in fish stores, but led to an outcry in California, and sales of these fish were not permitted in California.[33] The protest resulted primarily from the fear of the fish inadvertently being set free in nature and driving wild populations to extinction. After all, animals that are not even genetically engineered (e.g., the snakehead fish introduced into the United States) can devastate a given ecosystem. Other objections were ethical concerns about the trivial use of genetic engineering.

Some artist activists question the ethics of governments or suppliers not labeling GM products in our food supplies.[34] They believe that GM organisms invariably have undesirable consequences for native species of crops and that they decrease biodiversity. Their concerns may extend to fears of "biopiracy"

whereby large corporations can appropriate indigenous crops through patenting.[35] A charity named ActionAid became increasingly concerned that impoverished farmers must pay licensing fees to grow indigenous crops because large biotechnology and seed companies patented the crops. To publicize this, in 2002 ActionAid deliberately filed an absurd application to patent "chips" (as in "french fries") that are obviously available to anyone. ActionAid's protest was specifically aimed at U.S. Patent No. 5,894,079, the Enola Bean patent filed by the Proctor Company (not Procter and Gamble).[36]

In *The Global Genome*, Eugene Thacker discusses four groups of artist activists, exploring how their protests have been leveled at multiple issues stemming from biotechnology's effects on economy and labor. The activist art groups are SymbioticA, SubRosa, the Biotech Hobbyist, and the Critical Art Ensemble (CAE).[37] As with SymbioticA, such groups frequently collaborate with scientists and at times include biomedia in installations.[38] Thacker states, "With technologies such as industrial-driven genetic engineering or transgenics, we see a biological model that is inseparable from an economic-business model . . . it can be argued that the majority of high-profile ethical disputes within the biotech industry have to do with a conflict between interests, a conflict between medical benefit and economic benefit."[39] These conflicts have prompted some artists to critique the biotech industry.

Artists Heath Bunting and Rachel Baker challenged some of Monsanto's products, particularly its creation of herbicides. Bunting and Baker claimed they created and distributed "SuperWeed" kits intended to destroy the profitability of all GM crops by creating a weed resistant to herbicides such as those produced by Monsanto.[40] (It is unclear whether they actually have done this.) Many activists have been incensed about Monsanto's patented invention of a "terminator" (sterility) gene, which forces farmers to keep buying GM crops year after year. However, it is somewhat ironic to note that it is precisely the presence of a terminator gene that insures that GM crops with this novel feature will surely not spread. Some scientists believe it unlikely that most genetically engineered life forms would dominate or even survive if left free. They believe that husbandry and similar human refashioning of nature have been occurring ever since man first began to farm. In this accepting spirit, artist George Gessert hybridizes new plant seeds that challenge the popularity of more typical varieties.[41]

The patenting of genes has had a contentious background since it is not obvious whether others should be able to acquire rights over our genetic makeup.[42] One of the critical questions was to legally determine

United States Patent [19]

Chakrabarty

[11] **4,259,444**

[45] **Mar. 31, 1981**

[54] **MICROORGANISMS HAVING MULTIPLE COMPATIBLE DEGRADATIVE ENERGY-GENERATING PLASMIDS AND PREPARATION THEREOF**

[75] Inventor: **Ananda M. Chakrabarty,** Latham, N.Y.

[73] Assignee: **General Electric Company,** Schenectady, N.Y.

[21] Appl. No.: **260,563**

[22] Filed: **Jun. 7, 1972**

[51] Int. Cl.³ .. C12N 15/00
[52] U.S. Cl. 435/172; 435/253; 435/264; 435/281; 435/820; 435/875; 435/877
[58] Field of Search 195/28 R, 1, 3 H, 3 R, 195/96, 78, 79, 112; 435/172, 253, 264, 820, 281, 875, 877

[56] **References Cited**

PUBLICATIONS

Annual Review of Microbiology vol. 26 Annual Review Inc. 1972 pp. 362-368.
Journal of Bacteriology vol. 106 pp. 468–478 (1971).
Bacteriological Reviews vol. 33 pp. 210–263 (1969).

Primary Examiner—R. B. Penland

Attorney, Agent, or Firm—Leo I. MaLossi; James C. Davis, Jr.

[57] **ABSTRACT**

Unique microorganisms have been developed by the application of genetic engineering techniques. These microorganisms contain at least two stable (compatible) energy-generating plasmids, these plasmids specifying separate degradative pathways. The techniques for preparing such multi-plasmid strains from bacteria of the genus Pseudomonas are described. Living cultures of two strains of Pseudomonas (*P. aeruginosa* [NRRL B-5472] and *P. putida* [NRRL B-5473]) have been deposited with the United States Department of Agriculture, Agricultural Research Service, Northern Marketing and Nutrient Research Division, Peoria, Ill. The *P. aeruginosa* NRRL B-5472 was derived from *Pseudomonas aeruginosa* strain 1c by the genetic transfer thereto, and containment therein, of camphor, octane, salicylate and naphthalene degradative pathways in the form of plasmids. The *P. putida* NRRL B-5473 was derived from *Pseudomonas putida* strain PpG1 by genetic transfer thereto, and containment therein, of camphor, salicylate and naphthalene degradative pathways and drug resistance factor RP-1, all in the form of plasmids.

18 Claims, 2 Drawing Figures

Figure 1. A precedent for allowing living material to be patented and extending the definition of what is considered patentable was the Chakrabarty case in 1980. The patent was obtained for genetically modified bacteria that could consume oil (U.S. 4,259,444).

whether genetically engineered microorganisms are patentable. The 1980 U.S. Supreme Court decision of *Chakrabarty v. Diamond* confirmed the patentability of living organisms and allowed Chakrabarty to manufacture his oil-eating bacterium, setting a precedent. (Fig. 1: U.S. Patent No. 4,259,444)

Another milestone was the engineering of the oncomouse, which is susceptible to cancer (Fig. 2: U.S. Patent No. 4,736,866).[43]

Some scientists have also used the patent office as a forum for protest. Stuart A. Newman and Jeremy Rifkin, critics of the biotechnology industry, submitted a patent application to the U.S. Patent and Trademark Office for a hybrid creature that would be made by combining human and animal embryos. A lifelong critic of biotechnology and more recently of bioart, Rifkin believes the best way of preventing this is through calling public attention to the possibility of creating a monster such as a part-human chimera.[44]

United States Patent [19]

Leder et al.

[11] Patent Number: **4,736,866**

[45] Date of Patent: **Apr. 12, 1988**

[54] TRANSGENIC NON-HUMAN MAMMALS

[75] Inventors: **Philip Leder**, Chestnut Hill, Mass.; **Timothy A. Stewart**, San Francisco, Calif.

[73] Assignee: **President and Fellows of Harvard College**, Cambridge, Mass.

[21] Appl. No.: **623,774**

[22] . Filed: **Jun. 22, 1984**

[51] Int. Cl.⁴ C12N 1/00; C12Q 1/68; C12N 15/00; C12N 5/00

[52] U.S. Cl. 800/1; 435/6; 435/172.3; 435/240.1; 435/240.2; 435/320; 435/317.1; 935/32; 935/59; 935/70; 935/76; 935/111

[58] Field of Search 435/6, 172.3, 240, 317, 435/320, 240.1, 240.2; 935/70, 76, 59, 111, 32; 800/1

[56] **References Cited**

U.S. PATENT DOCUMENTS

4,535,058 8/1985 Weinberg et al. 435/91
4,579,821 4/1986 Palmiter et al. 435/240

OTHER PUBLICATIONS

Ucker et al, Cell 27:257–266, Dec. 1981.
Ellis et al, Nature 292:506–511, Aug. 1981.
Goldfarb et al, Nature 296:404–409, Apr. 1981.
Huang et al, Cell 27:245–255, Dec. 1981.

Blair et al, Science 212:941–943, 1981.
Der et al, Proc. Natl. Acad. Sci. USA 79:3637–3640, Jun. 1982.
Shih et al, Cell 29:161–169, 1982.
Gorman et al, Proc. Natl. Acad. Sci. USA 79:6777–6781, Nov. 1982.
Schwab et al, EPA–600/9–82–013, Sym: Carcinogen, Polynucl. Aromat. Hydrocarbons Mar. Environ., 212–32 (1982).
Wagner et al. (1981) Proc. Natl. Acad. Sci USA 78, 5016–5020.
Stewart et al. (1982) Science 217, 1046–8.
Costantini et al. (1981) Nature 294, 92–94.
Lacy et al. (1983) Cell 34, 343–358.
McKnight et al. (1983) Cell 34, 335.
Binster et al. (1983) Nature 306, 332–336.
Palmiter et al. (1982) Nature 300, 611–615.
Palmiter et al. (1983) Science 222, 814.
Palmiter et al. (1982) Cell 29, 701–710.

Primary Examiner—Alvin E. Tanenholtz
Attorney, Agent, or Firm—Paul T. Clark

[57] **ABSTRACT**

A transgenic non-human eukaryotic animal whose germ cells and somatic cells contain an activated oncogene sequence introduced into the animal, or an ancestor of the animal, at an embryonic stage.

12 Claims, 2 Drawing Sheets

Figure 2. The genetic engineering of the oncomouse, which is susceptible to cancer, was patented by Leder and Stewart in 1988. It was the first genetically engineered mammal to be patented (U.S. 4,736,866).

207

Should Techniques of Biotechnology be Accessible to Nonspecialists?

Individuals intent on doing harm can and will find ways to engineer harmful organisms without needing to use genetic engineering. The likelihood is that in time non-specialist access to genetic engineering will spread. The issue is to determine to what extent the public is willing to trade in basic freedoms to eliminate a threat. Artists who have worked hard to gain the necessary knowledge to make transgenic art may be unwilling to relinquish total control to experts. For example, genetic "home kits" manufactured by Natalie Jeremijenko (one of the group of biotech hobbyists described by Thacker) drive her point home that the technology should be available to non-specialists.[45] Many of the artists working with rDNA technology generally believe it important for the public that non-specialists can participate in decisions regarding biotechnology and develop familiarity with the techniques.[46]

Can Artists Contribute to Research in Biotechnology?

An important question is whether artists are likely to make contributions to research in biotechnology that can justify the space removed from scientists who would be expected to yield more productive inquiries. Artist Stephen Wilson makes a strong case that artists contribute to scientific knowledge through "offering alternatives in setting research agendas, interpreting results, and communicating findings."[47] Indeed, a subset of bioartists has successfully conducted interdisciplinary research with meaningful results. Artists such as Mel Chin (installation work involving genetically modified plants called hyperaccumulators),[48] Gail Wight (slime mold research),[49] Rachel Berwick (research on language transmission in birds),[50] and Christa Sommerer and Laurent Mignonneau (interactive work involving genetic algorithms)[51] bring insightful artistic eyes to the scientific study of complex systems.

Two relatively recent approaches in biotechnology that are engaging scientists are systems biology and directed mutagenesis. How likely is it that artists could contribute meaningfully to either approach, assuming that is a goal? Systems biology is generally characterized as an important approach to understanding how biological systems function. The aim is to provide guidance for eventually developing customized therapeutic drugs. Directed mutagenesis (seemingly an oxymoron since mutation is generally thought to be random) reopens the possibility of Lamarkism (the inheritance of acquired characteristics) in bacteria.[52] The hope is that some fundamental understanding of biology might be gained that could answer the question

of whether there is any direction in evolution, even to a small extent. It is my understanding that the aim is usually to create enzymes with new specificities.

Some artists might wish to participate in these scientific arenas, but could only do so if they have considerable scientific backgrounds and skills. Critics of artists undertaking this kind of research will claim that artistic approaches seem serendipitously designed (which is different from taking knowing advantage of the chance accident, as Alexander Fleming did when he discovered penicillin). On the other hand, even one significant contribution to scientific knowledge by an artist might provide sufficient justification for continued participation of artists in wet labs. After all, historically we have the dynamic model before us of the artist Lodovico Cigoli's fruitful relationship with Galileo. Cigoli's insights about cast shadows reinforced Galileo's changing conceptions of the moon and cosmos in favor of the Copernican system![53]

Conclusions

How the public judges the use by artists of rDNA techniques will depend on many factors. It depends not only on scientific knowledge but also on sociopolitical understanding of the assumptions and values prompted by the various interest groups involved in biotechnology. Other important factors to consider are religious values and national beliefs. For example, as compared to people within the United States, people in Britain largely remain opposed to GM food and agricultural biotechnology. There are clearly many interest groups, including the Council for Responsible Genetics (CRG) and People for the Ethical Treatment of Animals (PETA).

The public's view of bioart may also depend upon its sense of aesthetics and definitions of art. One of the serious objections to transgenic art forms is that it is not aesthetic. By contrast, artist Adam Zaretsky sees aesthetics as a primary impetus for bioart. He points out that "scientific and industrial organisms, created for specific utilization or for the furtherance of comprehension, are also expressions of aesthetic choices. This is why I feel it is my duty as an artist to learn these technologies. Instead of phobic reaction, I am attempting to critically embrace the processes of life's permanent and inheritable alteration."[54] Works of Zaretsky such as "Workhorse Zoo," which are intended to spur public discussion on issues important to society, are received by some art audiences as a form of deliberately provocative performance art or spectacle.[55]

Artists can conceivably restore an important dimension to the under-
standing of biotechnology by intimating a more complex understanding of
biotechnology through holistic approaches and through their critiques. Some
bioartists should be granted access to learn biotechnological techniques so
that they can attempt to contribute to scientific research on a competitive
basis. Nevertheless, in the United States today, it seems likely that the pub-
lic will want non-specialists to be able to employ genetic methodologies only
with assurance of adequate professional supervision. It is thus incumbent for
transgenic artists working within an institution to disclose their techniques
and avoid fraudulent claims. Because of the laboratory context within which
these artists work, they might reasonably be expected to uphold standards of
legitimacy not normally demanded of artists. It would only take a few non-
specialists with casual attitudes about scientific protocol to create problems.
In turn this might lead to a backlash against bioartists.[56] Artists have a great
deal to contribute, and my own hopes are that we preserve a future opportu-
nity to foster productive relationships.

In 1975 scientists instituted a voluntary moratorium on genetic
research during the Asilomar Conference to provide time to review the eth-
ical implications of genetic research and set appropriate safeguards in
place.[57] The guidelines now in place in the United States include those
required for all NIH funded projects, including the disposition of recombi-
nant materials, the policies that exist in all science laboratories, and the
increasing number of political constraints that the government has imposed
to eliminate the likelihood of bioterrorism.[58] It is somewhat ironic that just
as there is interest in creating wet labs in universities, the U.S. government
has funded universities to build biocontainment laboratories, which are
closed to all without security clearance.[59]

Despite threats of use, nuclear weapons have remained under control
as witnessed by the fact that they have not been used in war since World War
II. But DNA is ultimately different from nuclear technology and harder to
contain because of DNA's invisibility, replicability, and sustainability. These
attributes underscore the importance of effective guidelines and determina-
tions as to whether the general public, scientists, or a mixture of these
concerned parties should be making decisions regarding their use.[60]

The capabilities of science—from Three Mile Island and Chernobyl
to Dolly to proposed human/animal chimeras—present alternatively ter-
rifying and awesome spectacles and challenge contemporary artists to
respond to the ethical questions raised by these technologies. In turn,
artists who create new life forms are themselves raising ethical questions
of significant dimension for the public. It can be argued that through

providing us with models of the future, artists are far more likely than at any point previously to help bring about this future.

The author thanks Ernestine Daubner and Louise Poissant for the invaluable opportunity to exchange ideas about art and biotechnology with them and others invited to participate in their colloquium.

Endnotes

[1] Karl Gerbel and Peter Weibel, eds., "Genetic Art—Artificial Life," *Ars Electronica 93* (Vienna: PVS Verlager, 1993).

[2] Gerfried Stocker and Christine Schöpf, eds., "LifeScience," *Ars Electronica 99* (Vienna and New York: Springer, 1999), 310–312.

[3] Ellen K. Levy, guest ed. with Berta M. Sichel, "Contemporary Art and the Genetic Code," special issue of *Art Journal* 55, no. 1 (Spring 1996).

[4] David Joselit, "Biocollage," in *Art Journal* 59, no. 3 (Fall 2000): 44–64 (also note Carol Becker's essay on Kac).

[5] The artistic examples offered in this text are not intended to be comprehensive of all that has been done in the area of transgenic art but to single out certain ethical issues for discussion.

[6] George Gessert created an installation, "Art Life," at the Exploratorium in San Francisco called, "Diving into the Gene Pool; G. Gessert"; "A Brief History of Art Involving DNA," in *Art Papers* (September/October 1996), revised and reprinted as "A History of Art Involving DNA" *LifeScience*, eds. Gerfried Stocker and Christine Schöpf; Ron Platt, curator, "Inigo Manglano-Ovalle: The Garden of Delights," Southeastern Center for Contemporary Art (July 18–September 30, 1998), 14–15. For background also see Ingebourg Richle at *www.medienkunstnetz.de/themes/cyborg_bodies/transgenic_bodies/1/*.

[7] Eduardo Kac, "Transgenic Art," in *Leonardo Electronic Almanac* 6, no. 11 (December 1998).

[8] As a recent example, see Jens Hauser, ed., *L'Art Biotech*, exh. cat. (Nantes, France: Le Lieu Unique, 2003).

[9] See Robin Held's experience with similar problems at *www.genesis.net/essays/held_essay.pdf*, 2.

[10] Louise Poissant and Ernestine Daubner, eds., *Art et Biotechnologies* (Québec: Presses de L'Université du Québec, 2005); see information about the October, 2004 symposium at *www.colloquebioart.org*.

[11] For information about the Pacific Centre for Technology and Culture at the University of Victoria, British Columbia, see *www.ctheory.net/text_file.asp?pick=405*.

[12] *http://proboscis.org.uk/people/*.

[13] Discussion with David Kremers in 2004.

[14] Discussion with Victoria Vesna in 2005.

[15] *www.bek.no/BEKdot/1071317243/index_html*.

[16] I thank Victoria Vesna and Adam Zaretsky for providing this information (2005).

[17] From e-mail correspondence with Catts and Zurr in 2005.

[18] *http://web.mit.edu/newsoffice/2000/richaward.html*; Joe Davis, "Microvenus" in *Art Journal* 55, no. 1 (1996): 56; *http://digitalarts.lcc.gatech.edu/unesco/biotech/artists/bio_a_jdavis*; *www.thegatesofparadise.com/joe_davis.htm*.

[19] Joe Davis, "Microvenus" in *Art Journal* 55, no. 1 (1996): 70–74.

[20] Ibid.

[21] *www.ekac.org/gfpbunny.html*.

[22] See Kac's note 18 for Kac's process at *www.ekac.org/gfpbunny.html#gfpbunnyanchor*.

[23] Philip Leder, David A. Clayton, Edward Rubenstein, eds., *Introduction to Scientific American* (New York: Scientific American, 1994), chapter 2. To carry out genetic engineering, DNA molecules are cut and joined together. A vector molecule (often a bacterial plasmid) often carries the genetic material into a host. The gene is inserted into the bacterial plasmid by ligases that act as a genetic "glue." Sometimes restriction enzymes cut off the foreign DNA to be inserted into the host; other times "splicing" is used to recombine DNA molecules; also see *www.criver.com/techdocs/transgen.html*; *www.ncbi.nlm.nih.gov/entrez/query.fcgi?CMD=Display&DB=pubmed*.

[24] In response to my question, Dr. Robert Shapiro said, "You would need to have a sample of the foreign DNA that you think has been inserted, or at least know the sequence of it, or part of it, so that you could make the DNA on a DNA synthesizer. You would then attach a radioactive label to it (a probe), for easy detection. A second step would be to make a genomic library of the animal. You would collect the entire DNA from some cells and break it up into shorter pieces, using a restriction enzyme or even mechanical shearing. (If you did not have enough of the DNA, then the polymerase chain reaction could be used to amplify it.) The individual pieces would have to be separated by some technique, such as electrophoresis. This could be a big job if the animal in question has a large genome. The separated pieces would be fixed to an immobile support, and exposed to a solution containing your radioactive probe. If the probe matched any of the pieces of the animal's fragmented genome, it would stick to it and become immobilized on the support. You would then know that the foreign DNA was also present in the genome of the animal. The DNA sequence of the entire genome is known for a number of bacterial species, and a few higher organisms. That sequence is often a composite, an average taken from a large number of individuals of a species. Right now, very little is known about how much or in which way individuals of the same species differ from one another. An infection from a harmless virus, for example, could put a bit of extra DNA into the genome of an individual that his own twin brother might lack. And as you noted, normal genetic variance could produce differences between individuals of the same species who are not close relatives of one another."

[25] *www.ekac.org/gfpbunny.html#gfpbunnyanchor.*

[26] Ibid.

[27] Following a discussion with me in late December 2005, Dr. Robert Shapiro raised substantial questions about Kac's methodology as published on his Web site. He also addressed the issue of artists properly crediting scientists for their carrying out genetic engineering procedures resulting in artworks.

[28] Marta de Menezes, "The Artificial Natural: Manipulating Butterfly Wing Patterns for Artistic Purposes," in *Leonardo* 3655, no. 1 (2003). De Menezes describes how she changes butterfly wing patterns by manipulating the chemical microenvironments of chrysalises. She directs gene expression but does not affect the genes themselves. *http://mitpress2.mit.edu/e-journals/Leonardo/isast/spec.projects/art+biobiblio.html*; *www.martademenezes.com.*

[29] *www.tca.uwa.edu.au.*

[30] I thank Adam Zaretsky for informing me about this work.

[31] *www.lauracinti.com.*

[32] To read the varieties of belief and disbelief in the cactus project see *www.museumofhoaxes.com/hoax/weblog/comments/580/.*

[33] For California's Fish and Game Commission's decision to ban sale of the GloFish, see *www.cnn.com/2003/TECH/science/12/04/fluorescent.fish.ap/.*

[34] "New Labels for Genetically Engineered Food" and other works were on view at MASS MOCA's exhibition, "Christy Rupp: Swimming in the Gene Pool," February-August 2000; In "Free Range Grains," the CAE has used various laboratory techniques to identify unlabeled GMO products. The CAE originally consisted of Steve Barnes, Dorian Burr, Steve Kurtz, Hope Kurtz, and Beverly Schlee, and they have collaborated with Beatrice daCosta. Faith Wilding and Paul Vanouse have also worked with the CAE.

[35] Vandana Shiva, *Biopiracy* (Cambridge, Mass: South End Press, 1997); *www.law.duke.edu/journals/dltr/articles/2002dltr0008.html.*

[36] *www.law.duke.edu/journals/dltr/articles/2002dltr0008.html.*

[37] Eugene Thacker, *The Global Genome: Biotechnology, Politics, and Culture* (Cambridge, Mass., and London: The MIT Press, 2005), 307–318.

[38] Ibid.; also see the discussion of the Critical Art Ensemble in David Joselit, "Biocollage" in *Art Journal* 59, no. 3 (Fall 2000): 44.

[39] Thacker, 43.

[40] *http://web.mit.edu/dryfoo/www/Info/scary-weed.html.*

[41] George Gessert, "Notes on Genetic Art," *Leonardo* 26, no. 3, (1993): 205–211.

[42] Daniel J. Kevles, "Patenting Life: A Historical Overview of Law, Interests, and Ethics," Yale Law School, Legal Theory Workshop, December 20, 2001; Jorge A. Goldstein and Elina Golod, "Human Gene Patents," *Academic Medicine* 77, no. 12 (2002), part 2, 1315–1328 at *www.aamc.org/research/sloan/goldsteingolod.pdf*; for art and commodification see Dorothy Nelkin, "The Gene as a Cultural Icon," *Art Journal* 55, no. 1 (1996), 56–61; also see Suzanne Anker and Dorothy Nelkin, *The Molecular Gaze: Art in the Genetic Age* (Cold Spring Harbor: Cold Spring Harbor Laboratory Press, 2004), 153–184.

[43] Kevles, "Patenting Life: A Historical Overview of Law, Interests, and Ethics." Discusses U.S. history. *www.yale.edu/law/ltw/*.

[44] David Dickson, "Legal Fight Looms Over Patent Bid on Human/animal Chimaeras" in *Nature* 392, no. 6675 (April 2, 1998), 423–424; *www.legalaffairs.org/ issues/November-December-2002/ feature_slater_novdec2002.html*; see Rifkin's comments about bioart at *http://education.guardian.co.uk/higher/research/story/ 0,9865,874470,00.html*.

[45] *www.massmoca.org/press_releases/07_2000/7_20_00.html*.

[46] Poissant.

[47] Stephen Wilson, *Information Arts: Intersections of Art, Science and Technology* (Cambridge, Mass, and London: The MIT Press, 2002), 35–51.

[48] Sue Spaid, *Ecovention: Current Art to Transform Ecologies* (co-published by *greenmuseum.org,* The Contemporary Arts Center, and ecoartspace, 2002), 5–7.

[49] *www.exploratorium.edu/turbulent/exhibit/slime.html*.

[50] Ralph Rugoff and Lisa G. Corin, exh. cat. (London: Serpentine Gallery, 2000), 47–48.

[51] Christa Sommerer and Laurent Mignonneau, "Art as a Living System," in *Art @ Science* (New York: Springer-Wien, 1998), 148–162.

[52] Sahotra Sarkar, *Molecular Models of Life: Philosophical Papers on Molecular Biology* (Cambridge, Mass., and London: The MIT Press, 2005), 303–347.

[53] Eileen Reeves, *Painting the Heavens* (Princeton: Princeton University Press, 1997).

[54] Adam Zaretsky, "Workhorse Zoo Art and Bioethics Quiz," in *BioMediale: Contemporary Society and Genomic Culture* (Kalingrad, Russia: National Center for Contemporary Arts, 2004), 324–325.

[55] Adam Zaretsky effected the co-habitation of a variety of typically used lab animals in a Simplex Isolation System Clean Room within a gallery space curated by Stacy Switzer at the Salina Art Center in Salina, Kansas from January 26 to March 31, 2002. These "workhorses" (named for the most commonly used experimental animals) included E. coli bacteria, brewer's yeast, drosophila, arabidopsis, zebra fish,xenopus frogs, and mice. Zaretsky points out that because our medical

health sometimes depends on the research gleaned from experimenting on these animals, gathering information about the impact of years of special breeding might be significant.

[56] Randy Kennedy, "The Artists in the Hazmat Suits," *New York Times*, sec.2, July 3, 2005, 1, 21. Public attitudes will be shaped by articles such as this, which may pose problems for some bioartists.

[57] At that time an rDNA Advisory Committee had already been formed. The Asilomar conference was held under the auspices of the NIH and in the presence of the press but has since been criticized for not sufficiently encouraging the general public to attend.

[58] *www.ors.duke.edu/ask/hoops/clearances.html.*

[59] Jonathan B. Tucker, "Research on Biodefense Can Get Generous Funds, but with Strings Attached," *Chronicle Review of Higher Education* 50, no. 26 (2005): B10.

[60] Richard Lewontin, "Science, Money & Politics" in *The New York Review of Books* 49, no. 8 (2002): 28–32.

CHAPTER

Earthworks' Contingencies

Suzaan Boettger

*A sense of the earth as a map undergoing disruption
leads the artist to the realization that nothing is
certain or formal. —Robert Smithson, 1968*[1]

Earthworks presents an extreme example of the
intersection of art and ethics. As a large-scale, exterior outgrowth of inte-
rior environmental sculptural installations of the mid-1960s, Earthworks
displays that sculptural genre's characteristic of being designed in response
to the configuration of a specific site. As such, the works are best compre-
hended in situ—experientially—the lateral expanse understood in relation
to one's own size and movement, providing varying perspectives of place
and artwork. These two conditional elements physically parallel a view of
ethics that acknowledges contingency, for both the design and comprehen-
sion of environmental art and the application of a moral law depend upon
the particular circumstances, and where one stands in relation to them, a
position individually variable and motile.

Yet more particularly, the format of Earthworks is also materially con-
tingent. As the title of the unformalized movement indicates, Earthworks
were customarily constructed almost solely of the natural matter of their
wilderness locales. Sculptors of the monumental mounds, troughs, and marks
on terrain of this earliest form of contemporary Land Art eschewed what those
of the successor form incorporated: concrete, steel, or wood support toward
stability and structural permanence. So while "sculpture" and "terrain" fused

into environmental art, Earthworks, like their host sites and material, were subject to the vicissitudes of climatological change and geological movement. The inevitable morphological degradation alteration of these works prompts consideration of proper stewardship.

But beyond the conditional physical and formal characteristics, and before considering the care of deteriorating land sculptures, looking at Earthworks retrospectively highlights a more idiosyncratic aspect of this genre of environmental art: The practice of not reinforcing the exclusively natural materials used in large environmental constructions—the distinguishing quality of Earthworks—has largely become obsolete. Indeed, the most germane of Earthworks' multiple contingencies is a social one: Since these works began to be made in the late 1960s, estimations of artists' manipulations of their medium, nature, in regard to what is ethically just to do on or with the earth has changed.

And a tangential art world issue that also seems to have—at least in practice—altered over recent decades, as evidenced by posthumous treatment of works by Earthworks artist Robert Smithson, is the determination of a work's authorship.

Signs of the Times

Every work of art is born of values of its time—while some more than others transcend that into timeless appeal. Yet, the relative recentness of the Earthworks "movement"—1967–1973, during the period that art history still considers "contemporary art"—is contradicted by the strong difference between current values toward nature and those manifested in Earthworks, making them appear to be of a past era. The fruit of a strong postwar economy, social optimism, the baby boom generation's moving into teenage rejection of traditional forms of propriety, Earthworks was one of a number of new genres in the 1960s and 1970s (Happenings, Pop Art, Minimal Art, Conceptual Art, Body Art, Performance, Video Art) that the art world appreciated for the very boldness of their reimagining of what art could be. One of the major innovators in a few of these genres, Dennis Oppenheim, recalled, "The feeling was that art is what you don't know. Everything else is art history."[2]

At the time they were made, the artists' large-scale manipulations of terrain were considered both conceptually and physically heroic. Not only the art world, but mass media news and pictorial magazines were inspired by the image of New York artists going into wilderness to move sometimes thousands of tons of earth to create extraordinary sculptural spectacles that

few would experience. "Things like the Grand Canyon have always fright-ened artists," says Oppenheim. "They've always seemed like forms that are important but impossible to duplicate. Now artists have to be willing to meet these objects in their own ballpark."[3] That the mainstream *Newsweek* approvingly quoted this young New Yorker, then recently relocated from northern California, in its eight-page feature titled "The New Art: It's Way, Way Out," in the summer of 1968, indicates the times' confident reception of radical genres.

Oppenheim's earthen environments, while large, were often ephemeral: Famous works include his act of hacking rings in the snow on ground that spanned the United States-Canadian border (*Annual Rings*, 1968) and having an X mowed across a Dutch wheat field, followed by withholding the harvest from production (*Cancelled Crop*, 1969). In the late 1960s and early 1970s, several other American, European, and Canadian artists made temporary desert, mountain, or countryside envi-ronments out of natural materials or earthen land forms. Two major works are still extant in the United States: Michael Heizer's *Double Negative* (1969–70), northeast of Las Vegas, Nevada, two deep cuts in facing exten-sions of a mesa with a 1500-foot chasm between them, and Robert Smithson's *Spiral Jetty* (1970), a 1,500-foot-long, fifteen-foot-wide path built in the Great Salt Lake in Utah. In the middle of the Netherlands, outside of the modern suburban town of Emmen, is Smithson's 1971 *Broken Circle and Spiral Hill*, a commission as part of the "Sonsbeek '71" exhibition of art around the country. It consists of a solid hemi-circle in a lake with an arcing arm partially enclosing the top edge of the open half of the circle, and a small conical hill above it, and is located on the prop-erty of a commercial sand and gravel quarry. It is a more domesticated ver-sion of Earthworks. All of their locations in areas remote from urban art centers demands of the viewer considerable travel (and for the *Double Negative* and the *Spiral Jetty*, over unpaved, rocky, unmarked roadways) to be able to view and interact with their environments, a necessity that was justified by artists and critics as part of a work's "content."[4]

The earthwork that more directly went up against the Grand Canyon in the scale of its crevices in its desert locale and its dramatic effect is Heizer's *Double Negative*. To excavate the two fifty-foot-deep, thirty-foot-wide troughs in the facing sides of the mesa's projecting fingers, Heizer dynamited and then removed by bulldozer 240,000 tons rhyolite and sandstone and pushed them into the chasm between his "cuts," which then contained a huge mound as if generated by an avalanche. The land's own-ership jointly by Heizer and his New York art dealer Virginia Dwan, and

219

its isolated locale about ninety minutes' drive northeast of Las Vegas on a barren mesa outside the small town of Overton, evidently provided the artistic license. He didn't need legal permission, as President Nixon signed the National Environmental Policy Act while this work was in process, on January 1, 1970, and the ensuing agency was not established (with the requirement for environmental impact statements in the future) until the following September, after the *Negative's* completion.

But even in the absence of this institutionalized protection of nature, the art world did not raise questions about the artists' interventions in the landscapes. In what now appears to exude defensive denial, Philip Leider assured *Artforum* readers in 1971, "The [*Double Negative*] is huge, but its scale is not. It took its place in nature in the most modest and unassuming manner—the quiet participation of a man-made shade in a particular configuration of valley, ravine, mesa, and sky. The piece is a new place in nature."[5] Characteristic of the Europeans' historical idealization of the American pioneer sensibility, one critic enthused: "It is a rejection of the city and of civilization and a reincarnation of the American frontier spirit in seeking out and grappling with virgin territory on a grandiose scale."[6] The sexual analogy to fondling a virgin suggests a quality of aggression that has traditionally been coded as masculine.

An earlier work by Oppenheim also has that quality of humans' right of domain over receptive nature. In 1968 he made a "large spatial collage" by transferring a map's concentric lines describing a mountain's topography onto a nearby wetlands through the placement of aluminum filings (curled shavings that are the residue of milling machines). Conceptually, he in effect flattened and dissolved the mountain on the swamp surface. It took three to four months for his metal "drawing," *Contour Lines Scribed in Swamp Grass*, to disappear. The distribution of this industrial waste was undoubtedly detrimental to the swamp, but that was not addressed in published commentary on Oppenheim's work, which in *Artforum* praised him for "helping explode through to the landscape's giant scale."[7]

An opposition of active human and passive nature also appears in Leider's account of visiting Smithson's *Spiral Jetty*. "In a free society artists get to rearrange nature just like everyone else, lumber kings, mining czars, oil barons; nature, a kind of huge, placid Schmoo [a rotund comic strip figure and inflated toy] just lays there, aching with pleasure."[8] But this act, calling up an image of tickling a recumbent figure, called for rearranging 6,650 tons of rock and dirt, which Smithson had moved from the base of hills along the shoreline to a shallow bay on the Great Salt Lake. This act—and even Heizer's gigantic earth moving—probably did no ecological

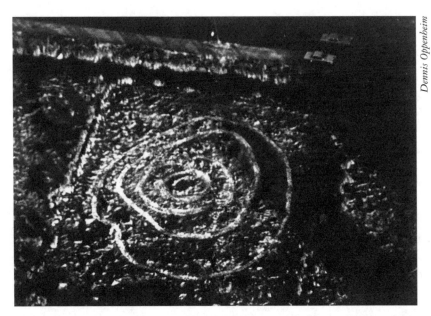

Dennis Oppenheim

Contour Lines Scribed in Swamp Grass, 1968, Dennis Oppenheim. Swamp grass and aluminum filings, 150 feet × 200 feet, New Haven, Connecticut. The contour lines from a nearby mountain were scribed into swamp grass using sickle mower. The complete project is submerged in water at noon (high tide).

damage. But their right to such aggressive acts no longer seems that it would be so easily given—at least not without prior research into the potential environmental impact. Another characteristic of a free society is the recognition that no one has the right to radically alter the public heritage of nature without substantial public benefit. In the 1960s, the creation of these bold forms was seen as a demonstration of our country's promotion of personal freedom and innovative creativity. That Heizer and Smithson both made their works in desolate areas in the western United States, and were each photographed wearing cowboy hats and boots, suggests that another source of their huge terrestrial sculptures is the bravado aggression of a maverick pioneer.

Furthermore, artists could take this position of aggressor in relation to the earth because there seemed to be little sense of the continuity between natural and living things, animate or not. In the early years of Earthworks, Smithson was described as being "far from a nature freak. 'There's no reason to accept the earth as nature,' he declares in deadly seriousness. 'I conceive of the outdoors as a museum—the sub-stratum of the earth is like a buried

museum.'"[9] He stated, "I think we all see the landscape as coextensive with the gallery. I don't think we're dealing with matter in terms of a back-to-nature movement. For me the world is a museum."[10]

Earthworks' founding was concurrent with, and tangentially inspired by, the incipient awareness of the environmental hazards of pollution and pesticides. The years of Earthworks coincided with the social evolution from genteel conservation to early activist environmentalism, and interest in them both from within and without the art world was stimulated by the presumption that these artists, as part of progressive culture, were encouraging sympathy with nature. Thus, the fact that these works were located in forbiddingly wild terrains, and often involved massive rearrangements of earth, was overlooked.

The only time the criticism of the earthwork artists' alteration of natural environments entered their contemporary art world was when Smithson introduced it into the dialogue to refute it. In what would be his final *Artforum* article before his death in 1973, Smithson quoted a *New York Times* article on painter Alan Gussow, the author of *A Sense of Place: Artists and the American Land* (Sierra Club, 1972) "Gussow advocates that artists 'make these places visible, communicate their spirit—not like the earthwork artists who cut and gouge the land like Army engineers.'" Smithson retorted that Gussow "fails to recognize the possibility of a direct organic manipulation of the land devoid of violence and macho aggressiveness." Smithson, who was struggling to get contracts to reclaim mining sites through the construction of Earthworks, wrote, "If strip miners were less alienated from the nature in themselves and free of sexual aggression, cultivation would take place."[11]

Smithson's changing consciousness followed that of society. In May 1971, Congress stopped, on environmental grounds, the development of supersonic air transport. And Nixon's vetoing of the so-called budget-wrecking Water Pollution Control Act in October 1972 was swiftly followed the next day—the last of the session—by Congress gathering the necessary votes to override it.[12]

In 1970, Smithson had derided the new interest in ecology as a naïve "media issue, like [President Lyndon Johnson's] War on Poverty. . . . There is no going back to Paradise or nineteenth-century landscape which is basically what the conservationist attitude is. . . . The early view of Paradise is a nostalgia for the enclosed garden."[13]

But he found a way to respond to the increasing public concern for industry's abuse of natural environments while imagining works that incorporated the appeal for him of the condition of entropy, of loss of

energy in a system and deteriorated states of being. In 1971, Smithson began to devise sculptural environments that would ecologically reclaim areas devastated by mining operations by incorporating tailings (sludge residue from the refinement of the ore) in arresting sculptural designs for places that would function as sites of both environmental sculpture and recreation. These were intended to be funded by corporations as part of government-mandated restitution of their sites. A 1972 letter seeking endorsement of this project from the president of the American Mining Congress, states, "I am developing an art consciousness for today free from nostalgia and rooted in the processes of actual production and reclamation. . . . A dialogue between earth art and mining operations could lead to a whole new consciousness.[14] Before any such proposals were funded, in July 1973, Smithson died in a crash of the small plane from which he was viewing the preliminary form of what posthumously became *The Amarillo Ramp*.

It would be a decade later, and by humanities scholars outside the disciplines of art history, less enamored of heroic formalist innovation and unfamiliar with the art world practice of continually embracing expanding conceptions of the identity of art, who would challenge what a 1985 article titled "The Ethics of Earthworks." Philosopher Peter Humphrey stated, "Whether or not moral criticisms can be made of works of art, such criticism can be made of environmental marks. . . . A thing is right when it tends to preserve the integrity, stability and beauty of the biotic community. It is wrong when it tends otherwise." He finds Earthworks "intrusions into the environment" to be "unnecessary (and unethical)."[15] Unethical doesn't necessarily follow from unnecessary (a nebulous quality when applied to works of art), and it has not been shown that any Earthworks actually harmed the "biotic community." The following year, Allen Carlson argued in the *Canadian Journal of Philosophy* that "the similarity of appearance of [Earthworks] to the eyesores produced by industry, mining, and construction is not accidental," and that "these works constitute something like aesthetic indignities to nature."[16]

The lack of references to these articles in art publications suggests that these sentiments had no impact in the art world. And neither did anyone within the art world denounce Earthworks as having harmed ecological environments. Nevertheless, concurrent with Smithson's 1973 death, the non-movement quietly ceased, evolving into Land Art. Smithson's major patron, Dwan, had closed her gallery in 1971 and was very selectively funding projects. Robert Scull, patron of Earthworks by Heizer and Walter De Maria, had moved on to other interests. Private and public

223

funding was constrained by the sharp economic recession underway due to the Organization of Petroleum Exporting Countries' (OPEC) dramatic increase in the world price of petroleum and the United States' phased withdrawal from Vietnam. The major works of the early 1970s, De Maria's *Lightning Field* in New Mexico, Nancy Holt's *Sun Tunnels*, Robert Morris's *Observatory* near Amsterdam, and James Turrell's ongoing *Roden Crater* outside of Flagstaff, Arizona, are far less intrusive constructions on the land, characteristic of Land Art. Artists took up other areas of investigation, or they and emerging environmental sculptors (prominently, women such as Alice Aycock and Mary Miss) made works out of materials that sustained their permanence and that were largely funded by institutions, and/or were located in countryside areas closer to cities. The fact that such large-scale movements of earth were rarely done after the early 1970s cannot be attributed solely to lack of funding (in the past thirty years Turrell has received numerous substantial grants from private and public institutions for his endlessly unfinished *Roden Crater* observatory). It also suggests a consensual lack of interest since then in making such aggressive reformations of landscape and reflects increasing general concern for environmental deterioration caused by technology under human control.

Preservation

A more recent and unresolved ethical issue is Earthworks' institutional owners' responsibility toward these works, which, being unreinforced and untended degrade due to the forces of nature. The devolution is strikingly evident at the *Double Negative* because its design is centered on crisply cut geometric walls whose form strongly contrast to the organic irregularities of nature. Large boulders from the top of the mesa and the walls have fallen onto the ramps, presenting a jumbled pile between pocked walls. Photographs by Mark Ruwedel convey a dramatic ruin.[17] The Museum of Contemporary Art, Los Angeles, its owner since receiving it as a gift from Dwan in 1985, illustrates it as part of its permanent collection on its Web site in its deteriorated state, and there has been no public announcement or discussion of restoring it. This laissez faire position seems consistent with the artist's intention, as his *Double Negative* was not reinforced at the time it was made to prevent this inevitable decay.

By contrast, the *Spiral Jetty* has experienced much more extreme changes in its immediate environment but has deteriorated less. Due to the long, several-years' cycles of the rising and falling of the Great Salt Lake's water table, the *Jetty* has been submerged for extended periods.

Elaine A. King

Documentation of students exploring *Spiral Jetty* (1970, Robert Smithson) on May 26, 2005, in Great Salt Lake, Utah. Carnegie Mellon University professors Elaine A. King and Ruth Stanford organized a special summer course titled *Earthworks and Sacred Sites*.

More recently, as the result of a several-years' drought, the water level in its shallow Rozel Point Bay receded to out beyond it, and the *Jetty* was dry and landlocked for a couple of years—a white coil with protruding black rocks on a white salt bed with pink water breaking through in places.

In early 2006, it is in low water. Its fifteen-foot-wide, 1,500-foot-long path has not altered in shape—probably due to its strong basalt rock edging. The salt water covering did exaggerate the effect that Smithson anticipated solely along the path's edges when he designed the work and sought legal right to lease the land it is on, that salt crystals from the saline water would form white incrustations that would contrast with the water's red color. (The name "Rozel Point" refers to the roseate hue of the water due to the site's interaction of algae, bacteria, and saline water, enhanced by the regular molting of reddish brine shrimp.) Instead of being a black basalt path edged with white frosting, the entire surface of the *Jetty* accrued a glistening white crust. This actually increases its contrast to the

red sea in which it sits, contradicting the thrust of entropy toward structural simplification.

The Dia Art Foundation, which acquired Smithson's *Spiral Jetty* in 1999 as a gift from the Smithson estate, believes otherwise. "'The spiral is not as dramatic as when it was first built,' stated Michael Govan, the then-director of the Dia Art Foundation in New York City. 'The *Jetty* is being submerged in a sea of salt.'" This quotation is part of a news article by *Salt Lake City Tribune* journalist Melissa Sanford that is posted on the Web site hosted by the Smithson estate. Sanford further notes that the Dia Foundation has surveyed the land area and discussed "raising it by adding more rocks. Dia is also studying whether nature will restore the contrast the *Jetty* originally had with its surroundings by dissolving some of the salt crystals when the lake's waters rise, or whether the foundation needs to do something more."[18]

Add black rocks atop the white? Scrub the encrusted rocks? Either act would be contrary to Smithson's intentions as articulated in his own writing to his letter requesting the lease of the land: "The purpose of placing the rock on the mud flat area will be to induce salt crystals on the rock and gravel as incrustations that will develop over a period of time. These will contrast with the red color of the water. Its purpose is purely aesthetic."[19]

Art historian Robert Hobbs reported, as per information from Holt, that "after 1972, when the *Jetty* was under water, [Smithson] in fact planned to build it higher if the water level of the lake did not recede."[20] But since he didn't, should it be done on behalf of the artist, to ensure the *Jetty* accessibility to future generations? There seem to be three reasons militating against that admirable goal. First, its present, salt-covered state does actualize the artist's written intentions as quoted above, and the curving pathway has not deteriorated. Second, Smithson was intellectually and emotionally engaged by the debilitated rather than the edenic, paradisical state of nature. To explain this proclivity, he described "the classical idea of making a piece of sculpture. . . . The idea is to take a block of marble and then chip away until you find this form or structure within there. Well I'm more interested in the chips, the things that are disposed of." Asked to explain, he said, "I think [the chips] correspond more to our constant state of disintegration, which I think is more fundamental than any attempt to build up some kind of object."[21]

Statements by critics on this issue agree that the *Jetty* should not be bolstered. In *Artforum* in 1994, Jean-Pierre Criqui stated flatly, "The jetty's vicissitudes, then—disappearance, reappearance, transformation—are

clearly relevant to the nature of the work as it was conceived by its author. Any attempt to restore or to reconstruct it would run counter to its concept."[22] A decade later, in Sanford's *Tribune* article quoted above, Robert Storr asserted, "Earthworks were not made to last forever. There is a danger when restoring them to make a more perfect thing than was originally done." The Summer 2005 issue of *Artforum* noted in passing the issue of "potentially raising the level" of the *Jetty*, suggesting that it is still under discussion, but the Dia Foundation says only that the situation is being monitored and is under discussion.[23]

The third reason not to posthumously alter the *Jetty* is that one may violate what the artist would have wanted. "Smithson had something to do with every rock out there," declared Bob Phillips, the contractor Smithson hired to work with him to build the *Jetty*. "It would not be the same thing if somebody else monkeyed around with it. It would no longer be Smithson's work."[24]

That is what happened with Smithson's *Broken Circle*, which the Dutch government restored and reinforced by applying a wood framework along its edges to stabilize and protect it from deterioration in the commercial sand quarry's pond. In contrast to its original state, the rigidity of the wood channel that the earth is within looks distinctly artificial and unlike Smithson's organic integration of rock and water. The separation presents a purity contrary to Smithson's view of nature, for he wrote, "The image of the lost paradise garden leaves one without a solid dialectic, and causes one to suffer an ecological despair. Nature, like a person, is not one-sided."[25]

Posthumous Smithsons

And yet another ethical issue that pertains exclusively to works by Smithson, but goes beyond their identity as Earthworks, is that of the Smithson estate's posthumous creation of two works by the artist. Reports of his death in July 1973 indicate that the work eventually titled the *Amarillo Ramp* had been staked out in a shallow lake when the small plane Smithson and a photographer were viewing it from crashed into an adjacent hillock, killing them and the pilot (everyone aboard). The work was completed by his widow, the artist Nancy Holt, along with Tony Shafrazi, then an artist (subsequently a major art dealer), who had brought Smithson and Holt along on his own planned visit to his potential patron Stanley Marsh outside of Amarillo, Texas (after they encountered each other at the Whitney Museum's Independent Study

program, held that year in Albuquerque, New Mexico) and by sculptor Richard Serra. While staying at Marsh's house, Holt and Shafrazi had had several days' conversation with Smithson about the Amarillo work's design and had been up in the plane previously to observe its progress, and Serra had visited Smithson and Holt at the site of the Spiral Jetty when that was in process.

Nevertheless, being only staked out in water, Smithson's environmental sculpture was in a very rudimentary stage when after his funeral Holt, Shafrazi, and Serra took up working on it. The water level had risen, making the posts unstable and construction difficult, and it was necessary to drain the artificial lake by cutting open a dike. They then built the work on the dry lakebed. Its form arcs into an almost-complete circle, and the path increased in width to ultimately about ten feet across as its elevation rose from ground level at the end nearest the shore to a height of twelve feet at its crest, at the head of the arc in the lakebed. When complete, it was photographed with the lakebed dry, and that is how it became known, rather than as a work emerging upwards from the water as Smithson imagined it. And given that he was planning for it to rise out of the water, he probably had not determined in advance of its construction the angle of the sweep upward or the ramp's culminating height. Two published drawings of the *Amarillo Ramp* show a much longer, thinner form than the one photographed soon after it was made.[26] The extent to which Holt, Shafrazi, and Serra made structural decisions in the creative process of this work's constructions suggests that their work can accurately be described as more an act of creation than of simply technical enactment or completion of another's articulated design and plans. As this work is on private land, cannot be sold, and is not open to the general public, the benefit of designating this work a "Smithson" rather than a "Smithson, Holt, Shafrazi, and Serra" was not economic. It must have been more one of prestige, both to the landowner and even more to the reputation of the artist. Since then, each of Smithson's posthumous collaborators has become well-accomplished and known, actually adding aesthetic value to the *Amarillo Ramp*. It is presently in a fairly degraded state, losing height, flattening out, and with irregular plant covering.

In literature on Smithson, the authorship of the *Amarillo Ramp* is identified as solely Smithson. For historical parallels, when a collaborative process is substantiated regarding paintings produced by dual artists or an artist's assistants, or the artist's own hand is not substantiated, the work is attributed to those who actually engaged in the process of

making it, or more generically the attribution is to the artist's "work-shop." Yet no one has challenged the proper "authorship" of *Amarillo Ramp*. It now seems surprising, but even I did not originally question the authenticity of work created on the basis of an artist's few sketches, conversations, and trial layout by three other artists who each had their own strong identities and who were collectively serving as artistic ventriloquists for Smithson.

Consideration of the issue of authorship regarding the posthumous creation of works attributed to Smithson was prompted by the more recent act by the estate of creating a work attributed to Smithson that had even greater distance from the participation of the artist. In conjunction with a large survey of Smithson's work at the Whitney Museum of American Art, the estate recently built a "Smithson" by extrapolating from his drawing *A Floating Island to Travel Around Manhattan Island* (1970). Holt and the Smithson estate (administered by the James Cohan Gallery in New York City) worked with the nonprofit organization supporting environmental art, Minetta Brook. The wooded landscape he sketched was created on a rented barge that was given new, artificially aged, steel siding. Diane Shamash of Minetta Brook selected borrowed selected boulders from Central Park and chose trees of species identified in the drawing and additional others. Nancy Holt worked with her directing the design of the plantings and arrangement of the rocks and had the blue tugboat hired to pull it painted red.[27]

The fact that the graphite drawing is without color is just a minor but telling detail indicating the extent that this transformation of a two-dimensional drawing into a environmental boat was an act of creation rather than actualization of the artist's ideas. The many preparatory drawings preceding the creation of the *Jetty* demonstrate the artist's evolving conceptualization from thinking of this work as a long arm with a short arc at the end, to one with a spiral of several turns. Several drawings preceded his large-scale asphalt and glue pours and his *Broken Circle/Spiral Hill* duo. The *Floating Island* did not spring from the artist's creative process and as such lacked authenticity.

This work's sweetly whimsical contradictions of "floating," "island," and "forest" seem alienated from Smithson's own deadpan, even dark, demeanor, manifested in the drawing by his designation of a "Weeping Willow" tree to be on his "island." And apparently no one recognized the parallel of his idea of a barge of forested earth to the ship carrying sand to desiccated continents that is the protagonist's base in Brian Aldiss's novel *Earthworks,* which Smithson wrote about purchasing before embarking on

his tour of the "monuments" of Passaic.[28] Again, the estate garnered no direct financial benefit from creating this work as it was dismantled after the few weeks that it circled Manhattan Island and its natural/organic matter was donated to New York City's Central Park. Instead, the creation of this "Smithson" by others, and the many lively receptions encouraging its viewing, suggested a vulgarization of his ideas into a pseudo-Smithson that served a publicity stunt to garner attention for the Whitney's exhibition and Smithson's oeuvre as a whole.

The history of Earthworks provides an art world correlate to what philosophers call "fallibilism—the sense that our knowledge is imperfect, provisional, and subject to revision in the face of new evidence."[29] Knowledge that we didn't have in the late 1960s about large-scale earthmoving's potential hazards to ecosystems parallels a shift in values toward less invasive procedures in nature (considered in the widest sense). Still appreciated for the boldness of artists' visions—*The Spiral Jetty* continues to be a pilgrimage site for international connoisseurs of contemporary art—the confident yet narrow perspective that produced such work in the late 1960s now seems as if from a bygone era of simpler certainties.

A rare, recent earthwork illustrates the altered ethics toward massively rearranged earth. The series of seven huge pyramidal flanges—36 feet high and 145 feet wide—of Scottish artist (and New York City resident) Patricia Leighton's 1991–1993 *Sawtooth Ramps* were built from soil excavated onsite for the construction of a corporate facility for Motorola, the commissioner of the piece. This sculptured environment has the characteristics of post-Earthworks Land Art in that it is located not in wilderness but near urbanization—along the highway connecting Glasgow and Edinburgh, Scotland—and its patron is institutional rather than private. The geometric forms are contained by layers of geotech reinforcement fabric throughout the compacted soil, which is covered by tightly sodded grass and kept closely trimmed by grazing sheep. The very mixture of aesthetic and ecological benefits of this sculptural environment shows much more social responsibility than the earlier "contemporary" earthworks.

Whether it is a style with nothing left to explore, or it is not fundable or ethical, the potential benefits of experiencing such Earthworks' massive earth sculpturing in the wilderness no longer attracts artists or supporters. Retrospective analyses of sculptors' engagement with earth, and the earthworks representatives' relation to these works, demonstrate changing views of appropriate ethics in regard to art, authorship, and the social identity of nature.

Endnotes

[1] Robert Smithson, "A Sedimentation of the Mind: Earth Projects," *Robert Smithson, Collected Writing*, ed. Jack Flam (Berkeley and Los Angeles: University of California Press, 1996), 110. This article was originally published in *Artforum*, September 1968.

[2] "Dennis Oppenheim Interviewed by Suzaan Boettger," conducted on July 12, 1995 for the Oral History Program of the Archives of American Art, 37.

[3] Howard Junker, "The New Art: It's Way, Way Out," *Newsweek* 72, no. 5 (July 29, 1968): 61.

[4] For a detailed art and social history, see Suzaan Boettger, *Earthworks: Art and the Landscape of the Sixties* (Berkeley: University of California Press, 2002).

[5] Philip Leider, "How I Spent My Summer Vacation or, Art and Politics in Nevada, Berkeley, San Francisco and Utah," *Artforum* 9, no. 1 (September 1970): 42.

[6] Bette Vinklers, "New York," *Art International* XIV, no. 3 (March 1970): 91.

[7] Jean-Louis Bourgeois, "Dennis Oppenheim: A Presence in the Countryside," *Artforum* 8, no. 2 (October 1969): 35.

[8] Leider, "How I Spent . . . ," 48.

[9] Junker, "Nitty Gritty," 46.

[10] Liza Bear and Willoughby Sharp, "Discussions with Heizer, Oppenheim, Smithson," in Flam, op. cit., 246.

[11] Robert Smithson, "Frederick Law Olmsted and the Dialectical Landscape," in Flam, 163, 164. This article was originally published in *Artforum*, February 1973.

[12] Allen J. Matusow, *Nixon's Economy, Booms, Busts, Dollars, & Votes* (Lawrence: University Press of Kansas, 1998), 207.

[13] Paul Toner and Robert Smithson, "Interview with Robert Smithson," April 4, 1970, in Flam 236–37.

[14] Smithson letter to Allen Overton, Jr., president of the American Mining Congress, dated July 13, 1972. Papers of Robert Smithson and Nancy Holt,

Smithsonian Institution, Archives of American Art [hereafter, RS & NH], reel 3833, frame 537. There is no documentation of a reply.

[15] Peter Humphrey, "The Ethics of Earthworks," *Environmental Ethics* 7, no. 1 (Spring 1985): 7, 9, 21.

[16] Allen Carlson, "Is Environmental Art an Aesthetic Affront to Nature?" *Canadian Journal of Philosophy* 16, no. 4 (December 1986): 637, 639.

[17] Photographs by Mark Ruwedel showing the condition in the early 1990s of several Earthworks are illustrated in his "The Land As Historical Archive," *American Art* 10, no. 1 (Spring 1996): 36–41 and on the cover.

[18] Melissa Sanford, "The Salt of the Earth," *Salt Lake City Tribune*, January 13, 2004, as given on *www.robertsmithson.com/essays/sanford.htm.,* mid-December 2005.

[19] Letter from Smithson to Charles R. Hansen, Director, Division of State Lands, Utah RS & NH, Reel 3833.

[20] Robert Hobbs, ed., *Robert Smithson: Sculpture* (Ithaca and London: Cornell University Press, 1981), 197.

[21] Willoughby Sharp interviewing Robert Smithson, undated audiotape (November, 1968?), in Willoughby Sharp Archives, published in Suzaan Boettger, "Degrees of Disorder," *Art in America* 86, no. 12 (December 1998): 76.

[22] Jean-Pierre Criqui, "Rising Sign: Environmental Artwork *Spiral Jetty*," *Artforum* 32, no. 10 (Summer 1994): 81.

[23] Anne M. Wagner, "Being There: The Art and Politics of Place," *Artforum* 43, no. 10 (Summer 2005): 287. Phone interview with Sarah Thompson of the Dia Art Foundation, November 2005.

[24] Quoted in Sanford, Ibid.

[25] Smithson, Olmsted, 161.

[26] *Robert Smithson: El Paisaje Entrópico, Una Retrospectiva 1960–1973* (Valenciana, Spain: IVAM Centre Julio González, 1993), 232, and *Robert Smithson, Retrospective, Works 1955–1973* (Oslo: The National Museum of Contemporary Art, 1999), 272.

[27] Author's conversations with Diane Shamash and Nancy Holt, September 2005.

[28] Robert Smithson, "A Tour of the Monuments of Passaic, New Jersey," Flam, 70. That was the title Smithson gave it; it was originally published in the December 1967 issue of *Artforum* as "The Monuments of Passaic."

[29] Kwame Anthony Appiah, "The Case for Contamination," *New York Times Magazine*, January 4, 2006, 38.

Unraveling the Ethics in Cultural Globalization

Robert C. Morgan

In traveling to points outside the mainstream of the art world—in Asia, Southeast Asia, South America, Eastern Europe, and the Middle East—I have observed and listened to the views of artists who express frustration with the manner in which contemporary art is marketed today. Most often, their complaints center on the exclusionary matrix of a few influential gallerists, art investors, and biennial commissioners who are actively engaged in the international art world. Trends in art are similar to those in fashion in that they are perpetually being generated and modified according to the precise stipulations of corporate advertising.

Ultimately, the promotional apparatus reflects strategies of investment or regional politics that have little to do with art. Artists who operate within this matrix function in the abstract like a system of logos. Like major corporations, their value fluctuates, often bereft of a context of significance. This is to suggest that art world logos like Jeff Koons, Matthew Barney, Damien Hirst, and John Currin—or any of their Chinese or European counterparts—function as advertising in a way not so dissimilar to Coca-Cola, Wal-Mart, Verizon, or Microsoft. Yet the need for a critical discourse that attempts to frame the significance of these artists' works in terms other than what the market has codified would be a necessary step in demystifying the impact of much of the rhetoric that is used to promote their investment status.

In my conversations with artists who work outside of this matrix, I am of the opinion that for them there is no real avant-garde or "cutting edge." Today's art world is a market-driven phenomenon in which quality

or significance is scarcely a factor. What was once the avant-garde in the West has finally collapsed under the overwhelming weight of kitsch—not genuine kitsch, but a kind of ironic pseudo-kitsch. Instead of the avant-garde being seen in opposition to this derriere-guard, as discussed in the famous Greenberg essay from 1939, the avant-garde suddenly became kitsch. What was once kitsch is now posing as the new avant-garde. In place of criticality, we are given cynical images, vapid episodes, simulated ornamental effects that go nowhere and hold virtually no aesthetic, let alone real conceptual value. The plethora of work being manufactured according to these non-criteria exists in diametric opposition to artists from the developing world whose concepts of art may hold a signifying value beyond the obvious veneer of marketing.

By the end of the 1970s, it was clear that the contemporary avant-garde—like other historical movements from Antiquity to Romanticism, from Impressionism to Abstract Expressionism—was not just something to collect, it was also something in which to invest; and because it was "con-temporary," there was an added advantage. Given the general uncertainty as to the meaning of quality in advanced art, this critical uncertainty could be easily manipulated by the media for the benefit of the market. In a period of high transition—or "globalization"—it would be an understatement to say that the commercial media has contaminated everything, including art. Thus, if art has any aspiration of redefining itself, either conceptually or aesthetically, artists cannot ignore that, for the present moment, what the public is told about art is essentially the media's view of art as determined by those willing to invest.

There is a distinction to be made between economic and cultural glob-alization. Each has a radically different approach to the evolving transcul-tural realities that have emerged over the past twenty-five years. Briefly, I see the distinction as follows: The more familiar usage of the term "globaliza-tion" is from the position of economics where corporate interests view the globe as a seamless unity, an encapsulated system of exchange as seen from the outside. Translated into art language, economic globalization is about fundamental bottom-line concerns that have little to do with aesthetic issues and opt instead to focus on art as a system of commodities with investment potential. In contrast, we have semi-indigenous cultures in various regions of the world overtly being altered through various forms of development fueled by economic globalization. For example, there are artists living in countries such as Indonesia, Morocco, Mali, Macedonia, Mongolia, or Iran who are seeking to communicate with artists in other parts of the world. Instead of looking from the outside in—as corporate business tends

to do—these artists are looking from the inside out, because they have no other access to communication, and therefore, no access to the art world as it has come to be defined as a system of investment commodities in the twenty-first century.

In contrast, powerful galleries, collectors, and international art institutions may speculate on economics as a means to contain culture, which is, in fact, a model closer to the Internationalism of the 1930s and is not related to the definition I have given to cultural globalization. Those who understand cultural globalization in purely economic terms and who continue to put emerging forms at the service of investment have little to do with ensuring the survival of living cultures that have little or no opportunity to participate in the international marketplace. In the Middle East, Southeast Asia, Africa, and South America, emerging forms from semi-indigenous cultures continue to evolve despite the ancient past that surrounds them. Those who live in the West, or who come from the West as representatives of various corporate interests, assume economic globalization to be the case. They do not see culture as a viable interest that has any relevance to their agenda. Their primary interest in culture is its disposability.

If there's a fourth-century Hindu temple in the way of "modernization," the assumption is that it will be destroyed by any means necessary to further develop the region. But living culture goes much deeper than ancient monuments. For the populations in these regions of the southern hemisphere who have learned to exist through toil for very little money, there is an inherent—instinctive—willingness to protect the indigenous quality of their lives. For them, quality is measured less in terms of materialism than how they spend their time, the rhythm of the day and night, the turn of the seasons, their inextricable proximity to nature as intrinsic to culture. Such indigenous values far outweigh their readiness to see developing interests from the West or Eastern Asia transform their lives into servitude under the auspices of culture tourism.

In recent years, some artists—often (not always) in exile from conflicted areas of the world—have reflected on issues of "identity politics" in their work. Once subjected to the pressures of the market, the work takes on the form of a simulated cultural identity. I would argue that this process has less to do with "identity" than with a global marketplace that operates according to consensus. While I am certainly not against the issues presented by exiled or emigrant artists such as Emil Jacir, Mona Hartoum, Walid Ra'ad, or the Indonesian artist Tiong Ang, I often question whether the identity issue is precisely the main issue or the most

important issue in their works. "Identity"—as discussed by graduate school theoreticians—has taken on an aura similar to "fragmentation" as the outset of the 1980s or "the body" as the outset of the 1990s. In contrast, I find the work of a lesser-known Palestinian, Tyseer Barakat, challenging in the way he sublimates the reality of his political and cultural circumstance into an intimate expression. Having seen Barakat's environmental sculpture, entitled *Father* (1997), in an exhibition entitled *Made in Palestine,* originally shown in an alternative space in Houston in 2003, I took note of its visual and conceptual power. The work was placed in a small dimly lit room. It consisted of an old wooden flat file with seven drawers. The viewer was invited to open the drawers of the file one by one and to see images burned into the empty drawers that faintly described various incidents in his father's life. As one moves through the drawers, the father's story unfolds—from his homeland, to his exile, to his placement in a refugee camp, to working in the field, and eventually to his death. This clearly conceived and emotionally moving narrative is both a personal account of his father and the story of what has happened in Palestine in recent decades. Through the intimacy of experience (yet not exempt from a disturbing allegiance to adverse ideology), Barakat explains what he understands as the reality of his existence. "Identity" is less the issue than the persuasive poetic means by which he transmits his experience to those both within and outside the Palestinian community.

On a modest level, Tyseer Barakat's work offers a contrasting perspective to the current trends that guarantee readymade admission into a global art market. When the art world defines itself according to fashion labels and political slogans, demanding conformity instead of reflectivity, art can no longer function as inner-directed or self-determined. Rather art becomes a matter of conforming to code words rather than to aesthetic criteria. In the current situation, artists are pressured into becoming cultural logos unwittingly inducted into a system of marketing that many would fear to avoid.

Never having met the artist and with no previous knowledge about him, Barakat's installation carries a certain intimacy with a family member, then carries a message to cultures outside of Palestine. Whereas logotypical artworks tend to avoid this kind of intimacy—possibly for fear of it— Barakat brings it into central focus. I see this approach as being in contrast to artists who focus more on the spectacle. This latter tendency is evident n some—but not all—works by Cai Guo Ciang, Do Ho Suh, and Doris Salcedo. As the spectacle in art has accelerated in recent years, it has moved well beyond the perimeters of the Western world and is now virtually

without geographical constraints. Some artists work with the spectacles in ways that do not give in to excess and allure as the sole ingredients. The recent work of Israeli artist Michal Rovner is a good example. Her *Fields of Fire* (2004–2005) with spouting torrents of oil burning in Kazakhstan was achieved by appropriating the spectacle into art in contrast to making art into a spectacle. This is not just a semantic play on words, but is based on a clear formal understanding of how to contain the content of ideas so as to sustain their meaning.

In such a random universe, artists struggling to adhere to a concept in their work may conclude that art has become everything that television is not. I have seen perfectly good artists from developing countries come to art schools in America where they are convinced by their American professors that to do well—indeed, to "make it" in the art world—they must focus their art on the problem of cultural identity, which usually implies their media image.

What is this identity problem? I think it begins with ideological pressures that evolve out of a frustration with art, a frustration that becomes over-determined to the point of vulnerability or an obsessive questioning of one's persona. In America especially, there has been the perennial pressure on foreign artists to conform to the latest trends, both academic and economic, and thus to replace self-effacement with an identity crisis. Artists coming into New York, including MFA students, are expected to augment a presumed loss of identity in order to make their work appear relevant. By offering a surface view of global politics, some artists appeal to the New York art media through carefully refined sound-bite maneuvers employed in the name of "identity politics." As these artists tend to avoid the more challenging complexities of individual experience, the concept of identity becomes little more than a series of manufactured emblems ready to conform to the latest academic theory.

But if the role of cultural globalization is to move us toward the center of a transcultural experience—the underlying alternative reality of our time—it must do more than rely on conformist spectacles. It must widen the gap beyond the "institutions of marginality" so endemic to the agenda of many art museums today. In one sense, we might speak of cultural globalization as a negation of the predictable art world trends to which too many museums, art schools, and related institutions conform. Rather than quasi-academic indulgence, cultural globalization should concern itself with how to translate concerns related to the practice of art in various parts of the world, including areas of cultural repression fueled by backward economic policies.

239

Outside of the triumvirate of art centers in New York, London, and Berlin, there are other models worth examining. For example, it is interesting to compare the community of Turkish artists working in Istanbul with those who travel regularly to Berlin and London. One can translate this situation as being a cultural rivalry between the conceptualists and academic modernists—the first coming from a global perspective, the second from an isolationist one. This rivalry is not only present in Turkey, but exists in artists' communities virtually throughout the world. I have seen similar rivalries in Indonesia and Korea, not to mention Poland, Israel, Argentina, and the Czech Republic. While one may recognize the potential for positive change, such provincial fractioning cannot help but problematize the way artists see their roles and how they continue to work. The separation of roles among artists cannot be avoided. Still, these economic and ideological factors will both directly and indirectly determine how much a role the Istanbul Biennial plays on the art world stage. The opportunity for a unique clarification of the conflicts and contradictions felt by artists in this area of the world could do much for showing the way to an expanded concept for cultural globalization.

At the moment, the art world stage appears dependent on the existing marketing strategies. An alternative form of cultural globalization suggests a redirecting of economic funding into cultural forms that ultimately give a structure to artists working independently in Istanbul and who are interested in developing communication with artists from other regions. Cultural globalization offers an incentive to organize exhibitions through exchanges from other regions of the world in order to engage with new cultural ideas that relate to individual histories and identities from the position of a real subjectivity. Again, there is real potential here—one that began with Conceptualism in the late 1960s, but was limited by the existing technology of the time. With the digital advances of recent years, artists have shown new possibilities by which to evolve ideas in art, not only with clarity and efficiency, but also through the richness of global diversity that is possible today. The aesthetic issue is still important in terms of the originality and substance of the ideas that artists choose to represent.

I see this richness in much East Asian art over the past few years. The quality of work in China, Korea, and Japan is variable, but some is unquestionably first-rate. Having spent four months in Gwangju (Korea) in 2005 as a Fulbright scholar, I was often overwhelmed by the precise intelligence and substance of emotional content coming from emerging artists such as Ham YounJoo, Nam Yoon Eung, Cho Yoon-Sung, Seo Hee Hwa, Hyun

SooJung, and Ja Young-ku. In each case these artists have arrived at a remarkable place in their bringing together material and concept into a form of transmission that is specific, yet without boundaries. But what all of these artists face is the problem of Western marketing and media. They need a conduit that can somehow detour the predictable ways of attracting attention, a means of support that does not impose conformity on the way their work is presented or communicating either within Korea or on an international scale. More attention needs to be given to balancing aesthetics with the conceptual value of art in order to establish a more serious critical discourse.

However, one cannot be naïve to the seduction of media attention and to the force of economic realities. Rather than transforming the route of economic globalization in art, I see a slippage into the same problems that the Western art world has endured for more than four decades. What some artists in China, for example, may not understand is how quickly reputations come and go once an artist buys into strategies of the artist rock star. I would suggest a slower course of action. Through patience, opportunity for digression, and a spirit of generosity, one might discover an alternative network by which to exchange ideas as an antidote to present-day cynicism.

The cultural issues of the future are not only how far we can go with artificial intelligence or genetic engineering or how small we can make mobile units of transmission. The scientific research community announced some years ago that chips have been developed that could fit inside DNA molecules. Is the essentialism of the technological research in science, removed from issues of human application, gradually becoming irrelevant? Not at all. Government-funded research now has the potential to create a new globalized aristocracy. Given recent political events, there would seem to be certain logic to this. But such arguments are contingent on many factors—namely, that in the context of human history, interventions toward survival exceed logic and are almost never predictable. Rather, they tend to happen irrevocably without notice. Relative to these concerns, a major issue for artists in this impending global/technical arena is how we are going to adapt the virtual world to the tactile world on the basis of everyday reality—including our emotional reality that is still fundamentally a tactile experience.

Human conscience must play a distinctive role in how we determine the ethical consequences of our actions in the future, and this, of course, will affect the future of cultural globalization. The role of art as a substantive and transformative force will only be realized if art liberates itself from

the pressure of corporate constraints that will determine its future. This is not to say that artists should ignore economic opportunities to further their ability to work and to succeed. This is not the point. It is a matter of seeing the larger picture from within the perspective of history, not only from the presence of the past but in the context of the present. If art continues to function solely according to the agenda of economic globalization without a clear cultural agenda, art will lose its significance and become a sideshow in the wake of commercial media. To invest in art may have a positive resonance, but I prefer the term "collecting" more. The connotation of collecting art is more personal, and therefore, more positive than merely investing in it. But if investment is the issue—as it appears to be—then it is important to address the art in those regions that are removed from Western lifestyles. Investment must also extend to those regions of the world and to those tactile forms of expression that exist outside of our perceptions of a global corporate hegemony. Art holds meaning for educated people who aspire to lead qualitative lives in terms quite different from the hegemony that aspires to neutralize reality in purely economic terms. This is where art becomes "ethical" and yet significant at the same time.

Law, Ethics, and the Visual Arts: The Many Facets of Conflict of Interest

Barbara T. Hoffman

Several years after becoming honorary counsel to the College Art Association (CAA),[1] I was visited at my office in New York by an English barrister who sought to retain me as an expert witness to testify on behalf of a Professor Frederick Hartt in his libel action against a newspaper in the United Kingdom. I was asked to provide an opinion that the ethics of art historians did not prohibit having a financial interest in works they write about and that accepting a fee and percentage for attributing an artifact was common among scholars in Italy and the United States.

Professor Hartt at the time was professor emeritus of art history at the University of Virginia, a distinguished scholar of sixteenth-century Italian art, and an eminent Michelangelo scholar. The libel involved two articles published in the *Independent*, a British newspaper, about Hartt's attribution of a seven-inch broken statuette as being a model for Michelangelo's *David*. In May 1986, the professor, who lived in Charlottesville, Virginia, was contacted by the agent of Michel de Bry, a Paris art dealer who wanted his opinion on the statuette, thought by some to have been the preparatory model for the *David*. The articles claimed that Hartt had been reckless in authenticating the work. Professor Hartt was later to remark, "On the basis of the photographs alone it seemed extremely convincing, crushingly so." De Bry agreed to pay Professor Hartt's travel expenses and a fee of one thousand dollars for his opinion and

a percentage resulting from attribution. Professor Hartt then traveled to Paris to examine the statuette, and said that within the hours of seeing the work he felt certain it was a Michelangelo.

Hartt made a detailed, scholarly, and careful analysis of the statuette and orally attributed it to Michelangelo. By a contract with Mr. de Bry, he agreed to write a book about the attribution and promote his attribution to enhance the value of the statuette in return for 5 percent of the sale price of the statuette or US$2.5 million, whichever was higher.

He agreed to keep his financial interest secret and concealed it when in 1987 he publicly announced that the statuette was Michelangelo's lost model for *David* and published his book.

Hartt in his libel action claimed that the stories—which revealed he was to receive a percentage of the value of the model should it ever be sold—implied that he was motivated by avarice and did not honestly believe the model was by Michelangelo when he declared it to be so.

The *Independent* contested the action, saying the articles were not capable of bearing that meaning, but justifiably implied the professor had broken with the general custom and ethics of his profession by obtaining a financial interest in the model.

The newspaper argued that the articles were also justified in implying that he had wrongly concealed his interest in the work; had sacrificed his scholarly objectivity for financial gain; that there were reasonable grounds for suspecting he had been reckless or dishonest in his attribution; and that in his book he had not assessed objectively the evidence as to whether or not the statue was by Michelangelo.

The solicitor for the professor argued that it was unreal and hypocritical to suggest art historians should not benefit from their work when other professions received fees and percentages.

I declined to act as an expert witness on Professor Hartt's behalf because I believed, as will be discussed more fully, that his actions were in conflict with the Code of Ethics for Art Historians adopted by the CAA (CAA Code of Ethics).[2]

In *Hartt v. Newspaper Publishing P.L.C. Queen's Bench Division* (1989),[3] Justice Morland found in favor of Professor Frederick Hartt, in a fifty-one-page written judgment concluding that there was a clear distinction between a gross breach of professional ethics involving disreputable, dishonorable, and deceitful concealment of the percentage, and the attack on him as a man and a scholar in the honesty of his attribution.

In his Lordship's judgment, "Professor Hartt had been exposed as a person who, despite his eminence as a Michelangelo scholar, has prostituted

his genuinely held scholarly attribution of the statuette for a disreputable venture with a person such as Mr. de Bry. . . . The mischief caused by the professor was that the attribution was being peddled by the means of the promotion contract which resulted in the enhancement of the statuette's value."

Justice Morland concluded that "an art historian acting honorably should know that it is wrong to take a percentage of the valuation of a work of art in consideration of his attribution, particularly if that percentage and the existence of a payment by a percentage was concealed. Museum directors and potential buyers would assume that the scholar's attribution was made disinterestedly and place greater weight on it. Professor Hartt did realize he had made an awful mistake and why. He was deceiving the art market."

Professor Hartt was entitled to damages for libel of the two newspaper articles that bore the defamatory meanings that there were reasonable grounds for suspecting that he had acted dishonestly or recklessly in making the attribution and that he had not assessed the evidence objectively, since those meanings were not justified and were not fair comment. The fact that Hartt acted dishonorably and unethically was relevant only to reducing the amount of damage awarded.

As discussed in previous chapters, accusations of conflict of interest also swirled about the *Sensation* exhibit at the Brooklyn Museum of Art, New York in 1999.

If the art world jumped to defend the First Amendment rights of the museum to exhibit Chris Ofili's *Virgin Mary*, they were less supportive of the museum's decisions regarding sponsorship of the exhibition. Questions about financing, undue influence, and possible conflict of interest in staging the exhibition generated fierce debate about the ethics of the museum's trustees and director Arnold Lehmann.

The art in *Sensation* was owned by Charles Saatchi, who also contributed $160,000 anonymously to the Brooklyn Museum, and Christie's was a show sponsor. Both Saatchi, a collector of the work and an important client of Christie's, and Christie's, as a promoter and financial supporter of the exhibition, stood to profit from enhanced commercial value for the art from the public exposure of the young British artists in *Sensation*.

Both Saatchi and Christie's denied they had acted inappropriately, Christie's stating that "nothing in this exhibition is for sale, nor is there any expectation for any of the works from the exhibition to be sold by Christie's."[4]

Following further disclosures after the *Sensation* exhibition that some museums, like dealers, request a commission when art they are exhibiting is

sold, museums in various parts of the country pleaded not guilty or said that they had stopped the practice and eliminated any such practice from their loan agreement.[5]

Prompted by the debate, the American Association of Museums (AAM), an association of 3,000 museums and 11,400 museum professionals, adopted new guidelines to address a set of basic conflicts that affect all museums.[6]

The guidelines recognize that "art makes its way to museums in ways that are often labyrinthine, closely caught up in the politics of power and money, the push and pull of international markets, individual collectors and powerful patrons. The public has had no way of knowing whether an exhibition of borrowed objects represented the best artistic judgment of the professional curators, or was staged at the behest of hidden donors." Thus, the guidelines urge avoiding even the appearance of a conflict of interest when accepting the loan of art for an exhibition. They also say the museum should maintain full authority in deciding which artworks to accept on loan and how they should be displayed.[7]

Perhaps one of the most well-known art world cases involving conflict of interest is *In re Rothko*.[8] Mark Rothko, an internationally recognized Abstract Expressionist painter whose works gained for him an international reputation of greatness, committed suicide on February 25, 1970. The principal asset of his estate consisted of 798 paintings of tremendous value. The conduct of his three executors, all of whom he considered trusted friends, in their disposition of these works of art led to a lawsuit based on their "manifestly wrongful and indeed shocking" conduct.

Rothko's will was admitted to probate on April 27, 1970, and letters testamentary were issued to Bernard J. Reis, an officer and owner of Marlborough; Theodoros Stamos, a friend and struggling artist; and Morton Levine, a friend and professor at Fordham. Hastily and within a period of only about three weeks and by virtue of two contracts each dated May 21, 1970, the executors dealt with all 798 paintings.

By a contract of sale, the estate executors agreed to sell to Marlborough AG (MAG), a Liechtenstein corporation, 100 Rothko paintings as listed for $1.8 million—$200,000 to be paid on execution of the agreement and the balance of $1.6 million in twelve equal interest-free installments over a twelve-year period. Under the second agreement, the executors consigned to Marlborough Gallery, Inc. (MNY), a domestic corporation, "approximately 700 paintings listed on a Schedule to be prepared," the consignee to be responsible for costs covering items such as insurance, storage, restoration, and promotion. By its provisos, MNY could

246

sell up to thirty-five paintings a year from each of two groups, pre-1947 and post-1947, for twelve years at the best price obtainable but not less than the appraised estate value, and it would receive a 50 percent commission on each painting sold, except for a commission of 40 percent on those sold to or through other dealers.

Kate Rothko, the decedent's daughter, then nineteen, and a person entitled to share in his estate by virtue of an election under New York's Estates, Powers, Trust Law 5–3.3, instituted a proceeding to remove the executors, to enjoin MNY and MAG from disposing of the paintings, to rescind the aforesaid agreements between the executors and said corporations, for a return of the paintings still in possession of those corporations, and for damages. She was joined by the guardian of her brother Christopher Rothko, likewise interested in the estate, who answered by adopting the allegations of his sister's petition and by demanding the same relief. The attorney general of New York, as the representative of the people of New York, the ultimate beneficiaries of the Mark Rothko Foundation, Inc., a charitable corporation and the residuary legatee under the decedent's will, joined in requesting relief substantially similar to that requested by the Rothko children.

The trial court, finding for the children, held that the appreciated value of the paintings at the time of trial was the measure of damages for the unreturned paintings. The court held that, due to the conflict of interest of two of the executors between the estate and the galleries, there was a breach of duty and trust to the estate. The third executor breached the trust by failing to exercise ordinary prudence in view of the others' divided loyalties. The use of the formula using appreciation damages was proper where estate assets were sold below value as a result of the conflict of interest. The case was affirmed by the Court of Appeals.

In *Rothko*, the prohibition against self-dealing was sourced in the law, not in a Code of Ethics. Under New York law, a trustee or an executor are fiduciaries. An executor must not be involved in self-dealing of any kind or nature, must avoid all conflicts of interest, and must not violate the duty of loyalty to the estate.[9]

The above examples introduce us to situations involving conflicts of interest that may occur in distinct if not entirely hermetic spheres of the art world: art historians and other experts esteemed for their connoisseurship and related ability to attribute, authenticate, or appraise the value and/or quality of the art object; the museum and director and board of trustees, many of whom may be collectors, and the dealer, artist, and collector. The Rothko case occurs technically and significantly in a fourth sphere, that of the administration of the artist's estate, discussed more fully in chapter 11.

A working definition of the concept of conflict of interest is provided in the glossary of the ICOM Code of Ethics for Museums, whilst numerous other codes provide definition of conflict of interest by example and cure. The ICOM Code of Ethics defines a conflict of interest as "the existence of a personal or private interest which gives rise to a clash of principle in a work situation, thus restricting, or having the appearance of restricting, the objectivity of decision making."[10]

Law and Ethics

The above examples implicate two different types of conflict of interest: financial and those sourced in a legally imposed duty of loyalty arising from a position of trust. They also provide insight into the relationship between legal and ethical rules. The former are in the form of international, federal, state, and local legislation and case law precedent whilst the latter are most often embodied in Codes of Ethics.

A Code of Ethics principally codifies the common understanding in a profession of ethical behavior. For example, the CAA Code of Ethics states that it codifies the common understanding in the art history profession of ethical behavior for scholars, teachers, and curators of art historical materials ("art historians").The Code provides a broad framework of rules of professional conduct and both requires and prescribes conduct as well as stating general ethical values. The Code does not, at the present time, include provisions for its enforcement.[11]

The Code of Ethics for Museums provides in pertinent part:

> Museums in the United States are grounded in the tradition of public service. They are organized as public trusts, holding their collections and information as a benefit for those they were established to serve. The law provides the basic framework for museum operations. As nonprofit institutions, museums comply with applicable local, state, and federal laws and international conventions, as well as with the specific legal standards governing trust responsibilities. This Code of Ethics for Museums takes that compliance as given. But legal standards are a minimum.

While ethics may influence the elaboration of a legal rule or legislation, as, for example, the Native American Graves Protection Act or the UNESCO 1970 Convention on the Means of Prohibiting and Preventing the Illicit

Import, Export, and Transfer of Ownership of Cultural Property, or even articulate the same principle as a legal rule, ethics as such are not legally binding and the violation of an ethical code without more, should not give rise to a cause of action nor should it create any presumption that a legal duty has been breached. In fact, no court explicitly has recognized a private cause of action based solely on a violation of an ethical code. This lack of legal enforceability does not prevent codes from asserting a "peer group pressure" or courts from using codes of ethics as the basis for establishing standards of care and duties that have legal implications in other civil actions.

The most recent AAM Code of Ethics for Museums requires members of the Association to frame their own specific codes of ethics that must conform with the general AAM code. Although these codes aim to ensure the ethical behavior of member institutions and their employees, they legally cannot bind the museum any more than the general code can, unless they become part of the corporate bylaws amounting to a binding contract.[12] On the other hand, a museum board of trustees can be placed in a situation of scrupulously following its legal responsibilities and exercising good faith on informed judgment, only to have its actions labeled "unethical."

Hartt's ethical infractions did not constitute a violation of law; nevertheless, such unethical conduct did serve to reduce damages stemming from defamatory injury to his reputation. A different situation might pertain if on the same set of facts he advised a client on the purchase of the statuette and the law imputed a trust (fiduciary) relationship between Hartt and the client.

Only occasionally has an art expert been held to be a "fiduciary" of his client, that is, to be in a special relationship of trust and confidence. This imposes a duty to fully and fairly disclose all facts that materially affect the client's interests, and to refrain from making secret profits or otherwise acquiring an interest adverse to the client.[13]

For those of us familiar with the art world, conflict of interest or apparent conflict of interest may appear to be a way of doing business.

Recognizing the unique practices of the art world and its tolerance of such conflicts, Hilton Kramer, art critic of the *New York Observer* remarked, "Art dealers, who often exert tremendous influence on collectors, naturally have a vested interest in flattering the taste of their clients. Museums, which likewise have a tremendous influence on collectors, have a vested interest in flattering the taste of their donors. Art critics, art historians and now what are called art consultants have also been known to be encumbered by similar conflicts of interest. . . . I frankly don't know of any better way for the art world to function."[14]

249

Art Experts and Conflict of Interest

Art historians and other art experts may be placed in any number of conflict of interest situations, including those that may arise out of authentication, acquisition, and appraisal of works of fine art, and the increasingly blurred and porous boundaries between art critics and curators.

The CAA Code of Ethics in Article IV provides in pertinent part:

In cases where an art historian is asked to render professional judgments on works, it is imperative that reasonable disclosure of an art historian's relationship to a seller, art dealer, auction house, etc., be made.

A. To avoid conflict of interest situations, CAA recommends that art historians set fees for attribution and connoisseurship at a fixed fee reasonable for the services provided rather than at a percentage of the sale price of the work of art. . . . It is unethical for an art historian to engage in attributions and/or the publishing or exhibiting of works of art if the art historian or his or her university or other employer has a vested financial interest in selling, brokering, or seeking tax deductions regarding such works, without full disclosure on the part of the art historian of his/her personal financial involvement (other than normal salary and curatorial remunerations) in the said dealings.[15]

This article of the Code was revised in 1995 and was the product of thoughtful debate. The section is careful to separate what is required to avoid the appearance of a conflict and what is mandated ethically. The last sentence apparently condemns Professor Hartt's behavior.

Article IV of the CAA Code deals with the Acceptance of Gifts. That article is based on the principle that an art historian's sole professional debt to another person shall be on an intellectual basis. Gifts from donors to the art historian's institution are treated more liberally. "A more difficult situation" is one in which an art historian is offered the gift of a work of art by an artist who is a friend, or about whom he or she will be writing or has written.[16] The CAA in that situation recommends refusal of the gift.

Subject to restrictions of Article 4 and Article 5, the CAA Code of Ethics is silent on the collecting by art historians of artists in their area of expertise or the authenticating of their work.[17]

No doubt as a result of the mission of the museum and the function of its director, the ethical standard regarding financial conflict of interest is set forth in the Code of Ethics of the American Association of Art Museum Directors (AAMD Code of Ethics) and is not identical to that of the art historian; however, what appears to be a more rigid standard at first read is made more nuanced by words such as "undisclosed" and "uncompromising."[18] A museum director is prohibited from appraising or authenticating works of art for a fee.[19]

A financial conflict of interest in both the authentication and appraisal process arises from the possibility of market manipulation. This, as well as other possible conflicts, has not been adequately explored in the area of a catalogue raisonné. A catalogue raisonné is a systematic listing of all known works by an individual artist, usually presented in chronological order and accompanied by details such as date, medium, dimensions, provenance, references, and sometimes exhibition history. What distinguishes catalogues raisonnés from the studies is the inclusion of a work-by-work itemization.[20]

Michael Findlay, former director of Acquavella correctly observes,

> Interested parties may be involved in the preparation of a catalogue raisonné—a living artist, for example, who actively collaborates with the authors. . . . An artist's dealer, estate or the foundation established by the estate can also be a participant, as in the catalogues raisonnés of Willem de Kooning, Andy Warhol, and Roy Lichtenstein. A catalogue raisonné can profit from this kind of collaboration, since most vital information is available only from the artist's principal dealers and the estate. But if the catalogue is prepared solely by these parties, it may be less than entirely objective. One of the functions of a dealer, after all, is to profit from the artist's work, and one of the functions of the artist's estate or foundation is to further the artist's reputation. To avoid such conflict of interest, the primary author(s) should have no stake in the relative value or popularity of the artist's work, no motivation to exclude works of minor importance or lesser quality, or to promote some works with color reproductions while relegating others to black-and-white.[21]

Similarly, conflict can also arise when an expert both deals in the works of a particular artist and authenticates them as the holder of the

artist's "moral right" of paternité. In a case involving Michael Findlay, *Findlay v. Duthuit,*[22] Marguerite Duthuit, the daughter of the French artist Henri Matisse, issued certificates of authenticity for Matisse works pursuant to *"droit de la paternité,"* that is, the right to prevent the artist's name from being used in conjunction with a work of art that he did not create. At the same time, she collected and sold the works of her father for her own account. In 1978 she denounced as a fake a certain Matisse previously believed to be authentic. Findlay sued her in New York state court for damages, alleging that Duthuit was attempting to manipulate the market for Matisse works by disparaging a work in the hands of a rival dealer. The case was dismissed for lack of personal jurisdiction over the defendant, who resided in France; however, the dissenting judge would have permitted the case to go forward based on the fact that Madam Duthuit is also a major collector and seller, in the international arena and in the United States, of the works of her father for which she issues certificates of authenticity, and her ability to manipulate the market through authentication created a potential conflict of interest position with respect to works of her father that are sold by rival dealers.[23]

The CINOA Guidelines to which all of the major U.S. dealer associations belong focuses on the illicit trade in art and antiquities, thus, tacitly endorsing at least in principle the UNESCO Code of Ethics for Dealers in Cultural Property. The CINOA Guidelines do not set forth a position on financial conflict of interest.

Although this might suggest that there is no consensus or ethical norm in this regard, the first substantive order of business taken up by the Art Dealers Association of America, following its inaugural meeting on March 2, 1962, was the establishment of a mechanism for providing honest and professional appraisals of donated art and a code is currently under consideration.[24]

The 1984 Tax Reform Act includes a number of financial conflict provisions directed at art dealers and experts who appraise fine art for charitable deduction purposes.

Two of the three major U.S. appraisal organizations that include fine-art appraisers in their membership expressly state that the appraiser has trust (fiduciary) obligations and make "absolute fidelity to the client's interest" a primary goal.[25]

At the other extreme with respect to financial conflict of interest are certain professional art consultants. Hilton Kramer has observed the professional art consultant has a built-in conflict of interest since such consultants normally work on a commission basis. The art consultant, a relatively new

profession, arose in the 1970s to assist corporations, professionals, collectors, law firms, and others who wished to acquire "serious" art for the office or home. Several lawsuits have been brought against such consultants. For example, in 1989, actor Sylvester Stallone sued his New York art consultant for $5 million, alleging she induced him to overpay for a "masterpiece" by nineteenth-century French painter Bougeureau on which she collected a 5 percent, $85,000 commission. The complaint alleged that Stallone purchased the oil painting sight unseen for $1.7 million on the consultant's advice, only to find that it was damaged, heavily restored, and worth only a quarter of what he paid.[26] Although the case was apparently settled to Stallone's satisfaction, Stallone would probably not have prevailed on a claim based on conflict of interest absent fraud, negligence, negligent misrepresentation, or some theory of contract, unless the consultant was considered to be in a special trust relationship with the client.

Normally, a court would not find such a relationship unless the consultant is found to be an "agent" of her client. An agent is one who represents another, called a principal, in dealing with third persons. In such case as previously noted, the consultant would be obliged to refrain from making secret profits and obliged to disclose all relevant facts from the client.

The difficulty of establishing that an art consultant has a special relationship is confirmed by the case of *Fenton v. Freedman*.[27] The consultant had agreed to advise her clients as to which artist's paintings were good investments and to assist them in locating and purchasing suitable artworks at the "best prices." After a work of art was selected, the consultant would purchase it from a dealer or gallery for her own account, then resell it at a profit to the clients without indicating the amount of the original purchase price. The court stated that although the clients relied on the consultant's discretion and expertise, they did not control her activities except to reject or accept her recommendations. The court therefore concluded that she was not an agent but an independent contractor with no special fiduciary or trust duties since allegations of superior knowledge or expertise in the art field are per se insufficient to establish the existence of a fiduciary relationship. Neither was the fact that the clients bought numerous pieces of art from the consultant over the course of two years sufficient to establish a trust relationship between them in a commercial transaction.[28]

If only under extraordinary circumstances, the dealer/collector or dealer/ purchaser relationship may be deemed to create a principal/agent, thus, trust relationship, by virtue of various states' artist-dealer consignment laws,

whenever an artist transfers artwork on consignment to a dealer for purposes of sale, display, and exhibition, the dealer becomes the artist's agent and a trust relationship is created.[29]

The primary implication derived from this characterization is that the art becomes trust property and proceeds from its sale are trust assets, subjecting the dealer to a higher standard of care. Failure to properly account for trust property may be embezzlement and may also provide a basis for a claim of unjust enrichment.

Although it is also generally stated that the relationship between the consignor and auction house is one of trust, "the auctioneer stands as an agent on behalf of the consignor with an obligation to act in the utmost good faith," the normal fiduciary standard, including the duty of undivided loyalty is not sacred.

In the case of *Greenwood v. Koven*, the court, although acknowledging that an agent such as Christie's was required under the law to act in a fiduciary capacity on behalf of its consignor-principal, noted, "the duty of undivided loyalty, however, is not the only pertinent principle. Equally relevant is the principle [citing the Restatement (Second) of Agency, section 387 (1958)] that the terms of an agency relationship may be modified by contract."[30]

Museum Trustees and the Duty of Loyalty

Most museums are organized under state law as either a charitable trust or a nonprofit corporation. Directors/trustees are charged with the management of the institution. In the first instance then, state law fiduciary principles impose upon a museum's trustees and officers a duty of care and a duty of loyalty to abide by the laws, ethical codes and internal rules and regulations that govern the institution. "The first responsibility of any nonprofit board is to comply with all laws, treaties and international regulations," says Edward H. Able Jr., president and chief executive office of the American Association of Museums (AAM) in Washington, D.C. "Board members need to be certain that procedures are in place to ensure that the organization is acting in compliance with the laws."

Most museums normally will also have obtained tax-exempt status as a charitable 501(c)(3) organization under the Internal Revenue Code. The IRS can impose prohibitive excise taxes for self-dealing. The exempt status prohibits "private inurement," excess benefit transactions, and acts of self-dealing or private benefit to directors and trustees. This prohibits certain relationships and transactions between a museum and its trustees or officers.

The art museum, a hybrid of charitable corporation and trust, presents truly singular problems for museum professionals and trustees. Confusion about the legal roles and duties of museum trustees persists among museum professionals, who often mix terms and titles from corporate and trust law to describe various leadership positions and institutional practices.

In the early seventies and mid-eighties, courses on museums and the law and the administration of museums such as the ALI-ABA Annual Course on the Legal Problems of Museum Administration often had presentations dealing with the liability of museum trustees for breach of fiduciary duties.

In part, the popularity of such discussions was provoked by two developments. On the one hand, changes in attitude about proper museum ethics led the attorney general in New York and other states to investigate and prosecute trustees' misfeasance involving breach of fiduciary obligations, often including deaccessioning.

The Museum of the American Indian-Heye Foundation, at the time of its deaccession controversy, held the largest collection of Native American art in the world.[31] Allegations of the Museum director's breach of the public trust prompted Attorney General Lefkowitz to investigate the "'surreptitious and wasteful' way in which artifacts from the museum's collection were either sold or given away."[32]

Self-dealing polluted the museum and its board. The attorney general found that a number of artifacts deaccessioned by its director were in fact purchased by trustees of the museum through the museum's gift shop. Another deal provided substantial tax benefits for a trustee who received artifacts and overvalued tax deductions in exchange for gifts of other artifacts to the museum.

In January 1973, Attorney General Lefkowitz opened an inquiry into legality of sales by the Metropolitan Museum of the de Groot bequest. Lefkowitz was concerned primarily about whether works of art that the museum was disposing were held subject to restrictions against such disposition, and if there were no restrictions, whether sales were provident, prudent, and reasonable.

Investigation revealed that in early 1972, the Metropolitan Museum sold de Groot paintings to dealers on sealed bids at undisclosed prices.[33]

The Metropolitan Museum and Lefkowitz arrived at an agreement, which included adopting guidelines for deaccessioning as well as an agreement by the Metropolitan to sell works of art only through public auction.

On the other hand, U.S. courts were considering the hybrid quality of nonprofit corporation and endeavoring to decide whether the strict

standard applied to trustees of a trust or the "business judgment rule" of the for-profit corporation should apply to museum trustees.

Justice Cardozo articulated the classic fiduciary obligations of a trustee almost eighty years ago in *Meinhard v. Salmon* when he stated, "Many forms of conduct permissible in a workaday world for those acting at arm's length, are forbidden to those bound to fiduciary ties. A trustee is held to something stricter than morals of the market place. Not honesty alone, but the punctilio of an honor the most sensitive, is then the standard behavior."[34]

Following the decision of the Court in *Stern v. Lucy Webb*,[35] courts tend to measure a nonprofit trustee's duty of care by the more lenient "business judgment rule" applicable to directors of for-profit corporations. Courts have participated in this "hands off" business judgment approach to the trustees of nonprofit corporations, stating that "if the trustees act within the bounds of reasonable judgment in the exercise of the discretion conferred upon them, the court will not interfere."[36]

There has been a renewed and heightened emphasis on duty of loyalty issues particularly resulting from conflict of interest situations. The typical conflict of interest arises when a museum trustee or director is on both sides of a transaction. A unique set of conflicts applies in the case of the trustee and director of a museum if that trustee is a dealer or collector of objects in the collection of the museum. Self-dealing and conflict of interest issues arise when, for example, a trustee acquires a work of art based on knowledge obtained at a board meeting, not allowing the museum to acquire it; the museum displays an object loaned by a trustee; or a trustee borrows a work owned by the museum and displays it in his or her collection.

Recently, a number of museums have developed conflict of interest policies for museum professionals and trustees. For example, the Canadian Art Museum Directors Organization in its handbook for trustees provides in pertinent part:

> Objectivity is essential for guiding the museum and for public confidence in the museum. Real and apparent conflicts of interest must be scrupulously avoided. This means for example that:
>
> Private collecting practices should be declared, and any advice sought from the museum's professional staff or any collection-related decisions that might benefit the trustee recorded.
>
> Private business interests should be declared and the trustee should withdraw from any decisions on purchase of

goods or services that might benefit the trustee directly or indirectly. Consultants who are trustees should not do paid work for the museum while serving on the board.

Artists who are trustees may not donate works of their own art to the permanent collection or be considered for an exhibition of their work, either solo, group or juried.[37]

Museums have also adopted restrictions concerning dealers participating on museum boards or acquisition or deaccessioning committees. New guidelines have been developed to deal with financial conflicts of interest and prevent self-dealing. For example, a trustee should not participate in discussions of any business dealing in which the trustee or an immediate family member has a financial interest; acquire any museum property (administrative property or items from the collection) whether sold at private sale, in the museum store, or at auction; or knowingly provide professional advice or act as an agent for another person regarding purchase of an object in competition with the museum.

One of the results of the revelations of corporate scandals such as Enron and WorldCom in 2001 led to the enactment of a new federal law, the Sarbanes-Oxley Act of 2002 that requires greater compliance with accounting rules and greater transparency. The consensus of the legal community is that the statute does not apply to nonprofit organizations, but that in light of Sarbanes-Oxley, regulators and the public are going to be taking a closer look at how nonprofit boards of directors manage the affairs of the corporation. In fact, the Internal Revenue Service is already drafting new regulations impacting nonprofit accounting and reporting.

In 2005, the ABA Coordinating Committee on Non-Profit Governance published a "Guide to Non-Profit Corporate Governance in the Wake of Sarbanes-Oxley." The guide recommends that a nonprofit organization "should adopt and implement ethics and business conduct codes applicable to directors, senior management, agents, and employees that reflect the commitment to operating in the best interests of the organization and in compliance with applicable law, ethics business standards, and the organization's governing documents. The guide observes in relevant part that such codes should include 'definitions of procedures for handling conflict of interest.'" The guide continues, "Conflict codes should cover self-dealing transactions as well as prohibitions against personal use of corporate assets . . ."

Steve Gunderson, president of the Council of Foundations, which represents more than 2,000 grant making foundations, recently stated,

"Foundations are clearly in an era of public scrutiny because we are growing in size and service, and in public awareness." In December 2005, the Council placed the Getty Trust on probation for allegedly allowing Mr. Munitz, the Getty's president, and Marion True, curator, "use of foundation assets for personal benefit and potential self-dealing as questions about its spending became public and the trust did not cooperate fully with an inquiry begun by the Council. The Council, which can censure or eject members, said it was looking into whether trust officials had used the trust's money for personal benefit; into a land deal between the trust and Eli Broad, a billionaire financier who is a friend of Mr. Munitz, the Getty Trust's president, and into whether there was "inappropriate compensation for the foundation's CEO and potential self-dealing."[38]

After a dearth of any discussion of these issues since the eighties, ALI-ABA announces that its 2006 Legal Problems of Museum Administration will include "Duty of Loyalty: What Is Required of Your Staff and Governing Board," "Developing Conflicts of Interest and Whistleblower Policies for Your Staff and Governing Board," "Ethical and Legal Audit for Museums," and "When Curators, Conservators, or Other Museum Staff Moonlight: Ethical and Legal Issues," reflecting a renewed interest in this area sparked by recent developments.

The subject of this chapter is in flux. Certain areas of conflict of interest involving museum trustees, auction houses, catalogue raisonné scholars, and the curator/art critic require further examination. Both law and ethics evolve in response to changing conditions, values, and ideas. Within each area and in the context of a particular art profession, ethical behavior may prohibit even the appearance of a conflict, or accept conflict with disclosure, or accept conflict as a way of business. When is undue influence a violation of law, ethics, or simply a question of power? Because of the sensitivity as well as the ambiguity surrounding conflict of interest, professionals involved in the authenticating, exhibiting, collecting, and appraisal of art and trustees of museums should develop conflict-of-interest policies. If there can be said to be any evolving consensus, it is that there is a need for increased transparency and accountability in the art world.

Endnotes

[1] Established in 1911, the College Art Association is a learned society of artists and art historians. It is the largest membership organization representing artists and art historians affiliated with universities.

[2] College Art Association Code of Ethics for Art Historians, 1971, *www .collegeart.org/caa/ethics/art_hist_ethics.html.*

[3] *Hartt v. Newspaper Publishing Queen's Bench Division* (Justice Morland, 6 December 1989).

[4] David M. Herszenhorn, "Brooklyn Museum Accused of Trying to Spur Art Value," *New York Times*, September 30, 1999.

[5] Judith Dobrzynski, "A Possible Conflict by Museums in Art Sales," *New York Times*, February 21, 2000.

[6] See also Curators Code of Ethics, 1996, *www.curcom.org/ethics.php.*

[7] See the Guidelines on Exhibiting Objects, July 2000, AAM Board of Directors. These guidelines were also followed by Guidelines for Museums on Developing and Managing Business Support, November 2001.

[8] 84 MISC 2d 830 379 N.Y.S. 2d 925 (Sur. Ct) aff'd 43 N.Y. 2d 305 (1977), modified 392 N.Y.S. 2d 870 (1st Dept).

[9] Restatement (Third) of Trusts § 170 (1990). ("Perhaps the most fundamental duty of a trustee is that he must display throughout the administration of the trust complete loyalty to the interests of the beneficiary.")

[10] See ICOM Code of Ethics for Museums, *http://icom.museum/ethics_ rev_engl.html.*

[11] College Art Association Code of Ethics for Art Historians, 1971, op cit. note 2.

[12] See Ellsworth H. Brown, Code of Ethics for Museums, in *Legal Problems of Museum Administration*, note 17, at 145, 149–50.

[13] Stephen Mark Levy, "Liability of the Art Expert for Professional Malpractice," *Wisconsin Law Review*, no. 4 (1991), 634.

[14] Hilton Kramer, "20th Century Collectors: The Patrons Have a Show," *New York Observer*, June 19, 2000.

[15] College Art Association Code of Ethics for Art Historians, 1971.

[16] Stephen Mark Levy, op. cit., note 15.

[17] Association of Art Museum Directors Code of Ethics, 2001, *www.aamd.org/about/#Code.*

[18] Association of Art Museum Directors Code of Ethics, id.

[19] *United States of America v. James Burke*, 718 F. Supp. 1130 (S.D.N.Y. 1983). ("The only concrete allegation defendants have made—that these experts owned many Dali prints—is without substance. It is natural that one knowledgeable about a prolific modern artist would own that artist's work; to the extent that mere ownership is evidence of bias, virtually any modern art expert would be suspect. There has been no showing that these individuals were hiding motives comparable to those of the informants in cases defendants cite where no probable cause was found.")

[20] Michael Findlay, "The Catalogue Raisonné" in *The Expert Versus the Object*, ed. Ronald D. Spencer (Oxford University Press, 2004), 55.

[21] Michael Findlay, id., 58.

[22] *Findlay v. Duthuit*, 86 A.D. 2d 789, 790, 446 N.Y.S. 2d 951, 952 (1982).

[23] *Findlay v. Duthuit*, id.

[24] Art Dealers Association of America Web page, *http://www.artdealers.org/ who.history.html.*

[25] See Alex Rosenberg's chapter.

[26] "Stallone Files $5 Million Suit Against New York Art Consultant," *New York Times*, December 27, 1989.

[27] *Fenton v. Freedman*, 748 F. 2d 1358 (9th Cir. 1984).

[28] *Jack Granat and Sandi Granat v. Center Art Galleries—Hawaii, Inc and William Mett*, 91 Civ. 7252 (1993 U.S. Dist. Lexis 14092).

[29] New York Art and Cultural Affairs Law § 12:01.

[30] *Greenwood v. Koven*, 880 F. Supp. 186 (S.D.N.Y. 1995).

[31] The Museum of the American Indian's deaccession "policy" came to light when a new trustee was offered artifacts for purchase that he recognized to be part of the museum's collection.

[32] Jason R. Goldstein, "Deaccession: Not Such a Dirty Word," *Cardozo Arts & Entertainment Law Journal* 15 (1997): 219.

[33] *New York Times*, January 14, 1973.

[34] *Meinhard v. Salmon*, 249 NY 458, 464 (1928).

[35] *Stern v. Lucy Webb*, 381 F. Supp. at 1013 (DDC 1974).

[36] In 1980, the Pasadena Art Museum's collection included both modern art and traditional art. After due deliberations, the board of directors decided that the museum could not do a good job collecting and interpreting both modern art and traditional art; accordingly, it was decided to dispose of the modern art collection and use the proceeds to augment the collection of traditional art. "So long as trustees act in good faith and exercise reasonable care . . . the decision must be left in the hands of the trustees, where it has been placed by law."

[37] Canadian Art Museum Directors Organization, "Roles and Responsibilities of Museum Boards of Trustees," *www.museums.ca/Cma1/ ReportsDownloads/ trusteesguidelines.pdf.* See also Metropolitan Museum of Art: Ethical Guidelines for Trustees; Art Institute of Chicago: Conflict of Interest Policy and Internal Revenue Service Sample Conflict of Interest Policy, pages 25–26 of the Instructions to Form 1023, Application for Recognition of Exemption.

[38] Randy Kennedy and Carol Vogel, "Executive Severance Is a Focus at Getty," *New York Times*, February 11, 2006. See also Statement of Values and Codes of Ethics for Nonprofit and Philanthropic Organization ethics @ Independentsector.org.

CONTRIBUTORS

Suzaan Boettger is the author of the comprehensive history, *Earthworks: Art and the Landscape of the Sixties.* An active critic and lecturer based in New York City, she has contributed to the exhibition catalog *Robert Smithson and Poetic Injury: The Surrealist Legacy in Postmodern Photography* and to the anthologies *New Feminist Criticism, Art, Identity, Action* and *The Columbia Guide to America in the Sixties.*

Eric Fischl was born in New York City in 1948, and grew up on suburban Long Island. In 1967, he began his studies of art at Phoenix Community College. He graduated with a BFA from California Institute of the Arts in 1972, and moved to Chicago. In 1974, he accepted a teaching position in Halifax, Nova Scotia. There he met his future wife, the painter April Gornik. They moved to New York in 1978.

Tom L. Freudenheim has served as a museum director in Baltimore, Worcester, Berlin, and London. He was director of the National Endowment for the Art's Museum Program, and as assistant secretary for museums at the Smithsonian Institution, had oversight responsibility for the national museums. He has written and lectured extensively on museum issues.

Barbara T. Hoffman is the principal in a national and international art, entertainment and intellectual property law practice based in New York. She has written and spoken widely on copyright and art law subjects with her most recent publication *Art and Cultural Heritage: Law, Policy and Practice* (Cambridge University Press, 2006). Hoffman counsels and litigates on behalf of numerous artists, collectors, museums, galleries, nonprofit foundations and other art world players as well as representing documentary film and TV producers, visual artists and photographers. Her Web site is *www.hoffmanlawfirm.org.*

Deborah J. Haynes has written about artists' engagement with new technologies, most recently having co-edited a special issue of the feminist journal *Frontiers* about gender, race, ethnicity, and information technology. (**Joyce Cutler-Shaw's** artistic work focuses on the dehumanizing consequences of splitting the image of the body from the physical and sentient self. She is the first artist-in-residence at the School of Medicine at the University of California, San Diego, and her drawings and artist's books are represented in international collections. **Margot Lovejoy** is a historian of new media and professor of visual arts at the State University of New York at Purchase, as well as a working artist whose installation and Web works have been exhibited internationally.)

James Janowski is associate professor and chair of the philosophy department at Hampden-Sydney College. His interests include ethics and philosophy of art, and he focuses in particular on the philosophical issues that arise concerning the conservation of artworks. Janowski is currently working on a project that assesses the appropriateness of resurrecting the Bamiyan Buddhas.

Elaine A. King, a professor at Carnegie Mellon, teaches the history of art/theory and museum studies. In 2000 and 2001, she was a senior research fellow at the Smithsonian American Art Museum and National Portrait Gallery. King was the executive director of the Carnegie Mellon Art Gallery (1985–1991) and the Contemporary Arts Center in Cincinnati (1993–1995). She is a freelance curator/critic who lectures and curates internationally, and writes extensively about artists and thematic issues. Currently she is completing books on the National Endowment for the Arts and on the evolution of portraiture in the United States since 1960 titled *In Your Face*.

Gail Levin's work has been published in more than fifteen countries. Among her books are: *Aaron Copland's America: A Cultural Perspective; Hopper's Places; Edward Hopper: A Catalog Raisonné; Edward Hopper: An Intimate Biography* and forthcoming, *Becoming Judy Chicago: A Biography of the Artist*. A professor of art history, American studies, and women's studies at Baruch College and the Graduate Center of the City University of New York, she was a curator at the Whitney Museum from 1976–1984. She has exhibited and published her photographs, which are represented in public collections.

Ellen K. Levy, an artist and teacher of art and science interrelationships, is president of the College Art Association (2004–2006). Recipient of a NASA commission in 1985, she was a distinguished visiting fellow of arts and sciences at Skidmore College in 1999, a position funded by the Henry Luce Foundation. She creates genealogies of technological inventions and has exhibited widely in the United States and abroad.

Joan Marter is distinguished professor of art history at Rutgers University and director of the certificate program in curatorial studies. She has been guest

curator for fifteen exhibitions at museums, including the Metropolitan Museum of Art, Corcoran Museum of Art, the Newark Museum, and the Detroit Institute of Art. Marter's books include monographs on Alexander Calder, José de Rivera, and Theodore Roszak, and she is the editor of *Woman's Art Journal*.

Robert C. Morgan is an art critic, curator, artist, poet, and art historian. He is a contributing editor to *Tema Celeste* and *Sculpture* magazine and received in 1999 the Arcale award in art criticism in Salamanca, Spain. In 2005, he was awarded an Albee and Fulbright Fellowship. He is the author of *Conceptual Art: An American Perspective, Art into Ideas, Between Modernism and Conceptual Art*, and *The End of the Art World*.

Saul Ostrow is dean of visual arts and technologies and chair of painting at the Cleveland Institute of Art. He is the editor of the book series *Critical Voices in Art: Theory and Culture* published by Routledge, art editor for *Bomb* magazine, and co-editor of Lusitania Press. Since 1987 he has curated over seventy exhibitions, and his writings have appeared in art magazines, catalogs, and books in the United States and Europe.

Dr. Alex Rosenberg was a publisher of original graphic art and ran a gallery in New York. He was formerly president of the Appraisers Association of America, and a trustee of Philadelphia University. He is a trustee of the Tel Aviv Museum of Art. In 2004 the National Arts Club honored him for lifetime achievement. In 1991 he won a consent decree from the U.S. government to be able to import art from Cuba in accordance with the First Amendment. Rosenberg is visiting professor of art at the Instituto Superior de Arte in Havana and an adjunct professor at New York University where he teaches appraising.

Elizabeth A. Sackler, a public historian and philanthropic activist, is the founder and president of the American Indian Ritual Object Repatriation Foundation, CEO of the Arthur M. Sackler Foundation, a member of the board of the Brooklyn Museum and the National Advisory Board of the National Museum of Women in the Arts in Washington, D.C. A lecturer and writer, her papers and articles are published in scholarly journals and national magazines.

Richard Serra is an internationally acclaimed sculptor who lives and works in New York City and Cape Breton, Nova Scotia. His public artwork titled *Tilted Arc* was removed from Federal Plaza in New York City in 1989, after a controversial federal hearing.

Nada Shabout is an assistant professor of art history at the University of North Texas, teaching Arab visual culture and Islamic art. She recently curated a contemporary Iraqi art exhibition, *Dafatir*, and is currently working on the documentation of modern Iraqi heritage, particularly the collection previously held at the Iraqi Museum of Modern Art, and investigating the relationship of identity and visual representations.

Ori Z. Soltes is professorial lecturer in theology and fine arts at Georgetown University and former director of the B'nai B'rith Klutznick National Jewish Museum in Washington, D.C. He co-founded the *Holocaust Art Restitution Project* and is the author of over 110 articles, exhibition catalogs, essays, and books on a range of topics, including *Our Sacred Signs: How Jewish, Christian and Muslim Art Draw from the Same Source.*

Alan Wallach is professor of art and art history and of American studies at the College of William and Mary. He is the author of *Exhibiting Contradiction: Essays on the Art Museum in the United States* (University of Massachusetts Press), and his writings have appeared in a variety of publications. His current scholarly concerns include American art museums and the history of landscape vision in the United States in the period 1800–1880.

Stephen E. Weil (1928–2005), long considered one of the most insightful and candid commentators on museum policy and practice, was widely recognized for his service to the museum profession. Weil was scholar emeritus of the Smithsonian Center for Education and Museum Studies (SCEMS), and served from 1974 until his retirement in 1995 as deputy director of the Hirshhorn Museum and Sculpture Garden. He was a presidential appointee to the Cultural Property Advisory Committee, U.S. Department of State, and received the Distinguished Service Award from the American Association of Museums in 1995. He was instrumental in the creation and development of the Museum Management Institute, and the annual ALI-ABA Course of Study on Legal Problems of Museum Administration. During more than forty years as an attorney and museum executive, Stephen Weil published numerous books and articles, including *Rethinking the Museum, Cabinet of Curiosities: Inquiries into Museums and Their Prospects,* and *Making Museums Matter* (Washington, D.C.: Smithsonian Institution Press, 2002).

CREDITS

So, What's the Price?—The PM Principle—Power, People, & Money © Elaine A. King

The Unethical Art Museum © Alan Wallach

Consuming Emancipation: Ethics, Culture, and Politics © Saul Ostrow

Museum Collecting, Clear Title, and the Ethics of Power © Tom L. Freudenheim

Politics, Ethics, and Memory: Nazi Art Plunder and Holocaust Art Restitution © Ori Soltes

Calling for a Code of Ethics in the Indian Art Market © Elizabeth A. Sackler

The Preservation of Iraqi Modern Heritage in the Aftermath of the U.S. Invasion of 2003 © Nada Shabout

Ethics of Appraising Fine Art © Alex Rosenberg

Artists' Estates: When Trust Is Betrayed © Gail Levin

The Moral Case for Restoring Artworks © James Janowski

Ethical Issues and Curatorial Practices © Joan Marter

Fair Use and the Visual Arts: Please Leave Some Room for Robin Hood © Stephen E. Weil

Interrogating New Media: A Conversation with Joyce Cutler-Shaw and Margot Lovejoy © Deborah J. Haynes

Art and Censorship © Richard Serra

The Trauma of 9/11 and Its Impact on Artists © Eric Fischl

Art Enters the Biotechnology Debate: Questions of Ethics © Ellen K. Levy

Earthworks' Contingencies © Suzaan Boettger

Unraveling the Ethics in Cultural Globalization © Robert C. Morgan

Law, Ethics, and the Visual Arts: The Many Facets of Conflict of Interest © Barbara T. Hoffman

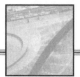

INDEX

Books from Allworth Press

Allworth Press is an imprint of Allworth Communications, Inc. Selected titles are listed below.

Sculpture in the Age of Doubt
by Thomas McEvilley (paperback with flaps, 6 × 9, 448 pages, $24.95)

Sticky Sublime
edited by Bill Beckley (hardcover, 6 ¼ × 9 ¼, 272 pages, $24.95)

Uncontrollable Beauty: Toward a New Aesthetics
edited by Bill Beckley with David Shapiro (paperback, 6 × 9, 448 pages, $19.95)

Out of the Box: The Reinvention of Art: 1965–1975
by Carter Ratcliff (paperback with flaps, 6 × 9, 312 pages, $19.95)

Beauty and the Contemporary Sublime
by Jeremy Gilbert-Rolfe (paperback with flaps, 6 × 9, 208 pages, $18.95)

The End of the Art World
by Robert C. Morgan (paperback with flaps, 6 × 9, 256 pages, $18.95)

The Quotable Artist
by Peggy Hadden (hardcover, 7 ½ × 7 ½, 224 pages, $19.95)

The Artist's Quest for Inspiration, Second Edition
by Peggy Hadden (paperback, 6 × 9, 272 pages, $19.95)

Caring for Your Art, Third Edition
by Jill Snyder (paperback, 6 × 9, 256 pages, $19.95)

The Swastika: Symbol Beyond Redemption?
by Steven Heller (paperback, 6 ¼ × 9 ¼, 288 pages, $21.95)

Graphic Design History
by Steven Heller and Georgette Ballance (paperback, 6 ¾ × 9 ⅞, 352 pages, $21.95)

Please write to request our free catalog. To order by credit card, call 1-800-491-2808 or send a check or money order to Allworth Press, 10 East 23rd Street, Suite 510, New York, NY 10010. Include $6 for shipping and handling for the first book ordered and $1 for each additional book. Eleven dollars plus $1 for each additional book if ordering from Canada. New York State residents must add sales tax.

To see our complete catalog on the World Wide Web, or to order online, you can find us at **www.allworth.com**.